MAXFIELD PARRISH

and the American Imagists

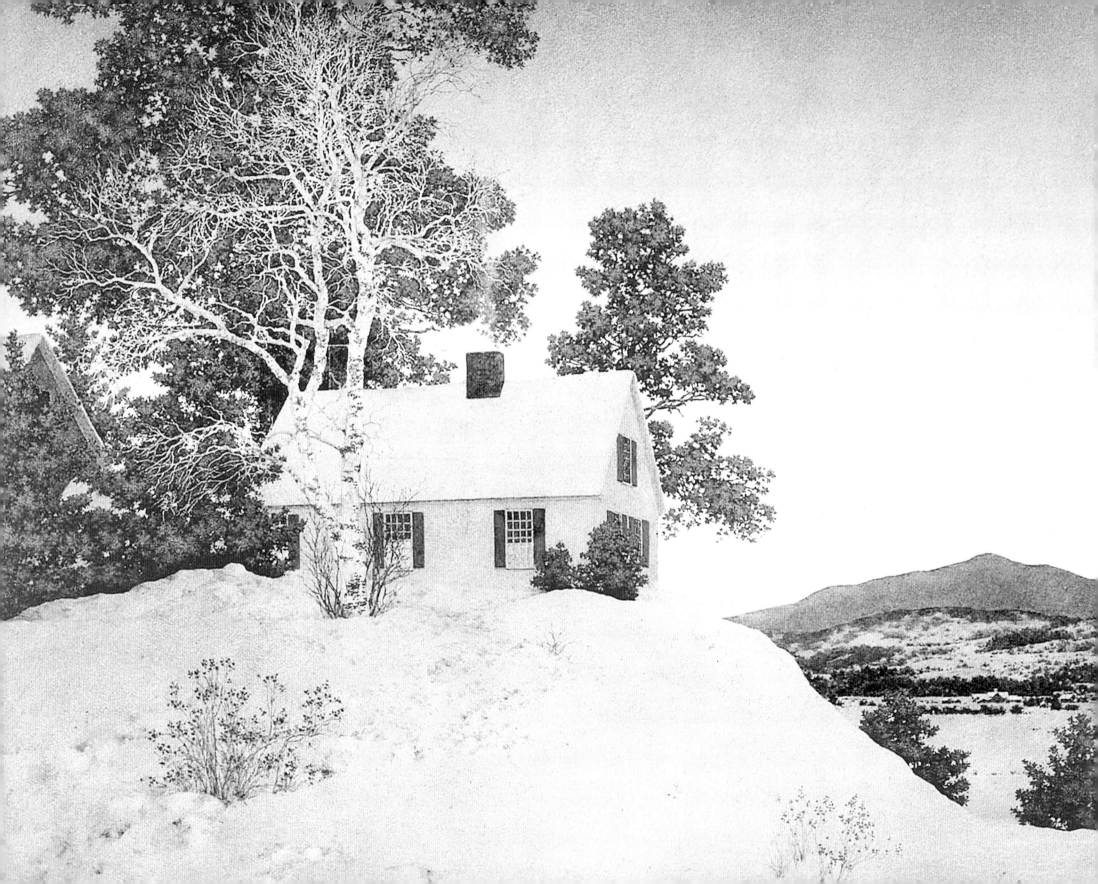

MAXFIELD PARRISH

and the American Imagists

Laurence S. Cutler, Judy Goffman Cutler, and the National Museum of
American Illustration

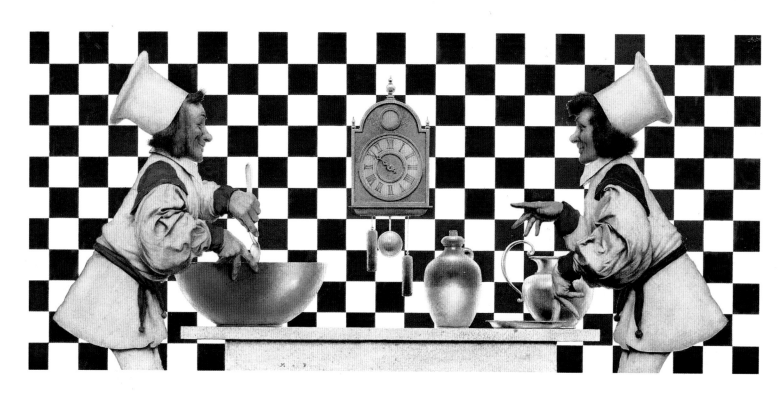

THE WELLFLEET PRESS
WELLFLEET

Published in 2004 by
The Wellfleet Press
A division of Book Sales, Inc.
Raritan Center
114 Northfield Avenue
Edison. NJ 08837 USA

Acknowledgements
In 1896, Professor Herbert von Herkomer wrote the first review of a Maxfield Parrish painting. Thereafter, a plethora of articles, reviews and scholarly critiques of Parrish's work appeared year after year. By the roaring twenties, the entire country had become familiar with Parrish's romantic fantasy images, though they knew little about the artist-illustrator himself. More than half a century later, in 1973, Coy Ludwig rediscovered Parrish's unique personality and titanic creative powers in the first book written about him, simply called, *Maxfield Parrish*, when a great creative talent and an extraordinary human being was revealed.

Our first book on Maxfield Parrish was written in 1993, with Coy Ludwig's encouragement. It was released 27 years after Parrish's death and 20 years after Ludwig's seminal book was released. In it, we included images never previously published before, as well as observations on the artist's closest relationships with insights into his remarkable personality. It also included the first analysis of the origins of his unique painting style.

When we first envisaged a Maxfield Parrish retrospective exhibition over ten years ago, Coy Ludwig supported that effort and attended the U.S. opening at the Norman Rockwell Museum in Stockbridge, Massachusetts, where crowds of visitors and the Parrish family were all in attendance.

The exhibition was the first non-Rockwell exhibition at that single-artist museum in the shadows of the Berkshire Mountains, not far from Cornish, New Hampshire. 'Maxfield Parrish: A Retrospective' opened at the Norman Rockwell Museum in the midst of a New England blizzard. It comprised 110 original artworks and 150 vintage prints, memorabilia and photographs; the exhibition had just returned from touring Asia and had been a resounding success, having achieved record attendance levels wherever it had been shown. Likewise, the opening party in western Massachusetts drew a larger audience than that for the Norman Rockwell Museum itself. Passionate Parrish aficionados came from all over the country, from as far away as Seattle and San Antonio, Miami, San Francisco and New Orleans – all remaining throughout brown-outs and other unforeseen winter conditions.

For Coy Ludwig's support and inspiration regarding our books and exhibitions, we sincerely acknowledge and thank him once again. For the foresight to undertake that benchmark Parrish retrospective exhibition, we thank Norman Rockwell Museum director, Laurie Norton Moffat and her exceptional staff, most especially Stephanie Plunkett and Linda Szekely for their customary professionalism. A few years later, at our suggestion, another Parrish retrospective exhibition was mounted by the American Federation of Arts (AFA) and the Pennsylvania Academy of the Fine Arts (PAFA). Unfortunately, their show was only able to borrow 56 original artworks, supplemented by 60 vintage items, but it was received with as much enthusiasm as ever. Parrish's magic has once again attracted new fans from travelling exhibitions such as these.

The authors wish to acknowledge these additional persons and institutions, for without their help it would not have been possible to complete this book: The Maxfield Parrish Organization; The Maxfield Parrish Catalogue Raisonné Committee; Nancy Norwalk and the Maxfield Parrish Stage Set Committee; Plainfield Historical Society; Joanna Maxfield Parrish; Dartmouth College Baker Library – Special Collections; the Quaker Collection at the Haverford College Library; Delaware Art Museum Library; Mary Ellen F. Ellis of the New Britain Museum of American Art; Susan and Ned Dana of the Trinity Episcopal Church in Lenox, Massachusetts. At the National Museum of American Illustration, we especially acknowledge and thank Zachary Cutler for his constant and professional assistance in this effort, Jennifer Paige Greenawalt, Jill Perkins and Brennan Shannon. The American Illustrators Gallery in New York City has several staff members whom we acknowledge for their enthusiastic and invaluable assistance and untiring efforts, including Max Cutler, Andrew Goffman, Daniel Haar and Jessica Labbé.

We also wish to thank these friends, colleagues and family for their contributions and understanding: Lena and Abe Alpert, Ona Alpert, Richard Bonarrigo and Diane Tabor-Bonarrigo, David Breznicky, Martin Bressler Esq., Kevin Doyle, Judy and David Glinert, Miselle Goffman, Jon Greenawalt, Jr., Mary Ann and Jon Greenawalt, Jim Halperin, Craig Hibbad, Joyce and Harry Himmel, Jack W. Jacobsen – 'The Man behind the Man behind the Make-Believe', Saskia Jell, Darwin Lin, Gary Meyers, Alan H. Rothschild, Esq., Bill Santos, Dr. Noel-Marie Langan, Ira Spanierman, Dr. Bruce Yaffe, and Roz Wells, along with her late son Jason and late ex-husband Tom, who were the first caretakers of Parrish's legacy at The Oaks. We also give thanks to the late Virginia Reed Colby, Lady of Black Swan Farm, for dismissing those baseless myths and bizarre ghostly sightings of Maxfield Parrish. If there really were ghosts, we know where you would be, Virginia.

When the idea for this book first arose, it was described as a large volume on the illustrator's life and works, with the works of other illustrators from the American Imagists School – an enticing idea indeed. One must constantly remember that illustrators were long scorned by the fine arts establishment, somewhat disparagingly regarded as mere 'commercial artists'. Ernest Elmo Calkins remarked in *A Book of Notable American Illustrators* (1926), that the time had come to drop the phrase 'commercial artist'. It is too often used as a term of reproach, and the reproach is no longer deserved. Those who use it mean artists looking to make the maximum profit from their work, rather than those who work within a commercial environment. Whether they are adding to the effectiveness of an advertisement or illustrating a book or making a mural, it can still be an art form, assuming that they can be regarded as artists in the first place. Patronage has varied throughout the ages and it is purely

incidental that today it is the business world rather than the church that is predominant today: there are many examples of art produced for utilitarian purposes which can still be regarded as art. The Cambio at Perugia was decorated by Perugino; Hogarth designed tradesmen's cards; Watteau painted a signboard for a milliner; Millais produced the famous *Bubbles* (1886) for Pears Soap.

Today, illustrators have the National Museum of American Illustration (NMAI) to support them, a non-profitable institution which looks after their interests. And there is this book, written to present Parrish's oeuvre to new audiences. For this reason we thank our publishers, Regency House Publishing Limited, who have worked with us on several other projects and understand our enthusiasm for Maxfield Parrish. With the help of the National Museum of American Illustration it will make the art of Parrish and his circle, those other masters of American illustration, available for everyone to see and enjoy.

Dedication
We dedicate this book to two new lives, our first grandson, Julian Asher Greenawalt, born on 28 March 2002, our second granddaughter, Renata Louise Goffman, born on 2 October 2002, also our first granddaughter, Allegra Rose Greenawalt, with hopes that their futures be bright. We also remember three friends, recently deceased, for their unwavering support when we were establishing the National Museum of American Illustration at Vernon Court: J. Carter Brown, Director Emeritus of the National Gallery of Art in Washington, D.C., a member of Rhode Island's Brown family and Honorary Trustee of the NMAI; Chauncey Dewey, World Bank executive and Newporter extraordinaire, member of the NMAI Advisory Board – New England Council; and Giulio Cesare Carani, chairman of Crisari srl of Rome, connoisseur, entrepreneur and lover of all things American, Italian and a few things Nigerian, member of the NMAI Advisory Board – International Council.

Finally, let us also dedicate this book to Maxfield Parrish, who translated for us his
Dreams into paintings
Fantasy into reality
The mundane into magnificence
Beauty into splendor
And
Paintings into dreams

A Prefatory Note
The first book we wrote on Maxfield Parrish was published in England in 1993 and our most recent appeared in China in 2002, the first book in Chinese on an American illustrator. Darwin Lin, the Taiwanese publisher, is a colleague in the art world, and is a member of the NMAI Advisory Board – International Council. Interestingly, Parrish's illustrations have become very popular with publishers in Europe and Asia and have also been the subjects of exhibitions in Japan, Italy and France, indicating that the art of Maxfield Parrish is not limited to his own country. Parrish art prints sell in 42 countries and there are collectors of his original artworks in many of these.

Given the fickleness of public taste, artists are often fashionable for a time before falling out of favour. It may be Keith Haring one day – John Currin the next, while even established masters go in and out of fashion. However, it is a sign of Maxfield Parrish's enduring popularity that his calendar images are published year on year, decade on decade, which has continued for nearly 100 years. In fact, the demand for Parrish's art continues to grow and publishers, film-makers, museums, scholars and collectors constantly approach us with questions, new discoveries and still more questions on every occasion possible.

It is a tradition that art books come bearing the artist's name in isolation. In fact, we were not surprised to find six books by Nancy Mathews on Mary Cassatt, the American Impressionist, all simply called 'Mary Cassatt'. Coy Ludwig's book on Parrish was similarly titled and we have usually followed suit. This time, however, there are some significant differences. The title is not only more

comprehensive, but more importantly acknowledges Parrish's place in the history of American illustration. The book is based on the premise that such illustration is serious art practised by talented, well-trained artists worthy of recognition by the fine arts establishment. In fact, illustration art is now considered 'the most American of American art'. Here, Maxfield Parrish is presented as one of the American Imagists, a 'school' of artists which comprises a circle of colleagues, all creators of iconic images, which has contributed significantly to American culture and which equates with other schools of fine art long established and recognized as such.

Laurence S. Cutler
Judy A. G. Cutler
The National Museum of American Illustration
Vernon Court
Newport, Rhode Island, U.S.A.
March 2004

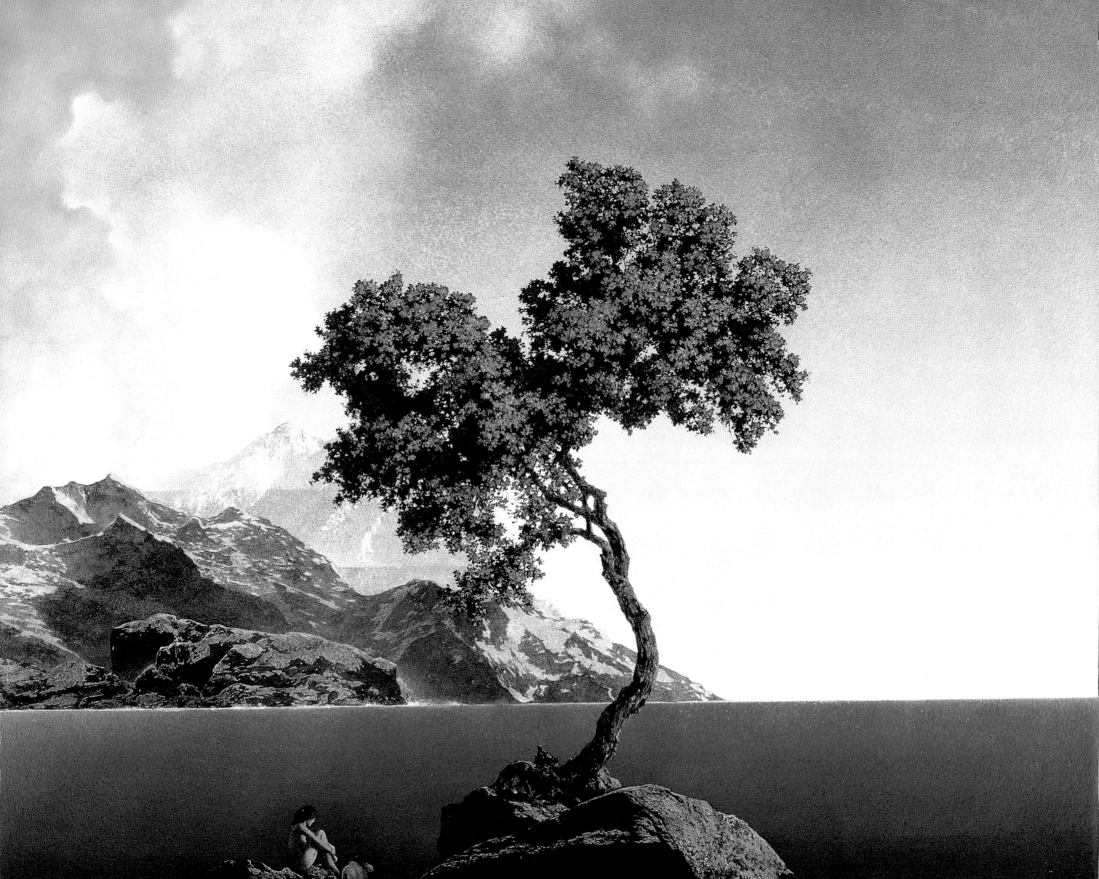

CONTENTS

PART ONE
INTRODUCTION

Maxfield Parrish is remembered as one of the greatest illustrators of the 'Golden Age of American Illustration', a period from about 1895 to 1930 of unparalleled excellence in illustrative art. Parrish's images achieved remarkable popularity and critical acclaim when they appeared on the covers of countless periodicals and books, making him the most celebrated illustrator of the first half of the 20th century, incredibly famous and immensely wealthy. Even now, more than a century later, his popularity has never waned and he continues to attract new admirers.

For over 65 years, Parrish produced book, magazine and calendar illustrations, advertisements, posters, paintings and murals, using a unique combination of luminous colour, photorealism, geometrically-based spatial composition and fantastical imagery which captured the imagination of a nation.

Maxfield Parrish began life in Philadelphia in 1870 at a time when his father, Stephen, owner of a stationary store, was dreaming of becoming an artist. Ultimately, Stephen Parrish was to become an etcher and his prolific artworks were destined to be coveted and collected internationally, winning him awards and national exhibitions across America. But Stephen Parrish could never have envisaged the future artistic accomplishments of his son, which were to eclipse his own by far. Maxfield Parrish became one of the most popular artist-illustrators in history, captivating the American nation with his unique vision: everywhere one looked his art prints were in evidence – on magazine and book covers, on advertising billboards, in newspapers and on flyers – they were literally everywhere. It was once estimated that one in every four households in America had Parrish's *Daybreak* on its living-room walls. This figure was estimated by taking the population of the U.S.A. in 1925 and dividing it by the number of prints produced by the House of Art, Parrish's exclusive distributor. It is astounding to even contemplate such popularity.

To understand this artist/illustrator, it is important to recognize that during his lifetime an extraordinary range of technological changes were taking place. From his birth, just a few years after the Civil War, until his death in the middle of the Vietnam War, great changes were afoot; it was a span of time which had begun when slavery was commonplace and ended with the Beat Generation, concepts not easy to reconcile. Parrish witnessed the presidencies of both Ulysses S. Grant and Lyndon B. Johnson, with all the historical events and upheavals that characterized the time.

Parrish's character is full of ambiguities. To a certain extent he was at odds with the world he had inherited, causing him first to 'drop out' from college and later from the mainstream altogether. Some years later, another famous dropout, J.D. Salinger, moved to Cornish, suggesting the possibility that Maxfield Parrish's earlier example had not escaped him.

It may not have been the desire to distance himself from such rapid changes, with all their upheavals, so much as a longing for a simple, private life in the New Hampshire hills, where he could be alone and concentrate on his art. Here Parrish could insulate himself from the brutalities of modern society, where he was more at home reading *Century Magazine* than coping with new machinery. Adjusting himself to his son's Stutz Bearcat had been bad enough after being accustomed to a horse and buggy, but the idea of an atomic bomb destroying Hiroshima and tens of thousands of people was intolerable to a creative artist whose most violent action had been shooting squirrels in the New Hampshire forests.

Parrish belongs to the School of American Imagists, creators of iconic illustrations and graphic images which have become an enduring part of the American way of life, and which are recognized and cherished as such. These images have contributed to both popular and mainstream culture: the New Year's Baby, Mother's Day flowers, Uncle Sam demanding of the viewer, 'I Want You', the idealization of American feminine beauty in the 'Gibson Girl', the 'Christy Girl', the 'Fadeaway Girl', not forgetting 'Arrow Collar Man' – all icons of the American way of life. It was inevitable that these images should

have spread far and wide, given the technological developments in publishing at the inception of the Golden Age. Consequently, the mass hunger created for such images fed upon itself and the public demanded ever more of the same. Enter Maxfield Parrish, a worthy member of the company of other great American imagists: Norman Rockwell, N.C. Wyeth, Howard Pyle, J.C. Leyendecker, Charles Dana Gibson and many others.

The American Imagists took their influence directly from the English Pre-Raphaelite Brotherhood (which in Parrish's case included an admiration for Frederic Leighton and Dante Gabriel Rossetti), from the Arts and Crafts Movement (William Morris and Charles Rennie Mackintosh), and from Art Nouveau (Alphonse Mucha and Aubrey Beardsley), the Symbolists (Pierre Puvis de Chavannes and Odilon Redon) and Les Nabis (Pierre Bonnard and Maurice Denis). These influential schools of thought valued naturalistic styles in art and eschewed academic conventions; they valued individual craftsmanship but also admired decorative elements consisting of intricate details and sinuous patterns. As individuals, however, the American Imagists could be quite different from one another, since they represented a cultural diversity in a new society for which they, as a group, were producing lasting images.

Some illustrators were willing to change their styles to accommodate the requirements of a particular commission or the whims of a client, but not Parrish; his work was unmistakably his own and it was consequently inimitable. At the same time, it was so enchanting and original that it was able to sell almost anything, from electric light bulbs to a simple dessert. His images were captivating yet powerful, hard to ignore and with a degree of fantasy so arresting that their creator became a legend in his lifetime. Yet in spite of this, Parrish retained his artistic integrity and was an exemplar to those who followed him.

Maxfield Parrish's use of colour was immediate: it came straight from the tube and was applied unmixed directly to the wooden panels on which he painted. The colours were bold and intense; in fact, the cobalt blue he used is still referred to as 'Parrish Blue'. To produce his fantastical creations, Parrish took scores of photographs of models in costume, cutting out the figures before laying them out according to 'dynamic symmetry'– a system derived from the golden section, which utilized proportions that were pleasing to the human eye and which was used in Classical architecture. This system of dynamic symmetry had been developed between 1915 and 1920 by Professor Jay Hambidge at Yale, whose lectures Parrish had attended at the nation's first art establishment, the Salmagundi Club in New York; thereafter, the system became an integral part of Parrish's own painting technique in which all his intellectual and technical abilities were combined, resulting in a virtual 'Parrish Formula for Art'.

Maxfield Parrish was as handsome as a movie star. He was born Frederick Parrish, the son of Quaker artist/etcher Stephen Parrish and Elizabeth Bancroft Parrish of Philadelphia. He was fortunate in having had a privileged upbringing and a solid education, coming from an affluent family of doctors, landlords and bankers. As an artist himself, and the only one in the family so far, it was natural that Stephen Parrish should have influenced his son in this direction. During the 1880s, Stephen had been recognized, along with Charles A. Platt and James Abbott McNeill Whistler, as an etcher of some importance, and it was natural that his son should go to Europe and visit the great art museums. During several long stays in Europe, therefore, Fred (Parrish later adopted Maxfield as his Christian name) was able to study the techniques of the old masters, and of Jan and Hubert van Eyck in particular, being especially smitten by the Pre-Raphaelites, their use of colour, composition and subject matter. Parrish was captivated by the work of Dante Gabriel Rossetti and John William Waterhouse, but most forcefully by that of Lord Frederic Leighton (president of the Royal Academy from 1878–96), who introduced a decorative, non-didactic style to classical subjects. Later, the direct influence of Leighton would be clearly discerned in Parrish's own work.

Stephen Parrish had made some progress in his desire to make an artist of his son, having already introduced him to the meticulous craft of etching; but while in Europe, Maxfield was startled to see how artists actually lived, Leighton in particular. At the time, scandalous stories were circulating in London regarding Leighton's relationship with his young model,

INTRODUCTION

Dorothy Dene, which more than intrigued the aspiring young artist. An uneducated cockney, the girl was reputed to be 'carrying on' with Leighton, though there are different opinions on the subject today and Leighton may merely have been fascinated as an artist by the girl's pneumatic body. He referred to her as 'fascination in drapery – wayward flow and ripple like living water together with absolute repose'. One need only glance at Parrish's later photographs of Susan Lewin, his own muse, to recognize a similar phenomenon. However, Parrish's experience of England ultimately shaped his artistic vision of himself, in which he combined an interesting mix of other 'ingredients' to produce a curious blend of naturalism, fantasy and romanticism in all his future works.

Parrish studied architecture and engineering at Haverford College for three years before finally enrolling at the Pennsylvania Academy of the Fine Arts (PAFA), where he received a formal training which brought earlier interests to mind – etching, the Pre-Raphaelites and his studies of the old masters. At PAFA, he also saw examples of Muybridge's photography, which had greatly affected Thomas Eakins, as well as developing an interest in the teaching methods of the academy. This experience of photography and the bold pure colour used by artist-teachers such as Thomas P. Anshutz and Robert W. Vonnoh, coupled with a respect for illustration, were mighty forces which left a strong impression. Coy Ludwig, in his seminal work on Parrish, remarked that Parrish's skill with a camera was the product of someone with great hand-eye co-ordination. He goes on to say that Parrish used photography as a tool; in other words, he used the camera for simple jobs, reserving his drawing skills for aspects which the camera could not capture, accuracy being of paramount importance. The camera he used most frequently was equipped with a Goerz Dagor lens with 4 x 5-in (10 x 13-cm) glass plates with fine-grain emulsion. There are even times when his photographs caught his own figure in the foreground and one can see him giving instructions to Susan Lewin, his model. Sometimes, he photographed himself intentionally, using a wire attached to the shutter. Above all, photography was a short cut, not because he was lacking in skill but because he was able to complete an artwork more quickly and spontaneously, concentrating effort where it was needed most, in the details and in the colour and shading.

Parrish was also an audit student (one who assesses the work of others) during the winter session at the Drexel Institute, in classes offered by Howard Pyle. When Pyle saw Parrish's drawings, he suggested that he abandon his studies and become an illustrator at once, which was not a bad idea, the demand for illustrators now being ferocious due to the rapid growth of national magazines.

Parrish's early years coincided with America's 'Gilded Age', Mark Twain's term for the period following the Civil War and ending with the great stock market crash of 1929, a time when corruption was endemic in commerce and politics. At the same time, Parrish's images were undergoing startling developments of their own, his imagination fuelled by prolonged travel in Europe at the climax of the Victorian age.

Parrish's professional art career began in 1895 with his first commissioned work, a mural of Old King Cole, painted for a theatrical society, the Mask and Wig Club, at the University of Pennsylvania. His first magazine illustration, for the cover of *Harper's Bazar*, led to even more magazine commissions for over 25 other national magazines during the next 40 years; moreover, his first book illustrations, for L. Frank Baum's *Mother Goose in Prose* (1897), made it one of the great classics to this day. Further book commissions followed, culminating in Parrish's 1925 masterpiece, *The Knave of Hearts*.

In addition to these, Parrish received a whole range of other lucrative commissions. Between 1918 and 1932 he produced yearly calendar illustrations for the Edison Mazda Company, and from 1920 through to the 1950s the House of Art distributed millions of Parrish's art prints, making him one of the most reproduced artists of all time. It has been said that *Daybreak* is one of the most reproduced images in history, surpassing even Andy Warhol's Campbell's soup cans. By the 1930s, however, Parrish had turned his attention

exclusively to landscape painting, signing a contract with Brown & Bigelow that yielded tens of millions of calendars, greeting cards and art prints from 1936 to 1962. His calendar, *Moonlight*, sold 750,000 copies in one month alone.

Needless to say, all this was in the halcyon days before television, movies and digital imaging began to dominate our lives. Maxfield Parrish became a media celebrity of his time – a virtual superstar. Illustrators were now regarded as valuable commodities, even cultural heroes, seen as the great communicators, the trend-setters, the arbiters of taste and other fleeting enthusiasms.

Parrish was married for 58 years to Lydia Ambler Austin, a pretty art teacher and possibly the first to document African-American slave songs. It is all the more surprising, therefore, that for over 55 years Parrish should have had a beautiful model-companion, his so-called 'costume sewer-upper', Susan Lewin. Susan lived with the artist in a studio building on his estate, The Oaks, in Plainfield, New Hampshire, which he had both designed and built. The Oaks was set in the middle of the Cornish Colony, an enclave of artists near to the banks of the Connecticut river.

Although Parrish also painted Lydia, it was Susan Lewin whom he returned to again and again during the course of his incredible career. His most notable single image of Susan remains his portrayal of her as a sublime Griselda, although she appears in various guises in his mural series, A Florentine Fête, in which she poses for almost every character, male and female.

In 1960, seven years after the mother of Parrish's four children, Lydia Austin Parrish, died, Parrish's lifelong companion, Susan Lewin, finally gave up waiting for him and married her childhood sweetheart, Earle Colby. At this time Parrish was 90 years old and still painting, so it may or may not have been a coincidence when his hand became completely frozen, supposedly from arthritis, on learning of Susan's marriage. Whatever the cause, Maxfield Parrish never painted again. He died six years later, alone in his beloved home overlooking the Connecticut river valley.

Parrish's life had been rich and full. Vincent van Gogh may have been driven to madness by his endless search for truth, but Parrish had never been given to introspection. On the other hand, a number of unusual circumstances had occurred to suggest that all was not as perfect with his life as some biographers would have us believe. Some of these are worthy of note for the effects they may have had and which would have defeated a lesser man; for example, his own father, with whom Parrish closely identified, had no success in his own marriage; Parrish himself had several bouts of serious illness in his life, followed by a possible nervous breakdown; one of his sons, Dillwyn, was so disturbed and unhappy that he ultimately committed suicide; there was a mysterious fire at the house of Parrish's friend, Winston Churchill, causing Susan Lewin, who had been deliberately separated from Parrish, to return to him; then there was an unexplained death on his property of one of Susan's former boyfriends – all of which reads like a movie script. Parrish must have been something of an optimist in that he calmly retreated to the remote hills of New Hampshire, where he created a world of make-believe which he rarely abandoned, personal tragedies and unusual events notwithstanding.

A quarter of a century after his death, Maxfield Parrish was rediscovered in 1989 at the 'Romance and Fantasy' exhibition at the American Illustrators Gallery in New York City, and a few years later at the 1993 'Great American Illustrators' exhibition at the American Illustrators Gallery, organized by Judy Goffman Cutler, its director, which later toured Japan. Parrish's work became even more popular after Judy Cutler's 1995 'Maxfield Parrish: A Retrospective' exhibition, which went to Asia and terminated at the Norman Rockwell Museum. Another Parrish exhibition, organized by the oldest art museum in the United States, the Pennsylvania Academy of the Fine Arts, opened in 1999 and ended in August 2000 at the Brooklyn Museum of Art.

As one of the most innovative and popular artist/illustrators of the past 100 years, it is surprising that there have been only a handful of exhibitions of Parrish's work. Indeed,

INTRODUCTION

from the beginning of his career until now there have been approximately 30 exhibitions, yet his impact has been nothing less than phenomenal.

The fine arts establishment continues to set its own standards as to what constitutes a 'successful' artist, which differs significantly from that of the ordinary man in the street. Exhibitions must be in the 'right' galleries and museums. Articles must appear in the 'correct' journals and lavishly-illustrated art books must continue to be produced by reputable publishers. But in spite of all the critical reviews and exhibitions, tens of millions of ordinary people recognize and love Maxfield Parrish, and own reproductions of his work. He can truly be said to have struck a chord in the heart of a nation.

One of Parrish's proudest moments came a year before his death in 1965, when the Metropolitan Museum of Art bought his painting, *The Errant Pan*, an event signifying artistic acceptance at last. Parrish never looked for critical acclaim: he was a man with a tranquil soul, at peace with the world, very different from the traditional idea of the artist doing daily battle with internal demons. Neither time nor critics were able to alter his artistic vision – he created what he wanted to create and never deviated from his goal. Near to the end of his life there came a new awareness of the visual arts, and mass communication was beginning to make a major difference to the public's perception of them. Now, the artworks of Maxfield Parrish are not only considered valuable and desirable, they are also universally regarded as timeless classics of their kind. The most important tribute to Maxfield Parrish to date was the permanent installation of the largest collection of his artworks in the National Museum of American Illustration.

It is interesting to compare the dates of birth and death of some of Parrish's contemporaries as an indication of what was happening in the world during his long life, 1870–1966: Queen Victoria (1819–1901); Frederic Leighton (1830–96); Eadweard Muybridge (1830–1904); Thomas Eakins (1844–1916); Mary Cassatt (1844–1926); Thomas Edison (1848–1931); Vincent van Gogh (1853–90); Henry Ford (1863–1947); Henri de Tolouse-Lautrec (1864–1901); Frank Lloyd Wright (1869–1959); Vladimir Illyich Lenin (1870–1924); Pablo Picasso (1881–1973); Adolph Hitler (1889–1945).

Parrish and Illustration

Illustration is a form of art that was created to be reproduced in periodicals, books, prints and later, with the advent of advertising, on posters, labels, wrapping paper and the products themselves. Today, illustrative art also encompasses the entire range of new information technology and its definition changes from day to day; it includes computer graphics, such as manipulated photographs, with images created to be reproduced but delivered on the internet, by cell phone and on monitors in motor cars, trains, aircraft and boats. Illustration is everywhere, but there was a time when things were simpler, when two-dimensional images were the only means of visual communication. This was a time when illustrators ruled.

The primary focus of this book is one of the greatest illustration artists of all time, Maxfield Parrish. It is also a tribute to his colleagues, members of the so-called 'School of American Illustrators', a group collectively known as the American Imagists. What was once a private collection of illustration art, known as The American Imagist Collection, is now housed in the museum founded to celebrate and share this collection with the public – The National Museum of American Illustration. So the second part of the book places Parrish in the context of these other master illustrators. Although he was a loner in many aspects of his life and career, many illustrators became his friends and/or classmates, while still more were competitors or colleagues in Cornish or at the National Academy of Arts and Sciences, the National Arts Club, the Players Club, the Salmagundi Club and the Society of Illustrators.

None of us can quite forget the first time we saw a book filled with Maxfield Parrish's romantic images, his ubiquitous Jack and the Giant, or even the conundrum of a benign dragon. We all remember the Scribner classics with N.C. Wyeth's muscular images of swashbuckling pirates, lone frontiersmen or an intrepid Robin Hood roaming his primeval

forest: these images are a part of the life of the imagination and remain forever. Jessie Willcox Smith's *Little Miss Muffet* takes us back to more innocent and happier times when childhood was perpetual summer. Yet, for many years, the creative talents of illustrators such as these remained largely unappreciated. Their ability to enter the mind of a child, espressed through make-believe worlds, was the most exciting part of the lives of previous generations. The fantasies which such images evoked created springboards for the imagination and have become unforgettable classics of their kind.

After a dearth of interest in original illustration, there is now a renewed interest in American illustrative art. Individuals now collect it, museums covet it, and popular international exhibitions increasingly feature this, the most American art form of all. Maxfield Parrish was admired by many other illustrators, and his work has had an influence on the art and styles of successive generations. He was not a born teacher, his vision being too personal to share, although the pulp artist, Hannes Bok, received some tuition from him and he was advisor and mentor to Alaska's pre-eminent artist, Fred Machetanz. He was something of an inspiration to first lady, Mrs. Woodrow Wilson, a keen Sunday painter and a veritable Parrish groupie during the summers of 1913 and 1914. Other illustrators learned much from Parrish, with George Hood perhaps the best of those who tried to emulate him, so successfully in fact that it is difficult to differentiate one from the other. There are, of course, subtle differences in technique, but Hood is as good an imitator as they come.

It is historically important that the entire spectrum of the Golden Age of American Illustration is understood, a period which stretched from 1895 until the collapse of a vibrant economy in 1929. Yet the Golden Age continued in differing forms, with other artist-illustrators and changing formats, until about 1965 and the effective demise of *Saturday Evening Post*. It was then, after the heyday of illustration (1895–1930), that it can be said to have truly died. However, during this period, image creators were at their most important, for they encouraged the public to see what magazine editors, authors and art directors wished them to see. Once illustration and the new technologies were able to bring such images to the masses, the mind's eye no longer had to 'guess' – the image was there, available to everyone and in a form that clarified what an author or journalist had been at pains to describe. In most cases, illustrators themselves decided what the viewer should actually see, rather than authors. Consequently, the illustrators virtually moulded public opinion, set fashions and styles, determined the outcome of political battles and provided the main body of thought throughout society. When illustrators collaborated with authors they influenced just about everything; when illustrators were not complementing or augmenting an author's work, they were creating worlds of their own.

It has been said that an illustrator once used bold red arrows on a depiction of the globe, indicating the hordes of Chinese and Russian invaders overwhelming Western civilization, single-handedly creating the concept of the Cold War, an image generating so much fear and animosity that it influenced politicians and created war-mongering fanatics; thus one illustration by a single illustrator could influence the entire world. In their heyday, the power of illustrators could therefore be pernicious, but it could also be a powerful force for good.

Prior to the very first intimations of the Golden Age of American Illustration, newspapers increased in numbers from about 850 in 1872 to nearly 5,000 in 1893, establishing the prototype of the idea of 'mass media'. Photography developed to the point where Civil War battle scenes included detailed portraits of General Ulysses S. Grant by photographer Mathew Brady, which created a public craving for ever more explicit images showing the full horrors of war: bodies strewn across a field with heads and limbs torn off, bleak scenes in which scavengers robbed bodies of their boots, starving dogs gnawing at human thigh bones; the grim realities of war were all brought to the living room. Yet the most poignant messages remained difficult to convey in a photograph or a Currier & Ives

INTRODUCTION

print, a job that was left to illustrators. Photography may still have been bulky and difficult, but illustrator Howard Chandler Christy could still lie in a trench during the Spanish-American War and sketch several scenes as he witnessed them, later to be published in the press. Action shots were too quick for a camera's crude technology, but could not escape the illustrator-witness to the event, skilful enough to encapsulate a precise moment in time.

With the proliferation of newspapers, the demand was not for illustrations, rather for text. As periodicals began to include illustrations in the form of engraved line drawings on wooden plates, the public began to demand more. It was far easier for a busy person to read a caption, see the image and decide whether it was worth reading the whole article. Newspapers became vehicles for current information, but they also became sources of entertainment as well. The Civil War certainly changed the situation ever more dramatically as the public had access to more newspapers and craved more images.

A fully descriptive single illustration telling a whole story was often many times easier to digest than a photograph. Whereas 'a picture was worth a thousand words', a good illustration could be worth a whole book! A photograph sometimes actually asked more questions than it answered, leaving the viewer somewhat perplexed, as a result of which the public became increasingly demanding of illustrative images to accompany the text. The early successful magazines were *Leslies Illustrated News*, *Harper's Weekly*, *Century* and *Scribner*'s, all published with resounding success and often serializing stories or articles prior to releasing them as books, which they also produced. They were able to cover the entire market in ideas, able to influence public opinion with a single image, a brief article and a cover picture!

Magazines sold better if articles were illustrated and better still if there were striking images on the front covers. The publishers soon realized whose illustrations were the most popular by the amount of copies sold, with the result that successful illustrators were keenly sought and handsomely paid, their talents later in demand by advertisers. Success bred more success and new magazines with titles that indicated to the public the nature of their contents, such as *Cosmopolitan*, *Good Housekeeping*, *Hearst's*, *Literary Digest*, *Saturday Evening Post* and others appeared. The Gilded Age had been a period in architecture when America's first millionaires had begun to appear. It also coincided with the height of the Golden Age of American Illustration, when magazines with the names of *Judge*, *Ladies' Home Journal*, *Life*, *Smart Set*, *Success*, *New Yorker*, *Town and Country*, and the most popular of them all, *Saturday Evening Post*, were founded. All of these reflected the current affluent lifestyle as well as all that was later considered trivial and decadent in society.

During World War I, illustrators proliferated, producing sketches ranging from battlefield scenes to images of war orphans in Belgium, but finding that once the conflict had ended the emphasis had shifted, opening new avenues of opportunity. New magazines were on the horizon which emphasized leisure and style in the form of *Esquire*, *Vanity Fair* and *Vogue*, coupled with the advent of advertising as a profession and then as a national fever. By the 1920s, the cream of the illustrators were flourishing, with artists such as Leyendecker enjoying what approximated to a Gatsby lifestyle.

Illustration in a different form continued through the Depression years. Pulp magazines flourished, being inexpensive at five cents the copy, cheap to print, with a single image on the cover which sold them quickly. Political cartoons also began to attract an educated following, in which politicians were constantly lampooned and satirized. The editorial cartoonists were producing a mixture of their own brand of wry humour in quick caricatures, encapsulating a situation in a way that would have been difficult to achieve by other means. Cartoon strips soon evolved, which were delivered in instalments, which readers looked forward to on a daily basis and remained faithful to a particular periodical as a result. There were fantasy heroes, tramps, talking ducks and dogs, characters with

foreign accents, gangsters chased by cops with radio wristwatches and Rube Goldberg contraptions, to quote but a few. Movies thrived and became a new way of getting images to the public – everybody loved them. Pin-up art also thrived in the new environment, as well as in new magazines and calendars; in fact, whole new areas of what is now considered 'illustration art' were developing. The pin-up went on to become popular as calendar art, the cartoon features appeared in colour in the Sunday newspaper editions and later in the dailies, enthralling the public and providing an escape from reality, a function the movies achieved so well.

Through to the demise of the *Post* in the 1960s, illustrators still had plenty of work, although they could no longer command the huge fees and royalties they had in the past. Illustrators were not what they once had been when they were trained as fine artists – many of them merely had natural facility. But times had changed and different techniques were now required. Advertising had developed into a pseudo-science, while comic books were proliferating; schools were founded to teach interested students how to make money illustrating advertisements, while magazines now relied on advertising for their survival. Illustration was now considered a strictly commercial enterprise, no longer a primary element of publishing but rather a subsidiary. Publishers no longer needed a bold dynamic image to sell a magazine when a photograph of Rhonda Fleming would do the same job. The aftermath of the demise of the *Saturday Evening Post*, the most popular magazine in America up to that time, saw television attracting audiences away from magazines and books, which also coincided with the advent of record players, battery radios, wire and tape recorders and the rapid development of new media.

The Golden Age had been the most vibrant period for illustrative art, produced by the most talented individuals of their time. It was also a period that saw the success of magazine publication in the U.S.A., lower-cost printing and new technological advances which now made four-colour printing economical.

Nowadays, a new respect for illustrative art is currently abroad in the fine arts establishment, though little has been written of the real-life giants of illustration. While the first part of this book is devoted to Maxfield Parrish, the second comprises an overview of the artist-illustrators of the Golden Age. For generations, these illustrators took authors' words and transformed them into living,, sometimes fire-breathing, reality. They were of enormous influence to American culture and it is heartening that illustration is now accepted for what it is – an important part of the rich spectrum of fine art. The attitude of the fine arts establishment has greatly mellowed, and most particularly towards the artist-illustrators of the Golden Age.

Recent events confirm this: the July 1999 cover of *Smithsonian* magazine featured 'Beyond the Blue: The Art of Maxfield Parrish', while ARTnews (September 1999) featured Norman Rockwell on its cover, with the tag line 'A Rockwell Renaissance?', while that same month, *Attaché* ran a Maxfield Parrish cover story. For the millennium issue of the London-based *Apollo* magazine, the journal of fine art scholars, curators and museum directors, the Rockwell image of *The Connoisseur* appeared on its cover, while President George W. Bush's inauguration was marked by an exhibition of N.C. Wyeth's works in the United States Capital Rotunda. Meanwhile, the Maxfield Parrish retrospective was touring the country, visiting such venues as the Corcoran Gallery in Washington and the Brooklyn Museum, also the first art museum in the nation, the Pennsylvania Academy of the Fine Arts. Likewise, the 'Norman Rockwell Retrospective', after a museum tour which lasted for two years, wound up at that bastion of abstract expressionism, the Guggenheim Museum in New York City, with a comment in the *New York Times* that 'Rockwell is the most important artist of the last century'. The Whitney Museum of American Art acknowledges illustration as one of the most powerful artistic forces of the 'American Century', so cited in its millennium exhibition. Who would ever have guessed?

Perhaps Norman Rockwell, who underestimated himself with 'I am just an illustrator', put it best when he added, 'Illustration was in the mainstream of the arts … [it] was vitalized by contact with fine writing …to us it was an ennobling profession.'

CHAPTER ONE
THE LIFE OF MAXFIELD PARRISH
(1870–1966)

In the Wake of the Mayflower

The family of Maxfield Parrish is as 'blue-blooded' as it is possible to get in America. The Parrishes trace their origins to Captain Edward Parrish (1600–79) who, after a long mercantile career at sea, was appointed surveyor-general of the Maryland Colony by its British colonial masters. According to family history, Captain Parrish was born in Yorkshire, England and immigrated to Ann Arundel County, Maryland, in 1637, the year after Harvard College was founded. When Lord Baltimore was awarded an honorific title and its accoutrements, Parrish was rewarded for loyalty by enabling his purchase of two large tracts of land for a nominal sum, and named these parcels, 'Parrish's Sphere' and 'Parrish's Range'. Each boasted extensive water frontage and was considered quite valuable, not for its spectacular views as would be the case today, but because of plentiful fishing, dockage potential and other practical considerations. Indeed, the captain's position as surveyor-general paid off handsomely, for the two parcels comprised more than 3,000 acres (1200 hectares), with large portions making up the bulk of what is currently Baltimore's downtown area.

To a Quaker State

In 1681, William Penn obtained a land grant from England's King Charles II for all the land in what is the present state of Pennsylvania. Penn's purpose was not to convert the Native Americans, as mentioned in the contract, but to provide a sanctuary for his countrymen who longed for religious freedom. The Quakers were absorbed into Pennsylvania along with many other sects.

Captain Edward Parrish's great-grandson, John, was a well-known farmer who died of apoplexy in 1745. His death is regarded as important to our story, being the last link to the family and its early roots in Maryland. After that date, the Parrishes vanished from Maryland altogether, the clan next making an appearance in the Commonweath of Pennsylvania. Evidently, their quest for religious freedom in America had not been satisfied in Maryland

and they had moved on. Little more than 100 years after arriving on Maryland's shores, the Parrish family suddenly moved en masse to Pennsylvania. The reasons for the uprooting of an entire family have long since evaporated, but it can only be presumed to be because of their Quaker faith and a lack of tolerance in Maryland. There are no known records of how their Maryland land tracts were ultimately disposed of after Edward Parrish left them in his will of 1722 to his sons Edward, William, John, and daughters Ann and Mary, nor are there records of any family members remaining in Maryland. What is known is that the community around Philadelphia formed the nucleus of Quaker life and that the Parrishes were devout Quakers. Members of the religious 'Society of Friends' were commonly called 'Quakers' or 'Friends'. A religious community founded in the 17th century, they believe that God is in everyone and anyone can be a minister. Individuals do not conduct formal religious services, but worshippers prefer to gather in silence unless someone is moved to speak. Quakers are pacifists and were among the first to oppose slavery. Pennsylvania is still known as the Quaker State, having then as now the greatest number of Quakers within its borders. That fact alone could well have been a magnet for a family of great religious conviction to have uprooted itself so dramatically.

Asylum from Persecution

The accomplishments of the Parrish family are recounted in *Parrish and Related Families*, 1925, by Susannah Parrish Wharton, who documented her family's quest for religious freedom and their yearning for 'The American Dream'. As Susannah remarks, 'Soon after William Penn obtained a grant from Charles the Second, and after the memorable purchase from the Indians, he, with many of his friends, sought in the wilds of America a peaceful asylum from persecution.'

A breakaway group of English Protestants, the Puritans sought to simplify their religion, but were forced to look elsewhere due to persecution and many emigrated to America. Once

The Parrish Family Tree.

ensconced in the Massachusetts Bay Colony in New England, they tried to influence colonists of different faiths, many of whom left Massachusetts and joined Roger Williams (1603–83) in Rhode Island, where the Quakers founded the Great Friends Meeting House in 1639, and the Providence Plantations. Williams was a preacher who, at odds with the narrowness of the Puritan way of life, ultimately fled south-west to Narragansett Bay, where he befriended local Native Americans and purchased land from a Narragansett chief, Miantonomi, naming his new independent settlement Providence. Pennsylvania, like Rhode Island, was clearly a more tolerant and God-fearing environment, but there may also have been other factors, since Isaac Parrish was said to have remarked, 'Had I remained in Maryland it is probable we should have all been gamblers and slaveholders.'

Susanna Wharton's genealogical work tells stories of the Revolution and the Parrish family, of their relationships with the indigenous people and of escapades in the earliest days of the colonies. Obviously these stories were compiled strictly for future generations of the family, but the ensuing fame of one of their number, Maxfield Parrish, makes us curious as to his origins and interested in establishing precedents for his unusual talent. Susannah's book provides valuable insights into what it was like to be a Quaker in Philadelphia and the kind of legacy handed down to the descendants of the family, including Maxfield Parrish.

Our Friends, the Quakers

The first mention of the Parrish family in Pennsylvania is in Quaker church archives recording the birth of 'Robert Parrish, son of John and Elizabeth Roberts Parrish, formerly of Baltimore County, Maryland'. In 1750, Robert joined the Philadelphia Meeting of the Society of Friends, otherwise known as the Quakers, and from that point forward, the origins of the Parrish family lie in Pennsylvania rather than Maryland.

Isaac Parrish, son of Robert, was born in Baltimore in 1735 and moved to Philadelphia as a teenager. It was originally intended by his father that Isaac should become a doctor, but

less than 100 years after their affluent life in Baltimore, their resources had diminished significantly and were now quite limited. From its position as one of the young nation's richest families it was now in straitened times, forced to send a son off as an apprentice in order for him to get an education. Isaac was apprenticed at the age of 14 to Abraham Mitchell, a Quaker businessman of significant means with no sons of his own and six pretty daughters. Isaac lived with the Mitchell family for a number of years and grew to love them as his own family while serving them well. It was hardly surprising that Isaac should marry one of the Mitchell daughters, Sarah, on 27 December 1759, at the Friends Meeting House on High Street. Over the years, Isaac learned 'the hatting trade' from Abraham and with Mitchell's blessing struck out on his own with his young wife. This was therefore fair and fitting, Isaac having helped Mitchell in his business, that Mitchell should in turn help his ambitious and independent son-in-law to set up on his own.

From Hatter to Haberdasher

Isaac and Sarah Parrish were the first of the Parrish family to actually live in Philadelphia itself, since the rest of the family lived on farms and in Quaker enclaves and villages in the nearby countryside; even the Mitchell business was a little outside the main commercial centre of the city. After early successes with hats, the young Parrish couple branched out into men's clothing and were soon generating a successful haberdashery business in a new, more vibrant location close to Independence Hall in the Society Hill section of the city. Their building doubled as both home and place of business and included a workshop, storage room, small barn stalls and a large sales salon as well as living quarters. Isaac provided clothing for some prominent citizens, including several members of the Continental Congress, while Sarah managed the manufactory with her assistants. This close connection with the great and good gave their clothing business a certain panache and caused the Parrish brand name to be well known throughout the region, bringing them close to the seat of power.

By Appointment

During the Revolution, Philadelphia had a besieging army constantly at its elbow and the Parrish household was periodically robbed and stripped of its furniture by British redcoats. Isaac described the shop and its accommodation thus: 'At the rear of the house was a building used for the manufacture of hats, in the lower apartment of which was kept a cow and other stock which was carefully secreted from soldiers. On one occasion a young pig escaped which would have invariably fallen prey to the British … but [Isaac] caught it, breaking his finger in the process.' After the Revolution, Isaac was appointed haberdasher to President George Washington, the financial rewards being commensurate with his reputation. At the time of Isaac's appointment, Philadelphia's population had reached 40,000 and it was the second largest city in all of the former British colonies. Already successful in business, Isaac now felt compelled to help with the plight of his fellow countrymen, plunging himself into community affairs by founding the Pennsylvania Society for Promoting the Abolition of Slavery, not yet a *cause célèbre* and a dangerous area in which to venture, given that his own ancestor, Edward Parrish, had been a slave owner and had bequeathed two negro boys to his sons.

Longevity: a Family Tradition

Isaac and Sarah Parrish had nine children, including two sons, Dillwyn, who trained as a pharmacist, and Joseph, who became a notable medical doctor in Philadelphia. The parents and their two sons, like so many other Parrishes before and after them, lived full, long and productive lives. In fact, Isaac and Sarah outlived all 87 people who witnessed the signing of their wedding certificate. Isaac died in Philadelphia in 1827 at the ripe old age of 92, proving that even in times of war and hardship the Parrish genes were healthy and hearty. This also applies to their descendants, with Stephen Parrish living until he was 92 and Maxfield Parrish reaching the age of 95.

Parrish Street, Philadelphia

The naming of 'Parrish Street' in Philadelphia was in honour of Isaac Parrish and not his son Joseph, as many have previously thought, since an old street map dating to the end of the War of 1812 shows that Parrish Street was already named. At the time, Napoleon was fighting Russia, Mexico had just declared independence, and the Spanish were trying to keep Venezuela as a colony: meanwhile, Joseph Parrish was just beginning to build his reputation as a young medical doctor. Joseph's father, Isaac, had been a notable figure for some decades, both in business and for his interest in social issues, but most of all as an abolitionist. In 1813, Isaac Parrish was described by a contemporary as 'one of the oldest and best known Philadelphians, while his son Dr. Joseph Parrish was a young physician of only thirty-four, who did not until a score of years later reach the height of his fame and reputation.' Joseph Parrish's dedication to medicine, civil rights and politics was significant, which is the reason why so many people attribute 'Parrish Street' to him.

Joseph Parrish (1779–1840), the youngest of nine siblings and a man of culture and intellect was proficient in six languages. In addition to Latin and four Romance languages, he also studied Hebrew so that he could read the scriptures in their original tongue. Deeply devoted to his Quaker faith, Joseph was committed to gaining an understanding of his Israelite brethren and their plight throughout history. He learned other languages so that he could communicate with patients, a motley group of immigrants from many races. An unusual man, Joseph truly sought to help the infirm, the poor and homeless and to better their lot in life. His dream came true in 1805 when, having completed matriculation at the University of Pennsylvania, he was given the chance of studying with Dr. Casper Wistar, for whom the Wistar Institute was named. Dr. Wistar was then known as the greatest medical man of his time and Joseph thrived under his expert tutelage.

THE LIFE OF MAXFIELD PARRISH (1870–1966)

The Epidemiologist

Dr. Parrish was best known for his work fighting epidemics, particularly the Yellow Fever onslaught of 1805. As a young, newly qualified physician, still wet behind the ears, he suddenly found himself in the midst of a dire situation and promptly rose to the occasion, saving many lives in the process. Although a doctor was regarded as a special type of human being in those days, Parrish was seen throughout the city as a kind of saint, even after the epidemic finally subsided, on account of his tireless work among the poor of the city. In 1832 his experience of epidemics meant that he was called upon again to fight Philadelphia's tragic outbreak of cholera.

Like most Quaker families, the Parrishes were interested in civil rights, but most especially in the abolition of slavery, eager to preserve Isaac's reputation in this field and continue his work. After Isaac's term of office had expired, Joseph Parrish assumed his father's role as president of the Pennsylvania Society for Promoting the Abolition of Slavery, continuing the progressive and liberal ideas of the Quakers, which the Parrish family as a whole were dedicated to following. They were interested in health issues and practised the virtues of hospitality whenever they could, welcoming strangers into their homes and ultimately offering it as a way-station for travellers on the Underground Railroad.

A Meeting with the President

In 1819, Joseph Parrish went to Washington for an audience with James Monroe, President of the United States, his purpose being to go where the buck stopped and discuss the issue of slavery with the head of state. Among other related issues, he argued the case against Arkansas, a slave state, being admitted to the Union. Dr. Parrish consulted with President Monroe time and again, registering his opinions on these and other issues, including the Monroe Doctrine. When Parrish died on 18 March 1840, there were lengthy obituaries in the newspapers, including this excerpt: 'The funeral of Dr. Joseph Parrish yesterday afternoon was attended by a very large concourse of our citizens, anxious to pay the last tribute of affection to the memory of one so justly and so universally beloved. The procession reached to the length of several squares, and both sidewalks were filled with people on foot, both white and black, and there was a long string of carriages; and in the street through which it passed, we noticed a considerable number of houses bowed, as a mark of respect.' Five thousand people attended the funeral.

Grandpa's Silhouettes

Joseph married Susannah Cox and they had 11 children, the first of whom was Dillwyn (1809–86). Although never officially an artist, it appears that Dillwyn, Maxfield Parrish's grandfather, had artistic inclinations. He enjoyed cutting out silhouettes of family members and could complete an entire profile without stopping or removing the scissors from the paper, indicating, perhaps, that he was not totally devoid of artistic talent, which, until that point had never before manifested itself within the family.

More important to Dillwyn than his creative talents were his overwhelming concerns regarding the plight of women and their role in society. Susannah Parrish Wharton quotes the following: 'A body of women students when first admitted to the study of medicine was hooted through the streets of Philadelphia by men students on the sidewalk, the women marching in the middle of the street with Dillwyn Parrish at their head.' Such was the influence of this important family that for a Parrish to lead a demonstration meant that there would be a noticeably positive outcome. Moreover, to a serious Quaker, taking a stand on important issues was far more important than cutting out silhouettes.

Dillwyn's Achievements

Dillwyn Parrish is credited with founding the Women's Medical College in Philadelphia and the Orthopedic Hospital and Infirmary for Nervous Diseases – revolutionary for its day – for

the acceptance of women into the medical professions paralleled the suffrage movement itself, and constituted a great leap forward.

In contemporary documents describing the founding of the Women's College, not for nothing is Dillwyn referred to as a 'radical Quaker abolitionist and temperance reformer'. It was originally named the 'Female Medical College of Pennsylvania'– when it opened in 1851 – the first woman's medical school in the world. At its first graduation ceremony, male medical students from a nearby campus harassed the teachers and graduates, while police stood guard to prevent a riot.

The Orthopedic Hospital had the distinction of being the first comprehensive neurological facility, making it viable as an area of specialization. The new hospital dealt with the interrelationships between orthopedic, nutritional and neurological disorders and made special studies of them. While not a medical doctor himself, Dillwyn Parrish had been trained as a pharmacist and was also a businessman with the vision to promote these facilities because of his commitments to both the suffrage movement and to public health. He organized the acquisition of the site as well as the construction work, recruited staff and provided overall management before organizing the operation of the facilities, and all this prior to the advent of modern turnkey systems. After retirement, Dillwyn was called upon to assume the role of president of the Philadelphia College of Pharmacy, founded in 1821, the nation's first pharmaceutical school. In 1851, like his father and grandfather before him, Dillwyn Parrish was elected president of the Pennsylvania Society for Promoting the Abolition of Slavery, which had been founded by his grandfather in 1775.

Revolutionary Parents

Dillwyn Parrish married Susan Maxfield in 1841, and it was from her that the artist, 'Maxfield' Parrish, later took his name. Dillwyn and Susan were staunchly religious Quakers who, like their ancestors, were widely known as activists in the national anti-slavery movement.

Dillwyn and Susan had two children, Joseph and Stephen (1846–1938), father of Maxfield. As Quakers, who as a rule tended to be firm but fair with their children, they were unusually liberal and tolerant parents, doing everything they could to encourage Stephen's youthful love of arts and crafts. This was unusual in that anything 'artistic' was considered frivolous, unnecessary and against God's teachings; adding decoration or applying colour to embellish an object was regarded as as a sin. As for creating paintings, this was at best considered a waste of time and at worst a serious deviation from the norm. Stephen's parents could therefore be regarded as revolutionary when it came to child-rearing and permitted their son to explore his talents to the full. Stephen later told his grandchildren that his parents had even offered their attic as a studio in which he was allowed to paint – an unheard of concession of parents to a mere child. Dillwyn also arranged for Stephen to take painting lessons from Thomas P. Otter, a popular Philadelphian artist, who had exhibited his own work at the Pennsylvania Academy of the Fine Arts and was well known for his images of the Western frontier.

Art as Personal Expression

Stephen's earliest known artwork, completed at the age of 17, was an oil painting entitled *Rain on the Lilla Rush Kill*, which he signed 'Step. M. Parrish'. As a young artist he decided to add the middle initial 'M' (taken from his mother's maiden surname, 'Maxfield') to give his plain Quaker name a more euphonious sound and a little more substance. This new signature was possibly symbolic of a longing for greater independence and a chance for Stephen to develop his own creative style: even though Stephen's parents were liberal, they may not have been quite liberal enough where a creative youngster was concerned.

On his 18th birthday, Stephen asked his parents for permission and funds to travel to Europe for the Paris Exposition. This was freely granted, as had others in the past. Stephen sensibly imposed a tight budget on himself and his frugal ways enabled him to squeeze in a

trip to London to visit more museums, exhibitions and galleries, which so inspired him that he vowed, then and there, to pursue an artistic career. He was now like a person possessed, wholly dedicated to the idea of art as a profession: he even began to dress the part and sought to emulate an artist's way of life. Until then, Stephen had not visited many museums, nor had he been exposed to the world of art on such a scale, other than a few lessons from Otter. He knew that he loved to draw, that he had talents others lacked, and that he could teach himself by studying paintings whenever he had the chance. He seemed to be able to grasp intuitively the way artists achieved particular effects and he craved to know more.

European Experiences

Stephen kept his parents well informed of his progress, and they enjoyed his travels vicariously, though they had certainly paid for the privilege. As loving parents they showed an intense interest in his every move, and he satisfied them with voluminous correspondence recounting all his experiences in detail. In one letter, he wrote of the 'tremendous eye-opener' he got from his visits to the Paris museums, especially to the Palace of the Grande Exposition: 'I never knew before that men could do some things which this day I have seen and wondered at. I never knew that the art of painting was such a vast and splendid profession. There are some effects produced on canvas, which I have never conceived the possibility of before … there is one thing certain, however, that is, they paint differently in this country than in our own. The European paintings have a certain massiveness and breadth and coloring and effect which I have never seen in any picture painted in the United States. Church's Niagara was there, and Bierstadt's Rocky Mountains, and others from the U.S. that did credit to the U.S.A.'

His letters were full of excitement and evidence that he had been thoroughly stimulated by this new experience; here he was, a young man on the threshold of life, with parents who believed in him, and who was well-off and lucky into the bargain. Stephen returned home with a totally different outlook on life, full of all he had seen and learned and determined to become an artist.

America to Europe and Back Again

On his return to Philadelphia from his first trip to Europe, Stephen unhappily resumed his former job as a coal dealer in a local supply company. Consequently, after several years of enduring a humdrum existence, he arranged a second trip to Europe, between April and June 1867. This time, Stephen borrowed $1,000 in gold coins from his parents, a tidy sum indeed, whose support had never for a moment waned. During this trip he kept a sketchbook and called it 'America to Europe and Back Again'.

It was a time of optimism, for the Civil War had recently ended and a new spirit of hope pervaded the nation. New magazines and newspapers were being launched almost daily and they were using illustrators for the first time to embellish headline stories and to attract a broader readership. The more illustrations appeared on covers, the more demand there was for even more to accompany articles and circulation increased as a result. It should also be mentioned that all this time Stephen's only brother, Joseph, possibly more in tune with his religion and his station in life, was building a small real estate empire. There were no trips to Europe for Joseph, nor excursions into the forbidden world of romantic imagery, only hard work. Both brothers, however, subscribed to the most popular magazines, which were bristling with new ideas and filled to the brim with exciting illustrations.

Stephen did not follow his father as an entrepreneur nor contribute to the advancement of women and medical research, neither was he attracted, like his brother, to a life in commerce. He gave up his job as a coal trader and apprenticed himself to a printer, seeking to further his technical skills in a direction compatible with his ambitions in the fine arts. Following this, he opened his own stationary store, where he offered custom printing services and sold stock letterheads and art supplies.

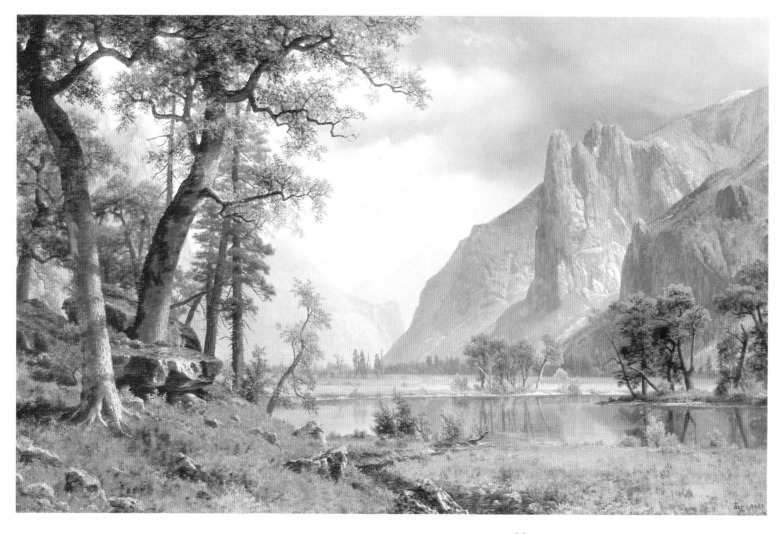

Albert Bierstadt (1830–1902)
Yosemite Valley, 1866
Oil on canvas, 38³/4 x 61in (98 x 155cm).

Parrish saw and admired Bierstadt's work, a painter of the Hudson River School, on his travels to Europe. Courtesy of Ira Spanierman Gallery.

RIGHT
Maxfield Parrish at 15 years old.
Photograph courtesy of Gary Meyers.

OPPOSITE
Stephen Parrish (1846–1938)
Low Tide – Bay of Fundy, 1886
Etching, 11¹/₂ x 18³/₄ (29 x 48cm).

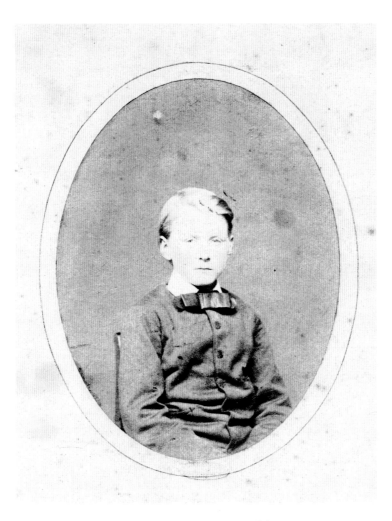

'Maxfield' Parrish

Stephen Parrish married Elizabeth Bancroft in 1869 and their only child was born a year later on 25 July 1870. He was named Frederick Parrish but was destined one day to follow his father's lead and change his Christian name to 'Maxfield', dropping the name Frederick altogether.

In the last 230 years, the Parrish family, with its thrifty ways and dedication to hard work, had become prosperous as property owners, haberdashers, real estate developers and accomplished medical professionals. They may have regarded themselves as plain Quaker folk, but in the eyes of many in their community they were admirable people. At least this had been the case until the arrival of Stephen M. Parrish on the scene, for he was the first successful artist in the family and would become famous at that. Stephen caught the eye of America and earned a reputation, not for leading demonstrations, but for his depictions of European fishing villages and genre scenes of New England.

Then along came his son Frederick, who at a young age rose to become a national phenomenon. This father and son were the first true artists to have been born into an otherwise orthodox Quaker family and no one could ever have guessed how their lifes would turn out.

The Master Etcher

Stephen left the coal business to open a print shop-cum-stationary store round about the time his only child was born. In those days,

printing required an artist's eye and an understanding of type, inks and paper; even colour was starting to appear. Etching had for centuries been regarded as an art form in itself and had specific uses, for it offered versions of artists' work at a fraction of the price of an original oil painting, making them accessible to the masses.

Few artists came looking for a printer and Stephen's idea of following a related profession did not seem to be materializing as he once had hoped. In the meantime, he sublimated his artistic yearnings by painting and sketching. He taught himself to etch during this period while exploring the art supply shelves in his shop and experimenting with different mediums, styles and techniques. Stephen also taught himself to paint by imitating techniques which he thought he had identified during his earlier visits to European museums, finding that he could reproduce the effects he admired in the art of others. He realized that to be good at etching he required more technical expertise and especially help from a knowledgeable professional.

Suddenly etching became exceedingly popular, one of its most important modern applications now being in the illustration of publications, as well as reproducing paintings at reasonable cost. Stephen was astonished when his own etchings began to sell from his stationary store and they sold well. The subjects which Stephen enjoyed most were landscapes and marine scenes and amazingly these were the images currently most popular at the time.

Stephen developed new-found interests through his etchings, inspired by various art movements from abroad. He was increasingly

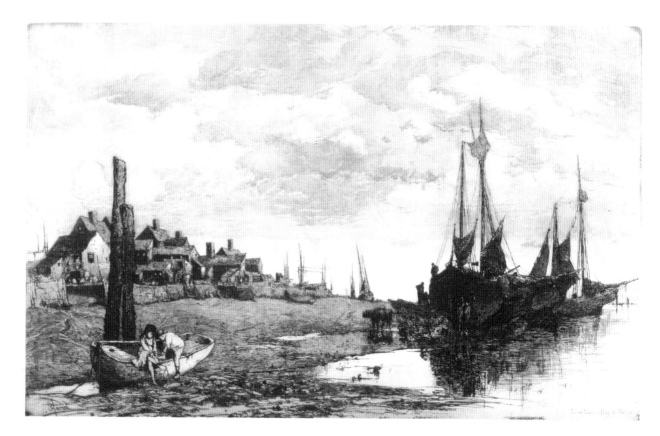

drawn to what for him was forbidden Romanticism (1815–40) and other newer explorations by avant-garde art studios in Europe.

Such innovative intellectual thought was what had originally attracted the impressionable young American to France to study art.

He recognized that certain individuals were redefining art in the late 19th century and personal expression was now what mattered to artists after the strictures imposed by the Classical tradition. Stephen had another hurdle to leap on account of his Quaker upbringing, which was hardly in tune with the new thinking, especially where art was concerned.

In 1876, Stephen was more than delighted to take his six-year-old son Fred (Maxfield) to the Philadelphia Centenary Exposition. Like his father before him, the child seemed to take a lively interest in etching and could not be dragged away from demonstrations of the technique. Stephen now felt he had a kindred spirit of his own creation.

In 1877, Stephen M. Parrish sold his small business and for the first time in his life devoted himself to doing what he liked best – creating art. He began to plan another trip to Europe, and this time both his wife and child would accompany him.

A Parisian Etcher

Stephen's favourite artist was the French painter and etcher, Adolphe Appian (1818–98) and his favorite etching was *Return of the Fishing Boats at Collioure, near the Spanish Border*. Appian was born in Lyon, but left for Paris as a young man with a mind to study art. Like Stephen Parrish, his family supported him and he was able to arrange painting lessons with the already famous Jean-Baptiste-Camille Corot (1796–1875). Corot was so important at the time that the Impressionist painter Claude Monet was quoted as saying, 'There is only one master here – Corot. We are nothing compared to him, nothing.' Corot, of course, overshadowed the young Appian, who felt that his work was not getting the attention it deserved. Moreover, Corot's interest did not lie in etching, which was a drawback as far as Appian was concerned and he decided to enter the Ecole des Beaux-Arts and focus solely on this discipline.

Appian's art directly affected Stephen Parrish's career. There is an undeniable similarity between their techniques and even their choice of subject matter. Stephen wished to find Appian, hoping to draw even more inspiration from direct contact with his hero, but it is not known whether or not they ever met. Yet, many of their respective landscapes seem to resemble one another, for some views are nearly identical, the horizon line is usually one third up from the bottom, and the vanishing points appear in the same three or four locations.

Japonisme

The French charmingly call the influence of Japanese culture on the Western world *Japonisme*, the word indicating a preoccupation with all things Japanese. This fascination was born with Commodore Matthew Perry (1794–1858), who was instrumental in opening Japan up to global trade in 1854. After two centuries of isolation, Perry entered Japan's Yokohama harbour in his large black trading vessel, and the world changed forever. Not long after Perry's treaty with Japan, however, his American compatriots were plunged into a tragic civil war, while Europe continued to trade with the intriguing island nation. Items brought from Japan included tea, fabrics and ceramics. The ceramics, especially, were packed in crates and were often protected by traditional Japanese prints, which arriving in France had a profound influence on the French Impressionists and began the craze for all things Japanese that spread throughout Europe. America, therefore, rather missed this development in art, which in any case had always come second to politics.

Following the Civil War, however, *Japonisme* began to filter into the United States, appearing at a time when America was becoming interested in European influences, the better to understand its own emerging styles. Now America too was seeing 'all things Japanese' through events like the Centennial Exposition of 1876, held in Philadelphia. Stephen and his son, Maxfield, visited these exhibitions and were impressed, even captivated, like everyone else. It was clear that in this area the Europeans had already stolen a march on America, but America was not far behind.

Linked by Art

By the end of the 19th century, Appian was considered an expert in landscape etching, certainly influenced by Corot but with elements of *Japonisme* in his work, which had invaded the

salons and cafés of Paris a few decades earlier. In common with other American artists, Stephen Parrish was also affected by 'all things Japanese' following his first exposure to Appian's etchings and after he had seen the work of James Abbott McNeill Whistler (1834–1903), who had also been influenced, like Monet, Gauguin and others, by Japanese prints. It is worth noting that Maxfield Parrish experienced Japanese art not only through his father and Appian, but also through a Whistler exhibition that was held in Boston. Thereafter, Maxfield was so impressed that he travelled from Cornish to New York or Boston whenever he could to see Whistler's work.

Adolphe Appian's form of *Japonisme* became internationally known and his artworks were exhibited at the Rijksmuseum in Amsterdam and the Metropolitan Museum of Art in New York, as a result of which other Asian art forms using new techniques and materials emerged. Years later, these same influences had become so much a part of Maxfield Parrish that he would often mention Corot, refer to an Appian etching, a Whistler painting or a Japanese print when explaining his own work. There is no doubt that the influence of his father was also strong. In a letter written in 1950 to a paint supplier, Maxfield Parrish described how he prepared a painting surface: 'I used to begin painting with a monochrome of raw umber …but now the start is made with a monochrome of blue, right from the tube ... the rest is a build-up of glazes until the end. The method of early Corots … is a good one.' One can assume that the lessons learned from Corot by Appian, then by Stephen, were ultimately passed to Maxfield Parrish, as was the Japanese influence.

A Philadelphian Etcher

In 1876, in order to prepare himself for life as an artist, Stephen Parrish enrolled in a class in etching technique taught by Philadelphia artist, Peter Moran (1841–1914), brother of artists Thomas and Edward Moran. Although Stephen had experimented with etching prior to joining Moran's class, and had even sold a few pieces, he was still without formal training. Even so, he was found to be almost the equal of Moran, astonishing classmates and teacher alike. Peter Moran, along with his brothers, had studied painting under Sir Edwin Landseer in London. Landseer was well known for his animal paintings, copied by others for reproduction onto copper etching plates, often at more profit than the originals, a fact not lost on the budding artists nor Peter Moran himself. By the time classes terminated, Stephen had produced 35 oils and over 50 different etching plates. Desiring to prove himself to his parents and to his own satisfaction, he managed to sell all the etchings and seven oils within a week. This was perhaps the reason why he chose etching over painting and the demand for his etchings began in earnest.

The Bohemians

After his experience of Adolphe Appian, Stephen Parrish decided that the bohemian lifestyle was for him, feeling himself to be finally liberated from Philadelphia and the Quaker ethic. Stephen had gone to France to seek out Appian and to work at his new vocation as a full-time artist. He longed to be in the company of other artists and live a different life from the one he knew only too well in Philadelphia – stifling and parochial to a person of artistic temperament. While in Europe in 1877, the Parrish family met whole communities of artists, musicians, architects, poets and writers, and had revelled in the climate of creativity which surrounded them. Elizabeth loved the element danger in these artistic circles, especially after her uneventful life back home, and was thrilled by the dashing, bearded young artists who thronged to their rented Parisian garret. The Parrishes tried hard to fit in and indeed succeeded in becoming part of the scene. (Young Fred/Maxfield can be seen in a photograph of the period, a large guitar in hand, surrounded by a disreputable crew of his father's cronies, as though gathered to binge on absinthe.) Needless to say, this was very strange company for a young Quaker boy, but a wild dream was coming true for a budding young American artist.

Stephen set about exploring ateliers, galleries and museums, hoping to learn more of the latest in etching techniques from established artists. In the process, he also learned a great

Stephen Parrish's paint box, measuring 13 x 18 x 3in (33 x 46 x 8cm), the artist's name on the top of box. The wooden paintbox has three landscape paintings in the inside top cover and there is an artist's palette below.

deal about oil painting by watching artists copying old masters at the Louvre, while his son soaked up the atmosphere like a sponge. Later, after moving about France from cottage to cottage, garret to garret, the Parrishes settled down for a longer spell in a small village by the sea. By this time Stephen was thoroughly occupied with perfecting his own technique, his one intention being to produce as many etchings as he could.

Phantasmagoria

It was inevitable that this first trip to Europe should occupy the mind of young Maxfield long after his return to America; in his dreams, he still wandered the winding lanes of old Montmartre, which he fancied were inhabited by imaginary dragons and hobgoblins. Gargoyles atop medieval cathedrals had spawned such images, insinuating themselves into the rich tapestry of Maxfield Parrish's imagination. His first known drawing is of a dragon, completed during this stay in France. Some years later, in 1905, the family friend, Homer Saint-Gaudens, wrote of Parrish as a youth: 'His inherent taste for artisanship created his earliest acknowledged aspiration to become a carpenter, and then, such is the vacillation of youth, a soda-water fountain man where he might shine up the nickel-work. But somewhat later in life, those who remember playing with him as a boy in East Gloucester, Massachusetts, say that his artistic sense had already begun to manifest itself in his tendency to decorate his autograph with architectural designs. Also, after the fashion of Charles Dana Gibson, he constantly made paper figures – as he continues to do when he finds difficulty in drawing them.'

A Confluence of Influences

Many artists in the late 19th and early 20th centuries found inspiration in Japanese art. After Japan opened her doors to the West, artists were among the first to peer inside, fascinated by the unique culture, its mores, art and traditions. The first influx into Europe of Japanese art came in the form of prints used as packing material, which made their way to the ports of

France and England. These prints quickly became popular and soon others of their kind could be seen in bookstalls in Paris. Like Appian, both Stephen and Maxfield Parrish, together with other artists and students, bought portfolios of Japanese prints from along the Seine or in London's Piccadilly Circus. They were entranced by the delicacy of their lines, the gentle tones and colours utilized so sparingly but to such great effect. Perhaps the first use of the term 'less is more' is apposite here.

Suddenly, everything Japanese was all the rage. European women learned *ikebana*, the art of flower arranging; European horticulturalists recreated Zen gardens that they had seen in art prints; and artists were influenced at every turn, Whistler among many others. Whistler, an American expatriate, originally moved to Paris in 1857 to study the Beaux-Arts painters. There, he got to know Henri Fantin-Latour (1836–1904), who later featured Whistler in the painting entitled, *Homage to Delacroix*, in which Whistler is one of a group with Baudelaire, Manet and others around a portrait of Delacroix. Later, Whistler's own painting, *Whistler's Mother: Arrangement in Grey and Black* (1871), became very well known, but his Japanese-influenced Peacock Room was truly his magnum opus. In fact, Whistler had so immersed himself in Japanese art that the poet Amy Lowell actually used Whistler himself as a metaphor for Japan.

Whistler, like his friend Stephen Parrish, visited the Brittany coast to paint, though the influences of *Japonisme* and Romanticism were never quite lost. It was in Brittany that Whistler met the Pre-Raphaelite artist Dante Gabriel Rossetti, later to influence the work of Maxfield Parrish. A confluence of these influences therefore affected the styles and techniques of each of these artists while they in turn influenced one another.

First Among Etchers

Stephen Parrish was considered to be in the first tier of American artists practising etching. He joined the ranks of contributors to a new magazine, *American Art Review* (1879–81), for it was commissioning popular etchers to create special editions for their subscribers. In 1880,

a critic remarked, 'Mr. Stephen Parrish, who should be put in the very first rank of our … etchers, and who is the most popular of them all … have found in him a first and most clear-voiced interpreter.' Such reviews attracted a substantial number of sales at a time when readers were unsure of their own taste and needed someone to decide for them. In 1881, Stephen Parrish was honoured as one of the first Americans to become a member and exhibitor at the Royal Society of Painters and Etchers; he eventually became a 'fellow', along with Thomas Moran, Charles A. Platt, James McNeill Whistler, Robert Swain Gifford and F. S. Church, a well-known illustrator. He was invited to become a member of the Society of American Etchers, the Philadelphia Sketch Club, the New York Etching Club and the Philadelphia Society of Etchers, which fostered connoisseurship, the development of printing techniques and collecting. The general public was finally able to own and enjoy original art created by established and emerging artists.

RIGHT
Maxfield Parrish
Ponte Vecchio, Florence, c.1887–1888
Watercolor, pen and ink on paper,
20³/4 x 22¹/2in (53 x 57cm).

OPPOSITE
Maxfield Parrish
The Monitor Firing on a Three-Masted
Sailing Ship, 1882
Ink on paper, 7³/4 x 12³/4in (20 x 32cm).

In 1884, after he had finished a successful etching of a rich landscape in dark brown ink entitled, *The Mills at Mispek*, Stephen took his small family and moved to France for two more years. His first etching, done while visiting England, was entitled *Hastings*. With large rocks and beached ships at low tide in the foreground, and Hastings, a seaside town, in the background, it was published by the *London Portfolio*, which, for an American artist abroad, was something of a major achievement.

During their second summer in France, Maxfield fell gravely ill and was diagnosed with typhoid fever from which he very nearly died. During a long and difficult convalescence, Stephen taught his son to draw and etch, keeping him happy and occupied. Art was becoming an obsession for both father and son, the son later emulating the father throughout his own career in a way that was quite remarkable. Maxfield worshipped his father for his talent and for the love and attention he received from him, while his mother became a non-entity, a mere appendage.

By 1893, Stephen Parrish had completed 86 etching plates and had achieved the reputation, along with Charles A. Platt and James Abbott McNeill Whistler, of being one of the three greatest etchers in the world.

Charles A. Platt (1861–1933), an architect, landscape architect and painter, worked under Stephen at both Cape Ann and Cornish, where he joined the colony. Platt studied painting in Paris under the Romantic painters, Gustave Boulanger (1824–88) and Jules-Joséph Lefebvre (1836–1911), both teachers at the Académie Julian. A great

friend of Whistler, Platt won distinction in both painting and etching before travelling throughout Italy in 1893, when he decided to concentrate on architecture and garden design. His seminal book, *Italian Gardens* (1894), comprised a series of photographs and was

the first such work to be published in America, causing a sensation among designers and architects. American gardeners began to adopt Italian designs, starting a new vogue for landscape gardening; even today its influence is felt, the style once again being very much in fashion.

Platt's book not only explained the rudiments of Italian landscape gardening, but also the use of plants, and nine years later inspired *Century Magazine* to commission a series of articles on Italian gardens. Ultimately, *Century* released the articles in book form, illustrated by Maxfield Parrish and with a commentary by Edith Wharton, entitled, *Italian Villas and Their Gardens* (1904). Before going to Italy to study and do research for his paintings, Maxfield Parrish consulted Platt on the villas that were worth visiting. Parrish felt that Platt was the most knowledgeable American on the subject, yet Wharton not only had no interest in Platt's suggestions, but also failed to include his book in her bibliography. Perhaps it was jealousy, but it disturbed Parrish for he liked to see fair play.

Platt's knowledge of Italy was not limited to landscape schemes nor to sketches and paintings from his extensive travels in that country, but was evident in his architectural projects, including designs for numerous townhouses and mansions. As a result of his great interest in the period, all of Platt's architectural designs are based upon Italian Renaissance models. In 1904, Charles Lang Freer made the acquaintance of Platt and soon became his patron. He was also introduced to Platt's circle of friends and bought many of their artworks. Freer visited Cornish frequently for drinks parties, informal dinners and intellectual conversation. Maxfield Parrish was in Italy during much of the time Freer spent in Cornish, but managed to meet him later on.

One of Platt's most important commissions came from Freer to design the monumental Freer Gallery of Art in Washington, D.C. (1918). This has a rusticated façade and like so many of Platt's projects is a near replica of an Italian Mannerist palazzo, with Whistler's *Japonisme* Peacock Room tailor-made to fit inside.

Maxfield Parrish and the Japanese Influence

In 1893, the Boston Museum of Fine Arts mounted a major exhibition of Katsushika Hokusai's work, where it caused a sensation among the local artist colonies, whose members attended in droves. These included the MacDowell Colony of Vermont; the Old Lyme Colony of Connecticut; Ogunquit Art Colony of Maine; Yaddo at Saratoga Springs; New Hampshire's Dublin Art Colony, and of course the Cornish Colony. From about 1823 to 1831, Hokusai (1760–1849) created and published the epoch-making series of woodcut prints known as the Thirty-Six Views of Mount Fuji. They became masterpieces in the history of Japanese landscape art and were considered the most typical of Hokusai's unique pictorial style. The work of Hokusai had strongly influenced the European Impressionists and had a marked effect in Boston. The exhibition was a watershed in the art history of New England, resulting in daring modernistic compositions that had never been seen before in America.

Nearly a quarter of a century later, Maxfield Parrish's painting, *Aquamarine* (1917), can be seen to have an unmistakably oriental flavour and could well be an oriental view. The handling of the clouds, alternating colours with land forms according to well-placed but lightly demarcated horizontal lines of 'dynamic symmetry', are balanced by a perfectly placed lone tree, which looks suspiciously like a Japanese bonsai. Yet, it is difficult to link the influence of particular styles or a single exhibition chronologically with any artist, for it is the totality of the artist's experience which combines at just the right moment to create a successful work. Yet we know that the 23-year-old Maxfield attended Hokusai's exhibition and, like so many other artists, was greatly influenced by it for decades after. In the early 1960s, on discovering some Japanese prints that Maxfield Parrish had brought back from Europe, his granddaughter Josie Maxfield Parrish remarked: '... there were not many Japanese prints left from the collection my grandfather brought back from his travels in the summer of 1895. But there were some things that I had grown fond of in my childhood visits ...the somewhat faded, but still lovely print was 'Ushibori', one of the Thirty-Six views of

Charles Adams Platt (1851–1933)
**Central Fountain of the Villa Albani,
Rome, c.1900**
*O*il on board, *18¹/₂ x 24¹/₂in (47 x 62cm)*

Illustration for Century Magazine.

THE LIFE OF MAXFIELD PARRISH (1870–1966)

Fuji by Katsushika Hokusai. Looking out the floor to ceiling windows of the nursery, across the valley to the south-west stands Mount Ascutney. Like Mt. Fuji, it is of volcanic origin and a beautiful shape. As Hokusai did with Mt. Fuji, Granddad had portrayed Ascutney in all seasons at all times of day, and with dramatic lighting effects.'

Hokusai referred to himself as 'the farmer of Katsushima' while Parrish, in a similar self-deprecating manner called himself 'the mechanic who loves to paint'.

In Europe Alone

Maxfield Parrish's youth had been one of constant exposure to art through his father, in which he had travelled in Europe from the age of seven, visited many museums, and through his own drawings imitated artists whom he respected; this enabled him to develop his own style while giving full rein to his vivid imagination. He married Lydia Austin, a young artist, and just three days after the wedding left for Europe alone. It is clear from the letter he wrote to his bride just how strong the Japanese influence was: 'Paris July 13, 1895. My trip so far has been such an unprecedented success, and I have gained and accomplished so much more than I anticipated ... I have managed to get quite a collection of Japanese prints which to my work are a perfect inspiration; there are places in Paris where there is a great assortment of these for half a franc apiece. Some are quite ancient and they tell me they are taken from Japanese albums and that after these are gone there will be no more. I dined with Lambert and McCarty ... Both fellows are wild on these Japanese prints and in the afternoon Lambert and I went about town looking at some stunning private collections. It doesn't take long to see where Whistler got his ideas ...'

There is no doubt, therefore, what the prevailing interest among young artists in Europe was at the close of the 19th century. Whistler's Peacock Room had been originally created for Frederick Leyland's London townhouse, after he had commissioned architect Thomas Jekyll to adapt his dining room so that he could dramatically display his collection of Japanese porcelain. Jekyll brought his American artist friend, Whistler, into the scheme to design the decorations for the vitrines and showcases as well as the special wall treatments. The dining room walls had already been covered with antique Cordovan leather, which Whistler proceeded to cover with many coats of blue-green paint to imitate the shiny surface of Japanese lacquer. He then decorated everything possible with peacocks and gold leaf. The Peacock Room was a prime exemplar of the Japanese influence on Western art at the time and remains so to this day.

From Fred to Maxfield

Something of a rebel within the Parrish family, Stephen Parrish was lacking a middle name, and decided to expropriate his mother's maiden name (Maxfield). Needless to say, it was rather eccentric for a Quaker boy to 'rename' himself, but thereafter he was known as Stephen M. Parrish. Likewise, his son Fred, who throughout his life seemed to mirror his father's every action, similarly became 'Maxfield' Parrish, dropping the name Frederick altogether. Fred Parrish therefore became known to millions of fans as 'Maxfield Parrish', but also as 'MP'. The last time he used his birth name was as a signature when he was 24, uncannily echoing the time of his dad's own name change. Maxfield Parrish liked the simplicity of his new name, regarding it as unique and distinctive. However, he was still known to friends and cousins by his nickname 'Buck' (short for 'Buckshire'), and his immediate family continued to call him Fred or MP for the rest of his life.

Actually, Parrish particularly enjoyed being referred to as MP, and signed many of his paintings simply with these initials. A letter written in 1974 by his closest companion and housekeeper, Susan Lewin, refers to him as he liked best: 'I remember a remark MP made, that he made more money on *Daybreak* than any picture he ever painted.' Susan Lewin indulged his preference, bellowing out 'EmmmPeee' whenever dinner was ready. Parrish liked the graphic strength of the simple block letters of his initials, which in some ways reminded him of Japanese chop marks. Norman Rockwell, on the other hand, took his initials from a Kraft paper stencil and placed the 'N' over the 'R' in another example of a chop mark. Maxfield Parrish rarely used a full signature on his paintings, only on letters and cheques.

A Family Link

In 1881, Samuel Longstreth Parrish (1849–1932), founder of the Parrish Art Museum in Southampton, New York and grand-uncle of Maxfield Parrish, commissioned the sculptor Louis Saint-Gaudens (1853–1913), assistant and younger brother of Augustus Saint-Gaudens, to sculpt a bust of his father, the Philadelphia doctor, Joseph Parrish. Samuel Parrish must have inherited some of his Uncle Dillwyn's artistic interests for in 1881 he began to collect Italian Renaissance art, having been inspired by Dante's *Divine Comedy* while a student at Harvard. After graduation, he became a successful New York lawyer and moved to Southampton where he established the Parrish Art Museum in 1898 to house his personal collection of Renaissance paintings and sculpture. However, it was his commission for the marble bust which formed the bond which linked Stephen and Maxfield Parrish irrevocably to the talented Saint-Gaudens family. It can be said that Samuel Parrish was directly responsible for Stephen's meeting and friendship with Augustus Saint-Gaudens (1848–1907); from that moment forth, the destinies of the two families were closely entwined, and Cornish was their common interest.

A Man of Wild Panache

In 1882, lusty Irishman Augustus Saint-Gaudens, a man of wild panache and commanding presence, was first introduced to Stephen Parrish by someone who thought they had interests in common. In reality, they had very little, yet Saint-Gaudens immediately took to the short, handsomely-bearded stationer-turned etcher, and later to

Mount Ascutney, a source of inspiration for Maxfield Parrish throughout his life. Photograph taken from the loggia at Aspet, the home of Augustus Saint-Gaudens.

THE LIFE OF MAXFIELD PARRISH (1870–1966)

Augustus Saint-Gaudens Cornish Colony
Presentation Plaque, 1905–1906
Bronze, relief, brown patina,
32¹/₂ x 19¹/₂in (82 x 49cm).

Maxfield Parrish designed this plaque in
the summer of 1905 for the residents of
Cornish, who mounted a theatrical
production called 'Masque of Ours' or
'The Gods and the Golden Bowl' to
celebrate the 20th anniversary of the
founding, by Augustus and his wife
Augusta Saint-Gaudens, of the art colony
in that town. Among the participants in the
production were Maxfield Parrish, Kenyon
Cox, Herbert Adams, Charles Platt,
Everett Shinn, and other painters,
sculptors, architects, writers and their
families.

his aspiring young artist son. Saint-Gaudens understood the Parrishes' longing to live an artistic life and saw that they were seeking like-minded people with whom they could communicate. A few years later, Saint-Gaudens invited them to visit New Hampshire for an autumn weekend, never mentioning his intention of founding an artist's colony in Cornish. Some weeks later, as the mild-mannered Philadelphians approached the northern New England state border, they witnessed a rainbow, an arc of colour against a clear blue sky – a promising augur to be sure. As they settled in for the weekend, they were introduced to a group of poets, artists and musicians, and met other who were either renting nearby farms or staying in guest cottages owned by the Saint-Gaudens family.

Augustus Saint-Gaudens took a cue from his friend, Charles Beaman, gathering enough creative people into the fold for it to grow into the prestigious 'Cornish Colony'. Stephen and Elizabeth had longed for such a place, seeing it as a fertile environment where ideas could be exchanged and which they had only experienced before in Europe. The creative contacts which Stephen had been seeking, though non-existent in quasi-cosmopolitan Philadelphia, were about to be realized.

Nearly ten years later, Stephen and Elizabeth were still seriously contemplating a move to Cornish. At that time, the Saint-Gaudens family was again looking for artists for the colony, which by then was successfully established with a growing reputation. When the Parrishes came again to Cornish to weigh up the situation, they found room and board with the Stephen A. Tracy family on their

farm on Lang Road, where they stayed for nearly two weeks without finding any properties which interested them before returning to Philadelphia. Two years later, during another exploratory visit, Tracy sold them 18 acres (7 hectares) on Austin Hill, a plot which they had previously admired. Stephen decided to act quickly and returned to Philadelphia, immediately, commissioning the architect Wilson Eyre, Jr. (1858–1944), a close friend of Charles Platt, to design a large manor with a carriage house. Eyre was not only an architect, he had also won significant recognition as an artist, which had led Parrish to commission him. Some years later, Eyre and Platt were responsible for the revival of an interest in formal gardens, the result of their time spent in Italy.

Northcote
When Stephen's parents died within two years of one another, a substantial estate was left to be divided between his brother Joseph and himself. However, Joseph suddenly died in 1893, and it was the combined inheritance from his parents and Joseph's commercial real estate in Philadelphia which enabled Stephen to build 'Northcote', leaving a substantial residue for other investments. Charles Platt had just completed his own mansion in Cornish, so social pressure and tax advantages to build a large house and studio were presenting themselves simultaneously when Stephen found the right parcel of land after so many years.

Elizabeth Gets Impatient
When completed, Northcote was architecturally intriguing, with magnificent surrounding gardens. Unfortunately, however, it had been far too long in the making for Mrs. Parrish's liking. She had been waiting from that first weekend when they had visited Augustus Saint-Gaudens until Northcote was ready for occupation, a period of nearly ten years, and in the process had become somewhat disenchanted with the whole idea. During this time, Philadelphia had changed from being a static, conservative Quaker stronghold into a virtual

centre for the arts. She was no longer interested in burying herself in the backwoods of New England. By 1898, she resolved her problems by leaving Stephen and their son, Maxfield, removing herself to a commune in California to begin a new way of life, never to be seen again. In her will, she left her half of Northcote to her husband, for they never formally divorced, and the balance of her estate to two friends from her California commune. She left nothing to her only child: 'My son Maxfield being already well provided for in this world's goods does not need the small portion I could leave to him …'

Northcote's site was a wooded hillside with views facing north-west towards Plainfield village and the Hartland Gap. The original garden plan had a curved 30-ft (9-m) long bench as a gathering place for family and friends. The studio building, which was built a few years after the main house, had a dovecote built into the cornices on the north and west elevations. Stephen extended his Northcote estate by building a small workshop and a stable before completing his formal gardens. His love of gardening was apparent in the various terraced areas and the large greenhouse for the exotic botanical species which he cultivated.

After moving into Northcote, Stephen gave up etching and painting for nearly a decade and lived on the income from his various inheritances. In the early 1980s, Max Parrish, Jr. found a diary entry dated 1903 in which his grandfather, Stephen, says, 'Painted in studio all day. Have taken it up again after years of neglect.' In other words, from 1893 until 1903, Stephen had succumbed to indolence, more commonly referred to in academic circles as taking a 'sabbatical'. When Stephen Parrish began to paint again he had already decided to give up etching altogether and to immerse himself totally in painting the landscape around Cornish for the balance of his life, his favourite subjects being Dingleton Hill, Prospect Hill and Fernald's Hill – also painted later by Maxfield Parrish. So instead of etchings, which had practically sold themselves, he was now selling oil paintings to wealthy summer visitors, straight off the easel by the roadside in Cornish. In fact, by the 1920s he was no longer using art galleries to sell his work as he was having more success selling them himself.

THE LIFE OF MAXFIELD PARRISH (1870–1966)

Stephen continued to paint landscapes until he had a stroke and was no longer able to continue. From that time onwards, he lived simply at Northcote, entertaining his friends and enjoying his remaining years.

Anne Bogardus Parrish

Stephen's cousin, Anne Bogardus Parrish (1878–1966), daughter of William G. Parrish and Josephine Whittier, was a sculptor who shared Northcote with Stephen after his wife Elizabeth left him, and continued to live there after Stephen died in 1938. Anne Parrish herself died in 1966, just six months after her cousin, Maxfield Parrish. She had been an 1899 graduate of Swarthmore College and had been asked by the Parrish family to assist Stephen for a summer; however, she decided to stay for a while longer and never left. Stephen, already a well-known artist, had been living alone for approximately a year after his wife left him 'to join a group of fanatical believers in a strange religion in California'. He needed companionship and care and Anne agreed to help out by running the household, a not unusual situation for an unmarried female in those days. She was also an ardent campaigner for women's rights, however, which had been something of a tradition in the Parrish family.

Stephen introduced Anne to Augustus Saint-Gaudens' assistant, the sculptor Frances Grimes, who took Anne under her wing and gave her lessons for some years. Though her output was not prolific, Anne's work was admired by many of the Cornish artists. Stephen grew quite fond of her, encouraging her sculpture and even building a studio fo her next to his own.

Anne inherited Northcote after Stephens's death and continued to live there until she died. A handsome woman with an olive complexion, golden hair, full lips and a lithe figure, she appears in a bas-relief by Frances Grimes, executed in 1905, and was later immortalized by Maxfield Parrish at the age of 38 in the largest of the Florentine Fête murals.

Parrish and Pennell in London

Maxfield Parrish began his education at Swarthmore Preparatory School, but took leave of absence in 1884 when his parents made a two-year trip to Europe. Consequently, he was educated by his parents during this period, though for a time he attended Dr. Hermann Kornemann's school in Paris. His letters to friends and family at home were typically Parrish. They were embellished with sketches, doodles, caricatures and anecdotes, revealing him as a precocious 14-year-old. In the following example, written to his cousin Henry from London on 19 August 1884, the large sheets are completely covered with caricatures of Africans, cats and dogs, English musicians, even a drawing of a human eye instead of the word 'I' to begin the text: 'Dear Hen, I hope you have enjoyed your Summer Vacation as much as I am doing now. Not long ago Papa hired me a bicycle for a week, and you may imagine what a fine time I had riding, as the roads here in London are just like glass being all asphalte [sic] pavement. Mr. Pennell (a friend of Papas') [the illustrator Joseph Pennell] has a tandem bicycle that will carry two persons and he invited me to take a ride with him out to Epping Forest (about twelve miles from London) so I went of course, and we had a delightful ride away out in the country. Mr. Pennell says we went 50 miles all together but I think he said 50 to make it a round number. The next day I took a ride up the Thames to Kew (and went about 30 miles) on our own machine (at least our hired one) and I was rather played out at night. I do wish you were here to see the "model shops," you would go half crazy over them, you know what I mean, stores that sell locomotives like yours. There are lots of different sizes and I never tire of looking in at the shop windows at the beautiful models. Papa thinks he will get me one, it is a beautiful engine 14 in. long, and it goes backwards or forwards (see ills. Above) [in the middle of the letter is a perfect drawing of a locomotive] and has lots of things like a real engine. We are going to Canterbury in a day or two, and Mr. Pennell says they have the largest Natatorium in England, and I guess I will have a paddle or two. Well I must close now so "bon jour" with love to all the family. I am your aff. Buckshire, Buck. Don't forget to write.'

As a schoolboy, family and friends were still calling Maxfield 'Fred', but he referred to himself as 'Buckshire', a nickname of unknown origin; however, his return address always read 'Fred Parrish'.

Because of his family contacts, Maxfield Parrish often met people important in the art world, such as Joseph Pennell (1860–1926), and his self-assuredness as an adult may well have stemmed from this. He was never 'impressed' by celebrities, nor did he seek celebrity himself. Nothing was unusual to this unusual man.

His father's friend, Joseph Pennell, was an extraordinary draftsman-artist who received many travel assignments from periodical and book publishers and was also well known for his etchings. He was 24-years-old when he first met young Maxfield and his father in London. One of Pennell's later books was called, *Our House and London Out of Our Windows*, but at the time he was working on a portfolio of drawings of Canterbury, which would account for him travelling there with Maxfield. Pennell was also the author or co-author, with his wife Elizabeth Robins Pennell, of other illustrated books as well as a biography of James McNeill Whistler, while Elizabeth Pennell wrote a narrative describing their trip to Canterbury entitled *Canterbury Pilgrimage* (1885), the first of their many travel books and articles. The Pennells had just married prior to coming to England, having changed their honeymoon plans to England because of a major cholera epidemic in Italy.

It therefore appears that Maxfield was sophisticated beyond his years, having travelled in Europe from the age of seven when he met many interesting people. After all this, it is difficult to imagine him settling down to a plain Quaker life in Philadelphia for he was clearly 'spoiled' in every way.

Parrish at the Louvre

On 4 January 1885, Maxfield Parrish wrote to his grandmother: 'This morning Papa and I took a walk through the long picture gallery at the Louvre and I enjoy the pictures more and more each time I see them. There is one picture there of a Spanish Princess which is in front of the Christmas St Nicholas.'

While in France, in the summer of 1885, Maxfield contracted typhoid fever and very nearly died. Elizabeth Parrish was at her wits' end but, fortunately, Stephen was able to keep his son occupied by giving him etching and drawing lessons. These were of immense interest to Maxfield, who was encouraged to follow in his father's footsteps and become a professional artist himself. While father and son were establishing a strong bond of camaraderie, Elizabeth was left out in the cold. The marriage was not a good one and began to deteriorate rapidly. Elizabeth was openly jealous of the shared interests of father and son and at the same time was seeing too much of her husband's cronies, some of whom were rather decidedly disreputable.

While in Paris, Maxfield took himself to the Louvre where artists were copying masterpieces by the van Eyck brothers, Rembrandt, Botticelli, Titian, Correggio and others. He marvelled at their facility and watched them for days on end. He was particularly fascinated to see egg tempera being used and glazed layers of varnish applied, above all, the arduous process of applying layers of colour, one at a time, which in due course he would adopt as his own technique. He was also impressed by the Rembrandt etchings, though they differed substantially from those of Appian and his father.

The Pre-Raphaelites

Maxfield was clearly attracted not only to the paintings as art, but also to the romantic subjects that unfolded before his gaze. He was particularly drawn to English artists such as Dante Gabriel Rossetti (1828–82) and Frederic, Lord Leighton (1830–96). At first, this was possibly due to their choice of subject matter but later to the intricacies and effects of their painting styles and techniques. As was the case with Maxfield Parrish later in life, the Pre-Raphaelites had been influenced by romantic writers such as Keats and Tennyson, using the

poets' writings as subject matter for their paintings. In the same way that writers use words to describe what is in their thoughts, so these artists transformed poetic allusions into sublime images of lovely maidens and chivalrous knights. Maxfield liked Chaucer and enjoyed poetry in general, but these artists were different from anything he had seen before.

The Pre-Raphaelite Brotherhood was a group that had been formed in 1848 in reaction to the cloying sentimentality and academic convention of Victorian art. One of their number, John Everett Millais (1829–96), produced the famous *Bubbles* advertisement for Pears Soap in 1886, which quite possibly provided Parrish with food for thought, proving how commerce need not necessarily compromise artistic integrity. The Pre-Raphaelites, with their casual way of life, their taste for exotic foods and outlandish clothing and, of course, the sexual liberty which surrounded them, seemed shocking but thrilling to an impressionable youth raised in the bosom of a devout Quaker family, and certainly encouraged the curious mixture of naturalism, romanticism and fantasy that characterized his own work.

Hidden Idol

A major influence in the shaping of Parrish's creative powers was his fascination with the legendary lifestyle of Frederic Leighton and the striking quality of his art. Leighton had a love of form, which led to a 'set of conditions, in which supreme scope is left to pure artistic qualities, in which no form is imposed upon the artist by the tailor, but in which every form is made obedient to the conception of the design he has in hand'. From an early age, Parrish subscribed to this same philosophy. In fact, one of his paintings has a girl with more than five fingers on her hand; but the extra digit curiously suits the composition and therefore remained, its use 'obedient to the conception of the design'. Leightonesque figures, androgynous beings and semi-nudes are often to be found in Parrish's paintings, for example, the so-called series of 'girls on rocks', such as *Morning* and *Contentment*, his Egyptian themes, and the elf-like images of children reflected in placid pools at dusk; even

the famous *Daybreak* is an abstraction – pure Leighton – albeit a quarter of a century later and an ocean apart. Parrish clearly agreed with Leighton's notion of each form balancing the overall design, for he too planned his work according to classical precepts relating to symmetry and a graphic balancing of elements (at heart, Parrish was also a shameless neo-Classicist!). In 1950, he said, 'I lay each painting out on the basic of "dynamic symmetry" or the mathematical proportion which the ancient Greeks and Egyptians found appealing to the eye. Thus by using "dynamic rectangles" and "whirling squares" (mathematical lingo for certain geometric forms) I design the dimensions of my pictures and block them off, placing the horizon in just the right place.'

Lord Leighton dominated the London art scene as president of the Royal Academy of Arts in London from 1878 until his death in 1896. His most recognizable and reproduced painting, *Flaming June*, was of an actress, an uneducated cockney and his favourite model, Ada Alice Pullan, known as Dorothy Dene, who from 1879 onwards modelled for the flamboyant Victorian bachelor. Parrish was captivated by Leighton's sense of style, not to mention the intriguing 'Leighton House', and was fascinated by the idea of an artist with a younger, compliant model willing to pose naked for him (in Leighton's case, sex with a woman was possibly not on the agenda.) Years later, Parrish painted his companion, Susan Lewin, as *Sleeping Beauty* (page 161), in a near-identical pose to that of *Flaming June*.

Leighton House, on the edge of Holland Park in London, was one of the most unusual buildings in 19th-century England, and was a magnet for a wide array of Leighton's cultured friends. Later on, The Oaks would serve something of the same purpose within the Cornish Colony, and was possibly modelled on Lord Leighton's salon in London.

Interestingly, like Lord Leighton and many of the Pre-Raphaelites, several late-Victorian and Edwardian painters, among them Sir Lawrence Alma-Tadema, could be regarded as illustrators, their work contributing much to the romantic climate of the day. Years later, looking back on his travels and visits to museums in Europe, Parrish made light of their influence on him; perhaps his own later successes had made him blasé.

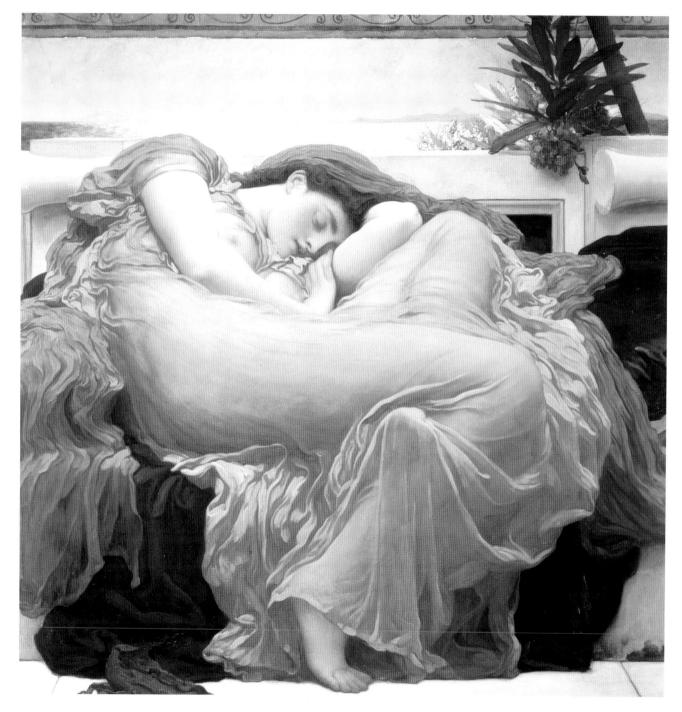

Frederic Leighton
Flaming June, c.1895
Oil on canvas, 47$\frac{1}{2}$ x 47$\frac{1}{2}$in
(121 x 121cm)
Museo de Arte, Ponce, Puerto Rico.

THE LIFE OF MAXFIELD PARRISH (1870–1966)

Maxfield Parrish in 1896, at the age of 26.

Like Father, Like Son

The way that Maxfield Parrish followed his father's lead continued in more important respects for the rest of his life. Consequently, it makes an interesting psychological study to trace the similarities between artist father and artist son.

•Both men abandoned secure careers for challenging and risky lives as artists, which was antithetical to their upbringing and Quaker religion.

•Both began painting at a young age: Stephen was self-taught while Maxfield had the advantage in having his father as a personal instructor. Father-son art lessons began when Maxfield was six-years-old.

•Both enjoyed travelling, especially in Europe, and did so frequently throughout their lives, often without their wives.

•Maxfield followed his father's lead by building his home in New Hampshire in the same artist colony at Cornish.

•Both relished their life in the Cornish Colony with its enclave of talented artists, writers and intellectuals. In spite of age differences, both father and son became personal friends of Augustus Saint-Gaudens, the noted sculptor and charismatic leader around whom the colony had formed.

•Both built separate studios on their estates so that they could work without interruption.

•Stephen gave up etching, after the decline in its popularity, turning exclusively to landscape painting. Likewise, Maxfield stopped producing illustrations, painting only landscapes in his twilight years: both men lived into their 90s.

•Stephen's wife, Elizabeth, left him for life in a California commune and never returned. Maxfield adored his father and was devastated by the split-up. It is possible that this precipitated his alienation from Lydia, causing him to focus, like his father, primarily on his art.

•Maxfield's wife never totally left him, but she did leave every winter to travel to the Georgia Sea Islands, where she eventually died alone and was buried there in 1953.

•Stephen felt that Maxfield needed more help at The Oaks in order to spend his time more effectively on art rather than 'family chores'. Stephen had an assistant, Marguerite Lewin, who suggested her younger cousin, Susan Lewin, as an assistant to Maxfield Parrish. Susan Lewin came originally as an au pair, but within weeks had become Maxfield's studio housekeeper and model and later his companion – a relationship that lasted over 55 years

Such similarities are astonishingly parallel and are surely more than coincidental.

From Haverford Days to Academy Nights

In 1888, Maxfield Parrish enrolled at Haverford College, not far from his Philadelphia home, with the intention of studying architecture, though he persevered for three years and failed to graduate. In the process he became interested in classical architectural forms, the study of proportion and geometry, and constructed basswood models in the machine shop. He paid particular attention to the effects of dimensions on the harmony of buildings and spent hours copying drawings of Corinthian column capitals or constructing complete cornices from hardwoods in the Beaux-Arts tradition. Other subjects, among them chemistry, bored him to distraction, causing his mind to wander when he doodled in his notebooks. Haverford retains one of Parrish's chemistry notebooks, each page illustrated with elements of the lessons, except that they are in the forms of cartoons. Reflecting on those schooldays, his room-mate, Christian Brinton, obviously impressed by the raw talent of this enigmatic young man, suggested that formal training was 'wholly superfluous, for he was a draftsman and a colorist

of individuality and power'. Christian Brinton became Maxfield's closest friend and confidant.

In 1914, both Brinton and Parrish received honorary degrees from Haverford College. In the meantime, Brinton had become an ambassador for American culture abroad, an art critic and orator, an art and book collector and a writer, before turning Howard Pyle's studio into a small art museum. Later, with N.C. Wyeth, he founded the Chester County Art Association.

Interestingly, all these artists' lives were linked in one way or another; Brinton, for example, was decorated by King Albert of the Belgians in 1931, while in 1915 Parrish was invited by Edith Wharton to contribute a painting for the cover of her *Book of the Homeless*, modelled on Albert's book. Parrish declined, being completely occupied with the murals for the Curtis Building – his true magnum opus – A Florentine Fête.

Another Haverford classmate, Stanley Yarnall, wrote in the *Haverford Review* of the room-mates in autumn 1942: ' ... their room became a center where we loved to see the designs and drawings flow ... who, even then [referring to MP] was rapidly developing the manner and techniques which have made his work delightful and significant in American art.'

While Maxfield Parrish was decorating the walls of his classmates' dormitories, he was beginning to realize that he needed more artistic discipline and formal instruction, and as he basked in the glow of congratulations for his efforts, he was planning to leave Haverford, having come to the irrevocable conclusion that he wanted nothing more to do with engineering and architecture. In taking this decision he was only too aware of the practical constraints that clients could impose, and this, he believed, coupled with the limitations of construction and building sites and newly formed building codes, would only serve to stifle his creativity. Architecture, the noblest profession of them all, failed to inspire Maxfield Parrish and in actual fact was an uncreative and limiting activity as far as he was concerned. Years later, he reflected on his time as an architectural student at Haverford: 'In those days I was all for becoming an architect, and once, exploring in some forgotten corner of the

library, discovered a number of giant French books of engravings and classical temples; books of wonder, smelling of old moldy leather and of long years unused. From the astonished college librarian, permission was obtained to take them one at a time to my room, where many hours were spent making tracings of capitals and things ...

'There may have been precious little art around, but there was surely a wealth of material for making it ... the sheer beauty of the place was an influence ... lying under those copper beeches, when we should have been doing something else, looking into the cathedral windows above did a lot more for us than contemplation of the Roman Coliseum. There were grand trees in those days, and grand trees do something to you ... Would one dare to say that some courses soon faded, but what remained forever and came back across the years is some small memory of shade under the trees in late afternoons, young summer moonlights, many, many trivial moments that entered our conscious and decided to stay ...'

This extract exemplifies Maxfield's youthful, idealistic state of mind while at Haverford. After three gruelling years of anguish immersed in Vitruvian principles, so saturated that he never got them out of his system, the study of building materials (his own building project, The Oaks, has some bearing here), professional practice and contract law (perhaps the source of his businesslike approach to art), the techniques of drafting and technical studies, all became too much for the young man and he dropped out of college.

This was a much more unusual occurrence in 1891 than it is today and Maxfield Parrish was certainly one of the first college dropouts. In most families, Maxfield Parrish would have been considered a 'quitter'. However, with his father's blessing, he immediately entered the Pennsylvania Academy of the Fine Arts, the idea being to formally study painting and become a professional artist.

At the Pennsylvania Academy, he soon realized that his talent and technical skill greatly exceeded those of his classmates, a fact also recognized by the faculty, and he was given commissions as a result. This was the beginning of his life as an artist.

The Chaperone

While Maxfield was matriculating at the Pennsylvania Academy and some years later when Northcote was under construction, from about 1891–98, Stephen Parrish rented a sail loft as a summer studio in Gloucester, Massachusetts, at Annisquam on Cape Ann. Many years later, Maxfield related stories of those languid days to his own son, Max, Jr. He told of the humid weather, of the lush wild flowers, of long wharves with sagging weather-worn shacks, fishing boats at anchor in the harbour, and of the famous Rockport shed with lobster traps and netting hanging from its walls, and, of course, of the Paint Manufactory building protruding from a precarious rocky promontory in the middle of Gloucester Harbor – perhaps the most painted scene on the North Shore. Some of this was described by Max Parrish, Jr. in 1972: 'His father and he lived in this shack, a small sail loft ... in one corner was a stove and in the opposite corner was a sink. In the other corners were beds. A long table in the middle was used for sketching, writing letters and eating. Sometimes relatives from Philadelphia would come to visit them for the day, taking the night steamboat from Philadelphia to Gloucester. Stephen often used this boat Friday night to commute from Philadelphia to Annisquam, get some painting in on the weekend, and back to Philadelphia on the Sunday night boat. Once a proper Philadelphia aunt suggested a chaperone when having young ladies in for meals in this primitive cabin out in the wilds. On her next visit, there was one to greet her, which Maxfield had painted on the door (page 233). Also, a knocker, which the door lacked.

'Maxfield must have enjoyed this rustic life, for he told us many stories about the shack and the goings-on there: how this was the first real "plain-air" [sic] painting he had ever enjoyed in day-long sessions. In the early 1890s, the scenery on Cape Ann was such as to drive a landscape painter wild and with their headquarters right there in the midst of it, the whole day could be spent painting ...With the coming of the gasoline engine, small sailboats were no longer used by fishermen and the shack, no longer needed, was torn down about 50 years ago. But, someone saved the picture on the door.'

Whoever removed that door from the loft was obviously taken with the image and was aware that Parrish had lived and worked in that space with his father. However, it should be mentioned that in the 1950s and '60s, Parrish's artworks did not command very high prices. A painting of this sort on a chunk of wood would not have been considered very valuable, yet it was apparently treasured for many years by someone on the West Coast, or so the story goes.

It turned up in California in about 1986, the property of a couple who had been told that Maxfield Parrish had painted it. The Californians brought it to New York and it was sold in the early 1990s to a Parrish aficionado, a collector of original artworks, and given pride of place in their home. The story of the Chaperone has trailed the painting all these years and is verified in notes written by Maxfield Parrish, Jr. The story told by the Californians was that the Philadelphian aunt, an 'old maid', was appalled that Elizabeth Parrish 'let her two boys off on their own in the midst of so many attractive tourists and artists', which was the reason why a chaperone was suggested. This, Stephen and his son found highly amusing.

World's Columbian Exposition, Chicago, 1893

On 1 May 1893, President Grover Cleveland opened the Chicago exposition by pressing a golden button and setting off newly-invented machinery, while electric lights turned on all over the huge complex known as 'The White City'. On 3 October, Maxfield Parrish and Christian Brinton arrived by train from New York City to visit the stupendous display of technological and architectural marvels. The two youths, both 23, remained in Chicago for a week, sampling the delights of the astonishing fair and its famous Midway Plaisance.

Maxfield had particular goals in mind, not the least of which was to see his father's etching on show and then to view the scientific miracles that were destined to lead America into the future, technologies which are now taken very much for granted. At the time they were presented, however, they seemed revolutionary and extraordinary, but they dramatically changed the way everyone lived thereafter. Needless to say, Brinton and Parrish were completely overwhelmed by what they saw.

Perhaps the greatest invention highlighted at Chicago's Jackson Park was the Hall of Electricity. This were described by Chicago's *Daily Dispatch* as an 'awe-inspiring fair which will go a long way in changing the fear of electric power into fascination'. The fair was taking place just a few years after the Great Chicago Fire of 8–10 October 1871, an event that lingers in the memory not only because of the extent of the devastation but also because the United States was simultaneously transforming itself into an urban industrial nation. Chicago embodied that transformation, having recently shaken itself free of its frontier past.

When the fire struck, Chicago was in a process of evolution from a rural hub to an international industrial metropolis. An obscure trading post at the beginning of the century, it had grown to accommodate more than 330,000 people on the eve of the fire, the rapid growth primarily due to the fact that most of the railroads either terminated or intersected with each other in Chicago. It was all the more astonishing that the city had totally rebuilt itself in less than 20 years and was now host to the most avant-garde exposition the world had ever seen. The fair was conceived in 1889, approved by the city fathers in 1890, and was the country's fourth largest urban centre at a total cost of an incredible $35,250,000. Stephen Parrish's friend, Augustus Saint-Gaudens, organized the planning for the site and remarked that 'nothing was wanting either to its greatness or its success. The edifices and their grouping were worthy of the pomp of imperial Rome. The artistic and scenic accessories made them seem like palaces in fairyland, critics of all nations vied with each other in eulogy on beholding the White City'.

The White City

The nickname of the exposition derived from the plethora of neo-Classical buildings executed in white marble and lightly-coloured masonry and concrete. Maxfield Parrish wrote

home on 6 October 1893, 'My dear Mama: Thy letter was very welcome yesterday, and especially so as I did not expect to hear from you so soon. This is just a breathing spell at the close of the day to say how do? Today has been trying to explain why this place is sometimes referred to as the 'Windy City.' It has been blowing up a gale, with a little rain and drizzle too: a stunning loose gray sky, just like Normandy, has made a beautiful picture all day long with the white buildings under it. Finer even than yesterday when all was a dazzling white under a clear ultramarine sky. I have not been much in the buildings, though what things I have seen inside are simply marvels of handiwork. What I love to look at most is the conception of the whole thing. Look at it, and realize the possibilities of this effect and that. One often dreams of laying out ideal cities with unlimited means, but such mental recreations have to be remodeled after seeing this. These stupendous architectural groupings could scarcely be surpassed in fairy tales without becoming absurd. And one of the strangest things about it all is that it is almost impossible to imagine such things can ever be done again. It seems the more fairy-like when one knows it is all to come down in a few months. The people one never ceases to watch. Such characters and types were never collected before, and in themselves they are a Fair. One only has to come here to find what is known as caricature is after all a literal rendering of the truth. I am enjoying it all in a general way and though horses made of prunes are no doubt very wonderful, yet I prefer to see it as I like best. The Fine Arts Building has seen me most. There are a few fine, really fine things. That man Zorn from Sweden is certainly a wonder. Tell Papa no pictures are hung in groups. The works of the same artist are scattered all over the place, their only limit being the US section, France section, etc. His etchings are however all together and look very well. The medals were evidently given to a boot-black to confer on the things he liked best: most every other picture has a medal and it seems as much of an honor to be without one as have one. Some of those with medals are almost comic. In haste, lovingly, Fred'

Maxfield was unaware at the time that his father had given up etching and that if ever he created artworks again they would be oil paintings; in the meantime his artistic pursuits had come to a halt.

A Place for the Parrishes

While Maxfield was finishing grammar school, his parents left Philadelphia to visit Cornish. On arriving in New Hampshire, Stephen discovered a wonderful landscape, with a mountainous backdrop reminiscent of France or even Tuscany. Most of all, he loved the serenity and the people he encountered there, leading him to dream of building a retreat some day within this Arcadian setting.

Some years later, and Maxfield Parrish was a budding artist, enrolled at the Pennsylvania Academy of the Fine Arts; but instead of doodling on notebooks and dormitory walls, he was now producing his first significant work.

In imitation of his father, he began to keep a scrapbook with a log of his work in which he describes his very first painting as 'painted in one sitting over an orange ground. The impression was received after a walk across Cape Ann at 2 o'clock in the morning ...'. One wonders what he was doing out at this time, but it must have been an inspiring and worthwhile experience for he created his first artwork as a result.

When he returned to the academy in the fall, Maxfield held a public exhibition of that first painting, *Moonrise*, at the Philadelphia Art Club. It is interesting to note that Stephen Parrish had exhibited at that gallery in the spring and his son's painting was no disappointment to him – quite the contrary. Maxfield wrote a letter to his classmate, Daisy Deming, in November 1893 regarding *Moonrise*, which was in response to her letter describing Vonnoh's critique of his painting. 'I am afraid, my young lady, in a mistaken idea of charity, you have left some of the worst out – for I cannot imagine him not jumping on my productions much more heavily than he did, let alone notice them in a general criticism ...

many things make me forever disgusted with my work. I get precious little enjoyment out of my results for I am forever comparing them with what I would have the results be, and it is needless to say, such a performance does not endear one to one's work …I suppose one must not be too impatient, but be content to slowly, very slowly advance …you know that I told you in secret confidence that I sent a little thing to the Art Club – and I am very sure that it will not be accepted, for it is very characteristic of me, flat and an attempt at the decorative, etc., but if you go to the exhibition when it is opened you might let a fellow know, you know, if you saw it anywhere. Look high! You may understand when I ask if one, even at our stage in the art, is justified in liking a thing he has done. But sometimes you may, I think. The one I sent is supposed to be moonlight. One glorious night last summer I walked across Cape Ann at one o'clock in the morning. It was moonlight and not a trace of a breath of air. The impression that night made upon me I shall never forget. The next morning I painted what I felt, and the result I sent it to the Art Club …'

The Cornish Colony

New York attorney Charles Cotesworth Beaman first came to Windsor, Vermont, in 1874 to visit his father-in-law and law partner, William Evarts. What Beaman found there was amazing: Evarts had founded a residential community for friends and clients and in the process had created a small resort, purchasing and developing several farms by converting them into summer residences, creating ponds, building roads, tennis courts and golf courses, and generally making money hand over fist as an entrepreneur and early real estate developer.

Ten years later Beaman returned to Windsor, crossing over the same Connecticut river bridge from Vermont into New Hampshire, the longest covered bridge in the country, where, like Evarts, he proceeded to buy more farm sites. Windsor, Vermont was the postal address and train station, but the land was mostly in Cornish on the New Hampshire side of the river. Ultimately, by the time of his death in 1900, Beaman had acquired over 2,000 acres (800

hectares), bought with the idea of expanding the concept his father-in law had envisaged. Beaman's dream was to create a refuge from urban life specifically for creative people. Infected with a love of bucolic settings, he bought a quantity of New Hampshire farms exclusively for New Yorkers and Bostonians with similar tastes. Envisioning a unique refuge from the noise and filth of city life, he went to great lengths to make them different from the tediously boring Long Island or Lenox communities, aspiring to a more casual retreat for a fortunate few.

Blowmedown Farm

In 1884, Beaman completed his own summer house in Cornish, Blowmedown Farm. The following year, he persuaded Augustus Saint-Gaudens to rent a dilapidated house on his property for the summer. It was during that August in Cornish that Saint-Gaudens produced a sculpture, *Abraham Lincoln: The Man*. During the summer of 1885, Beaman (a patron of Saint-Gaudens) rented the farm to the sculptor. The large amount of land which Beaman owned, and his own enthusiasm, were important factors in the establishment of what would become a vibrant art colony, allowing him to attract artists by renting or selling property at quite reasonable prices. Saint-Gaudens continued to rent the farm, later renamed Aspet, until 1891, when he was able to convince Beaman to sell him the house. Aspet is now a part of the Saint-Gaudens National Historic Site and the property is preserved in perpetuity by the Federal Government's National Park Service for the public benefit.

In 1886, Saint-Gaudens implored his painter friend, Thomas W. Dewing, to come to Cornish: '... a place to pass summer, when I told him of a cottage that could be rented from Mr. Beaman ... Mr. Dewing came. He saw. He remained. And from that event the colony truly developed ... the circle has extended.' The 'circle' was the group comprising artists, sculptors, writers, architects, composers, musicians, actors and art patrons, friends all and all sympathetic to the cause.

Aspet, the home of artist Augustus Saint-Gaudens.

Not a Place but a State of Mind

By 1900 there were 45 full-time families in residence between Windsor, Cornish and Plainfield, and the nation's very first artist colony was successfully established. The whole area was known as 'Cornish', and was frequently mentioned at Mrs. Astor's dinner parties in New York for the so-called '400' and at other occasions attended by the cream of sophisticated society. The Cornish Colony became widely known as a special place of refuge, creative industry and passion for the arts. By 1905, it comprised a community of over 375 creative professionals, with people from other disciplines, be they poets, composers or actors, also drawn to the community. Frances Grimes wrote of Cornish at that time: 'Its reputation was not wholly good, it was said to be not a place but a state of mind, as Boston was said to be.' The atmosphere was one of high culture and constant creative endeavour.

The Oaks

In March 1897, Maxfield Parrish and his wife Lydia left Philadelphia for New Hampshire. Borrowing $950 from Maxfield's father, they promptly bought 19 acres (8 hectares) on Freeman Hill in Plainfield, where their modest estate, The Oaks, was built. In fact, by the time they arrived in Cornish, it had become quite fashionable to live in this hidden corner of rural New Hampshire.

Maxfield Parrish remained in Plainfield, the actual township, for the next 68 years, while others came and went from the Cornish community. He remained there well beyond the heyday of the Cornish Colony, which all but terminated with the crash of 1929, long after its glory had nearly totally faded and the genuine, the parvenus and the sycophants had all departed.

Using his architectural training, Maxfield Parrish designed a 'dream house' and built it himself with the help of local carpenters, including his new acquintance, George Ruggles, a handyman and caretaker. The property was aptly named 'The Oaks' for the magnificent stand of oak trees in the midst of which the main house was to stand. Ruggles stayed on at The Oaks for the next 33 years until his death in 1931. In addition to his role as caretaker, his last few years were spent making picture frames and shipping crates for Parrish's paintings. He and Parrish became close friends over the years, and other than Susan, Ruggles was perhaps the person closest to the artist.

The main house started out quite small, but as it evolved Parrish became more and more enthusiastic and enlarged the earlier 15-room design into a grand 22, with outbuildings and a later separate nine-room studio building for himself and Susan Lewin. It had sliding storm shutters which slipped inside the wide walls, and there was a contraption he invented himself which permitted one to see a gauge from the ground to determine the amount of water in the storage tank high above the roof.

Sculptor Frances Grimes lived just down the road: 'We ... watched as MP and Ruggles built the house and we often walked over to see how the building was coming on and, one afternoon I remember, Adams called my attention to how perfectly the nails were driven in the tool house which Fred (MP) had built himself, that there were no marks of the hammer around the nail heads.'

Parrish, a proficient carpenter, later wrote of such craftsmanship on 22 August 1926 to his friend, Austin M. Purves Jr.: '... before you spoke of making drawers and things. O! don't I know what that means: but I dare say an artist is much better off if he doesn't know how to drive a nail. Or may be a tinkerer would be much better off if he would let painting alone. Life has too many interests these days, but may be it always had ...'

Cornish or Plainfield, Plainfield or Windsor

Maxfield Parrish and his young wife, Lydia, moved into their new home in 1898, the same year his mother left his father and departed to California. Thenceforth, Maxfield remained in Plainfield, leaving it only when absolutely necessary or when an event in New York or

Stephen Parrish at the age of 67, photographed at Northcote, his home in Cornish.

Maxfield Parrish with his sons, Stephen (1), Max Jr. (4) and Dillwyn (6), in 1910.

Boston warranted a trip to the outside world: ultimately, he died there. Plainfield was so small that it was forced to use the U.S. Post Office in Windsor, Vermont, across the Connecticut river. This juxtaposition has sometimes confused those who know that Parrish lived in and loved New Hampshire, but his paintings often indicated his return address as 'Windsor, Vermont', on the reverse side. Windsor is indeed, a stone's throw from Plainfield and the Cornish Colony, but they were in New Hampshire and Windsor is in Vermont. Windsor, still a small community today, is much larger in population and has more facilities than either Plainfield or Cornish. So for many other services, not only postal, New Hampshire residents have no choice but to continue to transverse the long wooden covered bridge spanning the broad Connecticut river which separates the two communities, the two states.

Maxfield's personal letterhead in 1905 made no mention of Plainfield, the actual town in which he lived, but rather it had this return address emblazoned in red ink across the top: THE OAKS Cornish: New Hampshire. Post Office and telegraph address: WINDSOR, VERMONT.

For Parrish to have used a letterhead without a mention of his town is something of a disappointment to the people of Plainfield today, as the town has always claimed him as their most important resident. Yet Cornish is what was known far and wide, so it is not surprising that he used the name instead.

It was said by Maxfield Parrish that he settled in New Hampshire so that he would always have a view of Vermont. The Cambridge educator, Dr. Diane Tabor, born south of Windsor in Springfield, Vermont, mentions that her father used to religiously partake of the local tradition of Vermonters, which is to stop on the New Hampshire side of the Connecticut river and point out the beautiful view to visitors, saying 'it is far more spectacular than from the other side – just wait a few minutes and you will see'. There is no question that local people all feel the same regarding the views from New Hampshire, Vermont looks far more beautiful. Yet, the attraction of New Hampshire for Maxfield Parrish was multi-faceted: his parents had moved there, the art colony was in Cornish, but most of all it was the natural beauty of the place that reminded him of Italy or France. The views of Mount Ascutney, the brooks and streams, the plodding Connecticut river, the foliage in the fall, the tranquillity, above all the unspoken rule of New Englanders that they respect the privacy of others – all added up to a near-perfect existence.

After the Heyday

The Cornish art colonists, like their counterparts throughout New England, were attracted by the natural beauty, dramatic seasonal variations and relative seclusion of the place, as well as by the mutual encouragement and intellectual stimulation offered by the residents. Unlike other, later colonies, Cornish was not incorporated and it had no central governing body; it was in fact disorganized, but with a definite purpose as a fellowship of colleagues in the arts.

The great Mount Ascutney was their common visual focal point and it became a symbol of the colony. Ascutney is said to be the second tallest monadnock (single mountain rather than part of a chain) east of the Mississippi river. It is a 120,000,000-year-old volcano, referred to by the Cornish Colony as 'The Sacred Mountain', and it appeared frequently in their artworks, including those of the Parrishes, Henry Brown Fuller, Augusta Homer Saint-Gaudens, Charles A. Platt, Arthur Henry Prellwitz and Henry Fitch Taylor. Originally, the Algonquin Indians named the mountain peak, 'Ascutegnick', which means 'meeting of the waters'.

'A Masque of Ours' or 'The Gods and the Golden Bowl'

In 1905, to celebrate the 20th anniversary of the founding of the Cornish Colony, a performance entitled 'A Masque of Ours' or 'The Gods and the Golden Bowl' was presented at Aspet, while members of the Boston Symphony Orchestra performed music written by

Stephen Parrish
East of Plainfield, New Hampshire, 1923
Oil on canvas board, 16 x 20in
(41 x 51cm).

The Oaks, at Cornish, New Hampshire, an aerial view taken in 1970. Photograph courtesy of Rosalind Wells and Gary Meyers.

A Classical urn at The Oaks, an example of the Italian influence on Parrish's garden design. Photograph courtesy of Rosalind Wells and Gary Meyers.

Arthur Whiting for the occasion. Maxfield Parrish designed the costumes and artist Eric Pape painted the sets.

In general, the colonists had arrived in Cornish in three stages: visual artists and sculptors in the late 1880s and early 1890s; writers and musicians in the 1890s. After 1905, the colony began to attract professionals such as lawyers, doctors, even politicians, as well as the shamelessly wealthy, striving to give some meaning to their lives by associating with people more creative than themselves.

Cornish Gardens
Apart from the Cornish art colony, Cornish gardens were a major summer attraction and soon gained a national reputation, particularly within the higher echelons of society. In 1903, *Century Magazine* sent a journalist to document some splendid New Hampshire gardens and to reveal their origins. At that time, The Oaks was just a few years old and its gardens had not yet matured; in fact, some areas had not even begun to take shape. When the *Century* journalist appeared and asked to take photographs, Parrish rejected the request: 'We are only beginning to make a garden now; there is nothing but raw dirt hauled in here and there, but some day, some day, we are going to have an affair here which will make Versailles look like a dory full of portulacas.' Italian gardens were then much in vogue as a result of Charles Platt's book on the subject.

A few months after the Cornish gardens article appeared, Maxfield Parrish returned from researching his own *Century* assignment in Italy. While there, he photographed and sketched 28 villas and their gardens for a series of articles and later a book, to be illustrated by him and written by Edith Wharton. It was entitled, *Italian Villas and Their Gardens* (see page 190 et seq.).

Although the garden of The Oaks could never have put Versailles or any part of it to shame, it did have a formal Italian feel. A small circular reflecting pool was a Parrish nod to what he had seen in Europe, but on a scale appropriate to his own property. Years later,

when Parrish was concentrating almost entirely on landscape painting (after 1931), the splendid but not overly elaborate gardens, trees and urns at The Oaks were a particular source of inspiration to him.

An Enviable Lifestyle
An important ingredient attracting people to Cornish was the social life. Formal dinner parties and teas were frequently followed by charades, plays and/or concerts. In fact, two outdoor amphitheatres were built in Cornish, one at William Howard Hart's estate and the other at Saint-Gaudens' Aspet, where performances approaching a professional standard were staged, and included a concert series as well as various pageants. In fact, some of the productions were of high quality since many of the participants were professionals. Ethel Barrymore visited during the 1906 season, having agreed to coach some of the Cornish children in a performance of Thackeray's *The Rose and the Ring*, while another memorable performance was presented some ten years later, *The Woodland Princess*, staged at Plainfield at the Town Hall with a stage set designed by Maxfield Parrish. The music was adapted by Arthur Whiting from an earlier piece composed for a dance pageant entitled, *The Golden Cage*, with verse by William Blake, while other musical contributors included composers Walter Damrosch, Arthur Farwell, John Tasker Howard and Louise Homer, a contralto with the Metropolitan Opera – themselves all residents of the colony. *The Woodland Princess* was revived by the townspeople of Plainfield a few years ago, once again using Parrish's set after it had been restored.

Civilization in Rustic Guise
Boston composer-conductor Arthur Whiting (1861–1936) lived in Cornish for 25 years and his presence attracted other prominent musicians to the area, in much the same way that Saint-Gaudens attracted sculptors and the two Parrishes painters. On special occasions an original musical work would often be written by a colony composer and presented at

soirées musicales. Concerts and plays were major social events, staged to celebrate a notable date or significant anniversary. These occasions were important opportunities for members of the community to show off their accomplishments and discover what their colleagues thought of their performances. Two string quartets, the Kneisel and the Olive Mead, were also in residence at the Cornish Colony and were invited by other members, including the Nichols, Lawrence and Parrish families, to perform at dinner parties or informal afternoon concerts; President and Mrs. Woodrow Wilson were at The Oaks for such occasions several times between 1913 and 1915. This was an exciting time in the cultural development of the nation, reflected in the life of this rural community, which, far removed from the city, fostered the arts and offered a stimulating lifestyle.

Lydia and Gussie

Lydia Parrish and Gussie (Augusta) Saint-Gaudens were good friends and saw a lot of one another whenever their husbands got together. Lydia describes Gussie as having 'the strength and virility of the Irish and the finesse of the French'. At the same time, she sympathized with Gussie, feeling that she put up with a great deal of aggravation from her famous husband. Lydia well understood Gussie's situation, though their age difference was significant (they were born 22 years apart), since they shared a common experience: both women wanted to be artists themselves, but had sacrificed themselves to their husbands' careers. They also knew that creative and powerful personalities also had their weaknesses, especially once they had achieved fame. Augustus was closer in age to Maxfield's father and wrote of him thus: 'Stephen Parrish's house was on a hill about a mile away from his son's across the valley. We visited him occasionally, but not too often ... He had great technical skill and he knew the art of painting well. He painted as naturally, easily and constantly as a bird sings, with no desire to be considered a great artist or to attempt more than to get into his landscapes the beauty of what he saw and enjoyed so deeply. They have, I think, the quality of pastoral poems.'

Celebrities and Socialites

Many famous people came to Cornish for long weekends, as did Mrs. Astor's cronies; in some ways the set-up was similar to the social scene at East Hampton, Long Island, where Steven Spielberg and Billy Joel now set the pace. East Hampton was first settled by Montauk Indians and later by potato farmers, and was the kind of place where, in the late 1940s and '50s, it was possible to get away from it all. Today, it is as busy as midtown Manhattan, with smart restaurants and nightspots and multimillion-dollar real estate. Likewise, Cornish, albeit on a different scale, had once been an altogether quieter place before the days when estate-building and Italian gardens were all the rage, attracting tourists to the area. Cornish was the late 19th-century equivalent of the Hamptons today.

An Aristocracy of Brains

In its heyday, members of the Cornish Colony included the sculptor Herbert Adams, painter and art critic Kenyon Cox, jurist Learned Hand, composer Sidney Homer, technical innovator Robert Paine, together with painters Everett Shinn and William and Marguerite Zorach. Others came for short visits and included journalist Walter Lippmann, architect Stanford White and artist-sculptor Frederic Remington. The community became known as an 'aristocracy of brains'. Consequently, Parrish mixed not only with these intellectual luminaries, but with movie stars as well. One of his near-fanatical admirers was Ethel Barrymore – apparently a reciprocal infatuation – and a cache of delicately worded correspondence remains as a testimony to their feelings for one another. In one such letter, Barrymore virtually begs Parrish to visit her New York hotel suite, emphasizing that she is as shy as he is! Barrymore came from a distinguished and creative Philadelphia family and had famous brothers, Lionel and John. Ethel had her own inimitable style of acting, and had a particularly distinctive voice coupled with a sharp Yankee wit. It has to be remembered that the Cornish community were rather selective when it came to issuing invitations – celebrity was not the sole criterion. But Ethel Barrymore was received without demur, her friendship

with Parrish providing her with an 'open sesame' to Cornish's 'Circle of Friends'. Cornish was now an important place in which to live, create, visit and be seen. Contacts made in the colony were invaluable in later life; in fact, it could be said that an artist without contacts was at a disadvantage in that it was all the more difficult to succeed in an artistic vacuum. Cornish provided the milieu whereby the artistic process could flourish.

There were not many colonies or clubs devoted to the arts which served such a direct function in so indirect a manner, providing a social platform for networking, meeting collectors, patrons, art dealers, and in the case of illustrators, publishers and art editors. But aside from the Cornish Colony, there did exist another institution, even more influential, which was limited strictly to men. It was The Players Club.

Legion of Power

One frequently hears the phrase 'it's a small world', yet with the population expanding and less personal time available, it is astounding that one can still make that statement. John Guare wrote a book called, *Six Degrees of Separation*, based on a true story reported in the *Boston Globe*. The book was later adapted as a Broadway show and then as a feature film. It tells how a young Afro-American used school contacts and name-dropping to gain access to a Fifth Avenue apartment in order to defraud a wealthy, sophisticated MIT graduate's family. His first action was to get to know a family member and steal his address book, and so the story develops. The thief then name-drops his way to the next individual and the next, creating a daisy chain of phony connections, the theory being that any person today has personal contacts with enough people to get to anyone else in the world, six being the requisite number. Presumably, this would mean that Elton John would have accessibility to a particular Australian aborigine through six mutual friends or acquaintances – although not particularly likely.

Yet it is interesting to examine the relationships, interrelationships and connexions between the people that surrounded Maxfield Parrish, and from The Players Club in particular, even though there were less than six degrees of separation. The Players Club was socially important and membership assured success as long as one had the required professional credentials and knew how to use them. Conversely, many of the members, including publishers, journalists, editors, writers and art directors, sought out the most talented artists to insure their own success.

Fountainhead of Culture

The world at the beginning of the 20th century was a relatively small place. The overall national population of the U.S.A. was then about 100 million; it was then a more homogenous society with little diversity. The educated few knew one another from school and as members of country clubs, while intellectuals and artists gathered in their colonies and clubs, such as the National Arts Club, Salmagundi Club, Providence Arts Club and The Players Club. Few uneducated persons without the right social contacts excelled in the arts, and those who had talent, education and contacts preferred to band together, sequestered in colonies at Provincetown, in lofts in Greenwich Village, or living in sub-communities as expatriates on the Left Bank in Paris.

In their own little worlds, artists exchanged ideas, often adopting a bohemian lifestyle and developing their respective crafts. Some formed movements, others were lumped together into groups ('The Ten', 'The Eight', 'The Luminists') or simply colonized elitist retreats peopled by patrons and bon vivants. The complementary nature of the arts tended to attract writers and poets, painters and sculptors, architects and landscape designers to seek one another out and form a melting-pot of ideas, where all flourished symbiotically. The most fertile ground was unquestionably in Gramercy Park at The Players Club. Usually simply called, 'The Players', it was a meeting place for burgeoning artistic talents, business men and those who enjoyed being referred to simply as patron of the arts.

MAXFIELD PARRISH AND THE AMERICAN IMAGISTS

In the late 19th and early 20th centuries in New York, almost everything revolved around one's social life, with summers spent on Bellevue Avenue in Newport and winters in Palm Beach. But the Players was the unquestioned fountainhead of culture. Founded in 1888 by the Shakespearean actor Edwin Booth (brother of the assassin John Wilkes Booth), the club was the American counterpart of London's legendary Garrick Club, a theatrical meeting-place, with the idea that people in the same walk of life would have much in common. Architect Stanford White, a founding member, did the renovations to the building in Gramercy Park that Booth purchased for the purpose, while New York governor and former presidential candidate Samuel Tilden (1814–86) owned the adjacent townhouse, which was converted into the National Arts Club ten years after the founding of The Players.

Maxfield Parrish became a member of The Players, where he associated with different members whose interests overlapped. Their circles of influence were avant-garde and some of the most creative people around became his friends.

The Power Legion and the Cornish Colony

It is interesting to examine how the interrelationships of a select few moulded the cultural life of a nation. Edith Wharton referred to then as 'The Happy Few', and their influence was considerable. For ease of identification, we have placed the letters (P) for Players Club members, (CC) for Cornish Colony residents, (POA) for Patrons of the Arts, and (NA) for members of the National Academy of Design after their respective names. Many of the group have multiple designations as they simultaneously belonged to more than one institution. They all knew Maxfield Parrish and his work, they were his friends, competitors and colleagues, while others were his admirers and fans; in many instances they were also his clients.

The Players Game

Maxfield Parrish (P/CC/NA), son of member Stephen M. Parrish (P/CC), settled in Cornish in 1893 as a result of friendships with both the Irish-born Augustus Saint-Gaudens (P/CC/NA)

and artist-architect Charles Adams Platt (P/CC/NA). Platt's garden designs in turn greatly influenced the Philadelphia architect Wilson Eyre, Jr., whom he introduced to Stephen Parrish. Eyre designed Stephen Parrish's Cornish home, Northcote.

Sculptor Augustus Saint-Gaudens first visited New Hampshire at the invitation of New York attorney Charles Cotesworth Beaman (P/CC). Both Beaman and Saint-Gaudens were founding members of The Players Club in 1888 and the Cornish Colony in 1885. The National Arts Club (1898) was founded essentially by the same select few, including Saint-Gaudens, Stanford White(NA/P), Henry Clay Frick (P) and Charles de Kay (P), to mention a few members of The Players next door on Gramercy Park. These prime movers blended seamlessly into the convivial atmosphere of artists and businessmen and attracted others of like mind to the new club, which offered its members a similar ambience to that which Beaman had been trying to create at the Cornish Colony.

The connection of the Parrish family to the Saint-Gaudens clan was originally through Stephen's uncle, Samuel L. Parrish (P), founder of the Parrish Museum in Southampton, who commissioned Louis Saint-Gaudens (P/CC), Augustus' brother and assistant, to sculpt a bust of his father, Dr. Joseph Parrish (great-grandfather of Maxfield Parrish). Rather like Beaman's to Saint-Gaudens, it was Saint-Gaudens' invitation to Stephen to spend a week in the country that ultimately persuaded him to uproot and move from Philadelphia.

Wilson Eyre, Jr., AIA, designed a mansion and stable for Charles Lang Freer (P) in Detroit. A noted society architect, Eyre was born in Florence, Italy to a Philadelphia family and completed the design for Northcote in 1893, when he was commissioned by the University of Pennsylvania to renovate a stable for its drama club. A year later, Eyre reciprocated his Northcote commission by recommending that Stephen's son be hired to paint the decorations for the club. Young Maxfield 'Fred' Parrish, already an honorary member of the Mask and Wig Club, painted his first commissioned work, a mural on the theme of Old King Cole, which hung above the club bar from 1895 until it was auctioned in 1996 for $662,000.

THE LIFE OF MAXFIELD PARRISH (1870–1966)

In 1888, Charles A. Platt (P/CC/NA) designed a house in Cornish for the artist Henry Oliver Walker (P/CC/NA), at the suggestion of Augustus Saint-Gaudens. Barry Faulkner (P/CC/NA), a Parrish family friend, created the murals for the American Academy in Rome designed by Platt. Maxfield Parrish drew on both Faulkner and Platt's intimate knowledge of Italy when the time came for him to produce the book written by Edith Wharton and illustrated by Maxfield, *Italian Villas and Their Gardens*, in 1904.

Painter Thomas Wilmer Dewing (P/CC/NA) arrived in Cornish in 1885 and settled in a farmhouse adjacent to the Beaman family near to where the Platts lived. In 1893, Thomas Dewing painted portraits of Beaman's wife, Hettie, and of his neighbour Charles Platt. Soon after, Dewing became known as the 'Degas of America', and was later included as a member of 'The Ten', a sobriquet stemming from the milestone Montrose Exhibition (1898), in which ten artists were featured, nine of whom were members of The Players. Dewing married Maria Richards Oakey (CC/NA), a friend of Helena de Kay Gilder (1846–1916), artist and wife of Richard Watson Gilder (1844–1909), (P), influential editor of *Century* and Maxfield Parrish's editor for 'The Great Southwest Series' and later for *Italian Villas and Their Gardens*. The Gilders were Edith Wharton's neighbours in Lenox, Massachusetts, and Gilder had been responsible for commissioning this, Wharton's second book.

Helena de Kay Gilder was a young art student when she first met Saint-Gaudens. Together, in 1877, they formed the Society of American Artists as a reaction to the National Academy of Design, criticized for its staidness and lack of imagination. Helena Gilder's brother, Charles de Kay (P), was an influential art and literary critic for the *New York Times*, who collected Maxfield Parrish's original artworks and was one of the founders of the adjacent National Arts Club – an club for artists and art-lovers, notable as the first of its type to admit women. Helena Gilder suspected that the poet, Emma Lazarus (CC), and her brother were having an affair, a difficult situation for two reasons: one, Emma was of Jewish blood and two, she was 'an aspiring young poet, and these are great stumbling blocks …'. Helena's husband, Richard

Gilder,, introduced Thomas Dewing to Augustus Saint-Gaudens and later to Stanford White (P), who eventually helped Dewing to sell his first tonalist painting.

In 1890, Thomas Dewing met his patron, the Detroit industrialist Charles Lang Freer (P) at The Players Club. Freer financed Dewing's studies and travels abroad, which ultimately enabled him to become the protégé of James McNeill Whistler. Many of Dewing's paintings hang in the Smithsonian's Freer Gallery near to Whistler's magnum opus, The Peacock Room. For the most part, the frames on Thomas Dewing's paintings at the Freer were designed and made by Stanford White.

When Stanford White was a young man, before he had a serious goal in life, his father, Richard Grant White, consulted the first American landscape architect, Frederick Law Olmsted, and John LaFarge (P/NA) with a view to a possible career for his son. Stanford White introduced Saint-Gaudens to John LaFarge, a painter and designer of stained glass. White, Olmsted, LaFarge and Saint-Gaudens, at one time or another, worked on projects together, which included the Admiral David Glasgow Farragut Memorial (1881) in honour of the hero of the battles of New Orleans and Mobile Bay in Madison Square Park, a few blocks from the *Century* offices and the Players Club. LaFarge and Parrish were good friends, having first met at The Players. Freer commissioned Stanford White in 1906 to design the gallery which he was proposing to build in Washington. Soon after, the moustachioed White was shot dead by the enraged Harry K. Thaw, an eccentric millionaire and husband of Evelyn Nesbit, immortalized as the Girl in the Red Velvet Swing. Interestingly, Parrish had already painted his favourite model and companion, Susan Lewin, in the work entitled *Reveries* (page 164). Her pose was reminiscent of Evelyn Nesbit, in classical robes with flowers in her hair on a swing with vines as cords. It is mistakenly thought that White designed picture frames for Parrish; while they knew each other from the Players, alas they never worked together. After White's untimely death, Freer commissioned Charles A. Platt to design Washington's Freer Gallery, which today houses his magnificent art collection. Platt later planned the Italian reconnaissance jaunts for

MAXFIELD PARRISH AND THE AMERICAN IMAGISTS

Maxfield Parrish, the Pennells and other Cornish cronies and Players Club compatriots.

Charles Lang Freer visited Cornish a number of times, and in 1894 the Dewings held an oriental masque in his honour at High Court, the country home designed by Charles A. Platt for poets Emma Lazarus (CC) – 'Give me your tired, your poor/ Your huddled masses yearning to breathe free' – and her sister Annie Lazarus (CC). Freer, Platt, Stephen M. Parrish, Dewing, and Kenyon Cox (P/CC/NA), shared a love of Japanese prints and Whistleresque interiors (which is why the masque had an oriental theme) as well as Italian gardens. It was held in the elaborate Platt gardens with cypress trees and Japanese lanterns lining the walkways making it a most memorable event.

Percy MacKaye (P/CC) was known to his many friends as 'The Good Gray Poet of Gramercy Park', and was one of the most influential members of the Cornish Colony. He had been inspired by the Freer masque to present the anniversary pageant 'A Masque of Ours': the 'Gods and the Golden Bowl', written by Louis Evan Shipman (P/CC) in 1905 to honour Saint-Gaudens. Maxfield Parrish designed the costumes, posters and programmes for this event, the most celebrated occasion in the history of the Cornish Colony. MacKaye often socialized with Parrish and referred to meals at The Oaks as 'chick-a-dee dinners', in other words, dinners attended by year-round Cornish residents. MacKaye once remarked, 'We had a wonderful dinner (of squabs, wines, etc.) as we always do there (at The Oaks). The witticisms just flowed from Mr. Parrish's lips! He is a very brilliant fellow, hardly a moment when these sallies are not amusing and delighting.'

While visiting a Whistler Exhibition in Boston, Parrish was introduced to Isabella Stewart Gardner, an important art collector and the proverbial Boston Brahmin. Mrs. Gardner collected the works of Botticelli, Degas, Della Robbia, LaFarge, Manet, Matisse, Raphael, Sargent, Titian, Whistler, Dennis Miller Bunker (P/CC/NA) and Paul Manship (P/CC/NA), all assembled and displayed in the Venetian villa which she built on Boston's Fenway as the Isabella Stewart Gardner Museum.

Elizabeth (CC) and Joseph Pennell (P/CC/NA), biographers and artists, authors of *The Life of James McNeill Whistler*, knew Stephen M. Parrish from the Philadelphia Society of Etchers, which they had co-founded in 1880 and had met up in London with Stephen and the teenage Maxfield in 1884. Stephen's studio, at 1334 Chestnut Street in Philadelphia, was very close to the Pennells' and was in the same building as that of portrait artist Cecilia Beaux (NA), a great fan of Maxfield Parrish. It was probably no coincidence that Beaux painted a portrait of Richard Watson Gilder in 1902, the year in which Gilder commissioned Parrish for the Italian Villas articles and book, as well as 11 other portraits of the Gilder family, including that of Helena de Kay Gilder. Maxfield Parrish's friend and classmate, children's book illustrator, Elizabeth Shippen Green, moved into the same studio building alongside Cecilia Beaux and Stephen Parrish in 1896.

The American writer, Winston Churchill (P/CC), Parrish's neighbour and close friend, wrote the best-selling novel, *Richard Carvel* (1899), that sold over a million copies. According to *Publisher's Weekly*, Churchill was 'the most popular fiction author in America between 1900 and 1925'. Charles A. Platt designed Churchill's Cornish home, which was used as the summer 'White House' between 1913 and 1915 by President Woodrow Wilson, the 28th president of the U.S.A.. One of the reasons for the Wilsons coming to Cornish was for Mrs. Wilson to take painting lessons *en plein-air*, and simply to be near Maxfield Parrish as a source of inspiration.

One could find Richard Watson Gilder and Charles Scribner (P) on any day of the week at The Players. *Scribner's Magazine*, founded in 1888, quickly became one of the three most popular magazines in America, along with *Harper's Monthly* and *Century*. These three became the vehicle by which Parrish flourished as an illustrator, making his national reputation overnight. The first Scribner office was about 20 blocks from Gramercy Park and the early success of *Scribner's Magazine* had a direct bearing on its proximity to The Players.

Joseph H. Chapin (P), art editor of *Scribner's Magazine*, worked with Maxfield Parrish

THE LIFE OF MAXFIELD PARRISH (1870–1966)

on the Eugene Field book, *Poems of Childhood*, their business and personal relationship enduring thereafter for 25 years. Chapin wrote an oft-quoted letter to Maxfield Parrish on 27 December 1901, in which he reported that he had heard from the artist Edwin A. Abbey (P) that the German emperor, Kaiser Wilhelm, 'is greatly interested in your work, after seeing *The Golden Age* published in Europe by John Lane'. The emperor ordered a dozen copies of Parrish's book for his personal library and to give away as gifts; it seemed that Maxfield Parrish's reputation was not only secure but also international.

Edward W. Bok (P), editor of *Ladies' Home Journal,* had been a Parrish client from 1896. In addition to covers, art prints, advertisements and murals, Parrish designed two unique projects for Bok for the Curtis Publishing Company building in Philadelphia. The first extraordinary project was the series of 18 murals entitled A Florentine Fête. The second was the legendary 15 x 49-ft (4.5 x 15-m) mosaic entitled *Dream Garden*, executed in favrile glass by Louis Comfort Tiffany (P). This was the only collaboration ever undertaken by Parrish, while Tiffany worked with many artists and architects over the years.

Ray Stannard Baker (P), author of 'The Great Southwest', a series of articles that appeared in *Century*, put in a word with the magazine on Parrish's behalf: 'There is an understanding of the perspective of these mountains and plains that lives in the mind of an artist of imagination, and that strikes the imagination of those who look upon them.' Baker first met Maxfield Parrish in the main salon of the Players, when they shared a bottle of red wine, a bottle of sherry and topped off their tanks with a half-bottle of Oporto and some cigars. They became fast friends and collaborated in projects for *Century*.

In 1911, Robert Underwood Johnson (P/CC), associate editor of *Century Magazine*, wrote to Christian Brinton (P), editor of *The Critic* and Parrish's room-mate at Haverford, regarding a forthcoming article on Parrish: 'We are going to have a somewhat similar article on Whistler as a decorator by the Pennells, with a lot of his work not known to the public – and this would be, as A.W. Drake says, a companion article to that.' The letter was addressed to Brinton at The Players, as he was resident there at the time. Shortly after joining the club (1900), Brinton suggested to Maxfield Parrish that The Players would be 'a great place to meet the swells'. However, there is some dispute as to exactly which year Maxfield Parrish actually joined. Some say that he was first invited to join by Brinton, while others say it was earlier or later. Parrish was a bona fide member, and the club records indicate that he remained a member until 1935. Many Players members were illustrators who formed a circle, with Maxfield Parrish at the centre, for during the first half of the 20th century he was the most famous and successful of them all. These illustrators included Harrison Fisher (P), John Falter (P), John LaGatta (P), Charles Dana Gibson (P), James Montgomery Flagg (P), McClelland Barclay (P), Frederic Remington (P), Frank Schoonover (P) and Dean Cornwell (P). Howard Pyle (P/NA) and Norman Rockwell (P) were also Players members.

Parrish met many other artists at The Players, such as Will Bradley (P), whose artistic style and graphic technique were more similar to his own than any of the others. In fact, some said that Parrish's style was more like 'Will Bradley's than Will Bradley'. Parrish was a great respector of A. Stirling Calder (P/NA), the father of modern American sculpture, and they enjoyed many years of friendship in their time spent at 'that certain club'. Stirling Calder and Mark Twain (P) usually sat at an artist-publisher-editor round table for lunch, thus combining creative talent with interesting conversation. Luncheon companions invariably included the likes of Gilder, Underwood, Drake and political cartoonist, Thomas Nast (P), while Dewing, Platt, MacMonnies, Saint-Gaudens, White and Parrish sometimes gathered at the next round table, making a circle of sculptors, architects and painters. Other Players members who were figures of significance and consequence to Maxfield Parrish were: L. Frank Baum (P), Herbert D. Croly (P/CC), Richard Butler Glaenzer (P), Childe Hassam (P/NA), Walter Lippmann (P/CC), Willard Metcalf (P/CC), J. Pierpont Morgan (P), Eric Pape (P/CC), George Bellows (P/NA), John Twachtman (P) and Arthur Whiting (P/CC).

The only artwork Parrish is known to have completed for the Players is a poster entitled,

Pipe Night, December 5, 1915, which he painted in honour of his old friend and classmate, cabaret singer David Bispham (P). In 1914, Parrish, Bispham and Brinton were simultaneously awarded honorary degrees at Haverford College.

One only has to review the Parrish commissions to see that his most important clients and closest associates were all members of this powerful body of luminaries in the worlds of art, business and letters: the influence The Players Club and the Cornish Colony had on Parrish's career and lifestyle cannot be emphasized enough

'A Mosaic of Richness'

In 1895, in a single momentous year, Parrish completed his first mural commission, sold his first painting and was hired to do his first magazine cover. Moreover, he had studied with Howard Pyle, the 'Father of American Illustration', had synthesized a system of painting, and had married a talented young Quaker beauty. Max, Jr. described his father's first meeting with his mother thus: 'Maxfield Parrish had left Haverford College in the spring of 1891. In September he enrolled at the Pennsylvania Academy of the Fine Arts. One of the first classes into which he enrolled was a drawing class. In this class he took particular notice of one of his fellow students, a young lady. One day she arrived late and all the seats were taken. The chivalrous young Maxfield went to an unused classroom nearby and returned with a chair for her. From that time on, she knew he was interested in her.' Lydia Austin was the daughter of Nancy and Henry Austin of Woodstown, New Jersey. The newly-weds were a strikingly creative and attractive young couple, yet one wonders why they ever married. Both their families strenuously objected to the union, which fell on deaf ears, but a few days after the wedding Maxfield Parrish took an extended trip to the capitals of Europe, abandoning his bride on the Philadelphia docks. He sailed off to England alone, though he wrote to Lydia frequently during the trip. Less than three weeks after his departure he wrote from Brussels, 'I have been feasting on glorious pictures in a great gallery. Oh the masters of the Dutch and

Flemish schools knew how to paint!', and from Paris ten days later, 'I had resolved to not enter the Louvre until I had thoroughly seen the salons, but Sunday as I passed one of entrances the temptation was too much for me and in I went ...I nearly fainted ...one had but to turn and there were Titians, Rembrandts, Botticellis, Correggios, van Eycks, all together in one glorious mosaic of richness.'

Hicksite Quakers from New Jersey

Maxfield's letters to Lydia were perfunctory, devoid of affection; they showed an interest in art and architecture rather than people, and certainly no interest in her. However, Parrish's interest in the history of his family seems to have increased after his marriage to a Hicksite Quaker, who took their name from the Hicks family which comprised the original nucleus and better part of a New Jersey splinter sect originating among the Pennsylvanian Quakers. The Hicksites were reputed to be cold-hearted and remote, regarding family affection as superfluous, so it is quite possible that Lydia did not notice Maxfield's coolness.

Parrish successfully convinced Lydia to name their children after members of his own rather than the Austin family. This was not so unusual for the time and Lydia, the good and loyal wife, graciously complied with her husband's wishes. The couple accordingly named their first child, Dillwyn, for his great-grandfather; the second son, of course, was Maxfield, Jr., and the third was named Stephen for Maxfield Parrish's father. The only daughter, Jean, born in 1911, was not named for anyone in particular and the family records show no 'Jean', either before nor since.

Edward Hicks (1780–1849) was a well-known primitive or naive artist, perhaps best known for his paintings entitled 'The Peaceable Kingdom' (circa 1830), in which he did over 100 versions on the same theme. The Hicks families dominated the southern Jersey Quaker Meetings and although their practices were nearly identical religiously, the Hicksites incurred the wrath of other nearby Quaker Meetings. Consequently, Maxfield Parrish was severely

criticized for marrying into that sect. Over the years, perhaps, as a consequence of such irrational prejudice, Maxfield Parrish became a decided agnostic and decided that he no longer believed in God, preferring to regard Nature as the 'life force'.

However, Parrish did espouse the Quaker philosophies of non-violence and equality between all men to his dying day. He had learned the virtues of service and humanitarianism as a youth at home, among his childhood friends., then in Quaker schools, including both Swarthmore and Haverford College. Yet he was not seen as a generous person. He sought payment for anything he ever did, even charging for the Plainfield Town Hall stage set designs, even though they were to be a gift from Hart to his home town. As for being a teetotaler in the manner of the Quakers, he often said that he had to rationalize taking mural commissions to decorate hotel bars, but at the same time he was known to enjoy quite a few stiff drinks. Quakerism was in his blood, however, as well as art; he also had the soul of a businessman. He was not above using his Quakerism as an excuse, especially when it was convenient for him to do so.

Frances Grimes (1869–1963) wrote of Maxfield and Lydia in her book *Reminiscences*: 'Their coming [to Cornish] made a great difference to me for they were about my age and we became close friends. Lydia charmed us by her appearance, she was demure, Quakerish in dress, the modeling of her face was rich and lovely, her hair grew in curls about her neck and her movements were characteristic, serious and direct ... in this setting, Lydia would have been recognized as a Maxfield Parrish, too, for he painted her in these days over and over – at the kitchen door with a basket on her arm, as a boy sitting under a table, a girl tending sheep in a pasture with knitting in her hands, and in many other guises. Their marriage had been romantic, almost an elopement, for they married against the advice, and more, of their families. Fred's account of a visit he received from several Quakers was amusing; he made you see their severely grotesque looks as he might have drawn them. He was not troubled by their warning and did marry as he liked, without delay.'

It is certainly possible that the marriage was simply an act of rebellion by two young and strong-willed people. In August 1895, when Maxfield returned from Europe, the fact that he was now known across the nation was confirmed with the Easter *Harper's* cover, an overnight sensation. Work on the Mask and Wig Club mural began that November and everything seemed to be falling into place; but Lydia soon realized that her own art career was taking a decided back seat to the dynamic genius she had married; she pondered the alternatives and reached the sad conclusion that she must resign herself to a lesser role in life.

The Problem with Painting

For Maxfield Parrish, the next few years were filled with a continuing frenzy of work, intermingled with exhibition openings, publicity events, honours and prizes, more commissions and more limelight. Parrish, now something of a celebrity, began to spend less and less time with Lydia. One doesn't need to speculate whether he was more interested in his art than his wife, for he was clearly happy to be married, but alas only to his work.

Lydia had a low opinion of her own worth, as was the case with so many creative women of her day. She allowed herself to take a back seat to her husband and assumed the role of a devoted mother. As her self-esteem dwindled, she immersed herself in the lives of the Afro-Americans, particularly their music and their plight in general, her own down-trodden existence making her sympathetic to those less fortunate than herself. It was the start of a lifelong interest.

In 1898, Maxfield and Lydia moved from Pennsylvania to New Hampshire to be nearer his parents. Unfortunately, Stephen and Elizabeth chose this moment to terminate their marriage. There were many rumours as to the reasons for this: some thought that Elizabeth was being sent to a sanatorium for she had lost her mind, but other accounts indicate that she was merely unhappy. However, it was an earth-shattering experience for their son. At the time, he and Lydia had been married for three years and had just built The Oaks. They seemingly had the world at

their feet, yet the combination of Maxfield's astonishing successes coupled with the plight of his parents and the aggravation of constructing a house, was the last straw. Maxfield virtually collapsed, seemingly with a nervous breakdown.

All he wanted was to get away from it all and be allowed to concentrate on his craft. It seemed that the move from Philadelphia had backfired, at least for the time being. Maxfield insisted on recuperating alone at a remote resort on Saranac Lake in the Adirondack Mountains. After some months of convalescence, he seemed to be escaping into a fantasy world and, fired with a renewed enthusiasm, decided to return to painting. A refreshed Parrish began work on his next book, an edition of Kenneth Grahame's *The Golden Age* (1899), which was one of his best when it appeared. *Life* approached Parrish with a first assignment at about this time and he established a relationship with the magazine that lasted until 1924.

Maxfield Parrish managed to complete sufficient work for a one-man exhibition in what was now the new art mecca, no longer Philadelphia but New York City. The Keppell Art Gallery agreed to exhibit his original illustrations to an adoring public with the result that all his paintings were sold.

Parrish in Technicolor

Parrish actually attributed the major turning point in his career to his Adirondack period. The fierce mountain winds blowing across the lake were so severe that they caused his drawing ink to freeze as he used it, forcing him to switch to glazes. This, in turn, led to his increasing use of colour.

Another effect of his time in up-state New York had been to arrest the usual frenetic pace of his existence and to reflect on life itself. Until then, he had used colour sparingly in favour of black ink, lithographic pencils, graphite pencils, crayons and textured paper, from which powerful images had evolved. Now colour was appearing in his

commissioned work, becoming one of the most important elements, particularly his use of the colour blue.

By the time he returned to New Hampshire his career had taken a turn for the better: book commissions were now plentiful and editors of magazines were queuing up with commissions. Soon he had become a complete workaholic. It was not long, however, before more ill-health befell him in the form of the then killer disease, tuberculosis. Sadly and resignedly, he was forced to convalesce yet again, the customary place being, not the north-east on a frozen lake, but in a rather warmer environment, which at that time was thought to expedite speedy cures. Consequently, in early 1900 Maxfield left New England for Castle Creek at Hot Springs, Arizona, where he became a different Parrish, complete with cowboy hat – a technicolor Parrish, a luminescent Parrish, a lunar landscape Parrish. He had already been tentatively introducing colour into his work, but Arizona presented an entirely new environment ablaze with colour: azure-blue skies, purple and lavender mountain peaks, the sienna and parchment tones of the desert floor. It was during his time at Hot Springs that his Great Southwest series was published by *Century Magazine*, first in serial form and then as a book. This resulted in another, even more exotic series for *Century*, which followed closely on its heels.

A Brilliant Idealization

Edith Wharton published her first short story in *Century Magazine* in 1902. It was illustrated with several photographs and one Parrish illustration, which she described as a 'brilliant idealization' of an Italian scene. The story was popular with the readership and critics and some would say that much of the credit could be given to Parrish's illustration. By this time he was a recognized artist and his illustrations were appearing on the covers and pages of most of the important periodicals and many best-selling books, while Wharton was still an unknown except at debutante parties in Union Square.

A Glamorous Assignment

In 1903, Richard Watson Gilder, publisher of *Century*, offered Parrish a glamorous assignment to illustrate Edith Wharton's *Italian Villas and Their Gardens*. A work of non-fiction, it was only Wharton's second book and the text she produced was very dry indeed. Gilder tried to persuade Wharton to write something more lively, to no avail. The book, however, brought Parrish back to Europe – to Italy – and the glories of its architectural heritage. The great Italian villas fired his imagination and he could not have had a more ideal commission. Wharton, on the other hand, was not equipped to write a technical book on either garden design or architecture. Her previous book, *The Decoration of Houses*, had been written with the help of Ogden Codman, an interior designer, whose knowledge of the subject surpassed that of Wharton. This time, unaided by Codman, Wharton produced a rather lacklustre text, boringly identifying urns placed hither and yon and orange trees here and there, only relieved by the accompanying illustrations of an illustrator of genius. Later, Wharton bristled at the reviews, which lavished praise on the pictures and disparaged her text. She blamed Richard Gilder for allowing Parrish's illustrations to put her own work in the shade. Wharton expressed her chagrin thus: 'My articles were quite out of keeping with the Parrish pictures, which should have been used to illustrate some fanciful tale ... but I knew that, even had I an architectural draughtsman as illustrator, the editorial scruples would not have been allayed, for what really roused them was not the lack of harmony between text and pictures but the fear their readers would be bored by the serious technical treatment of a subject associated with moonlight and nightingales.'

Wharton never ventured into the realms of non-fiction again, though perhaps she should have been a little grateful. Parrish's paintings had in fact redeemed the otherwise turgid text and had saved her book from obscurity.

Twelve years later, Edith Wharton, forgetting her hurt, asked Parrish to do the cover illustration for her *Book of the Homeless*, to benefit World War I orphans in Belgium. Other artists donated works to be included in the publication, including Renoir, Manet, Monet and Cocteau. The fact that Wharton chose Parrish for the cover showed that, in spite of everything, she still liked and respected his work. However, Wharton was approaching Parrish at the wrong time for he was working on a major undertaking, A Florentine Fête, and was unable to accede to her request. He did donate an earlier work for inclusion which was published, along with a Renoir sketch and the work of other artists, but there was no cover image.

Prior to his departure to Italy, Maxfield Parrish received some useful information on Italian villas from his Cornish neighbour, Charles A. Platt. This time he and Lydia left on what was her first trip abroad – the only time she ever accompanied her husband overseas. The trip must have rekindled a flame, for their first child, Dillwyn, was born on 1 December 1904, nine months and six days after their return from Italy. Parrish certainly loved the child, but the presence of a baby in the house was something of a nuisance: here he was with a colicky baby and a complaining wife, who hated the dank, frigid New Hampshire winters. His nerves were shot to pieces as he attempted to meet deadlines and, in a state of utter frustration, Maxfield Parrish went to his father for advice.

Fatherly Advice

Stephen suggested that his son get some domestic help in the form of an *au pair* to assist Lydia with the baby, with the result that Maxfield hired his father's housekeeper, Marguerite Lewin's younger cousin, a 15-year-old named Susan Lewin. Then he instructed his son to build a separate studio at The Oaks 'as a retreat from family life with its attendant obligations, and as a way to a more productive life with its attendant virtues'. Maxfield did just that and Lydia realized that she had another problem on her hands, apart from suppressing her own ambitions: an inordinately close father-son alliance. Maxfield worshipped his father, respected his talent and had adopted much of his attitude to life.

Stephen Parrish had completely immersed himself in his work at the expense of his marriage, and it now seemed that history was about to repeat itself. However, while their marriage was undoubtedly deteriorating, Maxfield and Lydia were continuing to add to their family, which exacerbated the domestic situation for many years to come.

Models – Beauties All

Susan Lewin was born on 22 November 1889, in Hartland, Vermont, to Elmer and Nellie Westgate Lewin. After meeting her, Parrish decided that Susan was suitable for the job in hand, but that she should also model for him, being a natural beauty with a bubbly personality. Unlike her two older sisters, Susan had been trained by a sophisticated Cornish neighbour to serve afternoon tea in the traditional English manner at precisely 4:00 pm. Parrish relished this out-moded ceremony, and felt that it gave him a reason to stop working when he would otherwise have continued painting. He watched with fascination as Susan poured the tea, thinking of Lord Leighton's Dorothy Dene and the halcyon days of Victorian London. The relationship between Susan Lewin and Maxfield Parrish developed over time from servant girl to woman companion – two unusual people unexpectedly thrown together – a fateful combination.

Not long afterwards, Susan brought her sisters, Annie and Emily, to help with the household chores, being occupied herself by the master of the house in helping him with his work. Susan posed frequently and Parrish would proudly remark, to anyone who cared to hear, how well she could model, a fact clearly apparent in the paintings. To her, posing was easy, for she was a natural ham. She was at once physically elegant and slightly awkward, a strange paradox which Parrish relished. The actual modelling sessions were comparatively short, the time-consuming part being Susan's preparation of the costumes, the creation of the settings, and the arrangement of the props. Other models were rarely used as Susan was Maxfield's all-time favourite. Sometimes, other roles were filled by younger girls or boys,

although Susan often assumed male poses as well. For younger girls, Parrish enlisted his daughter Jean and occasionally her good friend, Kitty Owen, granddaughter of three-times presidential candidate William Jennings Bryan (1860–1925). He also used the two daughters of Judge Learned Hand, both pretty girls; indeed he seemed to be surrounded by a surfeit of physical beauty.

Susan attracted several suitors from the village, and young men sometimes called on her at The Oaks, knocking on the kitchen's screen door, one such being the handsome young Kimball Daniels. Parrish even used him as a model on occasion and he appeared on at least one *Collier's* cover. Daniels also helped with hay-making and worked on the stone walls at The Oaks, but was eventually found on the property in 1913, having died of a broken neck. Another local boy, Earle Colby, with whom Susan had grown up, married her in 1960 when she was 71 years old.

Architecture in Paintings, Paintings in Architecture

Parrish's love of classical architecture explains the use of columns, broad staircases, balusters, archways and urns – elements which appear in so many of his paintings. The Oaks occupied a splendid site indeed, strategically placed between a screen of ancient oak trees and grey rocky outcroppings on the razor edge of a flat contour. It boasted panoramic views of the Connecticut river valley with the dramatic Mount Ascutney sugarloaf looming on the horizon directly opposite the main rooms.

The general area was thickly wooded with hilly fieldstone-walled pastures. So thrilling did Parrish find this natural landscape that he painted the surrounding scene over and over again. A neighbour, the late Virginia Colby Reed, tells how after the Great Hurricane of 1938 had destroyed one of his precious oak trees, Parrish climbed up and personally installed lightning rods in the tops of all the others. He also built walls within the buildings to frame and direct his views. He constructed a reflecting pool to complement the view, and placed urns

Parrish with two of his sons, Max Jr., left, and Stephen, right.

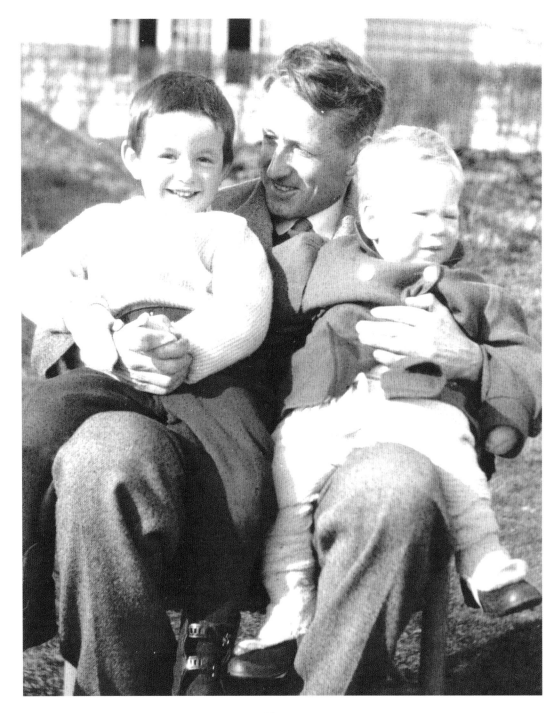

as punctuation marks on walls and terraces designed with Palladian symmetry. He was creating his own 'Garden of Allah'. Below the small Parrish building complex was a sheep meadow sloping progressively down to the river valley and the highway, with a studio sited about 40ft (12m) from the main building. Parrish thoroughly enjoyed his microcosmic world in the Cornish Colony, and described it vividly to Irénée Du Pont in 1938: 'As you descend some steps from the upper level to the house terrace, through them and beyond them, you have a confused sensation that there is something grand about to happen. There is a blue distance, infinite distance, seen through this hole and a sense of great space and glorious things in store for you, if only you go a little further to grasp it all. It takes your breath away a little, as there seems to be just blue forms ahead and no floor. Then you come upon the lower terrace and over a level stone wall you see it all, hills and woodlands, high pasture, and beyond them, more and bluer hills, from New Hampshire on one side and from Vermont on the other, come tumbling down into the broad valley of the Connecticut with one grand mountain over it all.'

Make-Believe, Reality and Susan Lewin

In 1904, Susan Lewin moved into The Oaks. One day, Parrish asked her to model for *Land of Make-Believe* (page 162), and was so happy with the outcome that Susan became his principal model thereafter, relegating the unfortunate Lydia to semi-obscurity. At the same time, Lydia was on her way to becoming a kind of baby machine, for after Maxfield Jr., a third son, Stephen, was born, followed in 1911 by Jean, their last child. All the while Parrish was painting and Lydia was left forlorn; then he and Susan moved into the adjacent nine-room studio, as a result of which Lydia began to spend her winters in the Georgia Sea Islands, mortified yet committed to a new distraction of her own – the documentation of Afro-American slave songs.

While Maxfield was basking in the admiration of a growing numbers of fans, Lydia put on a brave front, entertaining visiting celebrities at The Oaks and keeping up the pretence that she and Parrish were a normal married couple. At the same time, Susan Lewin was experiencing a lifestyle hitherto unknown to a country girl from Hartland, Vermont. She was a 'country bumpkin', without education, who had been abruptly thrown into the middle of the most effete social setting of the day. Susan handled it all with aplomb, while Lydia handled her own situation with a style and grace which befitted her position and which the times demanded. She deliberately closed her mind to what was becoming obvious to everybody else, though no one ever mentioned it. In those days the man of the house often had a separate bedroom from his wife as well as a mistress in town. Meanwhile, Lydia continued to bury herself in her work.

The rest of the family treated Susan in a matter-of-fact sort of way: 'Every afternoon at four o'clock, whoever was at The Oaks would go to tea with Granddad and Aunt Sue, usually on the studio's second-story porch. Susan Lewin had been with Granddad as housekeeper, model and companion from 1904 to 1961. Aunt Sue prepared cookies, sponge cakes and other tempting pastries. These were gratefully enjoyed by all, as we listened to fascinating conversation that always sprang up.

'As we gazed off to the east through grape vines, Granddad, Sue, perhaps Uncle Dillwyn or another guest, would bring my folks up to date on persons and developments in Plainfield, Windsor and the Cornish communities. Sometimes Granddad's cousin Anne would drive over from Cornish in her ageless 1932 Ford and sooner or later the talk would turn to the great sculptor Augustus Saint-Gaudens and the members of his family and his studio.'

Lydia and the Slave Songs

Afro-Americans were less than 50 years out of slavery at this time, but still retained all the characteristics of their Yoruba heritage when Lydia Parrish discovered them and their culture on the Georgia Sea Islands. They were mostly animists from the coastal area of West Africa, the Niger river delta then known as Nigeria but previously referred to as the 'Slave Coast'. Because St. Simons was an island, many of the inhabitants' Yoruba customs had been preserved intact, and Lydia's quest was to document their eating habits, clothing, tribal customs, implements,

as well as their vibrant and infectious music. Lydia Parrish applied herself to the task with enthusiasm and competence. When she first went south in 1912, no one much cared for ethnic studies, for the attitude then was that everyone should forget their origins and try to assimilate. She rented a house at Bloody Marsh and began a lifelong study of the black Georgia Sea Islanders. Lydia Parrish died in 1953 in St. Simons and was buried there, 58 years after having entered into a disillusioning and disappointing marriage.

In 1942, Lydia's work was published in a volume entitled, *Slave Songs of the Georgia Sea Islands*; when one looks at the acknowledgements it is sadly obvious that although she mentions everyone connected with her lengthy quest, including her son Maxfield Parrish Jr., the name of her famous husband does not appear.

She describes what motivated her in her quest: 'I was born in a Quaker community, thirty miles south of Philadelphia (one of my ancestors, John Pledger, was the first of the Salem Quakers to reach America ... in January 1674–75), where the descendants of slaves – and some ex-slaves themselves – were the only singers. Theirs was the only music worthy of the name that I heard in my youth. In those days members of the Society of Friends were not the liberal people they are now ... All forms of art, including music, were taboo among the overseers of our Meeting ... Their tolerance was such, however, that as far as I could see they never attempted to curb its musical exuberance in the kitchen or in the fields. Perhaps, with them as with me, the Negroes' music filled a real need.'

In 1920, Lydia formed the 'Spiritual Singers Society of Coastal Georgia', for it was the only way she could get shy and simple country folk to share their religious songs with a stranger, especially a white one. A brilliant idea, her contribution, for whatever reason, was significant yet little recognized. However, her social studies clearly filled a void in her life: her husband had virtually rejected her, a potential artistic career had been shattered upon marriage and her children had become a burden; moreover, a servant had usurped her position as mistress of her own house. Maxfield and Lydia married because they were both

Quakers from Philadelphia, shared a common interest in art and were initially attracted to one another. But in the end, it was simply a long-standing marriage of convenience, lacking in both passion and love.

Dillwyn's Problems

There had been another bone of contention in the Parrish marriage in the person of the Parrishes' first-born, Dillwyn, who had been sickly from birth. Lydia, worried by Dillwyn's many problems, blamed his father. In later years, in letters to her son, Max Jr., she expounds on her theories that his father's bouts of typhoid and tuberculosis, depression and nervous breakdown, had all combined to cause Dillwyn's rickets, his mental problems and ultimately his alcoholism.

Lydia implored Maxfield to take Dillwyn to specialists at Boston's Massachusetts General Hospital, begging him to explain her crude genetic theories regarding Dillwyn's defective inheritance which, she believed, came from him. This did not go down very well with Maxfield, for his ego matched his reputation: the more Lydia blamed him, the more he distanced himself. At last, Maxfield's answer was to retreat altogether, avoiding interviews and refusing to be photographed. Lydia responded by taking Dillwyn to Georgia and paying more and more attention to him and less and less to the other children. Dillwyn was indulged at every turn, but not only by his mother – his father competed with his wife for that dubious privilege.

Susan Lewin intuitively picked up on this and suggested that the remaining children call her 'Aunt Sue'. Little by little, Susan became a stronger influence in their lives, an influence which would continue in the lives of their own children later on. Lydia was now firmly out of sight, out of control, and well out of mind.

On the other hand, Maxfield still loved Dillwyn very much, coddling him, babying him and spoiling him. A letter addressed to 44 West 47th Street, New York City, dated 1 March

Letter from Maxfield Parrish to his son Dillwyn, then aged seven, in 1912. Watercolour, letter size 12$\frac{1}{2}$ x 12$\frac{1}{2}$in (32 x 32cm), envelope size 10 x 10$\frac{3}{4}$in (25 x 27cm).

1926, is particularly telling: 'My dear Dillwyn: I have yours of Feb. 26th, possibly it is more what could be called a "rhapsody" than your last one. I was scared a bit as I began to read it, for I got the impression you has fallen in love & wanted to get married or something. But if its nothing more serious than an old broken down, wheezy, fully blown foreign car, why sure, get it and welcome. Get two. I gather from reading your letter that you've almost taken a fancy to it. I am only too glad to make it possible for you and you needn't lie awake nights wondering how you're going to pay for it. Get the makers price, if possible, for computing the local tax here …Well, I wish we could use a car here, but it is still hopeless, & will be until we get a thumping big thaw. Over in Vermont, they plow out the roads …I suppose you will peddle north in the Daimler? Some time in June? …Put on your hat & coat & possibly rubbers, and go around and buy the car. As ever, Dad.'

Dillwyn was constantly ill, never completely recovering, and became a heavy drinker along the way. But he was a handsome young man and there was no shortage of girlfriends. His father showered him with gifts, among them flashy foreign automobiles, a new business each time he failed at whatever he was doing, trips galore – he always got what he wanted. Yet he was depressed and lonely.

Philadelphia, the Academy and Drexel

In 1892, Maxfield Parrish enrolled at the Pennsylvania Academy of the Fine Arts – a momentous step in his development as a professional illustrator. In his youth he had enjoyed the freedom an artist feels when facing a blank canvas, while his father taught him the meticulous discipline of the etcher. At Haverford, he had absorbed the precepts of the Beaux-Arts movement – Classicism, balance, proportion, form and order: the academy fashioned all this into a coherent whole and for the first time everything was coming into sharp focus.

The Pennsylvania Academy of the Fine Arts was founded in 1805 and was at once the first art museum and first art school in America. It had always attracted the finest talent to its studios, with teachers like William Merritt Chase (1849–1916) and students such as William Glackens (1870–1938), a future illustrator and painter and a member of New York's noted 'Ashcan School'. Twelve years before, when Maxfield Parrish had first enrolled at the academy, Thomas Eakins (1844–1916) had been the first to use photography as a kind of shorthand to aid composition and the layout of a painting. Eakins and his neighbour, Eadweard Muybridge (1830–1904), developed photographic techniques for studying bodies in motion, and for the first time brought the camera and photography into the realms of acceptability as fine art. By 1884, Eakins and his students were painting from photographs rather than live models and simultaneously experimenting with a zoetrope, an optical device which created an impression of continuous motion.

By the 1890s, Philadelphia was no longer simply a bastion of Quakerism but was now the accepted national centre for the arts and architecture. Muybridge was lecturing at the University of Pennsylvania, whose school of architecture was already considered the best of its kind: architect Frank Furness (1839–1912) was designing extraordinary buildings and gaining an international following and the Drexel Institute had approached Howard Pyle to teach. Before he knew it, he had founded the first school devoted exclusively to illustration art. These were heady and exciting times in the arts and technology for the world was changing dramatically. John Sloan (1871–1951), a leading artist working for the *Philadelphia Inquirer*, began a lucrative new career as an illustrator of periodicals, a brand-new profession. All in all, Philadelphia was developing into a cultural mecca: the Academy of Music was fostering the avant-garde, neo-Classical monuments were proliferating at major street intersections, new museums were being founded, and grand European-style boulevards were cutting impressive swathes through the city. In the midst of all this, Maxfield Parrish was germinating the seeds of his own talent, absorbing ideas from elsewhere and all the while evolving into a unique American talent.

MAXFIELD PARRISH AND THE AMERICAN IMAGISTS

Parrish threw himself wholeheartedly into his art studies at the academy, and for some weeks during the winter combined studies that put the finishing touches to his formal education. They came in three forms:

I: Working at the Pennsylvania Academy under the realist/colourist painter, Thomas P. Anshutz (1851–1912)

II: Attending winter session classes at the Drexel Institute offered by Howard Pyle (1835–1911)

III: Absorbing the ideas of art historian/theorist/artist and Yale professor, Jay Hambidge (1867–1924), and his writings and lectures on dynamic symmetry, a rediscovery of ancient principles of design force lines and their geometric relationships.

Thomas Anshutz and His Ways with Paint

1). Bold Colour and Photography: Thomas Anshutz was a realist painter, committed to craftsmanship, who well understood the underlying structure of a painting as well as being a proponent of scientific colour theory. He liked to experiment with unmixed colours and used them with a brilliant intensity spread over large areas, using pure oranges and yellows, contrasted sporadically with rich, complementary violet tones. These works were remarkable for their time, differing greatly from Stephen Parrish's black-and-white etchings and mildly traditional landscapes, and they influenced Maxfield Parrish greatly.

Anshutz actively encouraged his students to experiment with colour, while simultaneously consolidating Eakins' notions of the use of photography as a form of shorthand. Other students of note included Charles Demuth, John Marin, Charles Sheeler and Everett Shinn. Anshutz encouraged his students to use the camera as a replacement for long hours spent in a studio with live models, which he saw as an alternative, legitimate way of preparing for what they were about to paint. Parrish accordingly followed suit.

Howard Pyle, 'Father of American Illustration'

2). Subject Matter, Wisdom and Pragmatism: Howard Pyle, a natural educator, refused to accept a penny for teaching and did not need to as he was the most successful illustrator of his day. He was regarded as the vital force behind what was later known as 'The Brandywine School'. A Quaker like Parrish, and a man of great conviction, he saw no difference between fine art and illustration, yet he realized that there were different parameters which potential illustrators needed to learn. Pyle ranks historically with A.B. Frost, Frederic Remington and Edwin Austin Abbey as a giant of the first wave of great illustrators. He began teaching in 1894 at the Drexel Institute of Arts and Sciences in Philadelphia at the age of 41. Pyle felt that normal art schools were simply routine and were 'almost entirely an imitative exercise which seldom actively involved the imagination'. The next year, Pyle's classes were combined into the first formal training school for illustrative artists. The catalogue description of Howard Pyle's course read: 'A course in Practical Illustration in Black and White under the direction of Mr. Pyle. The course will begin with a series of lectures illustrated before the class by Mr. Pyle. The lectures will be followed by systematic lessons in Composition and Practical Illustration, including Technique, Drawing from the Costumed Model, the Elaboration of Groups, Treatment of Historical and other Subjects with reference to their use as illustrations. The students' work will be carefully examined and criticized by Mr. Pyle.'

During his time at the Drexel Institute in 1895, Maxfield Parrish had little contact with Howard Pyle while auditing his illustration classes, and accounts differ as to how long he was actually a student at the school, although nearly every book on Pyle proudly claims Parrish as one of his disciples. Estimates of their time together have ranged from two weeks to a year: however, a newly discovered letter answers the question once and for all, for Parrish wrote to Richard W. Lykes: 'I was in his class at the Drexel Institute for only a winter and did not have the chance to get to know him as well as members of his class which was

formed afterwards at Wilmington, Delaware. Wyeth's tribute to him is very fine and shows a keen insight. It was not so much the actual things he taught us as contact with his personality that really counted. Somehow after a talk with him you felt inspired to go out and do great things, and wondered afterwards by what magic he did it.'

When Howard Pyle saw the drawings prepared by Maxfield Parrish in his very first class, he suggested that Parrish take up illustration immediately, for his opportunities would undoubtedly be boundless. He felt that Parrish was already a superb draftsman who needed no further lessons. He emphasized to Parrish the importance of historical accuracy and the need for models to wear authentic costumes if at all possible, for the audience wished to transport themselves into the image and fantasize as to its meaning. The value to Parrish of the brief encounters with Pyle was that it made him realize that historical subject matter greatly interested the public. Pyle actually held a course in the treatment of historical subjects and offered another special one, 'Drawing from the Costumed Model'. This inspired Maxfield Parrish to use Lydia for the purpose, then subsequently his children, neighbours, and ultimately, Susan Lewin.

After a couple of years, Pyle suggested to the Drexel Institute that he offer summer classes at Chadds Ford, Pennsylvania. He wrote a letter to the president of Drexel stating, 'I know of no better legacy a man can leave to the world than that he had aided others to labor at an art so beautiful as that to which I have devoted my life.' By 1900, the success of the Drexel classes inspired Pyle to open his own school in Wilmington, Delaware, specializing in preparing students for careers in illustrative art. He selected 12 elite students at a time when every young artist for a thousand miles around was desperate to get into this unique school. Pyle's conditions for admission were that his students should not be 'deficient in any of the following criteria: first of all, imagination; secondly, artistic ability; thirdly, color and drawing'. The Howard Pyle School of Art flowered for just a few years, holding *plein-air* summer sessions at Chadds Ford and town classes in Wilmington, but he suddenly stopped teaching altogether in 1905. His teaching legacy, and certain elements derived from his teachings, have become known as 'the Brandywine tradition', a style of illustration named after a favourite river in Chadds Ford. Students lucky enough to have been admitted to Pyle's course for that brief period were immensely talented and some came to be recognized as superb exponents of a second wave of illustration. They include Harvey Dunn, Elizabeth Shippen Green, Arthur I. Keller, Violet Oakley, Frank Schoonover, John Sloan, Jessie Willcox Smith and N.C. Wyeth.

Jessie Willcox Smith (1863–1935), attended Pyle's classes along with Parrish and as a result developed a lifelong friendship. Smith is regarded today as one of the greatest of the children's book illustrators. Parrish and Jessie exchanged paintings and always had a great professional respect for one another throughout their careers. It is said that, seated at a dinner party at the home of Isabella Stewart Gardner, they talked all evening of their mutual love of illustration, Howard Pyle, and the state of modern illustration. At the end of the evening they resolved to trade paintings with one another, such was the extent of their mutual admiration.

Pyle knew that the demand for professional illustrators was now so great that proficient students could not fail to succeed, while Parrish, the consummate artist-businessman, sensibly felt that success could best be measured in terms of money. Pyle's own example, and his swift rise to fame, was not lost on Parrish. Pyle had proved his point that illustration was lucrative, for he could afford to teach without remuneration while earning $36,000 per annum as art director for *McClure's Magazine*. This was an immense sum in those days, a fact that was not lost on his students.

Before the end of the year, Parrish received his first book commission, Pyle being directly responsible for getting him the job. Pyle had persuaded the art director of *Harper's* to attend an exhibition at the Architectural League of New York, where Parrish's poster design for the *Century* competition was on show. It was coincidental that architect Thomas Hastings was the organizer of the exhibition, since he was the designer of Vernon Court, the National Museum of American Illustration, which would be a repository for the largest collection of Parrish's work.

Jay Hambidge and Dynamic Symmetry

3). Principles of Harmony: Jay Hambidge created great interest among artists and architects following his research on the Parthenon and ancient Greek vases while teaching at Yale University. He presented his findings in a series of lectures attended by Maxfield Parrish at America's first artist's club, the Salmagundi, in New York City. Hambidge also published his findings in several books which Parrish owned.

Professor Hambidge's thesis was based on the golden section or the mathematical proportions present in Classical architecture which most please the human eye. Hambidge took this a step further in a theory of proportion and harmony which he referred to as 'dynamic symmetry'. He contended that 'lines, angles and curves are regarded merely as defining areas which compose the units of a map-like arrangement within the boundaries of a picture frame or the canvas stretcher'. He claimed that these limits had a direct bearing upon all arrangements of form within an enclosed area and that when a composition is developed in accordance with this idea, every part interrelates in a harmonic and natural manner. He encouraged pupils to 'see some of the sketches by Degas who was struggling to find something of a like nature for this purpose'. This dynamic symmetry prompted Parrish to develop a personal formula for painting that he was to follow for the rest of his life. In 1950, he described this technique thus: 'I lay each painting out on the basic of "dynamic symmetry" or the mathematical proportion which the ancient Greeks and Egyptians found appealing to the eye. Thus by using "dynamic rectangles" and "whirling squares" I design the dimensions of my pictures and block them off, placing the horizon in just the right place.'

In summary, the individual theories of these three men, Anshutz, Pyle and Hambidge, were synthesized in the work of Maxfield Parrish into a unique whole, using the tools of bold colour and photography allied to a fertile imagination.

Like the Pre-Raphaelites, Parrish felt that style in art developed from an intelligent study of the past. The Pre-Raphaelites were not so much influenced by medievalism as by the spirit of the Middle Ages, which they demonstrated in their paintings and decorative arts. Maxfield loved the concept: like the Pre-Raphaelite Brotherhood he considered himself a craftsman, going so far as to design and build his own home and filling it with unusual details, even to the extent of casting his own brass door hinges. He was full of creative ideas: he made his own miniature stage sets so that he could check that his models were correctly placed before photographing them, and kept a library of these photographs for future reference; he persuaded Susan Lewin to make her own costumes; he set up little clusters of rocks on mirrors and took photographs of them, using them as mountain backdrops; he made the crates in which his works were transported and at times decorated them with paintings and special labels, embellished with cartoon characters and graphic designs. He often made the frames for his works, using simple arts and crafts-style details, and used contemporary motifs as well. All this added up to a unique style, which even the untutored eye could have recognized as Maxfield Parrish's own.

Parrish's Formula

A development of many influences, the 'Parrish Formula for Art' was also a product of the times in which Parrish lived, his personal experiences, contacts and friends, events and travel abroad. These all touched his life, setting certain standards, habits and techniques which were germane in making him the man he became and the work he produced. The following people and events were of primary importance:

1876–1938　　Stephen Parrish, Maxfield's father, a famous etcher and landscape artist, who taught his son etching and consequently to be meticulous and precise in his approach to any task. Just as Stephen did before him, Maxfield ultimately devoted himself to landscape painting.

1882–84　　Study of the techniques of the old masters in Europe, from which Parrish developed his method of painting in layers using single colours, with varnish glazes between applications of colour. The Pre-Raphaelites and the American Renaissance influenced his choice of subject matter; he used

THE LIFE OF MAXFIELD PARRISH (1870–1966)

Romantic and Classical elements in costumes, settings, etc.

1888–91
Study of architecture at Haverford College, where he learned the effectiveness of the use of architectural elements (vases, columns, porticoes), how to make picture frames, and the way to produce meticulous perspective drawings.

1892
The Pennsylvania Academy of the Fine Arts, where various teachers made a contribution; 'making pictures from life' was encouraged, and there was an emphasis on perspective, anatomy, photography and illustration. Of particular significance were Thomas P. Anshutz, who taught photography and the theory of colour, and Robert Henri, for his use of pure colour – 'Mannerism in color'.

1893–1929
The Cornish Colony, where Parrish met some of the greatest artists/intellectuals of the day, to whom he looked for inspiration and approval and who provided a network of support.

1895
Frederic, Lord Leighton, an English painter, who gave Parrish the idea of using a single model, which he did for years.

Howard Pyle, who encouraged a respect for illustration as an art form and a valid way of earning a living. He was keen on using historical costume in illustration as long as it was well-researched and authentic. Believed in experiencing an environment at first hand before painting it.

1903–04
Travels in Europe, particularly in Tuscany in Italy, resulted in a use of landscape elements as isolated objects in compositions, i.e., castles, villas, fantasy settings.

1915–20
Jay Hambidge and his lectures on dynamic symmetry, which he incorporated into his own 'system' by which he plugged elements into paintings by utilizing the dynamic force lines.

Prototitles

As unusual as Maxfield Parrish's artistic style was, his use of short titles for paintings, as in *Moonrise*, was practically unique in the art world, when most artists used full sentences to describe their work. Long titles had been used in the past to provide clues as to what viewers were supposed to be seeing, for example, *The Visit of Hippolyta, Queen of the Amazons, to Theseus, King of Athens*, by Carpaccio, and were often allegorical, as in Tiepolo's *Fame Heralding the Visit of King Henri III*. The use of long descriptive titles continued into modern times, not least in the work of Joseph Mallord William Turner (1775–1851) – a master of light; one of his landscapes was called, *Mortlake Terrace: Early Summer Morning*, not such a very long title, but not short enough for Parrish. Even among Parrish's beloved Pre-Raphaelites lengthy titles were often used, for example, Burne-Jones' *The Birth of Pegasus and Chrysao: King Cophetua and the Beggar Maid* or *The Knights of the Round Table Summoned to the Quest by a Strange Damsel*. Such titles left no one in any doubt that a story was being told. Even more contemporary artists/illustrators like Rockwell Kent (1882–1971), a minimalist in many ways, used full titles such as *Toilers of the Sea*, when *Toilers* would have been sufficient for Parrish, who considered that the image should speak for itself. *Moonrise* is a prototypical title, or more properly a prototitle, and as such set a precedent. His subsequent titles continued in this vein with *Daybreak*, *Stars*, *Enchantment*, *Dreaming*, and *Contentment*. Parrish was above all suggesting a mood, which was a revolution of sorts, and other artists followed suit.

Parrish was so absorbed with his painting that many of his works went unnamed; in fact, the entire 18-painting series of murals, collectively known as A Florentine Fête, were not individually named by Parrish, who probably thought that a blanket title was sufficient, but rather by his client, Edward Bok, when they were used as covers for *Ladies' Home Journal*.

Parrish Disciples

Maxfield Parrish passed his knowledge on in only a limited way and never had formal pupils.

The closest he ever came to teaching was in the case of his dear friend, Austin Purves, Jr., son of Parrish's patron, the art collector Austin Purves. Purves, Jr., was in art school (1921) when he wrote to Parrish to ask point blank if he could come to Cornish and study with his idol; however, he was rebuffed, and treated to a bit of Parrish philosophy instead: 'Throw away your life preservers now & try deep water, alone … use nature, instead of making a likeness of it …So, to sum it up, I want to see you break away for a while & lean on no one …without another's help, it makes for individuality & imagination, & what you do is your own.'

Very few were ever able to have a serious discussion with Parrish about his art or get help from him regarding their own work. Parrish gave few interviews with the press, perhaps a dozen or so in his whole, long career. He did not believe that creativity could be taught, but that it must be learned after a certain amount of technical grounding; he even believed that art schools did more to smother the creative spirit than to enhance it. This notion was later espoused by Dr. Albert Barnes when he limited access to his art collection at the Barnes Foundation, setting the boundaries even for art historians.

Parrish was a very private individual, having chosen the woods of New England to escape from people so that he could work in peace. Besides Purves, however, he did speak with Hannes Bok a few times about art and discussed Jessie Willcox Smith's work with her in exchange for comments on his own; he was also pleased to see Mrs. Woodrow Wilson's paintings and discuss art in general – but that was the extent of his involvement.

On the other hand, there were, and still are, many imitators of Parrish's work, but no one could quite capture the particular radiance of his paintings, or replicate him accurately. In fact, many imitators jumped onto the bandwagon of his fame, attracted to the vogue for Maxfield Parrish images and the fact that they were now regarded as valuable.

Parrish's work is nearly impossible to copy for a number of reasons, mainly his ability to layer paint, one colour at a time, between alternating layers of coloured varnish in the tradition of the old masters – which does not prevent it from being frequently reproduced. However, Parrish himself destroyed most of his preliminary work as 'just studies'. As with most serious artists, almost none of those that remained were signed, including his famous study for *Daybreak*. There are precious few genuine studies in existence, yet from time to time a number of crude copies of parts of drawings, cartoons and purported studies do turn up for sale – usually badly-executed fakes. Sometimes they are signed in a manner never used on paintings by Parrish, let alone preliminary drawings; at other times they are signed with crudely-executed block initials, and so on. Most artists do not sign studies unless asked, as they are considered unfinished works and a signature usually declares them to have been completed. The American Impressionist, Mary Cassatt, only signed a painting when it was to be sold, thus declaring that it was in its final form, the sale itself being the last step to a logical conclusion.

Parrish did share something of himself on occasions, though he hated giving interviews or discussing his techniques in public. So, it is all the more interesting to see just who these people were:

1). Hannes Bok (1914–1964) was a young lad in his teens when he first made his way to Cornish to meet the master. He took advice from Parrish and went on to become an illustrator of science and pulp fiction.

2). Fred Machetanz (1908–2002) studied art in college and was captivated by the north-west territories, especially Alaska, during his years in the Coast Guard service during the Second World War. His technique was derived from Parrish's artworks which he assiduously sought to emulate.

3). Ellen Axson Wilson (1860–1914), the wife of President Woodrow Wilson, was a keen Sunday painter, her love of art equal to her endeavours to help the homeless. She sought out Maxfield Parrish after she had been influenced by the American Impressionists at the Old Lyme Colony.

THE LIFE OF MAXFIELD PARRISH (1870–1966)

Hannes Bok started life as Wayne Woodward in Kansas City, Missouri, but after a tragic childhood, when he suffered abuse, he moved to Seattle to be near his mother when his parents divorced. Woodward was looking for a unique pseudonym for his art career, so he took his inspiration from Johann Sebastian Bach and invented a similar name, Hans Bach, later, Hannes Bok. Equipped with his new name, Bok adopted an avant-garde, homosexual lifestyle, living the kind of existence he later depicted in his fantasy paintings.

Bok struggled to make the grade as an artist in the dark days of the 1930s, yet was confident enough to approach Parrish with a view to showing him his work and asking for an opinion. It has been said that Parrish was Hannes Bok's teacher, yet there is no evidence that Parrish ever gave him a formal lesson. However, it is known that Hannes Bok was an admirer of Parrish who, possibly flattered, permitted him to come to The Oaks. As a result, the wide-eyed fan and the 60-something illustrator of international repute began to correspond and discuss painting techniques, when elements of Parrish's fantastical imagery may have been transmitted to Bok. Other than that, Bok was largely self-taught, lonely and poor, though very ambitious. His contacts with Parrish were the high point of a dismal existence on the fringes of society.

When Parrish learned of Bok's impoverished state during the Depression, he bought him paints to help him along and in 1935 offered to introduce him to Celia Mendelsohn, art director of the American Artists Company in New York City. Bok, in turn, wrote to Mendelsohn, possibly exaggerating his friendship with Parrish, describing his destitute state and his dreams of a career as an illustrator. Parrish also suggested Bok contact Maud M. Daniel of Charles Scribner's & Sons' art department. Unfortunately, nothing came of either.

Bok moved to New York City in 1939, a relatively unknown illustrator of fantasy books, who ultimately produced a collection of almost surrealistic oil paintings. For a time, his science fiction pieces were in great demand by pulp magazines as cover illustrations, with such fanciful titles as *Enchanted City*, *Aliens Under A Golden Sky*, *Starscape*, *Siegfried Slaying the Dragon* and *Woman Wailing for Her Demon Lover*.

Bok's paintings are by no means similar to Parrish's, neither were they copies or derivatives. They are rather flat works, wildly imaginative and cartoonish, sketchy rather than detailed: they were not beautiful. However, they were unusual. Bok developed a style of his own which has a cult following today. Part of his estate, when he died, consisted of two study sketches which had been given to him by Maxfield Parrish – *Twilight*, a Brown & Bigelow calendar image from 1937, and *The Glen*, from 1938. Both are exemplars of proportion and symmetry, as if Parrish were intending them to be a form of instruction.

Science fiction guru Ray Bradbury said that Bok 'was one of the finest, yet least known, fantasy artists of our time'. Bok wrote short stories and poems as well as articles on astrology for *Mystic* magazine. Two of his novels, *The Sorcerers Ship* and *Beyond the Golden Stair*, were published after his untimely death. Bok's work was featured on the cover of many pulp fiction magazines, such as *Super Science Stories*, *Weird Tales* and *Famous Fantastic Mysteries*. He painted over 150 covers for science fiction, fantasy and detective magazines, as well as inside illustrations for pulp fiction periodicals and books for publishers such as Arkham House, Shasta and Fantasy Press.

Bok died alone at the age of 49. A few years after his death, a group of friends, Emil Petaja of *Gay Fandom*, his lover Harold Taves and Ray Bradbury and the Golden Gate Futurians of San Francisco, organized the Bokanalia Memorial Foundation, the intention being to keep the imaginative art of Hannes Bok from fading into oblivion.

Frederick Machetanz, a painter of Alaskan wildlife, was born in 1908 in Kenton, Ohio, and studied art at Ohio State University. Today, he is recognized in Alaska as the most accomplished artist to have depicted the traditional frontier image, the Arctic landscape, the wildlife, and regional genre works of the North-West. He is also noted as one of the few artists who actually received direct instruction from Maxfield Parrish, whom he always considered a friend. Parrish's granddaughter tells a story that, for a number of years,

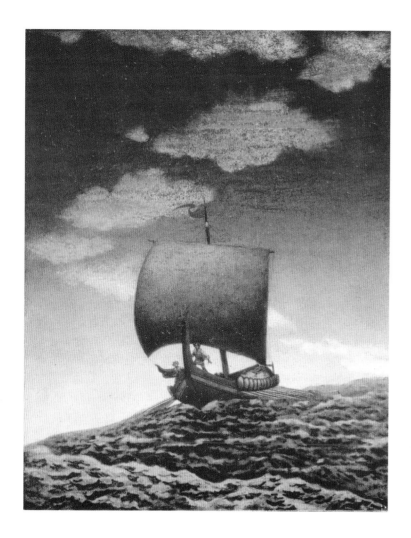

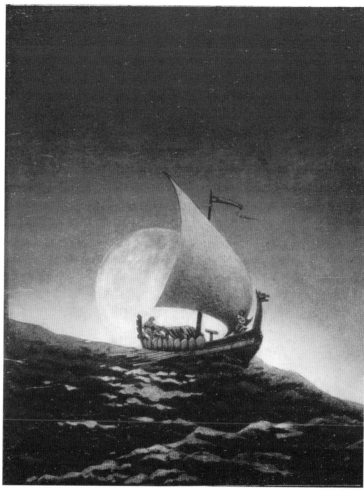

Hannes Bok
Viking Ship at Sea
Oil on paper mounted on Masonite,
11¼ x 8¾in (29 x 22cm).

Hannes Bok
Viking Ship Framed by a Setting Sun
Oil on paper mounted on Masonite,
11⅜ x 8⅞in (29 x 22cm).

Machetanz would arrive at The Oaks with his family in tow and a great white husky, and stay for several days when Parrish would give an opinion of his work.

Parrish had been known to Fred since the early 1920s, when his own art prints were in such great demand. At the time, Machetanz was an impressionable teenager, Maxfield Parrish's name was on everyone's lips, and his images were everywhere – an inspiration to the young student to study fine art and illustration.

Like Maxfield Parrish's, most of Machetanz's works are executed on Masonite panels, which he covered first with cobalt blue paint while Parrish's preference was for white. Machetanz, again like Parrish, utilized several coats of varnish between applications of colour to achieve a quality of luminosity. As an Alaskan artist, he naturally focused on the usual subjects, Native Americans, hunters, trappers, animals and incredible landscapes and again like Parrish used dramatic colours with blues and greens for snow and ice and pinks and golds for sunsets. He called his technique 'Alaska's Kaleidoscope of Color', referring to the time in which he lived as 'Alaska's Romantic Period', lying between a boom in gold and one in oil. Machentanz was indeed a chronicler of Eskimo life, and while his paintings were similarly luminescent, with a preponderance of 'Parrish Blue', he was a world apart from his mentor.

Fred Machetanz worked in New York City as an illustrator and later discovered his love for Alaska while serving in the Coast Guard off the Alaskan coast during the Second World War. After graduating from Ohio State, he went to Unalakleet in 1935 to visit an uncle who ran a trading post, with the intention of staying for six weeks. He stayed for two years and immediately fell in love with Alaska. During the war Fred volunteered to serve in the Aleutians and when it was over returned to Unalakleet, where he met and married the writer Sara Dunn. It was in Unalakleet that he recognized the intense bond he had formed with the land, reminiscent of Parrish's love for the New England countryside. He and his wife worked together on books and films and were popular on the lecture circuit for their combined charm and the exciting stories they told, lavishly illustrated with slides of bold paintings and wildlife in magnificent settings. Sara died in September 2001, while Fred died the year after.

Machetanz is something of a legend among Alaskans – not known for their interest in the fine arts. Although he did not have his first one-man show until he was 53, he is considered to be Alaska's pre-eminent artist and has since had exhibitions all over the world. In 1977, when he was 69, he was named Alaskan of the Year and was also awarded a seat in the Alaska Press Club Hall of Fame as well as being named Artist of the Year in 1981 by *American Artist* magazine. His work is included in several museums in Alaska, Washington and Canada.

Among the Parrish papers at Dartmouth College, there is a letter from President Woodrow Wilson's daughter, requesting that Parrish help her parents find a summer rental in Cornish. Parrish asked his friends, the Churchills, to rent their house to President Wilson and deeming it a great honour they agreed. Thus, President Wilson rented Harlakenden House as a summer White House for successive years beginning in 1913 and ending in 1915.

In 1902, Woodrow Wilson, then a professor of jurisprudence and economics, became president of Princeton University. While at Princeton, the professor and his wife, Ellen Axson Wilson – the first Mrs. Wilson – spent a number of summers along the New Jersey coast. However, Mrs. Wilson changed her opinion of it as a place to vacation when she became seriously interested in fine art. She studied art in New York while Wilson was finishing his graduate studies at Johns Hopkins University. After their marriage, her energies were devoted to raising three daughters, managing the household and encouraging and supporting Wilson's academic and political ambitions. In 1905, Professor Wilson wrote in his diary, 'A later consideration of our summer plans determined us to join the colony of artists at Old Lyme, Connecticut where Mrs. Wilson will have a much coveted opportunity to return to her old artistic pursuits …I have engaged two rooms with Mrs. Thibits and am very much attracted to the place indeed.'

Ellen Wilson was an unusual woman, being dedicated not only to her family but also to the arts, but with a strong sense of social responsibility. Coping with the challenges of

academia and then Washington politics, she was able to raise a family, develop her artistic talents and build new housing to replace the alley slums in Washington. She first selected the Old Lyme Art Colony, which at the time suited the Wilsons quite well. In 1909, Mr. Wilson wrote, 'Lyme is one of the most stately and old-fashioned of New England villages, and we shall be boarding not with New Englanders, who get on my nerves, but with a jolly irresponsible lot of artists, natives of Bohemia, who have about cleared the air of the broad free world ... Lyme is a delightful haven in which to sleep, sleep interminably, as I love to do, when I am worn out.' Many leading American Impressionists had been associated with the art colony in Old Lyme, including Childe Hassam, William Chadwick, Frank DuMond and Willard Metcalf, which was why the Wilsons had been attracted there in the first place. Mrs. Wilson particularly enjoyed mixing with professional artists, being a budding artist herself, and was later accepted as a member of the American Impressionist group of painters, among whom she was known, not only as a 'great and good lady', but also as an accomplished artist.

It wasn't until after Mr. Wilson's inauguration as president in 1913 that he concluded for political reasons that they could no longer return to New Jersey or even to Old Lyme in the summer – 'if we take a house by the sea, it must be in old New Jersey, which would not forgive us if we went elsewhere'. Thus the couple opted to forgo the coast altogether and settle for the hills of Cornish in the New Hampshire countryside.

Many people were drawn to the beauty of Cornish and became full-time residents, while others came only part of the time during the summer. A Cornish Colony member, landscape architect Ellen Biddle Shipman (1869–1950) had a calling card printed which read, 'Geographically in Plainfield, Socially in Cornish', an indication of what had initially attracted her to the art colony. Cornish was also known far and wide for its gardens, created through the influence of garden designers like Charles A. Platt and Ellen Shipman, who persuaded many to spend considerable time, money and their own efforts on their gardens. Edith Galt Wilson – the second Mrs. Wilson – wrote in her book, *My Memoir*, 'Cornish is a charming spot, a Mecca for artists and cultivated people, the chief rivalry among these delightful folk seemed to be who could make the loveliest garden ... there seems to be about it all a halo of gorgeous colors from all the flowers.'

Winston Churchill (1871–1947), the American novelist, was one of the most popular writers of his day and a prominent member of the Cornish Colony. It was his house that President Woodrow Wilson rented in 1913 and for the next two successive summers as the summer White House. Churchill's historically-based novels, which included *The Celebrity*, *The Crisis*, *Richard Carvel*, and the best-selling novel *Coniston* (1906), were all set in New Hampshire. Churchill and his wife, Mabel Harlakenden Churchill, were close friends of the Parrishes and like Parrish, Churchill had great popular success with his work. They were the same age and both enjoyed researching historical subjects prior to creating new novels or paintings. In 1899, Churchill commissioned Charles A. Platt, the Cornish etcher, architect, landscape architect, author and photographer, to design his home. It was the most massive and impressive structure in Cornish to date, and was designed to be well protected from the eyes of curious sightseers. It was named Harlakenden House, Mrs. Churchill's maiden name.

Beginning in 1913, the first year of Wilson's first term as 26th president of the United States, the Wilsons spent their first summer at Cornish. The president gave a speech at the 4th of July celebration in Gettysburg, Pennsylvania, and after an hour's talk, the Wilsons boarded a train for New York en route to New Hampshire to spend the rest of the summer. It was during their Cornish summer that Mrs. Wilson convened a group of artists to discuss a kind of national support for the arts which France already enjoyed. It was suggested that the federal government should establish an agency for the arts to encourage them, to award prizes and honours as well as scholarships, even agencies to purchase artworks for government buildings, to which Ellen Wilson replied that the congressmen who would endorse such a position were 'not yet born'. She was quite correct.

The Wilsons returned to New Hampshire for the summer of 1914, but prior to leaving Washington, the president gave a speech on the meaning of the Declaration of Independence

at Independence Hall in Philadelphia, wherein he used the phrase, 'Our country, right or wrong'. He could not wait to arrive in Cornish, which had become the focus for an 'aristocracy of brains' and also very fashionable, like a 'little New York'. Harlakenden House was almost directly across the road from Parrish's 22-room estate, and the Parrishes and the Wilsons became good friends.

Unfortunately, after one and one half summers in Cornish, Mrs. Wilson died early in August 1914 from Bright's disease, the *New York Times* claiming that her disease had been aggravated 'by a nervous breakdown, attributed to the exactions of social duties and her active interest in philanthropy and betterment work'. President Wilson was heartbroken when she died, but decided to continue to spend his next summer in Cornish, hoping that the social whirl would take his mind off his tragic loss.

Rural Cornish was evolving into a famous resort and many of the local farmers took in boarders to meet the new demand. The attractions were many, including the natural beauty of the place and the interesting people who gathered there.

Seven months after Ellen Axson Wilson's death, the president was introduced by his cousin, Helen Bones, to Edith Bolling Galt (1872–1961). The President was already having an affair with another woman and the Secret Service was obliged to buy his love letters back to keep the press quiet. However, the president immediately became infatuated with the 42-year-old Miss Galt and began to court her immediately, having a direct telephone line to her home installed in the White House.

On 22 October 1915, President Woodrow Wilson wrote to Winston Churchill on White House stationary as follows: 'My dear Mr. Churchill: To my great regret I find that it will not be possible for me to take Harlakenden House another season. The place is altogether suitable to my taste and uses and I have become very much attached to it. I am going to stay away from it next summer only because I must take some part in the political campaign and it is an imperative that I should be somewhere near headquarters and easily accessible to those who wish to consult me. I have, therefore, felt obliged to promise to take a house in New Jersey. I want to tell you how much I have appreciated all your generous courtesies in connection with my leasing of the house at Cornish, and to express my pleasure in having been associated with you in any way. I only wish that my visits had been less brief and that I might have had the pleasure of seeing something of you. I hope that this is only a pleasure postponed.'

Powerful Women

Not long after the couple married, Edith Boling Galt Wilson began to be referred to as the 'first woman president', a sobriquet attached to her a few years later after the president suffered a devastating stroke in 1919 and she was left virtually to run the country. The summer before, Edith had arranged for the president to spend time in Cornish once again, and he enjoyed the surprise vacation very much; but not long after returning to the rigours of Washington, he was struck down. Mrs. Wilson took over both the household and the Oval Office, just as Susan Lewin had the Parrish household, but on a different scale. Perhaps Mrs. Wilson remembered the way Susan protected Parrish from various fans, press and hangers-on. Even when the president visited Maxfield Parrish for afternoon tea, Susan would make him wait until Parrish completed whatever he was doing, to the great annoyance of Mrs. Wilson, who later decided who should see the president and who should not, setting a precedent in existence to this day. She decided which issues could be brought before the president for consideration, actually vetted all his work, and made herself the most powerful person in the nation. She died on 28 December 1961, the anniversary of her famous husband's birth.

As Cornish developed into a cosmopolitan enclave of artists, politicians and intellectuals, Susan Lewin became more and more indispensable to the Parrish household. In addition to practical duties, she grew increasingly competent and confident in her dealings with the public, the media and other notables. She continued to act as a model, serve meals and afternoon teas, and was always on hand to assist the artist in his work. As for Parrish, he was discreet when he spoke of her and treated her like a father in front of other people.

Meanwhile, with the children away at boarding schools, the cold winters found Lydia

exclusively in Georgia and the main house at The Oaks was closed up until spring. With the rest of the family gone, Parrish found the welcome calm conducive to work. He characterizes Susan and his needs in a most unusual and revealing letter: 'I seem to have a certain amount of notoriety, and it's nearly finishing me. In summer there is a steady stream of people arriving which makes work well nigh impossible. My clothes enable me to circulate among many of them as the hired man ... so I look forward to winter ... I have to work alone in the quiet. Some winters a native young woman keeps house for me + helps me paint + sometimes poses for me. She has done this for a dozen years or more + knows my ways, + is one who happens to fit in like a piece of furniture. Otherwise I am alone ... just living in my work.'

Whatever the true nature of their relationship, the fact remains that they lived alone together for 55 isolated winters. At about the time of the above letter, in early 1923, Lydia asked the Churchills to help her to mend her marriage; it was Mabel Churchill's opinion that if they could only find a way of getting Susan away from The Oaks it would be the end of the relationship – the proverbial out of sight, out of mind! Accordingly, the Churchills offered Susan a place in their own household and surprisingly Susan accepted and moved into the servants' wing at Harlakenden House; Lydia and the Churchills, well pleased with their successful manoeuvre, left for Europe. However, no sooner were they out of Cornish than Harlakenden was burnt to the ground. Parrish was first on the scene, and called the fire brigade, assisting volunteers by passing water buckets, but the house was destroyed. Susan immediately moved back into the studio at The Oaks, remaining there for another 40 years.

A Singular Technique

Unlike most other artists, Parrish's paintings are nearly impossible to copy. His grandfather taught him to make paper silhouettes and cutouts, his artist father taught him to draw and etch, Haverford College taught him architectural drafting and model building, while visiting European museums taught him the techniques of the old masters. He experimented on his own with different materials and mediums, first with watercolour papers and pencil drawings, then with India ink, crayons, pastels, watercolours and later with varnishes and oils. He changed brushes and pen nibs to achieve different effects, something he must have learned from preparing architectural drawings. At about the turn of the 20th century, he started using transparent coloured glazes. His sensitive use of a certain number of colours almost always coincided with the printer's needs, depending upon how many were to be used in the printing process.

Parrish wanted his artworks to last and therefore prepared his painting surfaces well before starting work. Recognizing that other artists were not as careful or patient, he once commented, 'For those very few who care at all for craftsmanship the time will not be begrudged for thorough drying time between coats.' They were usually painted on board, a Masonite panel, paper stretched over a wooden frame or on paper applied directly to composition board, and each colour was applied separately and left to dry, then glazed and varnished; the next colour was applied after the coloured glaze coat and varnish coats had dried completely, and so on. Some of his paintings have 50 or 60 coats, with as many in-between glaze and varnish coats, which is said to be the reason for their unique radiance. Even his drawings, some in colour and others in blacks and greys, using different kinds of pencils and washes, often had glazes.

His clear knowledge and understanding of the printing process was also a major asset, which enabled him to plan the 'construction' of his artwork. He would create it in a layered manner akin to the sequence and methods used by the printer. It meant that the printed version was a more accurate replication than other artists were able to achieve and the results were singularly captivating as a result. Finally, his use of photography and architectural models to create scenery, background and settings was a further attempt at controlling the total image. He used friends and family as models because he felt that professional models had long lost their quality of innocence, which he valued greatly for the credibility it lent to the image.

Parrish was quite insistent that his paints be applied directly from the tube and not

mixed beforehand, his opinion being that the 'original purity and quality …the quality of each is never vitiated by mixing them together … and the result is a surface color instead of a transparent one, a color you look on instead of into'.

Maxfield Parrish spent more time preparing and planning his work than actually painting it; in fact, one might say that the important part had already been done before he even began to contemplate the living model. Usually, when a copy of a Parrish turns up, one finds that it was done purely as an exercise rather than to deceive; this is how students learn technique, by copying the work of the masters. When such a copy is made, the copyist never signs the name of the original artist and usually does not sign the painting with his own name either. In the case of Maxfield Parrish, however, his works are difficult to replicate because of the manner in which he painted and the materials used. Moreover, few artists would be willing to spend the necessary time that Parrish devoted to a work.

Many have merely sought to capture the 'look' of a Parrish artwork, borrowing elements of Parrish's subject matter (columns, urns, foliage, etc.) and expropriating his colour palette ('Parrish Blue'). These copyists, individuals such as R. Atkinson Fox, George Hood, Charles Townsend and others, tried to construct their own art images as if Parrish had painted them himself, laying claim to a style which derives only from Maxfield Parrish. In some cases, attempts to capture elements of the composition were made, but they were unable to catch the radiance of the whole, not fully understanding Parrish's technique. In some cases elements were taken directly from a Parrish image. For example, two columns (from *Daybreak*), overhanging trees (from a Brown & Bigelow landscape), girls sitting on rocks (*Waterfall*), but there was always something that did not quite convince.

Imitators, Copyists and Collectors

Robert Atkinson Fox was born on 11 December 1860, ten years before Maxfield Parrish, in Toronto, Canada. He studied painting in Canada and in Europe prior to arriving in the U.S.A. to find work as an illustrator. He was best known for his images of animals, landscapes and gardens, girls in romantic settings, historical figures and Native Americans. Companies wishing to imitate Parrish calendars, due to their popularity, sought Fox out to do the job.

Fox was successful because he was much less expensive to hire than Parrish. The quality of his work was clearly inferior to Parrish's for a variety of reasons: his imagination was limited, his original artworks were lifeless and his technique was such that his work came across as flat and uninteresting, especially in printed versions. However, the public is not especially sensitive to such things and they often confused the two.

In the course of undertaking various commissions, Fox and his less than forthright clients decided that he should use pseudonyms to make it appear that many artists, apart from Parrish, were involved in creating beautiful and unique images that were just as good. Consequently, R. Atkinson Fox did not sign all his artworks with his own name, but used various others, such as R. Fox, R. Atkins, John Colvin, Arthur DeForest, Dupre, Elmer Lewis, Chas. Wainright, and so on. In spite of his lesser talent and reputation, Fox became very popular and was quite prolific; his images were reproduced as art prints, calendars, magazine and periodicals, children's books, and on all kinds of products, packaging and in advertising.

Although many of Fox's works were signed with his real name, many were left unsigned and, because so much confusion surrounds some of the pseudonyms he used, other similar prints are often referred to simply as 'Fox prints', which are knock-offs of Fox in the same way that Fox did knock-offs of Parrish. When Fox artworks derived from those of Maxfield Parrish made an appearance, other copyists got in on the act and took their works from Fox, all being cheapened as a result. Today, the market is such that R. Atkinson Fox is now collected. However, so many copyists have produced scenes reminiscent of *Daybreak* and *Garden of Allah*, that it is sometimes difficult to determine whether or not the image was a Fox, one of his pseudonymous works or that of another copyist. Fortunately, the Parrish works are clearly and distinctively different.

A biographer of R. Atkinson Fox is quoted as saying that Fox was 'a Parrish imitator

because of the similarities of many of his most popular works. It is also true that many other artists attempted to capitalize upon the romantic style popularized by Parrish because that was what the public wanted'.

George Hood (1869–1949) was a contemporary of Parrish and a successful illustrator of children's books in his own right, having studied art at reputable art schools. He came closer than any other artist to reproducing the 'Parrish Formula for Art' in his own works.

Hood was born in Weehawken, New Jersey, a year before Maxfield Parrish, and matriculated in studio art across the Hudson and East rivers at the Pratt Institute Art School in Brooklyn. After graduation, he realized that his fortune lay not in fine art but rather as an illustrator, a burgeoning profession guaranteed to produce a steady and substantial income.

After a few years of struggling to make ends meet, Hood returned to art school to fine-tune his technical skills and took further courses at the Art Students League in Manhattan. With this second period of training and a further art degree under his belt, he once again struck out for himself, and this time with a degree of success. He got several commissions for covers and inside illustrations, but produced nothing startling or of national importance.

By the time he had reached the age of 30, George Hood could not help but notice Maxfield Parrish's artworks on magazine and book covers, as well as his graphic images, which were winning national competitions and appearing on posters at exhibitions in New York City's most prominent art venues. Hood realized that he, too, had immense creative talent as well as the academic training and impetus to succeed. He carefully studied the work of his rival in an attempt to discover just how he managed to do it.

In his Greenwich Village studio, Hood and his artist colleagues discussed Parrish's works in detail, with the result that Hood made a deliberate decision to imitate Parrish's painting. Soon some commissions for children's books came his way and he began work on both the Chinese and the Spanish Fairy Books.

Hood was a member of the National Academy of Design (Parrish was admitted in 1905) and received recognition for his proficiency. Finally, he started to be published and was earning a fair living, though nothing like that of his greatest rival. Moreover, while Hood was trying to catch up with Parrish, museums were acquiring Parrish's work for posterity.

Soon, George Hood's work was being described as 'in the style of' Maxfield Parrish. His use of media was the closest ever achieved by another artist, yet it was still a copy; art directors chose to avoid what they considered to be second-rate Parrishes, opting for the real thing instead.

After a while, Hood began to paint images and subjects so similar to Parrish's that the differences were becoming blurred. Hood used oil paints on stretched paper and executed covers for the Plimpton Press of Norwood, Massachusetts, including *Browning's Italy* by Helen A. Clarke in 1907. When that book appeared in bookstalls, it was as if it were a sequel or a second volume to the Italian villa paintings completed by Parrish just three years earlier. The J. B. Lippincott Company then commissioned Hood to illustrate *Legends of the Alhambra* by Washington Irving in 1909, and there was little to distinguish it from Irving's classic *Knickerbocker's History of New York*, illustrated by Parrish in 1900. Hood's cover image for *Legends of the Alhambra* is an amalgam of Maxfield Parrish's Italian villas, a little girl from *Dream Days* (1902), with a touch of the Rubaiyat thrown in for good measure. It was uncanny but it worked.

However, George Hood was never as financially successful. He did not have the reputation or the loyal following of Maxfield Parrish, neither did he have his business acumen. His name has all but disappeared, even though his skills as an artist cannot be ignored. It is a fact that no one else could replicate a Parrish original artwork as well as George Washington Hood.

Charles Newcomb grew up in Hagerstown, Indiana, in a moderately wealthy family. In his early 20s, he took an interest in art and was engaged to decorate various business establishments around town. In 1894, he was offered a job painting billboards in Texas for

RIGHT

George Hood (1869–1949)

Cover illustration for Browning's Italy, *by Helen A. Clarke, 1907. Oil on paper, 20 x 14in (51 x 35cm).*

FAR RIGHT

George Hood

Legends of the Alhambra (Knight and Troubadour Walking in Forest), 1909

Washington Irving. Oil on stretched paper, 17¹/₂ x 12³/₄in (44 x 32cm). J.B. Lippincott.

a regional tobacco company. In those days, the violent and disruptive range wars had just ended in Texas, barbed wire fencing and ranches having made incongruous bedfellows, and it was still a wild territory, where a young man with ideas could strike it rich overnight. Newcomb developed a great business idea into a major public corporation in which he sold stock and gained the rights to set up inland waterway routes to Chicago, allowing him to walk away with a small fortune.

By 1898, Newcomb had lost most of his money on other 'get-rich-quick' schemes, and returned to Hagerstown once again to his small painting and decorating jobs. His most notable achievement was when he took inspiration from Parrish's A Florentine Fête and painted similar, but much less competent, murals for the Odd Fellows Hall in Hagerstown. The Hagerstown 'Fête' was apparently executed in 1913, while many of the Parrish murals were still being painted. Parrish's murals were not due to be installed in the Curtis Building until all 18 had been completed in 1916. Newcomb could not have seen them in Philadelphia, but must have copied the *Ladies' Home Journal* covers, where some had been reproduced in advance.

For many years, Newcomb's murals were thought to have been his own, and the wily fellow never disclosed their origin. He died without a trace of evidence against him, with little known of his business career, no photographs, and an unmarked grave. His only legacy was the Hagerstown murals – which lay dormant for years – a strange local attraction indeed. In 1989, it was accidentally discovered that Charles Newcomb, too, had been a Maxfield Parrish copyist, like so many other artists and wannabes. Even though his artworks were not unique, his town still honours and respects him for having transcribed Parrish artworks into a setting that would otherwise have been totally devoid of beauty. He was responsible for bringing culture to Hagerstown because of his admiration for a great artist. Parrish would have enjoyed the thought, if not the primitive copies of his artworks.

Austin Purves was the nearest thing to a Parrish patron, not in the sense of a protector or an influential supporter, but rather as a close friend and serious collector of Parrish's artworks. Parrish even referred to Purves as a patron and enjoyed the thought of having such a relationship, perhaps unknown to any other illustrator. It was, however, not quite the *modus operandi* for someone creating images for reproduction. The two men first met in Cornish, where the Purves family had a summer residence. Austin admired Parrish's original paintings before they were valued by anyone else; most people had no idea that oil paintings came before the illustrations which they saw published in magazines and the like.

It was not surprising, therefore, that Purves' son should have grown up with Parrish originals on his walls. Parrish was Austin, Jr.'s hero and mentor in many ways, and the young man often came to the master for advice. Austin ultimately became a mural painter, sculptor, and an extraordinary craftsman, experimenting with aluminum as a new art medium.

His father purchased more paintings directly from Parrish than anyone else by far. Amazingly, the Austin M. Purves Collection comprised 85 paintings, all acquired during a six-year period; in fact, Austin Purves' most important endeavour seems to have been to collect Maxfield Parrish's best paintings. In 1953, an extensive collection of Purves papers, letters, receipts, etc., was donated by his estate to the Archives of American Art at the Smithsonian Institution, the same year that Lydia Parrish died. Some years later, when Betsey P. C. Purves (Mrs. Austin Purves) died, a list and photographs of 30 paintings in the collection were loaned by the trustees of her estate to the archives for copying. While her son is listed among many noted artists at the Smithsonian in their special collections, the documents in his file pertain not to his own artistic endeavours but rather to the Parrish collection.

Austin Purves, Jr. lived most of his adult years in Philadelphia and later in Litchfield, Connecticut; in fact, the Litchfield Historical Society offers his name as a possible subject for research, for they have so little information on his artworks. Maxfield Parrish's place in

American art history is so important that it was his father's connoisseurship of Parrish's art which now distinguishes Austin Purves, Jr. from others.

Purves, Jr. studied painting at the Académie Julian in Paris, then at Fontainebleau, the American Conservatory, and at the Pennsylvania Academy. His own creative efforts range from consultant on 'The Meaning of Modernism' at Macy's Department Store in 1929, to sculpting an aluminum coat of arms and renderings of state birds and flowers and other decorative works for the S.S. *America* and the Grace Line ships *Santa Rosa* and *Santa Paula*. He also created mosaics for the memorial at the Cimetière Americain et Mémorial du Rhône – also the apse at the National Shrine of the Immaculate Conception, the decorative map in the Boston Federal Reserve Bank and the spandrel sculpture on the barracks at the United States Military Academy, West Point, N.Y.

Austin Purves made an appraisal of his Parrish collection in 1924, and remarked, 'I have today finished a careful examination and consideration of the works by Maxfield Parrish listed above and believe that the amount placed opposite the table of each represents the reasonable and fair valuation. In addition to this appraisal …is the hope that the collection will remain intact and some day find a home in a public museum, because its importance in the history and development of the graphic arts in America can seriously not be overestimated. The individual beauty of the various works speaks for itself.'

He goes on to say, '… if one has to sell – our thought were money would be made by selling separately so as not to glut the market. Also we spoke of offering the collection intact to different museums for purchase. Museums being able to offer reasonable prices & our family, if we did not feel able to give outright to a museum, could keep the collection where it would do the most good and at the Saw Mill we would be since buried. Collection to be known as the Austin M. Purves & Betsey P. C. Purves Collection.'

The value Purves ascribed to the 88 artworks was just short of $100,000, the largest single amount being $7,500 for *Cadmus Sowing the Dragon's Teeth* (page 134), a painting Parrish was said to have loved more than any other at an early stage of his career. Purves also owned an Edmund Dulac painting and a portrait of his son, Pierre M. Purves, by Jessie Willcox Smith. Pierre's portrait was painted at Parrish's suggestion by his good friend and colleague Jessie Smith.

Over the years, Austin Purves Jr. visited Parrish many times, and they frequently communicated, the relationship continuing for the rest of their lives. Because of the 'father-son' affection between them, Parrish sometimes gave artworks to the family, the best example being *St. Patrick* (page 121), a *Life* magazine cover painted in 1903, which Parrish produced while at Castle Hot Springs, Arizona. In 1911, Maxfield Parrish gave that painting to Purves, Jr., yet in 1952, Lydia Parrish, being so fond of it, asked the Purves family if she could buy it back. Purves was an understanding man and although he had appraised the work at $1,200 in 1924, nearly 30 years ago, asked for only a small percentage of its actual value and charged Lydia $250. Lydia then gave it to her son, Max, Jr., with the stipulation that it be passed on to his daughter on her 21st birthday, 7 September 1968.

Letters from Maxfield Parrish to Austin Purves, Jr.

Some years ago, when the Austin Purves Jr. home in Litchfield was sold, a stack of letters from Maxfield Parrish was discovered. The following are excerpts, which indicate the depth of friendship between the two that lasted for half a century. The first letter is written as an accompaniment to the painting *Father Time* (page 122), which appeared as a *Colliers* cover in 1907.

Circa 1910 – Special price to God's own only $25.00
Dear Mr. Austin: I have this minute returned from New York + found your good letter. I doubt if this will be of the slightest use to you, but if it is you are welcome. If any boy prefers anything I ever did to a bicycle he can have it. J.P. Morgan, The Louvre and the

Metropolitan Museum have been after this beautiful etude for years but they never offered me a bicycle for it. It may not suit the boy at all, but alas its the only possible thing about the palace …In dreadful haste, God bless the boy/Maxfield Parrish/A Merry Christmas to you in spite of this original …
(Austin Purves, Jr. was ten years old when he received this letter)

January 9th, 1911
My dear Austin: This isn't the letter, and this is only to tell you that it isn't. I told your father I was going to write you Sunday, yesterday, but something happened which prevented …So this isn't the letter at all, only to tell you things were delayed. But the chimney is clear and I wish I could draw half as well. With good wishes: Maxfield Parrish.
(Austin Purves, Jr. was eleven years old when he received this letter)

January 10th, 1918
My dear Austin: Do you ever come over to New York? I wouldn't advise coming just now, as you might get into the National Academy Show by mistake, which would be a pity …strange as it may seem, the tendency of an art school is to unfit one from becoming an artist. It doesn't mean to, of course, but as they can't tell you how to do everything, they concentrate on a few (things)…three quarters of them have it knocked out of them in the average school, thinking that to draw in the life class well is about all there is to it. And

Letter to Austen Purves, Jr. from Maxfield Parrish, circa 1904. Handwritten letter in pencil on paper, 18³/4 x 15¹/8in (48 x 38cm), inscribed 'Special price to God's own only $25.00'. It accompanied a painting called Father Time. *(See page 88.)*

picture painting is generally looked upon as a downright poison …only now do I feel that in a year or two I can do something I'll be proud of, & I'll find I'm wrong even then … give my love to your mother …and every good wish to you in the big career. Maxfield Parrish.

November, 1922

Dear Austin: I'm miles behind, as usual, but you're kind enough not to allude to it …What on earth you want to hanker after in Rome praise for I don't know ... Still you might survive it, though not every one does. As I've said many times, it's the one cry of studious goats everywhere, "I don't know enough, I must study some more!" We, none of us know enough and never will: it's the using the knowledge we have is the problem …In October, for a week of golden, hazy days, I wandered over to that coast to have a look at the sea, got down to Boston, visited the scenes of my youth (which I don't recommend) and returned by the deserted White Mountains. Boston …do see the Egyptian things at their very spic and span Museum …I had to take my hat off to Sargent's little hall in the library. To me it is real, rich decoration. A wall surface embellished. I met him by the way, at the hotel & like his big modesty ... Abbey's things were dreadful decorations, and first class illustrations ... I had to run down to New York to see a premiere of a colored movie. It was good too, and the best things were the colored subtle things, shadows on faces, white in shadow, and white against flesh, all beautifully rendered. Generally I've had to pay from .20 to $1.00 to get it, but its time they gave me $500 to enter! I'll get fond of the theatre if that keeps up …

January 12th, 1921

My dear Austin: It is a difficult matter to give you intelligent advice, to give anyone advice, for after all it would be trying to be judge of conditions for another, by my

own …Now about being with me. I will be frank, brutally frank. For your own sake don't do it. I do hope we can be wherever we can see each other often & I think then I can give you the benefit of my experience. But don't work with or under anybody, for a while … and there is another reason. I am in rather a bad way with my work. I seem to have a certain amount of notoriety, and it's really finishing me. In summer there is a steady stream of people here which makes work well nigh impossible. My clothes enable me to circulate among many of them as the hired man, but there are ever so many …It is so serious that I am almost down & out financially, whereas if I could work in peace I would be quite well off …I have to work in the quiet …I would rather have you than anyone I know, were it possible to have anyone …When I was your age I was going to be an architect, or thought I was, then, to fool away the time one summer took up landscape painting with an out-of-door class w. Joe Decamps. Rather liked it & went to the Academy & while idling away my time there, made soap ads & covers for Wanamakers' catalogues & goodness knows what. Taught some, had a chance to do some decorative work, got a picture in an exhibition & managed to keep from sinking, somehow, ever since. But that illustrating was good experience …you might begin that way. It makes you dare, all sorts of things …My best love to you all & O but it will be good to see you again. M.P.

February 3rd, 1938
Dear Austin: Movies! Austin! Why man dear, that is so exciting: that's front page news. You are a bit vague … are you going to act, produce,

direct, censor, release, or mickey-mice? Whatever department you have in mind I am all for it: There are possibilities in the business whose surface has been scarcely scratched as yet …he [I] make a living painting landscapes exclusively, which seem to be liked well enough by a firm in St. Paul to be published as calendars. Its good fun but rather discouraging, as a good one is produced only at rare intervals. Give me 60 years more and I think I would know how …My father in his 92nd year, still has the zest to live from day to day, still looks forward to tomorrow, like an unopened package …I was taken into an exhibition of Abstractionist art, but I do not think it decent to talk to you about … As ever, M.P.

January 10th, 1948
Dear Austin: Indeed if you could tell us on a postal of your mother's condition it would be most welcome …Do you think she would care if a body wrote to her? That would call for her address, would it not?…Pardon this machine made affair, but cold fingers might make it hard to read [Winter in New Hampshire caused M.P. to use a typewriter rather than his usual script] …M.P.

August 29th, 1951
Dear Austin: It was good of you to write me. Yes, Orville Fitch told us of your mother's death, and it came as kind of a blessing, for her condition when I last saw her has haunted me, lying there helpless, only a faint change in her eyes telling that she took in what I was saying …I wish I could suggest something of worth about the

pictures. I never took my work very seriously, and it is hard to believe a museum would want it as a collection. Any decision I pass on to you and yours, knowing full well it will satisfy me …Here or there, anything to see you again. Hopelessly the same: M.P.

July 3rd, 1958
My dear Austin: I was delighted to get your letter of June 20. We all were. The faint suggestion that you might run up here was an item to think about and we hope it will receive intense consideration on your party …And our phone is Plainfield 140 – we have many things to talk about …Your kind words of "Jason" [*Jason and His Teacher*] sank in deep. I haven't painted for ever so long, and should begin again before long. I presented to the Stockton. Cal. Art Museum an old Collier cover. I will tell you about it. "Never in the history of human endeavor has there been such a to do over such an insignificant trifle." We await you, M.P.

November 1st, 1960
Beloved Austin: I have thine of October 26 and was glad to hear from you. As to that show: listen to this. In February last I came down with a misery: arthritis I think they called it: anyway it was something ending in itis, and for a while it looked as though my next job was selling apples on some sidewalk. Since then things have improved a lot: no more pain, and general health A-I, all but my fingers, but even now I can paint …In July two unfortunate things happened. I had a 90th birthday and a fool write-up on me in NEWS-WEEK magazine, both coming at the same time. May be it was flattering, I wouldn't know, but my mail was simply staggering: letters from all over the country, gifts arriving, and people wanting come see me …Those "Gallery fellows you talk with in New York", it would be my advice, give it up. My interruptions here are carefully planned by some clever devil: we won't go into that now: it has no elements of interest … We all hope you will run up here in the summer, but I fear you won't, though hope springs eternal. From your ancient and sometimes honorable: M.P.

On 28 October 1913, Maxfield Parrish wrote the following note on a novelty caricature, *Man and Woman at Grand Piano*: 'Austin M. Purves – Most Charitable Patron of Maxfield Parrish'. The note was a verification of the way he regarded Austin M. Purves, his valued friend, even though the drawing of Betsy and Austin Purves was not very flattering.

Businessman with a Brush
Commissions from *Collier's* magazine began in 1904 under an exclusive six-year contract and Parrish was paid $1,250 per month at a time when the average income was $500 a year! His commissions and fees bordered on the excessive, but Parrish's illustrations drew massive audiences, a fact the publishers of *Collier's* well knew. However, the idea of these long-term contracts came from Parrish, who being a cautious person and aware of the fickleness of public taste wished to capitalize on his current popularity. Unlike other illustrators, he prepared his own strongly worded contracts and demanded they be observed to the letter: his celebrity was such that all his clients unhesitatingly complied.

The next 30 years of Parrish's life (1905–1935) were hectic as his fame grew, his star now firmly in the ascendant. Commissions for illustrations rose to $2,000 apiece, and were in demand even to adorn products – a sure-fire way of attracting customers. The advertising profession was still in its infancy and illustrators in America had never had it so good. Parrish's portfolio included magazine advertisements, window displays and billboards; in fact, the very name 'Parrish' on a product guaranteed it to be the very epitome of style and class. Windsor & Newton called its cobalt blue oil paint, 'Parrish Blue', Strathmore paper used him to promote watercolour boards, his characteristic signature cutting across the bottom of every advertisement, and a fountain pen company used Parrish to assure the public

that the best artist in the United States used its writing implements: he was famous and he enjoyed the feeling. Fees continued to climb and in one year alone he was honoured by the National Academy of Design, Phi Beta Kappa, the Pennsylvania Academy of the Fine Arts and the Architectural League of New York. To Maxfield Parrish, however, the most significant accolade was a Haverford honorary degree for he had never actually graduated from that establishment.

Collier's published his works regularly, books illustrated for *Scribner's* flew off the shelves, his murals were installed in the finest hotels, a 49-ft (15-m) long favrile-glass mosaic was executed in collaboration with Louis Comfort Tiffany, who skilfully interpreted Parrish's painting, *Dream Garden*, for the lobby of the Curtis Publishing Company building. More advertisements, more covers, more calendars and a plethora of superb works made the name 'Parrish' a household word. As fees for his commissions soared, he sardonically described himself as the 'businessman with a brush', in self-acknowledgement of his acumen in striking unique 'sweetheart' deals with publishers. It seemed that he was the only winner, for other illustrators were exploited left and right by the business world as a result of their sensitive temperaments and lack of business experience. Parrish seemed to be a born businessman, an uncommon facility where an artist was concerned. He was perhaps the first artist to copyright his work and to allow only one-time usage of his licensed images.

Other skills that Parrish had acquired in business were sharpened by his long relationship with the art dealer Martin Birnbaum (1878–1970), who with Bernard Berenson and Lord Duveen ranked as a serious intellectual, having translated Verlaine's poems, and who was a playwright, lawyer and a violinist into the bargain. Of a similar age to Parrish, the two had shared interests in poetry and music, not to mention art, and especially a love of the Pre-Raphaelites. A German, Birnbaum is credited with introducing America to Paul Klee, Oskar Kokoschka, Lyonel Feininger, James Ensor and Edvard Munch, and was one of the first dealers to recognize the talents of Maxfield Parrish and to consider his work worth collecting.

Birnbaum arrived in the U.S.A. in 1910 to open a branch of the Berlin Photographic Company, dealers in photography and art books as well as original artworks, in a small gallery attached to its showrooms. Here, Martin Birnbaum successfully presented the art of Rockwell Kent, John Sloan, Aubrey Beardsley and John Marin, which boosted the photographic business so significantly that in a few months its profits exceeded those of the art sales, which then continued on a steady basis. Collectors relied on Birnbaum's opinion and were impressed with his articles on Oscar Wilde, John Singer Sargent, James Abbot McNeill Whistler and Winslow Homer, flocking to his small gallery to hear his views and suggestions.

Birnbaum was also an advisor when the Grenville L. Winthrop Collection, which was donated to Harvard University in 1943, was assembled. A selection from the collection toured several major museums in 2004, and included an installation at the Metropolitan Museum of Art. In all, the collection has 4,000 items of incomparable quality, ranging from early Chinese jades and archaic bronzes to Buddhist sculptures, 19th-century French art and works of the Pre-Raphaelites. There is also an early Maxfield Parrish, dated 1899, executed in stippled pen and ink and entitled *A Hill Prayer*.

The Scott and Fowles Gallery

In 1916, a year after its first exhibition, which included the work of Maxfield Parrish, Birnbaum joined the Scott and Fowles Gallery, focusing on Paul Manship and Maxfield Parrish, though he also promoted Jules Pascin and the illustrator Edmund Dulac. It follows, therefore, that his first major American exhibition should be the 'First Exhibition of Original Works by Maxfield Parrish'. At the time, the work of other artists in the gallery's portfolio were presented as side exhibitions and included that of George Bellows, Paul Dougherty, Paul Manship, Elie Nadelman, Jules Pascin, Mari Peixotto, Everett Shinn and Gertrude Vanderbilt Whitney. As a result of the exhibition, every Parrish artwork was sold, which was a great credit to Birnbaum's judgement and a tribute to Parrish's art.

Maxfield Parrish when he was getting on in years.

Parrish and Birnbaum had many discussions regarding the saleability of art in general. They each had their own opinions when it came to framing pictures and choosing wall colours against which to display them, important factors that could enhance or detract from a painting. A letter dated 3 December 1917 from Maxfield Parrish to Birnbaum indicates the extent of Parrish's involvement, '…don't show them in the back gallery [referring to *Cinderella* and *Snow White*] with the light yellow walls: the middle gray room will be better. My things are all dark compared to the average run of modern work, and they will not look well in a light colored room, naturally. The laws of juxtaposition must be observed. That is the chief reason why I hardly think it worth while to change the frame of *Solitude*: I do feel that even if the red were camouflaged, the picture would not be helped …after all the people are not going to buy the room, and when it comes to contemplating each picture by itself, believe me that wall cloth holds too much light of its own. A Rembrandt there would look like a black rectangle by contrast …you will find it very difficult ever to show my things with the work of others. A work painted with glazed transparent colors placed among those painted the modern way where all color is mixed with white, makes a most unpleasant combination. And you cannot blame a hanging committee for placing mine where it will do least harm. Mine makes theirs look chalky, and theirs makes mine look like linoleum. Neither are to blame: both methods are right, only strict segregation is necessary.'

Action and Reaction

Parrish's reaction was characteristically modest in the spring of 1918, when Birnbaum suggested that he add elements of his own arts and crafts to an exhibition of his paintings. Items suggested were tables and chairs, hinges and door locks, candlesticks and lampshades, all designed by Maxfield Parrish, some of which had been built by him in his shop – others by his handyman-caretaker, George Ruggles. 'Now about the household goods. Birnbaum, I do not see how in the name of modesty we can show those. They are no good really, and I

don't like the idea one bit. It looks exactly like we are saying to the public: "See what I can do"…It isn't modest …I hope to have another letterbox, somewhat on the lines of the one you sold for charity …that ought to be enough to show them my "marvelous and uncanny versatility".' Parrish was never as modest as he pretended, except to make the points he wished to make. He enjoyed fame, notoriety, praise, honours and money, and the truth was that he did not think his craftsmanship was in the same league as his artworks. He went on to say to Birnbaum, 'But the kind of show you suggest is only proper after a man is dead. Even then only after cremation, to preclude turning in one's grave.'

Birnbaum was a close friend of such disparate personalities as Cecilia Beaux, President Grover Cleveland, Bernard Berenson, Lord Duveen and Georgia O'Keeffe, and became a close friend and confidant of Maxfield Parrish. For the next several years he promoted Parrish and in 1925 held another one-man showing of the artist's work. Over 6,000 people attended the exhibition and 50 Parrish paintings were offered on display. Two-thirds of the paintings were sold in the first evening, and Birnbaum was as proud as a peacock. *Daybreak* (page 232) was included in that sale, as was its counterpart, *Romance* (page 222) – which Parrish thought to be the superior work – each realizing $10,000. Parrish's original paintings were true museum-quality artworks and they were readily accepted by the cognoscenti at a time when illustrators were in great demand. It was some time later that art historians and critics would begin to disparage illustration as mere commercial art.

Five to One

Maxfield Parrish, the consummate businessman, exploited the possibilities of making a profit to the full, without compromising his artistic integrity. An intriguing account of his way with money describes how he enjoyed getting the most he could out of a picture; he would sell a client the rights to one-time use of the image for, say, playing cards, then sell the rights for it to be used as a calendar, sell another client the art print rights and yet another the greeting

RIGHT
Jean Parrish
Not Guilty, c.1936
19 x 15in (48 x 38cm)

FAR RIGHT
Jean Parrish
Toy Polo Player, c.1936
19 x 15in

Both of these were proposed covers for Collier's magazine.

cards rights – all for royalty fees. Finally, he would sell the actual painting to a collector. In other words, the work was sold three, four, sometimes even five times, whereas 'other illustrators paint a picture and just sell it once'. Other illustrators simply turned over their original paintings to a publisher for a cover commission and received a set fee from a schedule. In those cases, the originals were usually never returned to their creators, but wound up in storerooms, attics, in an art director's living room or in the archives of a magazine. Parrish made sure he never lost sight of his original work.

Dealing with His Daughter

The cool businessman in Parrish is demonstrated in the following account of an incident in 1936 concerning his daughter Jean, then a budding artist. Jean painted two cartoon-like comic characters and submitted them to *Collier's* magazine, which declined to publish them. Parrish saw them and particularly liked one, which showed bright autumn colours being painted on leaves by a gnome. Although he was by now no longer painting such works, having made the transition to landscapes, he seized the opportunity of exploiting Jean's idea (knowing that her cartoons would never do for a cover, even though the concept was sound) and developed the idea in his own style. He made a business deal with his daughter and did the job himself, whereupon he submitted it, with Jean's permission, to *Collier's*. This time it was accepted and he split the $2,000 fee with her right down the middle. Max, Jr. described the occasion thus: 'Jean got $1,000 and promptly took the train to New York, and came back home with a whole new set of clothes and shoes. She found, as did dad, that comic art paid less well than other types. And she soon went into landscape work in which she now makes a good living.' Jean went on to become a successful landscape artist in her own right, based in New Mexico.

It was not easy, being one of Parrish's children, but it is difficult to understand why he should have made this 'deal' with his own daughter. Some have speculated that it was to prove his talent was greater than hers, that it was to get her to become a serious artist, or that he simply wished to show that he could still do it. Jean's drawings were essentially cartoons and not artistically or financially viable, while Parrish still had the golden touch and knew it. In any case, Jean obviously received several things of value from the transaction.

Art and Fashion

So far, copyists had been kept strictly at bay, due to Parrish's inimitable style and the protection of his copyrights. But, alas, he became just too popular for the copyists to ignore. With the immense success of his art prints, particularly *Daybreak*, his work had become something of a national craze. Consequently, the copyists set to work with a will and clumsy attempts to reproduce the Parrish style were suddenly everywhere. But they never quite got it right, though it was probably good enough for the average undiscerning person. They managed to produce images that were almost as good as a 'Parrish', even though they had never seen the originals. By this time, however, Maxfield Parrish had grown tired of trying to protect his images; all he wanted was to be left alone to focus on his new interest: painting landscapes.

With the proliferation of look-alikes, however, the great vogue for Parrish originals inevitably declined. Moreover, the availability of vast numbers of his images as art prints were cheapened in the public eye when similar ones flooded the market. Parrish images had lost their rarity value: copies and imitations could be seen everywhere – in galleries and advertisements – while styles were changing and fashion was moving on. Parrish and his copyists-copycats were now lumped together as passé – even Parrish was tired of his own themes. The sentimental images of a world of make-believe had become increasingly difficult to stomach after 1929, with the impact of the Depression taking its toll of a society in shock.

In 1931, Parrish, depressed at losing his friend and caretaker, George Ruggles, decided

he was no longer going to paint 'girls on rocks'. In an Associated Press interview he declared, 'I have painted them for thirteen years and I could paint and sell them for thirteen more. That is the peril of the commercial art game. It tempts a man to repeat himself.' As early as 1932, momentous political events were already taking place in Europe, which made thoughts of dragons, knaves, damsels in distress, romance and fantasy seem somewhat irresponsible. It was as though the public had been caught day-dreaming, when more serious matters were afoot.

In 1934, Parrish painted Susan Lewin for the last time after 25 years of portraying her in various guises. She was now showing her age and they both decided it was time to stop. The painting was the *Enchanted Prince* and Susan loved it (page 279). She considered it the best painting of all and Parrish gave it to her, being one of only two paintings she ever received from him. A Plainfield resident who modelled for Maxfield Parrish claimed to have been the girl in this painting, but Max, Jr. confirmed in a letter that Susan was the model, for he recognized her thick legs. In any case, it makes no logical sense that Parrish should have given another woman's image to Susan Lewin, after all the times he had painted her.

In the 1940s, new technologies were beginning to arrive with the advent of radio, photographic printing techniques, moving pictures and television, which all had a marked effect on public taste. It seemed that the brave new world no longer had a place in it for Maxfield Parrish.

The Death of Lydia

On 29 March 1953, Lydia Austin Parrish died at the age of 81 on her beloved St. Simons Island, Maxfield Parrish being 83 at the time of her death. Susan Lewin remained with Parrish after Lydia's death and most probably thought they would be married. She was 64 and had devoted her entire life to Maxfield Parrish, enduring the finger-pointing which existed in the earlier days of their relationship. Though times had since changed, she still yearned to be a married woman. Parrish thought not. He just could not bring himself to marry a woman from a humbler background. She was still the uneducated country bumpkin, his social inferior and, to the outside world as well as to his family, his housekeeper. Susan longed for a regular relationship with this man, had been denied children of her own, and had lived her entire life as a mere appendage to his.

Susan Lewin Marries

Finally, in 1960, when she was nearly 71, Susan married Earle Colby, who had dated her as a girl. She had admitted to herself at last that she had her own life to live, and needed a true companion for her remaining years. Parrish, still handsome though set in his ways, could not believe what Susan was contemplating. However, he behaved like a gentleman but with one exception: he changed his will, leaving her a mere $3,000 – a bleak gesture after a lifetime of love and service. Parrish wrote to his friend, Austin Purves, Jr.: 'Do you remember Susan? The other day she got married, a blushing bride of 70, but she is loyal to the place and comes up about every other day to cook my dinner and look after things.' Parrish then wrote Susan this note for her 71st birthday: 'November 22, 1960. Here's to you Dear Susan: Congratulations and every good wish on your best birthday of all, And I am glad to have lived till the day when you two, hand in hand, walk along into the Vales of Happiness. M.P.'

Parrish's Last Years

Parrish had been steadily painting from his days at Annisquam in 1893 until Susan married Earle Colby. Shortly after writing this last note to her, his right hand simply froze. He completed his last painting entitled, *Away From It All*, and never painted again. The practical explanation was that it was an acute attack of arthritis, but it is a strange and somewhat romantic coincidence. He died five years later in his beloved home overlooking the

Connecticut river valley and Mount Ascutney. Confined to a wheelchair, he had a nurse caring for him, but neither his family nor Susan Lewin was there at the time.

Parrish's life had been rich and full. He had never been given to introspection like so many artists before him. He had never felt the need to suffer for his art, neither did he believe it to be a prerequisite for creativity. Consequently, he had never been driven to despair or self-destruction, neither was he moody or particularly self-critical. On the other hand, there had been a number of rather unusual circumstances in his life, which like anyone else, would probably have affected him; his life was not the perpetual bed of roses that some contemporary biographical accounts would have us believe. If these events had any effect at all, one must also look to his life's work. Maxfield's father, with whom he strongly identified, had had a broken marriage himself (unheard of in the late 1890s); Maxfield himself had been plagued with life-threatening illnesses, followed by a nervous breakdown; he had a son who was never well and addicted to drink, who ultimately committed suicide. Then there was the case of the mysterious fire at the Churchills' house, a couple who had recently persuaded Susan to leave Parrish; an unexplained death on his property of one of Susan's previous boyfriends; and other occurrences which sounded like a movie script. Maxfield Parrish himself resembled a Hollywood star, yet he hid himself away in the remote hills of New Hampshire, and once there, created his own make-believe world, which he rarely left.

Maxfield Parrish no longer received guests after his last illness began. The family hired a nurse to look after him, for most lived too far away to be of help. He had no wish to enter a nursing home nor any such facility. Susan dropped in to see him whenever she could, visiting The Oaks every other day if possible. In 1964, 94-years-old and infirm, Parrish appeared at a retrospective exhibition, 'Maxfield Parrish – A Second Look', at Bennington College. At about the same time, the most important art museum in the United States, New York's Metropolitan Museum of Art, bought *The Errant Pan* and Maxfield Parrish was rediscovered

at this late stage of his long life. This pleased him, for it was a consolation for having been regarded as a mere illustrator for a good part of his life. He was not particularly surprised at being rediscovered, however, for it had all happened before.

Maxfield Parrish's view of the world, what he liked and how he created his art were moulded both by his personal experiences and the eventful times in which he lived. Parrish was born as the American Renaissance was unfolding, in the year during which the first transcontinental railroad was completed. It was during those early years that the Brooklyn Bridge opened (1883), that Geronimo surrendered his last ragtag band to an overwhelming military force (1886), that the first public motion picture was shown in Paris (1894), the first telephone conversation was held (1915), the first transatlantic flight was taken (1919), and F. Scott Fitzgerald's novel, *This Side of Paradise*, was published (1920). Exciting times to be sure, a dynamic era in which to grow up and mature. It was a period in America that saw an influx of European fashions and styles from centuries earlier, yet the yearning for things truly American never diminished.

Maxfield Parrish's long life ended in 1966, when the Modern Age was in full swing. By this time, information technology was beginning to explode, with fax machines, transistor radios and colour televisions in many households, while Abstract Expressionism was the art form in vogue. Brutalism was all the rage in architectural circles, and it would not be long before Neil Armstrong would walk on the moon. The American nation had finally come into its own; it was seeing itself as a world leader at last, with a unique voice of its own.

The Last Renaissance Man

Interestingly, the people with the most creative influence during his lifetime were Parrish's associates, his professional colleagues and personal friends. These artists and architects took what they wanted from European culture and claimed them as their own. Later, the environment became cluttered with modernist banalities and grey concrete slabs. Egos

became enlarged, great concepts became grandiose projects, and achievable goals with sustainable missions became unattainable. Amid all of this, Maxfield Parrish made his indelible mark on an entire culture and in the process became America's Renaissance Man.

Parrish always regretted selling a painting, and fewer remained as his life progressed. He clearly did not need the money and eventually sold none at all. Once in a while he would give one away, for example, a very small winter landscape to his postman. Another he loaned to the 'girls at the bank in Windsor', for treating him kindly, but it too was only a loan and he expected it to be returned to his family one day. Because of his failing eyesight and a defective memory, the girls kindly showed him where to sign, fill in dates, and even walked him down the street to find his car when he forgot where he had parked it. It was characteristic, then, that when one of the girls jokingly asked to 'borrow one of your masterpieces', he should impose conditions on the loan. About this same time, he destroyed nearly all of his studies, deeming them neither saleable nor valuable in any way.

Parrish's interest in making money cannot be denied. His son, Max, tells a story in which Maxfield Parrish was asked in an interview, 'What is the difference between an easel painter and a commercial artist,' to which he instantly replied, 'About twenty-five thousand dollars a year!'

On 17 April 1965, John Dillwyn Parrish, formally known as Dillwyn (he legally changed his name in 1951), replied to a letter from a distant relative to say that he regretted '... my father, Maxfield Parrish has recently been confined to a wheel chair for about 4 hours a day, when not in bed; also he's no longer able to write; he stopped answering letters just about a year ago.' Dillwyn was answering for his father when he said, 'I can't think of anyone left who knows the family history; up here we are so far away from the land of our ancestors. Sincerely, John Parrish.'

The Death of Maxfield Parrish

On 30 March 1966, ten days after the closing of the largest retrospective exhibition of his artworks ever held, Maxfield Parrish died peacefully on the second floor of his beloved home. He was 95 and still quite handsome, with a full head of pure white hair, having lived a full and relatively serene life.

It was an unusually cold day, but by that evening the weather had warmed up considerably. The next day was the last of March and spring arrived in New Hampshire right on schedule.

Obituary

'ARTIST MAXFIELD PARRISH DIES IN N.H. MANSION. March 31, 1966
Maxfield Parrish, whose romantic illustrations and paintings enjoyed great popularity, died shortly after midnight yesterday morning in his hillside mansion here, at the age of 95.

A member of his family said yesterday that no formal funeral services will be held for the famed artist but his ashes will be scattered on his estate under a beloved oak tree which he had painted "at least three dozen times."

The handsome, white-haired artist had been a familiar sight here since he took up residence in the home he designed himself in 1898. He had once worked for an architect and blended many styles in the hillside retreat where he lived and worked.

The main house offered a splendid view of Mt. Ascutney in Vermont, and his studio faced on Croydon Mountain.

Mr. Parrish had been in good health until October 1964 when he was hospitalized by serious illness. He had driven his own car around the countryside here until 92 years of age, and in 1962, when he was denied a renewal of his driver's license, "he somewhat resented it," a member of his family said.

Mr. Parrish, whose art works included murals and paintings for book and magazine illustrations, told his son, Maxfield Parrish Jr., some years ago, that his two favorite works were "Cadmus Sowing the Dragon's Teeth," and the "Talking Oak." The latter was a dramatic picture of a lone man standing at attention as though listening before a great forest oak.

Maxfield Parrish at 86.

THE LIFE OF MAXFIELD PARRISH (1870–1966)

Mr. Parrish was part of a group of artists and writers that settled in the Plainfield-Cornish area around the turn of the century and which became known as the Cornish Art Colony.

It included noted American sculptor Augustus St. Gaudens, novelist Winston Churchill and Judge Learned Hand.

Mr. Parrish did magazine covers for Life and Collier's in the early 1900s. Later he switched to scenics and his works appeared on calendars and at exhibitions.

The son of an etcher, Stephen Parrish, his earliest acknowledged aspiration was to be a carpenter. In later years at Haverford College he wanted to become an architect but was advised first to get some art training.

Upon leaving school, Mr. Parrish executed his first advertising posters and began his career as an illustrator, a career that produced "Old King Cole," a mural which once graced the bar in the Knickerbocker Hotel in New York; the illustrations for "The Arabian Nights," Eugene Field's "Poems of Childhood," Palgrave's "Golden Treasury," Hawthorne's "Wonder Book and Tanglewood Tales," and Edith Wharton's "Italian Villas and Their Gardens."

So widespread was the popularity of his landscapes at the height of his fame, that the phrase "Maxfield Parrish Blue" passed into the language because of the dominant, pervasive, distinctive coloration to be found in many of his paintings.

Born in Philadelphia July 25, 1870, the son of Stephen and Elizabeth (Bancroft) Parrish, he originally was christened Frederick Maxfield Parrish, but dropped his first name in signing his paintings. He married Lydia Austin in 1895 and she died in 1953.

Members of the family include three sons, John Dillwyn Parrish of Plainfield, Maxfield Parrish, Jr. of Lexington, Mass., and Stephen Parrish II of Miami, Fla., and a daughter, Miss Jean Parrish Seymour of Albuquerque, N. Mex.; nine grandchildren and several great-grandchildren.'

This obituary is from the *Newport Argus Champion*, a local newspaper. After Maxfield Parrish died, obituaries appeared in newspapers all over the country. Most of them were littered with inaccuracies, but few people noticed and nobody complained.

The Death of Anne Bogardus Parrish

On 22 October 1966, the sculptress Ann Bogardus Parrish died aged 88 in Lebanon, New Hampshire. A second cousin of Maxfield Parrish, she had been a companion to Stephen Parrish, his father, from 1899 until 1938.

The Death of John Dillwyn Parrish

On 6 January 1969, Maxfield Parrish's son, John Dillwyn Parrish, died aged 64 from a self-inflicted gunshot wound to the head. Dillwyn hated his name and like his father legally renamed himself by adding 'John'. The first-born of Parrish's four children, Dillwyn was very ill and depressed as a child. As he matured and seemed to outgrow his childhood maladies, both of his parents were extremely patient and understanding for they too were distressed at his suffering.

Dillwyn grew up to be a dashing young man and his father spoiled him with fast cars and exotic vacations while his famous surname made him a celebrity of sorts. Certainly it added to his attraction for young ladies. Indeed, Dillwyn kept a long roster of the women he had lured into bed, describing their ethnicity and sexual proficiencies with notes in the margin. At one point he started an automobile repair garage in Plainfield to restore exotic cars, but it was a dismal failure, in fact, all his dreams of success and his various attempts at careers failed. He was a serious disappointment to a father whose own fame had spread worldwide. At the time of his death he was caretaker at The Oaks, which allowed him a degree of comfort and dignity. A brief suicide note was left which said, 'It had to happen one of these days.'

The Oaks is Sold

Two years after Maxfield's death, the Parrish family sold The Oaks to a couple from Cambridge, Massachusetts, but after Dillwyn's tragic suicide the couple sold it to Rosalind and Thomas Wells, who knew little of Maxfield Parrish when they bought the property, but quickly learned that they had purchased a very special place and became more interested in it as a result. The Wellses, along with their young son, Jason, restored The Oaks, turning it into an attractive inn with a gourmet restaurant which thrived for years. In 1979, however, tired out from working so hard to maintain the inn's high standards, they sold the property to a Mexican woman calling herself a 'countess', who proclaimed a love for Maxfield Parrish.

A woman without formal art education, the new owner turned The Oaks into a Maxfield Parrish museum and art gallery. Shortly after, however, it burned to the ground, although it was later rebuilt. After the museum became bankrupt in 1991, The Oaks was sold to a Bostonian with a view to develop it into condominiums. Most of Maxfield Parrish's coveted oaks and his cherished views remain.

The Death of Susan Lewin

Lull Brook, Winter (page 287) and the *Enchanted Prince* were the only Parrish paintings Susan Lewin Colby owned at the time of her death on 27 January 1978. Susan especially loved *Enchanted Prince*, but after her death the paintings were sold by her heirs to pay for college tuition for two grandnieces. Her niece inherited the dress from *The Idiot* and the famous felt hat from *Florentine Fête*, which Susan had moulded into different shapes, depending on which costume she was wearing. Susan Lewin died in the middle of one of the coldest winters in New Hampshire history. She is buried in Plainfield, next to her husband, Earle Colby, who died two years after Parrish; the couple spent a brief seven years together.

Lull Brook, Winter and *Enchanted Prince* were the only paintings Susan Lewin ever received from Maxfield Parrish. Parrish, ever the businessman, had little regard for

Enchanted Prince, and gave it to Susan, not because he wanted to give her a gift but because he thought it would be difficult to sell. He once described it in a letter to Celia Mendelssohn of the American Artists Company, the same woman he had recommended to Hannes Bok some years earlier: '... I will send you as soon as finished the *Enchanted Prince*, shall we call it, the girl and the frog in a wood. As I told you I do not care for this, which may or may not mean anything. There is quite a little cross-section of the public comes to my studio, away off here in the wilderness though it be, and they one and all pronounce this picture "real cute." Maybe it is, but not much else. At any rate it is an unpublished picture ... '

Susan loved it, as it was her last pose, which may very well be the reason why Maxfield Parrish did not like it. Susan spent her last years living in Claremont, New Hampshire, near to her niece Betty Skillen. She often reminisced about her days with Parrish and when she died, Betty was named executrix of her estate.

A month after Susan's death, Betty received this letter dated 20 February 1978 from Maxfield Parrish, Jr., who wrote: 'Dear Mrs. Skillen: Thank you so much for your letter about Sue's passing. I am very relieved that she was not in much pain even at the very end. You did not say that it was cancer but I assume that it was. Sue and I got along very well over the years. She knew she could tell me anything and I wouldn't get mad. Some of the other members of my family would. Even so, she was really more "family" to us than many relatives who were, but lived far away. Since Earle's death I have written fairly often to Sue, and she to me, at least once a year at Christmas time, a thumbnail diary of what went on during the year. Her replies weren't long but conveyed a great deal of news. Once I crabbed a bit about the weakness of the body occasioned by having achieved the age of seventy. She wrote back, "You ought to try 86." (She was 16 when I was born.) I guess that put me in my place. Well, Sue certainly was a beautiful girl in her youth. I suppose no other person had her portrait painted as often by my dad. And he did a good job; she is always recognizable. She was a wonderful model too. Dad said to me once that he didn't have to tell her to pose. He

would simply hand her a lamp or a candle and say, "You are in a large and strange empty hall. You do not know whether there are any lurking murderers waiting behind the next archway or not." And she would automatically show fear as she tiptoed down the hall. She also was excellent in sewing up all the costumes for dad's medieval court scenes too. We will all miss her. Sincerely yours, Maxfield Parrish, Jr.'

Maxfield, Jr. Rises to the Occasion

As a proud son, Maxfield Parrish, Jr. decided to produce an 'Illustrated Catalog of the Paintings and Sketches of Maxfield Parrish'. The text was an inventory of his father's paintings, prepared in January 1965, a year before the artist's death. Although it was primarily intended for family use, related to inheritance taxes, Max felt that some day it might be 'for possible other use, as yet undetermined'. A few years later he realized just how valuable the document was when Parrish forgeries began to appear.

A year after his father's death, Max asked Robert Vose of Vose Galleries of Boston to handle the sale of the remaining artworks in the estate's possession in order to pay Uncle Sam his due. At first, Vose, member of a respected art dealership for four generations, was reluctant to handle an illustrator, but finally agreed after Max's many requests. The 1968 Vose sale turned out to be quite successful.

Max often wrote of his father and his artworks, with accompanying sketches. Although not an artist himself, he had a talent for drawing and reproduced his father's sketches with cartoon-like doodles of his own, almost as though he was seeking to emulate his dad. He and his family lived in Lexington, Massachusetts, while he worked as an engineer at the Polaroid Corporation in Cambridge. He had a great love of machines, which was probably inherited from his father, who liked to work in his own machine shop. He was an inventor and built a steam-engined motorcycle and was able to repair anything mechanical.

Yet his judgements were not always sound. Though decisive in other areas, his timid

ways where people were concerned allowed strangers to penetrate the world of Maxfield Parrish and sometimes to intimidate him. One such moment took place in 1977, as a result of a sketch submitted for authentication. Max wrote: 'There are a number of puzzling things about this sketch …he had an intimate and profound knowledge of perspective …I find it hard to believe that in 1894, poised on the brink of his art career, he drew a newel post top as if it was at eye level when standing up, and right below it drew a three legged table whose top was also seen at eye level as if seated on the floor. And yet he also put the vanishing point in the distance, also at eye level, sitting in a chair …however, in spite of these puzzlements I am inclined to accept this sketch as dad's work.' In addition to these questionable issues, the signature was not right. Parrish only used his actual signature in his letters and almost never on a drawing or painting. Max mentions the signature as a further signal that the picture was not authentic. But even while pointing to all this obviously negative evidence, he accepted the sketch as authentic. In his heart he must have known the truth, though he had been clearly bullied by the owner.

On another occasion, however, he showed more fortitude when he responded to a strange woman telling outrageous stories of seeing and talking to Maxfield Parrish's ghost. She then had the audacity to ask Max for his father's ashes, claiming that Parrish had instructed her to spread them under an oak tree at The Oaks. Max wrote: 'I don't know why he went to her, he didn't even know her, especially when I have his ashes in an urn on a shelf in my basement. You would think he would have asked me first!' The woman never got the ashes, but she was remembered for her irrational behaviour thereafter.

Max Dies

After the estate had been settled, Max convinced his siblings and the rest of the family that they should donate letters, sketchbooks, photographic plates, correspondence, and even an oil painting to Dartmouth College, as a contribution to Parrish scholarship. Maxfield Parrish, Jr.

died in 1983 in Lexington, at the age of 77. A proud man and a grandfather, he took the greatest pride in his father's legacy and corresponded with everyone who ever contacted him.

Far-Reaching Influences

Victor Vasarely (1908–97) proclaimed that Parrish's images bordered on his own Op Art and that his own work had been derived directly from details of Maxfield Parrish's paintings, particularly the optical illusions of juxtaposed patterns in the dress and outfits of characters in the illustrations for *Knave of Hearts*.

Andy Warhol (1928–87) owned Parrish's *The Glen*, and it was his favourite painting! Warhol credited Parrish with influencing his own repeating, reproducible Pop Art prototypes, and Parrish may have even been responsible for his business-like approach to art.

Norman Rockwell (1894–1978) described Parrish as his 'idol'. Rockwell owned an original Parrish painting, *A Good Mixer* (1924), which is a Parrish self-portrait of the artist seated at his easel.

Realists, Photorealists and Superrealist movements all owe their direction to Parrish's legacy, particularly his early use of photography as a basis for his work.

Maxfield Parrish Exhibitions

In 1975, the Parrish Art Museum (founded by Samuel L. Parrish, a great-uncle of Maxfield Parrish) in Southampton, New York, mounted a show entitled, 'The Dream World of Maxfield Parrish'.

In 1989, nearly a quarter of a century after his death, Maxfield Parrish was rediscovered yet again at the 'Romance and Fantasy' exhibition at the American Illustrators Gallery in New York City.

In 1993, Parrish's artworks were featured in 'The Great American Illustrators' exhibition, which toured Japan. Other significant illustrators whose artworks were shown included Howard Chandler Christy, J.C. Leyendecker, Howard Pyle, Norman Rockwell and N.C. Wyeth.

In 1995, Parrish's work gained even greater popularity after Judy Cutler's 'Maxfield Parrish: A Retrospective' exhibition travelled to museum venues in Asia, scheduled by NHK, the Japanese public television network. The show terminated at the Norman Rockwell Museum in Stockbridge, Massachusetts.

In 1999, a Parrish exhibition was organized by the oldest art museum in the United States, the Pennsylvania Academy of the Fine Arts, taking in the Currier Museum, the Corcoran Gallery in Washington, D.C., and ending at the Brooklyn Museum of Art.

The National Museum of American Illustration

The most important tribute to Maxfield Parrish yet is the inclusion of the largest collection of his artworks in the National Museum of American Illustration, where they are a permanent feature. The museum was founded in 1998 and opened to the public on 4 July 2000. It houses the American Imagist Collection, which highlights milestone works by Parrish, Rockwell and N.C. Wyeth, with 75 other artists from the Golden Age of American Illustration.

Museums and Institutions with Parrish Artworks

Over the years, many museums and other institutions have collected Parrish artworks, including the Addison Gallery of American Art, Boston Museum of Fine Arts, Boston Public Library, Harvard University's Fogg Art Museum, Brandywine River Museum, Carnegie Museums of Pittsburgh/Carnegie Institute, Charles Hosmer Morse Museum of American Art, Cincinnati Art Museum, Cleveland Museum of Art, Delaware Art Museum, Cooper Union, Dartmouth College – Hood Museum, Detroit Art Institute, Everson Museum of Art, Fine Art Museums of San Francisco – M.H. De Young, High Museum of Art, Free Library of

THE LIFE OF MAXFIELD PARRISH (1870–1966)

Philadelphia, Haverford College, Lyman Allyn Museum, Mask and Wig Club of the University of Pennsylvania, Metropolitan Museum of Art, Minneapolis Institute of Arts, Museum of Art – Rhode Island School of Design, National Academy of Design Museum, National Museum of American Illustration, New Britain Museum of American Art, Pennsylvania Academy of the Fine Arts, Philadelphia Museum of Art, Phillips Academy, Phoenix Art Museum, Pioneer Museum, Saint-Gaudens National Historic Site, Society of Illustrators Museum, Smithsonian American Art Museum, Stauffer Foundation, Syracuse University, St. Louis Museum of Art, United States Department of the Interior, National Park Service, University of California at Davis, University of Rochester, John H. Vanderpoel Art Association, Virginia Museum of Art, Wadsworth Atheneum Museum of Art, Yale University Art Gallery, and others.

A Florentine Fête is Installed in Newport

In 2003, Maxfield Parrish's largest and greatest work, A Florentine Fête (1910–16), a suite of 18 murals, each more than 10ft 6-in (3.2-m) high, with recurring images of Susan Lewin in various costumes, was finally installed at the National Museum of American Illustration. It had originally been painted to decorate the Girl's Dining Room at the Curtis Publishing Company building in Philadelphia. Parrish's smallest painting, on a mother-of-pearl button measuring 1½in (4cm) diameter, entitled *The Tallwood Pearl* (1955), along with A Florentine Fête, is now on permanent exhibition there.

A World-Famous Artist

Artcyclopedia's 2004 internet listing of the 30 most famous artists in the world has Maxfield Parrish listed as 28th between Peter Paul Rubens and Robert Rauschenberg, along with Pablo Picasso, Vincent van Gogh and Rembrandt. Artcyclopedia claims the listing indicates which artists have 'the greatest mindshare in our collective culture'. Goya ranks 30th most famous and Titian is 42nd. Parrish is the only illustrator listed and is one of seven Americans, including Robert Mapplethorpe, Andy Warhol, Mary Cassatt, Jackson Pollock, Roy Lichtenstein and Robert Rauschenberg.

On AskArt, Maxfield Parrish is listed among the greatest American artists commanding the highest auction prices between 1988 and 2003, and includes George Bellows, John Singer Sargent, Childe Hassam and contemporary giants such as Roy Lichtenstein, Andy Warhol and Jasper Johns. Parrish's *Daybreak* sold in 1996 for $4.292 million, the 17th highest price paid for an American painting. Another similar listing values paintings by the square inch and indicates that Parrish ranks 26th in the top 100 at $3,560 per square inch, while Norman Rockwell is ranked 78th at $2,384.

Paintings by illustrators Maxfield Parrish, N.C. Wyeth, Norman Rockwell and others are featured on the covers of American painting auction catalogues at the major international auction houses: Christie's, Phillips and Sotheby's. They are auctioned on a par with artists such as Mary Cassatt, Albert Bierstadt, Winslow Homer and John Singer Sargent.

A Comment to Consider

Maxfield Parrish left us a legacy of unparalleled enchantment, but one with a message taken from his writings: 'If you look too long at life and nature through others' eyes, you will never see them through your own.'

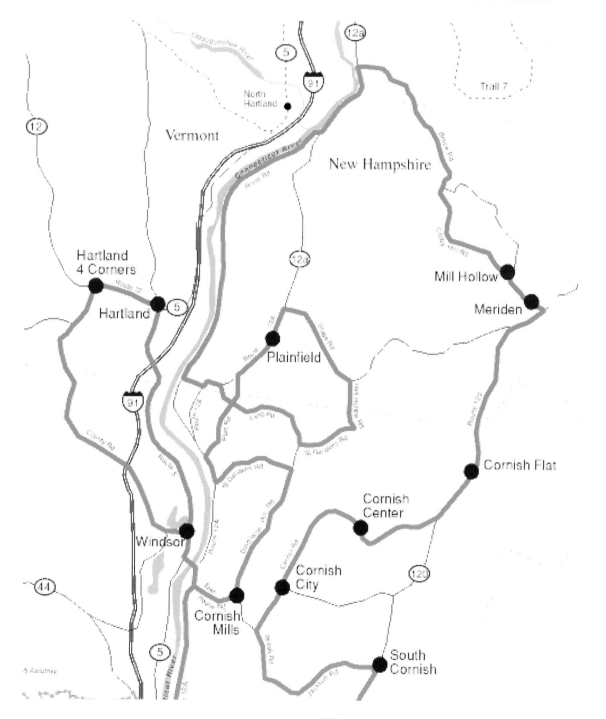

Cornish trail guide, showing Windsor,
Plainfield and Cornish.

CHAPTER TWO
THE WORKS OF MAXFIELD PARRISH

THE ILLUSTRATIONS: PERIODICALS (1895–1923)

Whatever quality I may possess, I truly think, is the result of being alone and working it out without another's help. It makes for individuality and even imagination, and what you do is your own.

Parrish's first commissioned work was the Old King Cole mural at the Mask and Wig Club at the University of Pennsylvania, a commission that was directly responsible for launching his career. The Pennsylvania Academy of the Fine Arts bought the study and later released it as an art print. At the time of its completion, the painting was exhibited at the Pennsylvania Academy Art Museum and subsequently at the Architectural League of New York, where it was enthusiastically received. Having already seen the artwork, Howard Pyle suggested that Thomas W. Ball, of Harper and Brothers art department see it in New York. Ball liked the work and he in turn suggested that the editor of one of their most popular magazines, *Harper's Bazar*, ask the young artist to submit designs for the cover of its 1895 Easter edition. Parrish complied and submitted two different cover designs, both of which *Harper's* accepted. Maxfield Parrish was just 25 when his first magazine cover was published, exposing his work to a national audience in an instant. In this day and age, it is tantamount to appearing on the Today Show, Oprah Winfrey's afternoon show and Jay Leno's talk show, all in the same 24 hours. For decades afterwards, Parrish's work was in constant demand by art directors and publishers for he had attracted an immediate following: he was now famous.

Harper's was one of the first magazines to change its cover image. Whatever the image was, it reprinted it as a poster and pasted it all over local news-stands and lamp posts. This proved to be a successful marketing ploy for the magazine and it adapted well to Parrish's bold, graphic images. Many other magazines followed suit, and most of them wanted Maxfield Parrish as their illustrator, for it was his images that sold the magazines. Soon, many other magazines became more sophisticated and developed formats for their covers with regular logos, strong and compelling decorative borders and space for captivating illustrations to attract new readers. The years following that first *Harper's* cover saw Parrish designing and illustrating covers for a number of other Harper and Brothers magazines, including; *Harper's Round Table*, *Harper's Weekly*, *Harper's Monthly* and *Harper's Young People*.

The height of Parrish's career came in the days before radio, cinema, television and computers, so there was little competition for publishers of printed matter, apart from one another. Printed matter was the only means of conveying images, and the more magazines sold the more audiences craved beautiful illustrations to complement their reading. Illustrations on covers sold magazines quicker and in the process illustrators became celebrities. Names like Howard Pyle, A.B. Frost, Edward Austin Abbey, Charles Dana Gibson and others were on everyone's lips as directly responsible for making life more colourful and interesting. It was far more exciting to receive a magazine with a dynamic image on the cover than simply a colourless one filled with type.

For the first time, the public saw images on covers and later images appeared more and more inside the magazines. The readership no longer had to rely on its own imagination when reading a serialized story or an article. Moreover, illustrations had the power to encourage a far greater interest in politics, social issues and healthcare, in fact, in everything under the sun.

The most popular magazine of the time was *Century Magazine*, and Stephen Parrish produced etchings for it. He mentioned his son's name at *Century* and in view of Maxfield's immediate success at *Harper's*, the response was positive.

Other new clients and more commissions appeared on Maxfield's doorstep each time one of his illustrations was published, and circulation numbers soared. Sometimes he was asked to spruce up not only the cover image but also the entire magazine. This meant preparing headpieces and tailpieces for articles, designing borders for the cover itself, and specifying the fonts to be used, even designing his own fonts and letter styles. In short, Parrish was able to make over the entire magazine and give it a new lease of life. Upgrading like this caused more

companies to advertise, as a result of which circulation increased, more readers subscribed and the cycle began all over again. The biggest problem, in the heyday of magazine publication, was to find the most talented illustrators and keep them.

In an era of celebrity illustrators, Parrish quite dominated the scene; the public could not get enough of him. Commissions flowed in at a steady rate, causing him to become richer and more famous; he also grew somewhat intolerable, for his ego enlarged as his celebrity grew. He was wined and dined in Boston and in New York City, wherever he ventured beyond his beloved Cornish turf – and he loved every minute of it.

In 1901 Parrish illustrated *L'Allegro* by John Milton for *Century Magazine*, to the delight of his old friends Augustus Saint-Gaudens and the artist Cecilia Beaux, who some years earlier had had a studio in the same building as Parrish in Philadelphia.

Maxfield Parrish, still routinely producing bold graphics for poster designs and magazine covers, was now undertaking more sophisticated commissions in the world of literature and was beginning to exploit other aspects of his many-faceted talent. His work had become delicate and elegant enough to illustrate poems and short stories for a more educated readership.

Century commissioned Parrish to paint a suite of illustrations in Arizona for a series of articles written by Ray Stannard Baker entitled, 'The Great Southwest'. Something happened to Parrish among the rugged mountains and canyons far from New Hampshire, and his treatment of colour and light was never the same again. Something also happened to his public after the Great Southwest series was published in full colour. It demanded that Parrish always paint in colour and would accept nothing less henceforth. While in Arizona, Parrish took hundreds of photographs of mountains, details of rocky outcroppings and other aspects of the barren, dry wilderness, images that found their way into subsequent assignments, no matter what the location.

The most striking use of this photography came a decade later in Parrish's Florentine Fête

murals, even though the Rocky Mountains bore little resemblance to the hills of Tuscany. Yet, in spite of the fact that these Parrishscapes were collages of a sort, the public always took Parrish's interpretations at face value, simply because they had been created by Maxfield Parrish. He was never questioned nor challenged – everything he painted somehow was acceptable, from a dragon with a Howdy Doody smile to Rocky Mountains looming above a Florentine garden party.

Parrish became even more excited and stimulated by his own success and rather than slow down and rest on his laurels, he continued to enter more competitions and contests and to win more awards, as a result of which he received more commissions from other periodicals such as *Scribner's*, *Life*, *Collier's* and *Hearst*. All of the major popular magazines were now clamouring for his works, most of which Parrish was able to satisfy. His output was astonishing as he painted more covers, illustrated frontispieces and articles, advertisements, short stories and poems for 25 national magazines – many at the same time.

A specific feature of Maxfield Parrish's magazine art was that it was unmistakably American. European elements were discernible, but it was like nothing else ever created before. Even his humour had an American flavour, a mixture of irony and naiveté irresistable to his audience. He describes what it was like illustrating for periodicals: 'Even making covers for Life is mighty good fun. They pay just as well as posters for only the reproduction rights: the originals come back to me, of which I have the exclusive print rights, should any be suitable for that purpose, and I can sell the originals ... I also want to do some serious painting for publication as prints for it would be a grand satisfaction to have an income three or four times the price of one poster for a number of years, and own the original as well. This is plain arithmetic, not to mention common business sense ...'

Other periodicals for which he produced illustrations included: *Agricultural Leaders' Digest*, *American Magazine*, *American Magazine of Art*, *Architectural League of New York*, *Book Buyer*, *Book News*, *Bradley His Book*, *Collier's*, *The National Weekly*, *Everybody's*

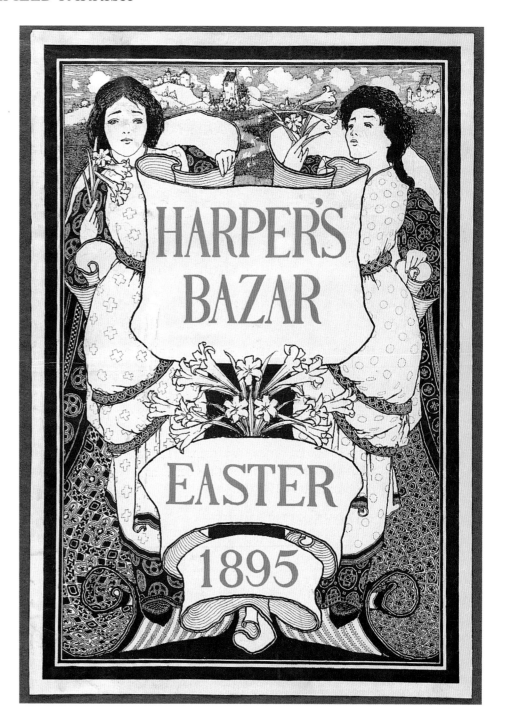

Magazine, Hearst's Magazine, Illustrated London News, McClure's Magazine, Metropolitan Magazine, Nation's Business, New England Homestead, New Hampshire Troubadour, Outing, Progressive Farmer, Red Letter, St. Nicholas, Scribner's Magazine, Success, Survey and *Yankee.*

In 1903, Parrish reached a turning point in his career when *Ladies' Home Journal* held a contest for illustrators to do a special cover for its 250th anniversary issue. Parrish won the competition with a painting entitled *Air Castles* (page 169), which was so popular that the magazine issued reprints that were widely distributed to the delight of its creator. This inspired him to explore the possibility of an even wider distribution of his illustrations in the form of open edition art prints. For decades, the appeal of Parrish's magazine work had never waned, as far as the public was concerned, but producing the work itself could be tedious, due to monthly deadlines and the fact that they were long-term contracts. Although Parrish's work was consistently excellent, his commitments to other projects necessitated that he gradually eliminate periodicals from his commissions.

In 1923, Parrish severed his connexions with periodicals altogether after the great success of his art prints, *Garden of Allah* and *Daybreak* (pages 232 and 254). Thereafter, he only painted a few other magazine covers in the 1930s. Parrish realized that it was much more rewarding to paint an image, any image he wished to conjure up, and sell it for one-time use as an art print, rather than to subject himself to the rigours of a strict publishing schedule. Moreover, he had grown tired of pandering to art directors less talented than himself. He was also limited by the shape and size of the magazine themselves, and the choice of subject was not always his own as the magazine attempted to please its public. Seasons, holidays, events created an unbreakable cycle in the mind of the readership, and one broke this cycle at one's peril.

OPPOSITE
Harper's Bazar, Easter, 1895
Original vintage cover,
13$\frac{1}{2}$ x 8$\frac{3}{4}$in (34 x 22cm).

FAR LEFT
The Maiden, 1896
Oil on canvas
Cover for Ladies' Home Journal, June
1896.

LEFT
Harper's Weekly, 1897
National Authority on Amateur Sport
original poster, 24$\frac{1}{2}$ x 20in (62 x 51cm).

Century Midsummer Holiday Number,
August 1897. Oil on canvas, 18 x 19³/₄in
(46 x 50cm). Original illustration. Lydia
Parrish posed as her husband's model.

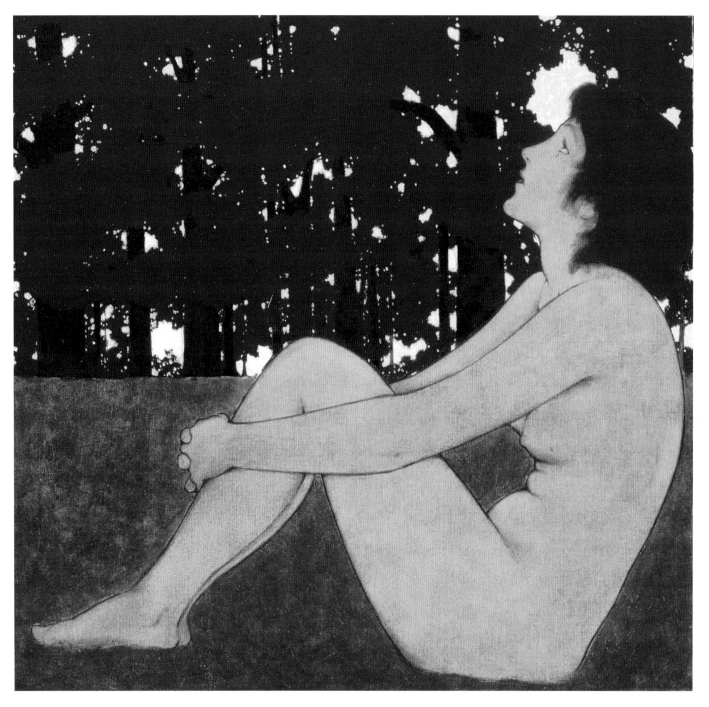

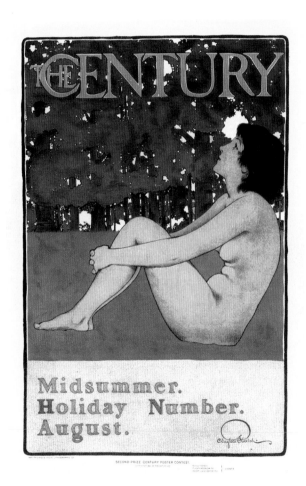

FAR LEFT
Century Midsummer Holiday Number,
August 1897, 14¹/₄ x 10in (36 x 25in).
Parrish made a design in April 1896 to be
entered in a competition to select a poster
for the Century midsummer holiday number
for August 1897. The rules of the contest
stated that the design should require no
more than three printings. This painting
took second place because it did not comply
with the requirements of the competition – it
required not three but five printings.
Among the panel of judges which reviewed
the several hundred entries and selected the
winning design were the artists Elihu
Vedder and F. Hopkinson Smith. The judge
could not award Parrish first prize – that
honour went to J.C. Leyendecker – but
Parrish was given second prize and his
poster, published by the Century Company
in 1897, went on to become one of the most
widely reproduced in America. Copyright,
1897.

LEFT
Shepherds with Sheep, 1998
Century, Christmas Eve 1898. Poem by
Edna Proctor Clarke.

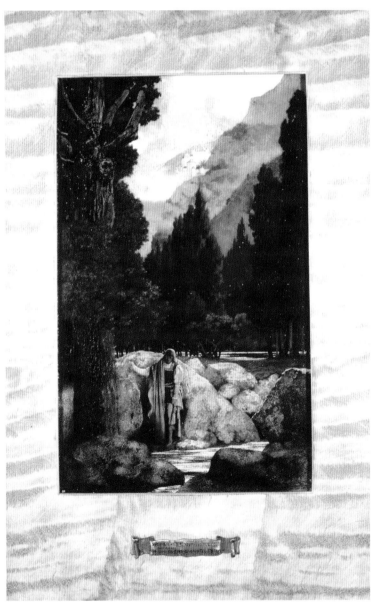

Autograph with Sherlock Holmes
character, 1898. Pen and ink and
watercolour on paper, 4¹/₁₆ x 7⁵/₆in
(10 x 20cm). St. Nicholas Magazine,
Molly's Sketch Book and Mine, December
1914.

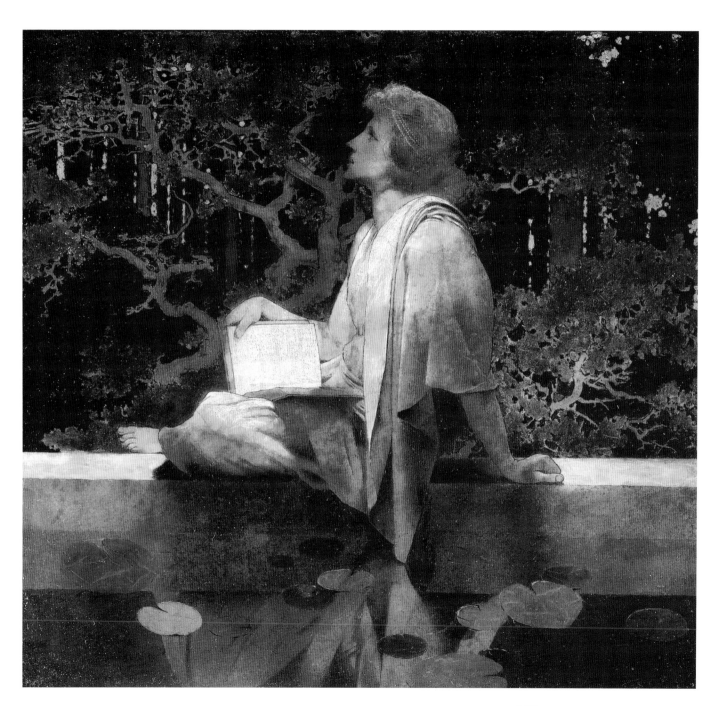

OPPOSITE RIGHT
Such Sights as Youthful Poets Dream on
Summer Eves by Haunted Streams, 1901
John Milton's L'Allegro, Century,
December 1901.

LEFT
Youth by a Reflecting Pool, 1899
Oil on paper attached to board,
10 x 11¹⁄₈in (25 x 28cm). Scribner's
Magazine cover, August 1899.

RIGHT

Formal Growth in the Desert, 1902

Oil on board, 17³/4 x 11⁷/8in (45 x 30cm). From The Great Southwest, *Part II, The* Desert, *by Ray Stannard Baker. Century, November 1902.*

FAR RIGHT

Hot Springs: Yavapai, 1902

Oil on illustration board, 15¹/2 x 10in (39 x 25cm). From The Great Southwest: *Irrigating a Canal in the Salt River Valley, by Ray Stannard Baker. Century, July 1902.*

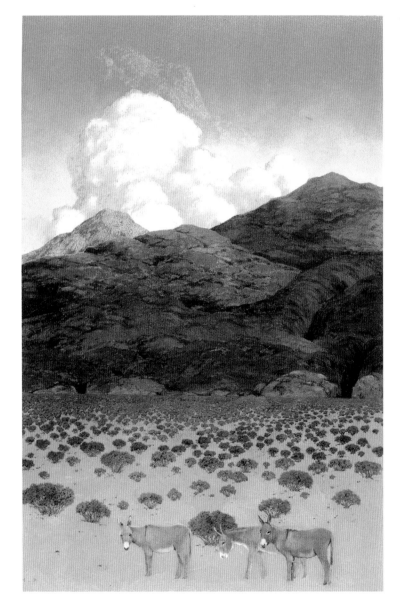

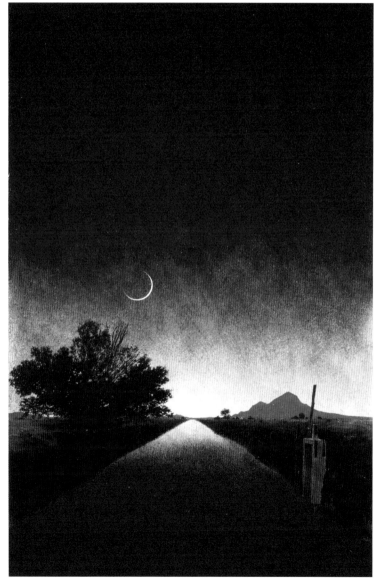

FAR LEFT
Wise Man, 1902
Oil on paper on panel, 17 x 10⁷⁄₈in
(43 x 28cm). Scribner's Magazine,
December 1902. Frontispiece for The
Desert , '... he drew out two flowers, one
withered, the other fresh ...'

LEFT
Bill Sachs: The Flying Dutchman, 1902
Oil on canvas on paper on board,
$17^{1}/_2 x 12in$ *(44 x 30cm). From* The Great
Southwest Series: *The Tragedy of the*
Range by Ray Stannard Baker, Century,
August 1902.

RIGHT
RIGHT
Aucassin Seeks for Nicolette, 1903
*Vintage print, 11¹/₂ x 17in
(29 x 43cm). Scribner's Magazine, July
1902.*

FAR RIGHT
**The Cardinal Archibishop Sat on His
Shaded Balcony, 1901**
*Oil on paper on board, 18 x 12in
(46 x 30cm).* The Turquoise Cup and the
Desert, *1903. Charles Scribner's Sons,
New York.*

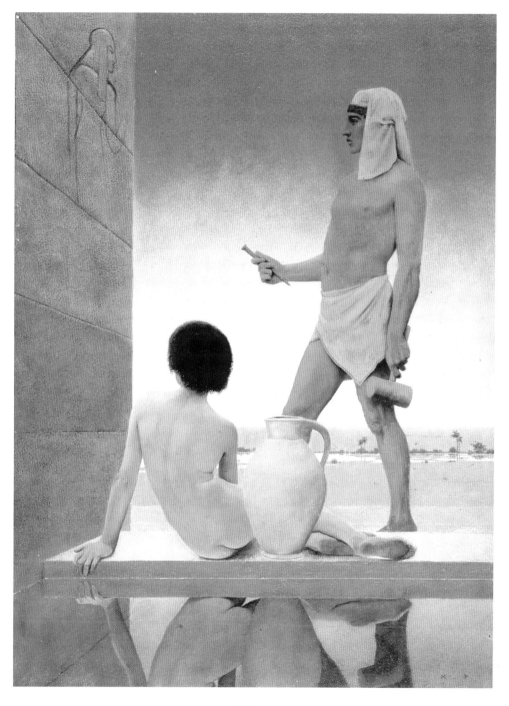

Egyptian (Sculptor), 1903
Oil on paper laid down on board,
15 x 11in (38 x 28cm). The Three Caskets.
St. Nicholas Magazine, December 1903.

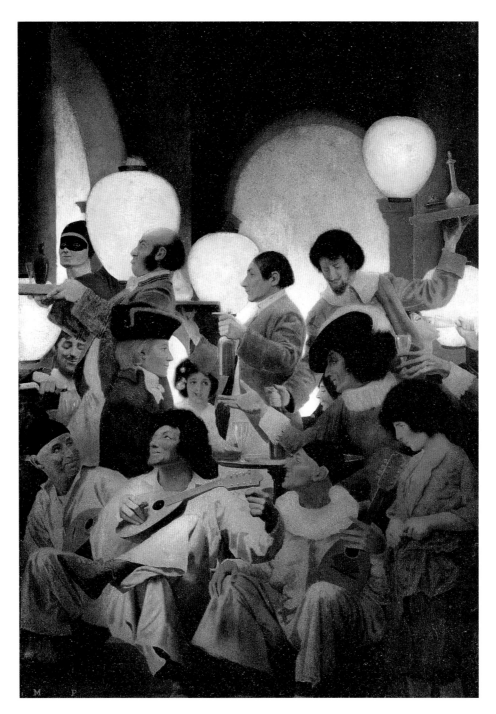

A Venetian Night's Entertainment, 1903
Oil on panel, 17^1/4 x 11^3/4in (44 x 30cm).
Scribner's Magazine, December 1903.

Saint Patrick, 1903
Oil on panel, $16^5/8$ x $14^3/4$in (42 x 37cm).
Cover of Life magazine, 3 March 1904.
Exhibited at the 1904 World's Fair.

RIGHT
A Grape Gatherer, 1904
Oil on panel, 24 x 20in (61 x 51cm).
Cover of Scribner's Magazine, October
1904.

FAR RIGHT
Father Time, 1904
Stippled pen and ink with gold leaf on
paper, 22³/₄ x 16in (58 x 41cm).
Collier's, The National Weekly Annual
Review number, 7 January 1907.

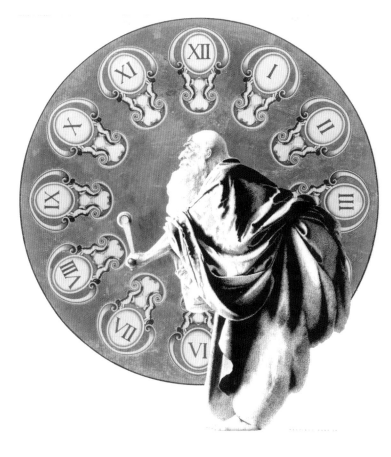

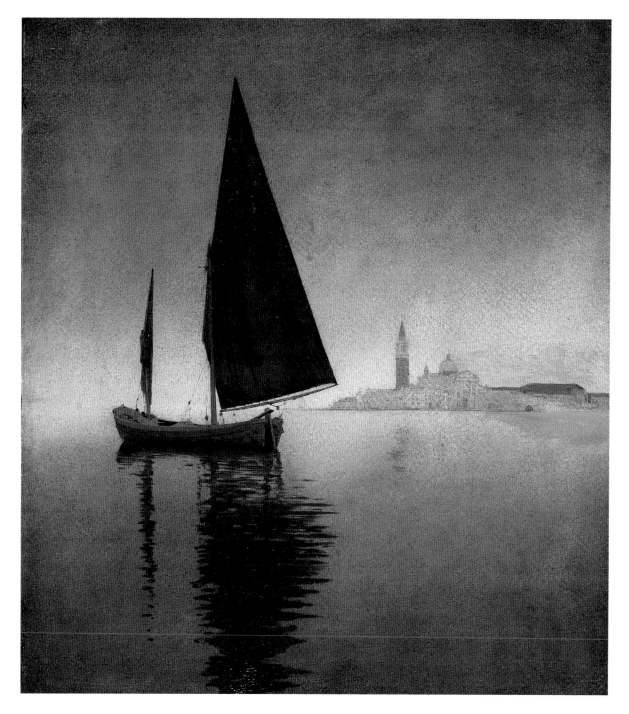

Venice – Twilight, 1904
Oil on paper, 16 x 14in (41 x 36cm).
Scribner's Magazine frontispiece, April
1906, illustrating Arthur Symons' The
Waters of Venice.

RIGHT
Three Wise Men, 1904
Collier's Christmas number.

FAR RIGHT
What the World is Doing, 1904
Ink on paper, $8^{1}/_{8}$ x $14^{3}/_{8}$in (21 x 36cm).
Collier's, 10 February 1906.

Collier's, The National Weekly, 4 March 1905.

Potpourri, 1905

Oil on stretched paper, 16 x 14in
(41 x 36cm). Potpourri *by H.G. Dwight,*
Scribner's Magazine, August 1905.

FAR LEFT
Collier's, 15 April 1905 Easter issue.

LEFT
Collier's 22 July 1905 Summer issue.

The Tramp's Dinner, 1905
Oil, 28 x 18in (71 x 46cm).
Illustration for Collier's, The National
Weekly.

FAR RIGHT
Collier's 18 November 1905 Thanksgiving
number.

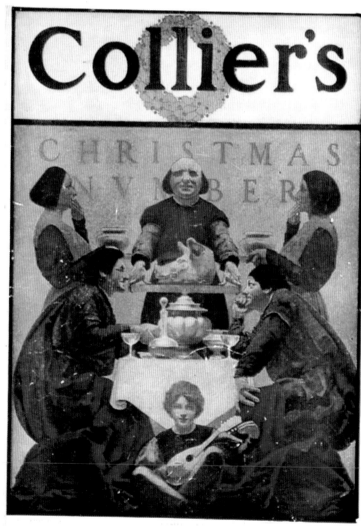

FAR LEFT
The Boar's Head, 1905
Oil on panel.

LEFT
Cover for Collier's, 16 December 1905.

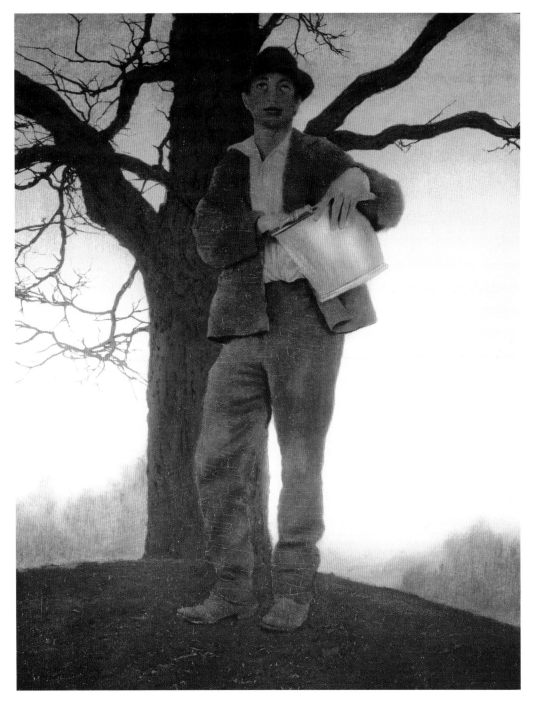

Dawn (Milking Time), 1906
Oil on panel, 18 x 14in (46 x 36cm).
Cover for Collier's, 19 May 1906.

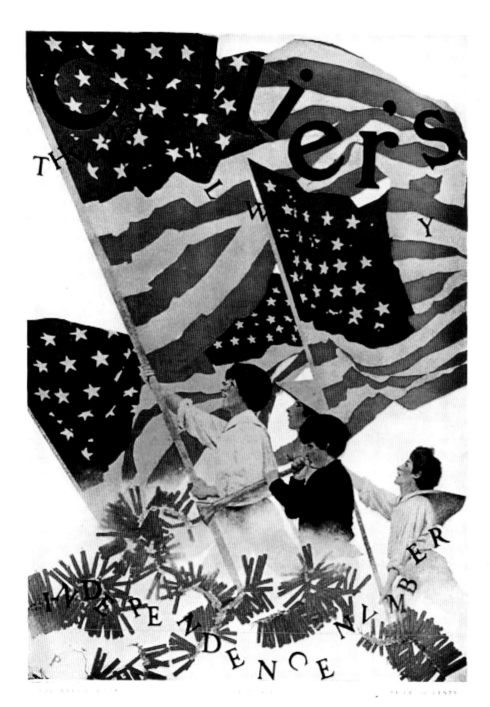

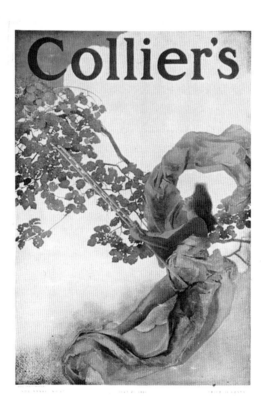

FAR LEFT
Cover for Collier's, 7 July 1906
Independence number.

LEFT
Cover for Collier's, 21 July 1906.

RIGHT
Collier's cover, 17 November 1906
Thanksgiving number.

FAR RIGHT
The Last Rose of Summer, c.1906
Drawing in black and white with colour
added by the publisher. Outing Magazine
cover, November 1906.

OPPOSITE LEFT
Collier's cover for the May Fiction
Number, 24 April 1909.

OPPOSITE RIGHT
Winter, 1906
Oil on paper mounted on board,
16 x 15$\frac{1}{4}$in (41 x 39cm).
Collier's cover, 1909.

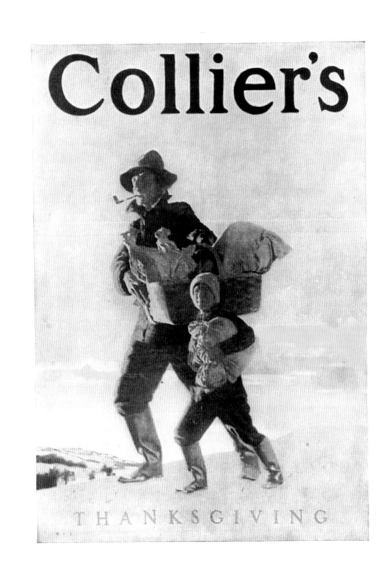

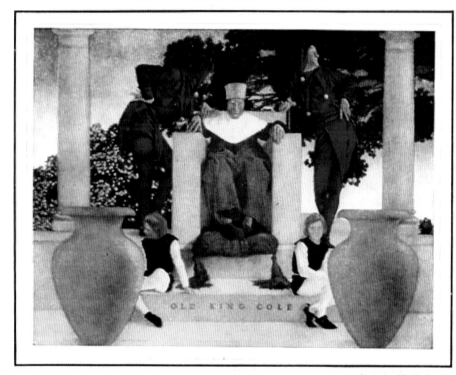

MAY FICTION NUMBER
Collier's
THE NATIONAL WEEKLY

Containing Three Stories:

"BUCKO"
BY PERCEVAL GIBBON

THE TROUBLE HUNTER
BY FREDERICK UPHAM ADAMS

FILIBERTO
BY SARAH COMSTOCK

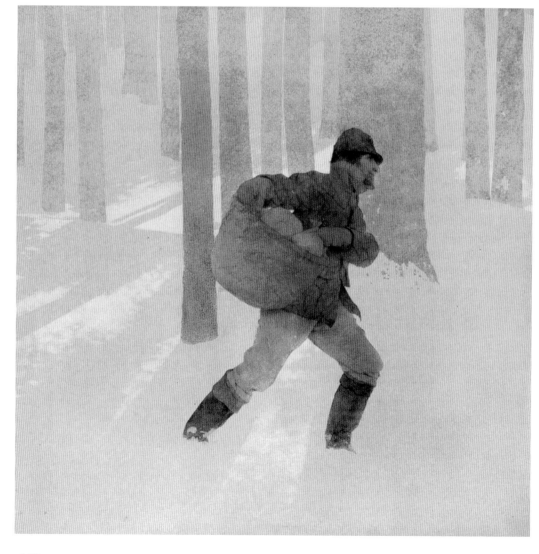

Cadmus Sowing the Dragon's Teeth,
1908

Oil on canvas on board, 40 x 33in
(102 x 84cm). A Wonder Book and
Tanglewood Tales *by Nathaniel*
Hawthorne, Duffield and Company, 1910.
First appeared in Collier's 31 October
1908 edition.

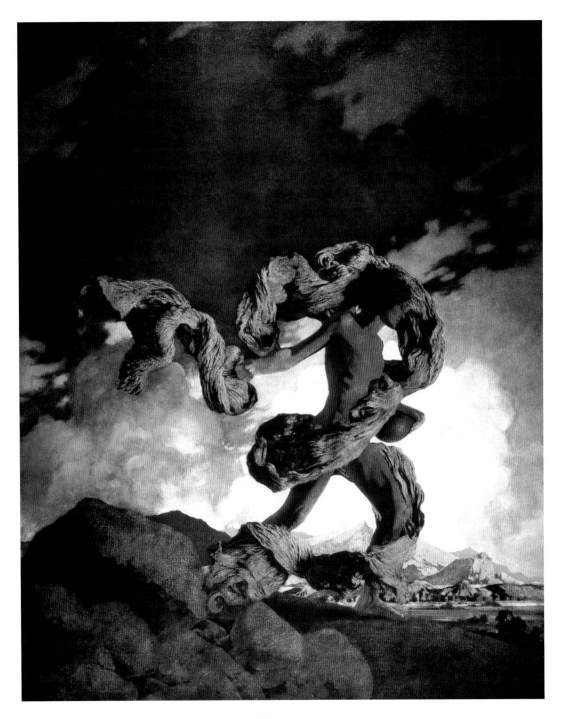

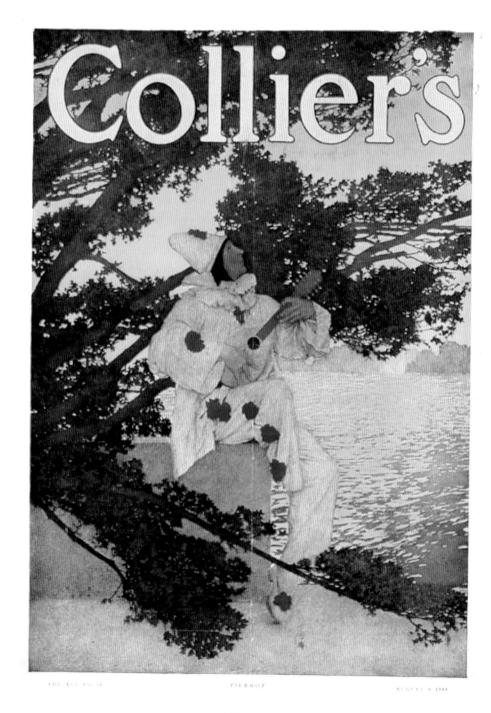

Collier's cover, 8 August 1908.

Atlas Landscape, 1907–1910
Oil on panel, 21 x 29¹/4in (53 x 74cm).
Collier's cover, 16 May 1908. Originally
painted as Atlas Holding Up the Sky
(figure in background painted out and tree
painted in by artist), from A Wonder Book
and Tanglewood Tales *by Nathaniel*
Hawthorne. Duffield and Company, New
York.

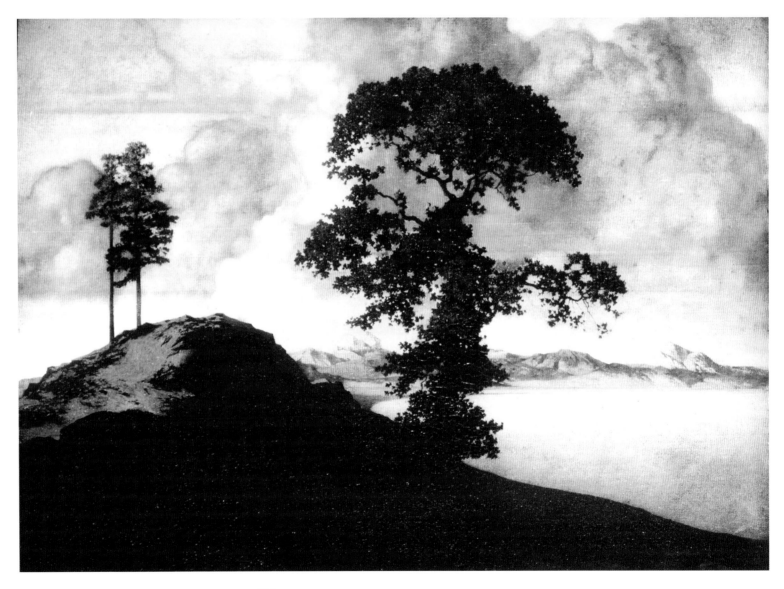

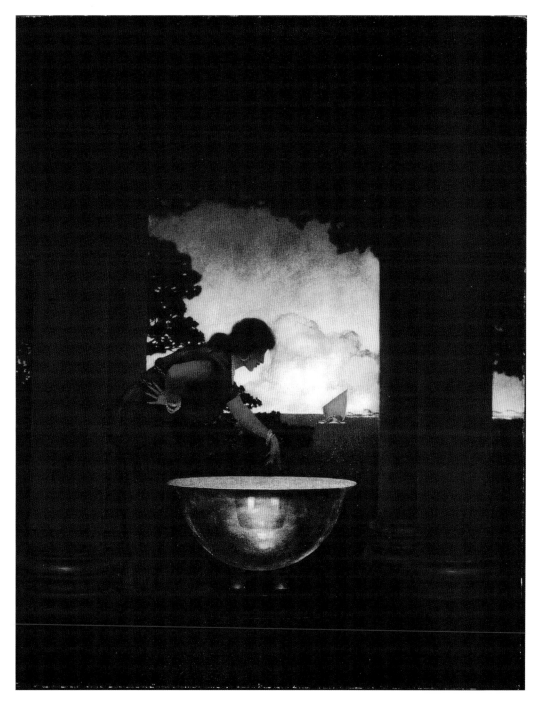

Circe's Palace, 1907
Oil on canvas, 40 x 32in (102 x 81cm).
First of a Greek mythology series for
Collier's, 25 January 1908, and a
frontispiece for A Wonder Book and
Tanglewood Tales *by Nathaniel*
Hawthorne, Duffield and Company, 1910.

'But, delightfully as the wine looked, it
was mingled with the most potent
enchantments that Circe knew how to
concoct. For every drop of the pure grape
juice there were two drops of the pure
mischief; and the danger of the thing was,
that the mischief made it taste all the
better. The mere smell of bubbles, which
effervesced at the brim, was enough to
turn a man's beard into pig's bristles ...'

RIGHT
Collier's cover, 2 January 1909.

FAR RIGHT
Collier's cover, 20 March 1909.

OPPOSITE LEFT
Mask and Pierrot, 1908
Oil on paper laid down on panel,
22 x 16in (56 x 41in). Collier's magazine
Cover for Dramatic Number, 20 March
1909.

OPPOSITE RIGHT
Study for a Collier's cover, 1908.
Oil with graphite on board, 22 x 16in
(56 x 41cm).

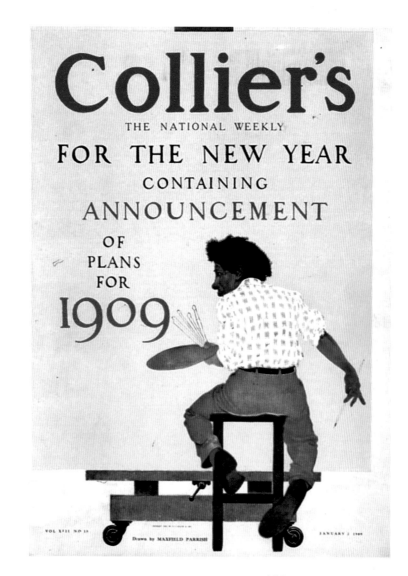

The Fourth of July, 1909
Illustration for Collier's magazine.

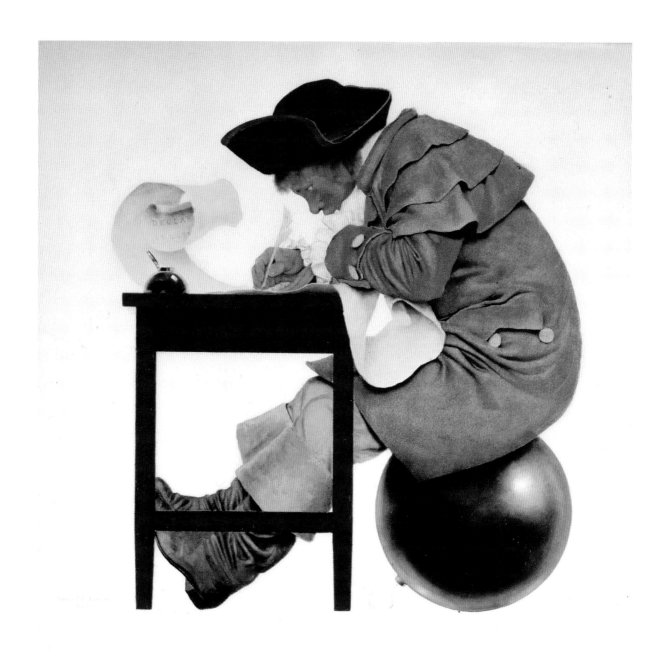

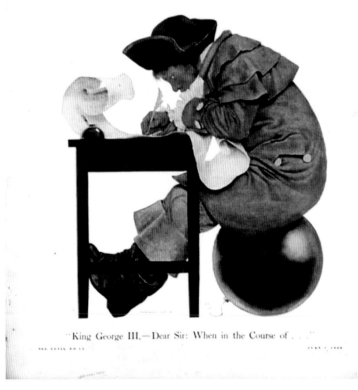

"King George III.—Dear Sir: When in the Course of"

THE TOVRIST

OPPOSITE LEFT
Collier's cover, 3 July 1909. Fourth of July Number.

LEFT
Collier's cover, 10 July 1909. Vintage print.

RIGHT
The Botanist, 1908
Ink and oil on paper mounted on wood panel, 15¾ x 10in (40 x 25cm). Illustration for a Collier's cover, 18 July 1908.

FAR RIGHT
Collier's cover, 18 July 1908.

OPPOSITE LEFT
Dillwyn Parrish posing for School Days (Alphabet) illustration. Maxfield Parrish is on the left of the picture as he snaps his son holding a book (Simplicissimus). The Oaks, Plainfield, New Hampshire, 1908. Courtesy Special Collections, Baker Library, Dartmouth College.

OPPOSITE RIGHT
School Days (Alphabet), 1908
Oil on paper mounted on board, 22 x 16in (56 x 41cm). Illustration for a Collier's cover, 12 September 1908.

RIGHT
Collier's cover, 12 September 1908.

RIGHT
Collier's cover, 12 September 1908.

FAR RIGHT
The Book-Lover (The Idiot), 1910
*Oil over graphite on paper, 22 x 16in
(56 x 41cm). Collier's, 24 September 1910.*

OPPOSITE LEFT
Susan Lewin posing for The Idiot,
*(Parrish in foreground on the right). The
Oaks, Plainfield, New Hampshire,
July 1910. Photograph taken by Maxfield
Parrish.*

OPPOSITE RIGHT
Chef with Lobsters, 1908
*Oil on paper, 22 x 16in (56 x 41cm).
Collier's cover, 26 November 1910.*

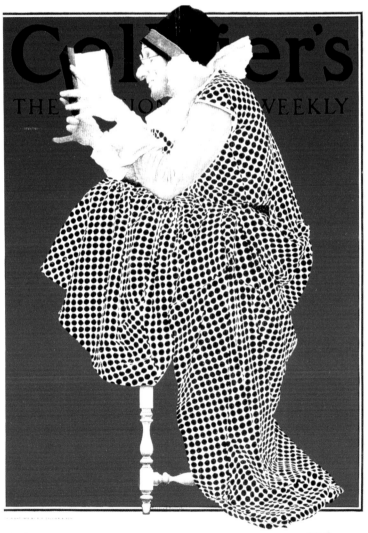

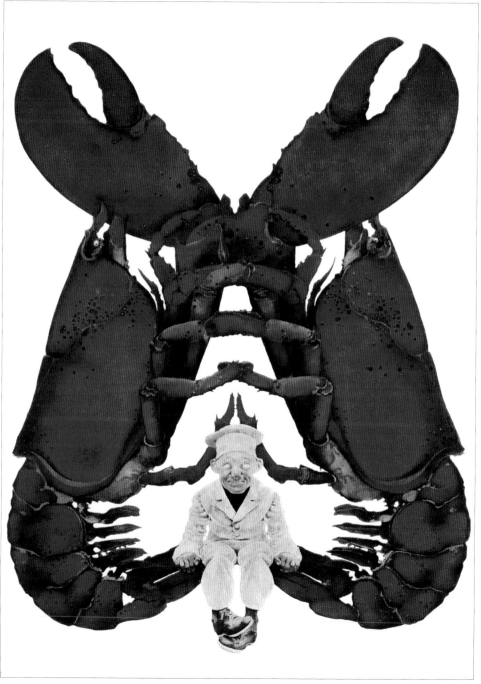

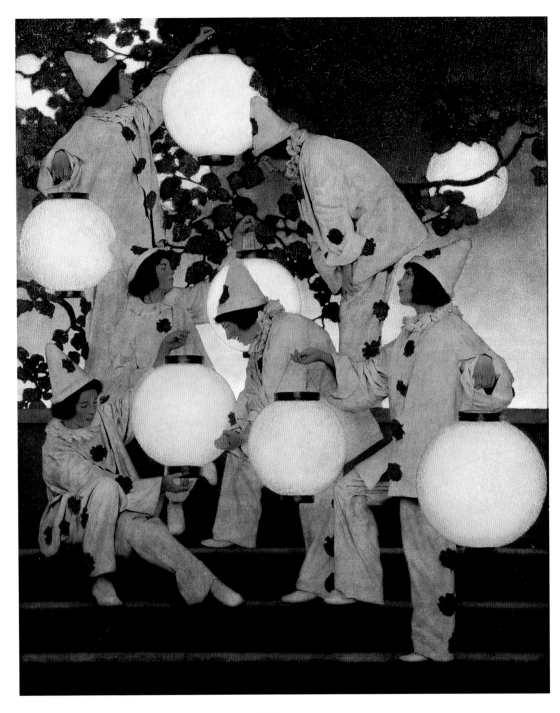

The Lantern-Bearers, 1908
Oil on canvas, 40 x 30in (102 x 76cm).
Collier's magazine, 10 December 1910.

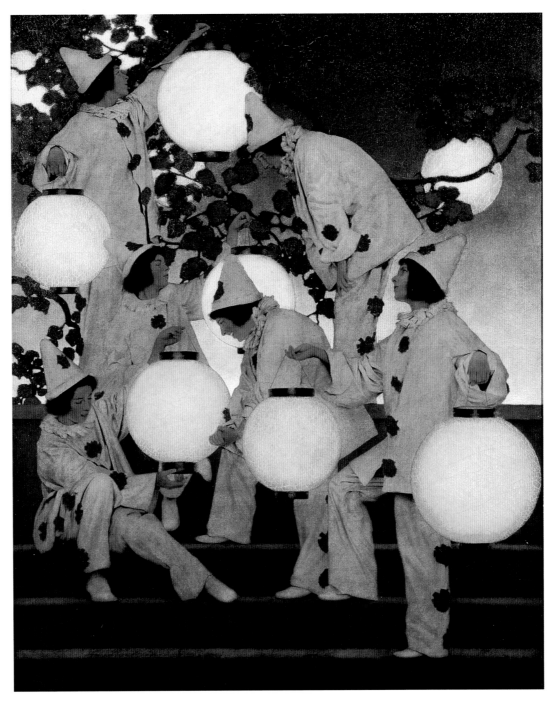

The Lantern-Bearers, 1908
Oil on canvas, 40 x 30in (102 x 76cm).
Collier's magazine, 10 December 1910.

Susan Lewin posing for the Lantern-Bearers. *The Oaks, Plainfield, New Hampshire, 1910.*

Jack and the Giant, 1908
Oil on paper, 22 x 16in (56 x 41cm).
Collier's cover, 30 July 1910.

Maxfield Parrish posing as Jack for Jack and the Giant.

RIGHT
April, 1908
Oil on stretched paper. Proposed cover for the Easter edition of Collier's, 8 April 1911.

FAR RIGHT
Collier's cover, 2 November 1912.

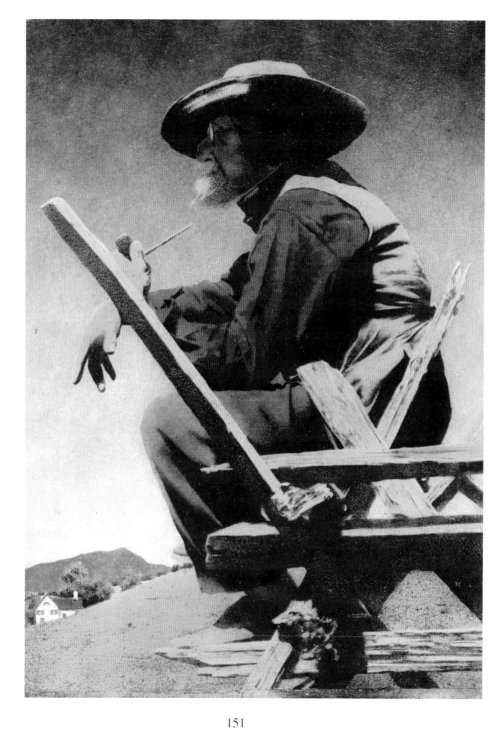

Farmer (Philosopher), 1909
Oil on paper mounted on canvas,
16³/4 x 12¹/2in (42 x 32cm). Cover for
Collier's 2 November 1912 edition.

The Prospector, 1909
Oil on paper, 15¹/₂ x 14¹/₂in (39 x 37cm).
Collier's cover, 4 February 1911.

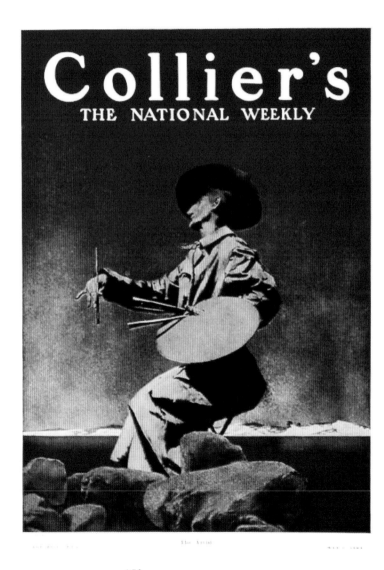

FAR LEFT
Collier's cover, 17 April 1909.

LEFT
Collier's cover, 1 May 1909.

RIGHT

Jack the Giant-Killer, 1909

Oil on panel, 30 x 24in (76 x 61cm).
Hearst's magazine, June 1912.

FAR RIGHT

Comic Scottish Soldier, 1909

Oil on brown paper, 22 x 16in (56 x 41in).
Collier's cover, 11 March 1911.

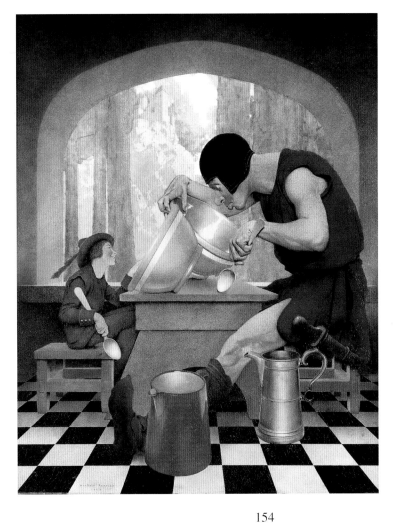

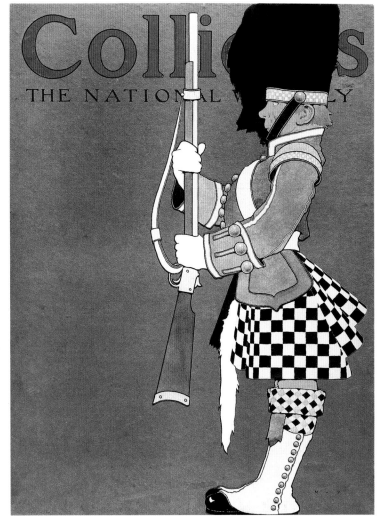

FAR LEFT
Collier's cover (Old King Cole). Fiction issue for June 1909.

LEFT
Collier's cover for July 1909, fiction issue.

April Showers, 1909
Oil on paper, 22 x 16in (56 x 41cm).
Illustration for Collier's cover, 3 April
1909.

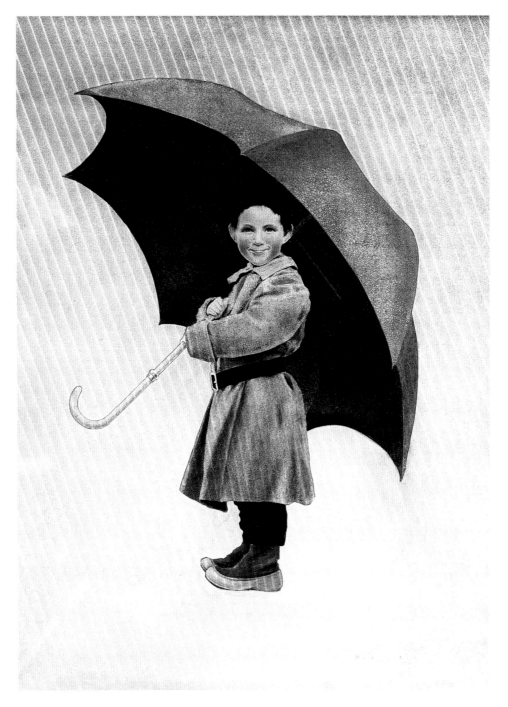

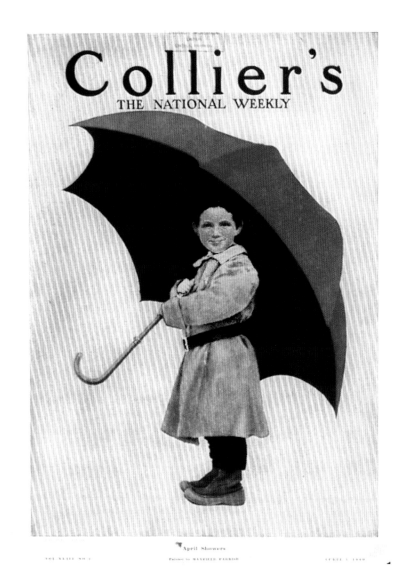

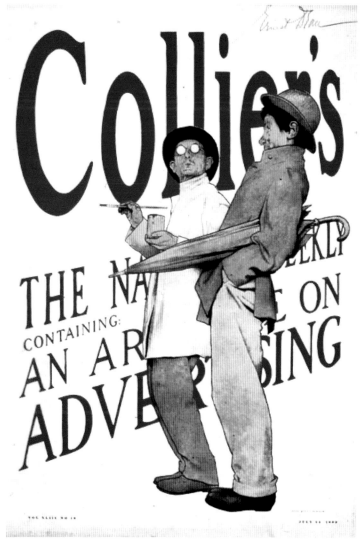

FAR LEFT
Collier's cover, 3 April 1909.

LEFT
Collier's cover, 24 July 1909.

RIGHT
Collier's cover, 8 January 1910.

FAR RIGHT
Collier's cover, 3 September 1910.

OPPOSITE LEFT
Collier's cover, 30 September 1911.

OPPOSITE RIGHT
Collier's cover, 10 May 1913.

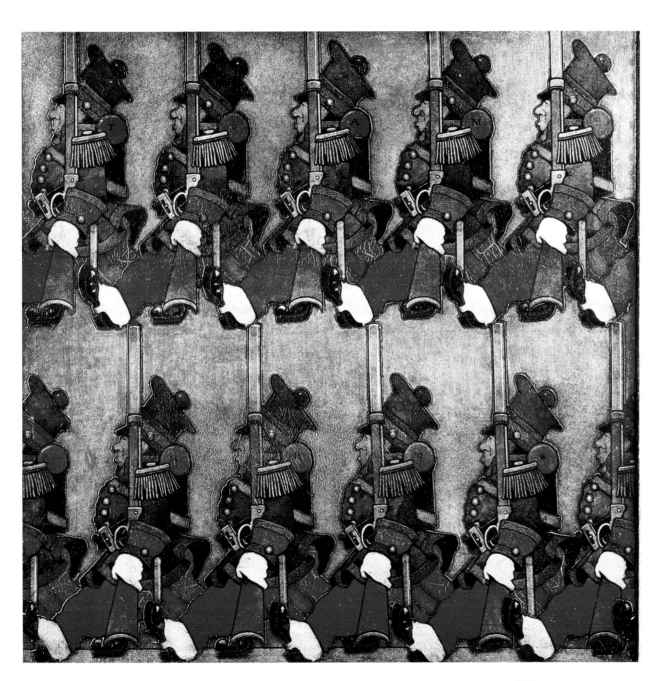

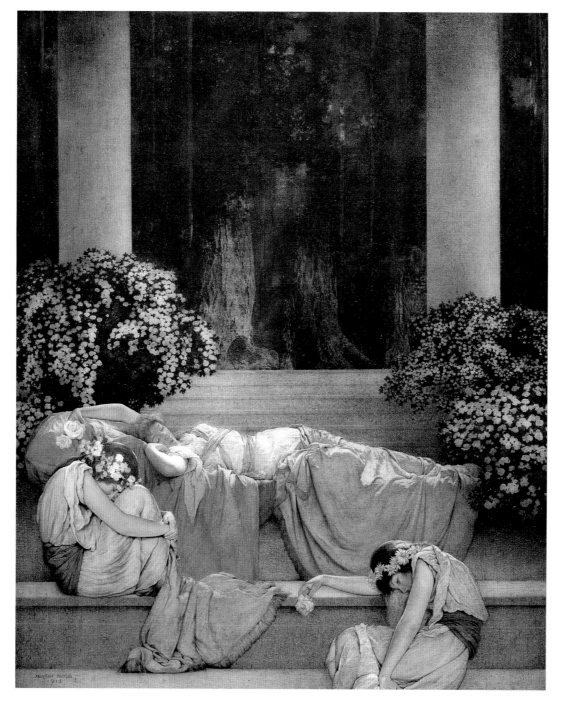

OPPOSITE LEFT
Parading Soldiers, 1912
Oil and collage, 16 x 16in (41 x 41cm).
Illustration for Collier's cover,
16 November 1912.

OPPOSITE RIGHT
Collier's cover, 16 November 1912.

LEFT
The Sleeping Beauty, 1912
Oil on canvas, 29¹/₂ x 24in (75 x 61cm).
Hearst's magazine cover, November 1912.

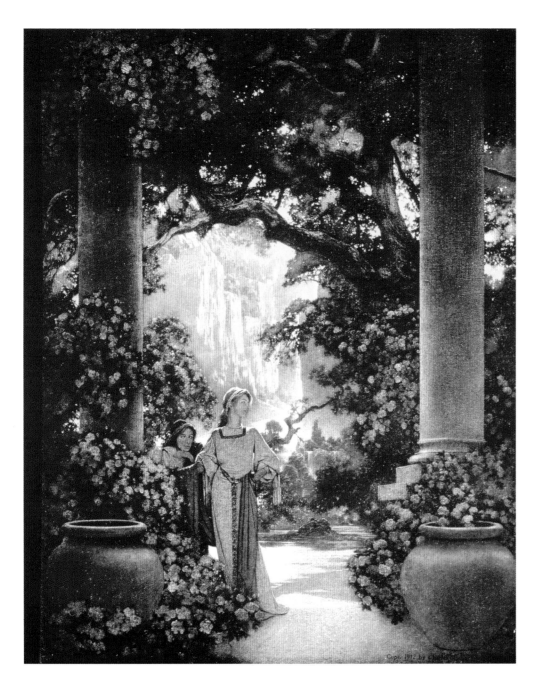

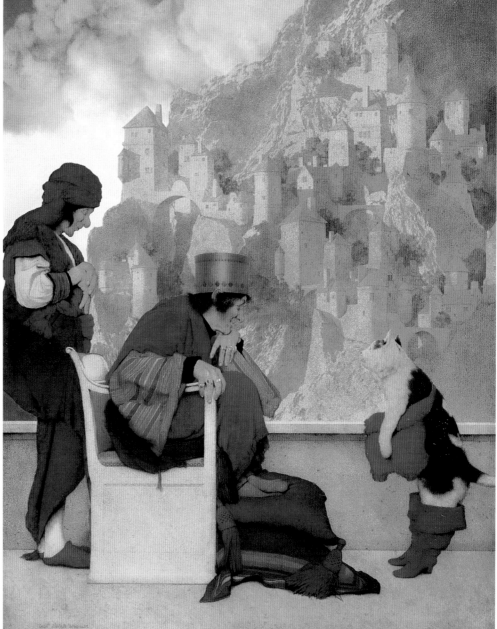

OPPOSITE LEFT
Land of Make-Believe, 1912
Vintage print. Frontispiece for Make-Believe *by Rosamund Marriott Watson, Scribner's Magazine, August 1912.*

OPPOSITE RIGHT
Puss-in-Boots, 1914
Oil on panel, 30 x 24in (76 x 61cm). Hearst's May 1914 cover.

LEFT
A Man of Letters (Sign Painter with Mud Ball), 1921
Oil on panel, 15¹/₄ x 12¹/₄in (39 x 31cm). Life magazine cover, 5 January 1922.

Reveries, 1913
Oil on canvas, 38³/4 x 45³/4in
(98 x 116cm). Proposed cover design
for Hearst's magazine, May 1913.

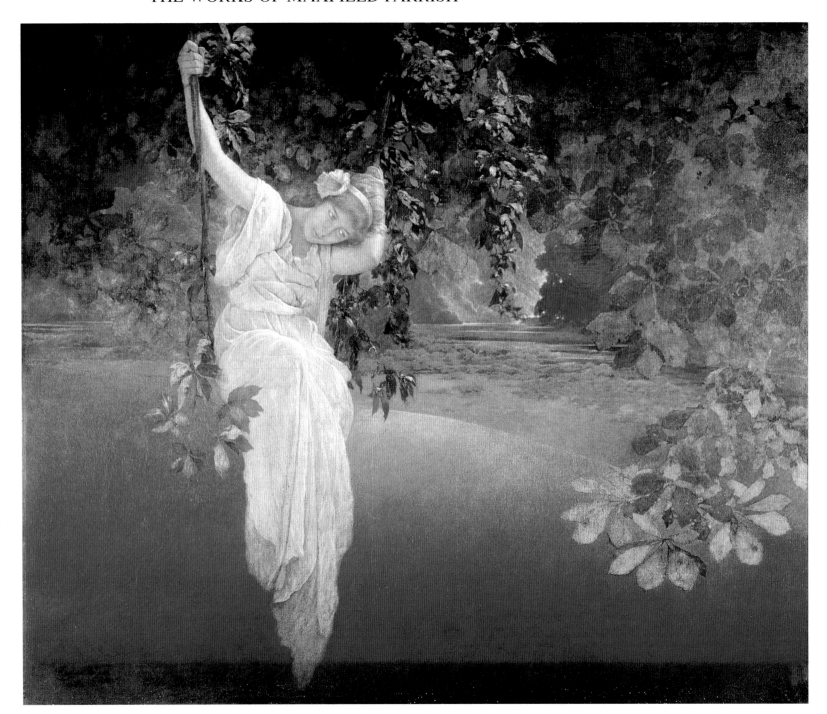

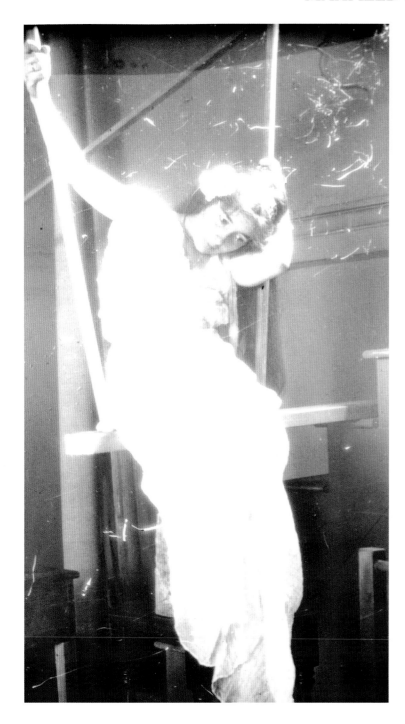

FAR LEFT
Susan Lewin posing for Reveries.
The Oaks, Plainfield, New Hampshire,
1913.

LEFT
Hearst's cover for May 1913 (not
published).

RIGHT
A Swiss Admiral, 1921
Oil on panel, 15¹/₄ x 12in (39 x 30cm).

FAR RIGHT
Collier's cover, 5 January 1929.

Plum Pudding, c.1921
Oil on board, 19³/4 x 16¹/4in (50 x 41cm).

RIGHT
A Dark Futurist, 1923
Oil on panel, 14 x 12in (36 x 30cm)
Life magazine cover, 1 March 1923.

FAR RIGHT
A Good Mixer, 1924
Oil on panel, 14 x 10in (36 x 25cm).
Life magazine cover, 31 January 1924.

OPPOSITE LEFT
Morning, 1922
Oil on panel, 19⅝ x 15in (50 x 38cm).
Life magazine Easter cover, 6 April 1922.

OPPOSITE RIGHT
Air Castles
Vintage art print, 15 x 12in (38 x 30cm).
Original painting 1904.

THE ILLUSTRATIONS: BOOKS (1897–1925)

... if a picture does not tell its own story, it's better to have the story without the picture.

Of all the illustrations that Maxfield Parrish produced during his long career, his book illustrations have the most lasting appeal, the most significant being the images he created specifically for children. More impressionable than adults, children are particularly responsive to pictures, which stimulate a child's imagination even before it can read. Consequently, admirers of Parrish illustrations tend to be of long standing, because many of them discovered his work as children and never forgot them. Moreover, frequent reprints of Parrish's images have enabled them to pass this love onto their own children.

Unlike the cursory glance given to an art print or a calendar, pictures in books tend to be studied more closely, for the reader is hoping to find elements of the story reflected in them. Although most of the books Parrish illustrated could be termed children's books, they were the preserve of art lovers and collectors from the day they were published, considered to possess deeper meanings within their contexts than is immediately apparent.

The first book illustrated by Maxfield Parrish was L. Frank Baum's *Mother Goose in Prose*, published in 1897. It contains 15 black-and-white illustrations, each one more difficult to place historically than the next. The nebulous, indeterminate settings were deliberate on Parrish's part, yet each one is wondrous to behold, full of fantastical beings and goblin-like creatures. Such early Parrish illustrations were usually in monotone but are as imaginative as the later tapestries of rich colour for which he is known best. These more dour black-and-white illustrations were painted using stipple brushes to produce micro-dot effects, allowing him to graduate every shadow. He was able to capture every ripple of a garment, even the subtle texture of the wool on a lamb's neck. Parrish was something of a magician with pencils, crayons, lithographic crayons and watercolour washes, and was able to achieve other three-dimensional effects. *International Studio* magazine remarked that his 'novel combinations of

line and tone were well mastered'. Other contemporary reviews equated Parrish with Howard Pyle in terms of imagination, and regarded him as having 'shared a linear, decorative quality with the Philadelphia illustrators who had studied with Pyle'. The truth was that Parrish's technical and photographic vision was unique; there were echoes of the Pre-Raphaelites in his work, but it was essentially new. In another issue, *International Studio* described Parrish as 'deserving of all the popularity the public has accorded him ...not like the slipshod imitations of Abbey and Gibson ...for his drawings are carefully wrought out designs, balanced in every part'. *Mother Goose* was immediately successful and was subsequently reprinted in editions of varing sizes.

Parrish felt that the cover of a book was of primary importance and should be designed to serve two purposes, first, as a bold, graphic statement to attract immediate attention on a shelf or in a display, and second, that it could also be used to advertise the book, perhaps as a poster or as an advertisement on a magazine page, and this is what invariably happened. The publishers simply had to increase Parrish's fees if they decided to use the cover image a second or third time, for when they sought to do this they were reminded by Parrish of the original aggreement, which was for one-time use only.

Advertisements are regarded as disposable, irrespective of their ingenuity or beauty – they are here today, gone tomorrow and not usually preserved. Posters are applied to walls with tacks and glue and are removed and discarded to make way for the next. Books, however, endure: indeed, most people would hate to destroy one. Consequently, Parrish is best known as a book illustrator, books having an immortality of sorts.

Maxfield Parrish was given the task of illustrating Washington Irving's historic parody, *Knickerbocker's History of New York* (1900). These early illustrations are in ink and lithographic pencil on textured paper and are characterized by fine contour lines, again achieved with Parrish's stippled ink technique. They are almost Pointillist in style and have a rich granular texture throughout. Masses and forms and their respective shadows are architectonic

and, as such, are appealing as graphic design or as intricate constructions and marvellous examples of Parrish's incredible skill. The figures admirably reflect the satirical content in Washington Irving's text.

In Kenneth Grahame's book, *The Golden Age* and its sequel *Dream Days*, Parrish departed from the earlier linear and pure geometrical compositions seen in *Mother Goose*, and made the transition towards the photographic illusionism of his later works. Parrish's illustrations for *The Golden Age* were published in New York and London in 1899 by John Lane: The Bodley Head, and were enthusiastically received. In 1902, John Lane commissioned Parrish to illustrate Grahame's sequel, *Dream Days*, which utilized a new photogravure process which produced a much higher-quality product, flattering Parrish's images and emphasizing the quality of his technique. So popular were these volumes that Lane subsequently re-published *The Golden Age* in 1904, using the same new printing process. For the first time, Maxfield Parrish's illustrations were exposed to the critical eye of the Europeans, as well as the ever-expanding American reading public. Professor Hubert von Herkomer, the German artist and art critic, reviewed Parrish's illustrations in *International Studio* magazine on 15 June 1906, where he remarked: 'Mr. Parrish has absorbed, yet purified, every modern oddity, and added to it his own strong original identity. He has combined the "photographic" vision with the "Pre-Raphaelite" feeling ... He can be modern, medieval, or classic. He has been able to infuse into the most uncompromising realism the decorative element ... an extraordinary feat in itself.'

The Golden Age was well-received, both in the U.S.A. and abroad; in fact, Kaiser William II of Germany ordered 12 copies for his own personal use after reading Professor von Herkomer's review. Coy Ludwig thought that 'rarely ... have an author and an artist been in more complete accord in their treatment of a subject than were Maxfield Parrish and Kenneth Grahame'. In fact, one can say the same about every work illustrated by Parrish.

Poems of Childhood, by Eugene Field (1904), and *Italian Villas and Their Gardens*, by Edith Wharton (1904), were the first of Parrish's books to be published in colour, partially as a result of Parrish's travels in Italy, where he made full use of his camera and sketchbook. Both Wharton and Parrish were already interested in garden design and architecture, interests that would be reflected in their own properties, and had been deeply involved in research for *Italian Villas*. The two travelled separately to Italy before meeting to discuss the project at The Mount, Wharton's home in Lenox, Massachusetts. Wharton returned from Italy full of ideas which her niece, landscape architect Beatrice Farrand, could use at Lenox and Parrish resolved to introduce some Italian features into his evolving gardens at The Oaks. The publication of Edith Wharton's *Italian Villas and Their Gardens*, with Parrish's illustrations, was the first wholly collaborative effort between Parrish and an author. It was Wharton's second book and her last work of non-fiction, but sales were largely disappointing. Wharton was far from pleased with Parrish's illustrations, feeling that they were too dramatic and fantastical and stole the limelight from her text. Others, however, thought that her text needed some life pumped into it.

The pictures and text were first published in serial form in *Century* before they were combined and issued in book form in 1904. When he first received the commission, Parrish enlisted the help of his father's friend and Cornish neighbour, Charles A. Platt, who was an authority on the subject, while Wharton turned to her lesbian friend, Violet Paget, also known as Vernon Lee (1856–1935), for guidance as to the villas which should be included. Paget was an expatriot resident of Italy and a writer, and was considered by Wharton to be an expert on Italian culture. Parrish was disappointed with Wharton's final selection of villas and her less than sparkling text. He decided to photograph each villa, for his plan was to paint them when he returned to Cornish. Though not an overall success at the time, present-day collectors eagerly search for copies of the book to cannibalize as colour prints, which they then frame and sell.

The Arabian Nights, edited by Kate D. Wiggin and Nora A. Smith (1909), was the result

of a portfolio of illustrations which were previously published in and then compiled from *Collier's* magazine by *Scribner's* for turning into book form. These illustrations were later released as art prints. *A Wonder Book and Tanglewood Tales* (1910), by Nathaniel Hawthorne, and *A Golden Treasury of Songs and Lyrics* (1911), by Francis Turner Palgrave, were subsequent best-sellers, outstripping many others at the time. However, *A Golden Treasury* had been irksome to Parrish, since Duffield and Company, the publisher, reprinted various covers from *Collier's* magazine and issued the book without Parrish's input or permission and totally without remuneration. From then onwards, Parrish was more careful where reproduction rights and control over his work were concerned. The incident taught him yet another lesson: whenever a commission was offered, he would draw up a strong but simple contract, the key phrase standing out clear and strong – for one-time use only. However, he could not prevent his images from being 'stolen' through plagiarism and imitation unless he copyrighted the images.

The last book Parrish illustrated, *The Knave of Hearts* (1924), was his masterpiece. When Parrish discovered this children's play, he proposed an illustrated edition to *Scribner's*, to which the publisher enthusiastically agreed. Parrish considered it 'a bully opportunity for a good time making the pictures'. It was written by Louise Saunders, who was the wife of Maxwell Evarts Perkins of *Scribner's*, an important editor in the 20th century and discoverer of the authors Thomas Wolfe, Ernest Hemingway, F. Scott Fitzgerald and others. The couple were summer residents at Cornish and close friends of the Parrishes.

The Knave of Hearts included 26 illustrations executed over a period of three years beginning in 1921. It was first published by *Scribner's and Sons* in a perfectly-bound, elegant, slip-cased edition, and originally sold for ten dollars (rather pricey for its day). The first printing, a magnificent undertaking, was not a commercial success, however, due perhaps to its large size (14 x 11$\frac{1}{2}$in/35.5 x 29.2cm) or possibly its high price. A second edition was released with a spiral binding, but this also was too highly-priced for the

marketplace. Later, the House of Art released puzzles, art prints and greeting cards based on the *Knave* book illustrations, as well as another lower-priced edition of the original book. The royalties were low, but ultimately Parrish earned over $65,000 from the sale of just a few of the original paintings. Art dealer Martin Birnbaum at the Scott and Fowles Gallery in New York City, exhibited the original paintings in 1925 and sold them all, bringing a measure of financial solace to the artist. Today, copies of the book in good condition can command as much as $15–20,000.

Although Parrish remains best known as a book illustrator, many of his book illustrations were first produced for magazines. His discovery that it was necessary to control the rights to his images enabled him to reuse many of them in other applications, in short stories, magazine articles, and later as art prints throughout his career. This is a lesson that most illustrators have yet to learn.

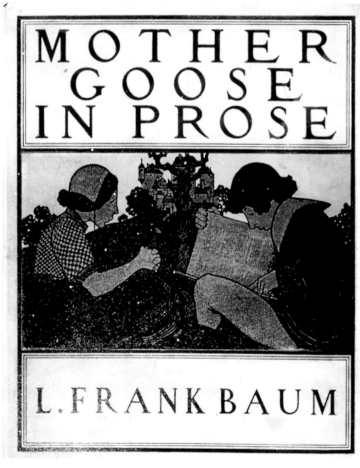

FAR LEFT
Indian Drinking Rum, 1889
*Pen and ink and splatter on paper,
12¹/₂ x 9¹/₂in (32 x 24cm). Illustration for
Washington Irving's* Knickerbocker's
History of New York, *1899.*

*'They introduced among them, rum, gin
and brandy and the other comforts of life'*

LEFT
Mother Goose in Prose, 1897
*Cover for L. Frank Baum's book, Way and
Williams, 1897.*

RIGHT
Mother Goose in Prose (Wond'rous Wise Man), 1887
Pen and ink, 11 x 9½in (28 x 24cm).
L. Frank Baum. Way and Williams,
Chicago, 1897.

FAR RIGHT
Mother Goose in Prose (Baa Baa Black Sheep), 1897
Lithographic crayon and India ink on white paper, 12¾ x 10⅜in (32 x 26cm).
L. Frank Baum. Way and Williams, 1897.

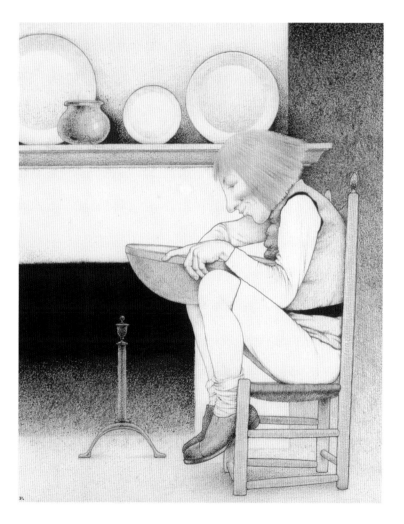

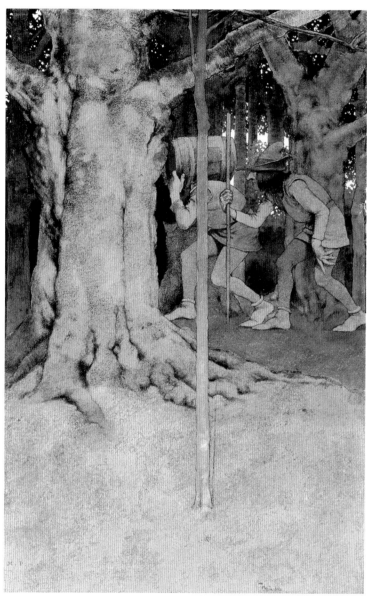

FAR LEFT
Mother Goose in Prose (Little Jack Horner), 1897
Pen and ink on paper, 12^1/$_2$ x 10^1/$_2$in (32 x 27cm). L. Frank Baum. Way and Williams, 1897.

LEFT
The Golden Age (The Olympians), 1899
Watercolour, oil and black ink on paper, 11 x 7in (28 x 18cm). Kenneth Grahame. John Lane: The Bodley Head, 1899, London and New York.

'For them the orchard (a place elf-haunted, wonderful) ...'

RIGHT
The Golden Age (Young Adam Cupid), 1899
Ink and wash on paper, 11 x 7in
(28 x 18cm). Kenneth Grahame.

'Who would have thought ... that only two short days ago we had confronted each other on either side of a hedge?'

FAR RIGHT
The Golden Age (Sawdust and Sin), 1899
Oil on brown paper, 15¹/₄ x 10¹/₄in
(39 x 26cm). Kenneth Grahame. John Lane: The Bodley Head, 1899.

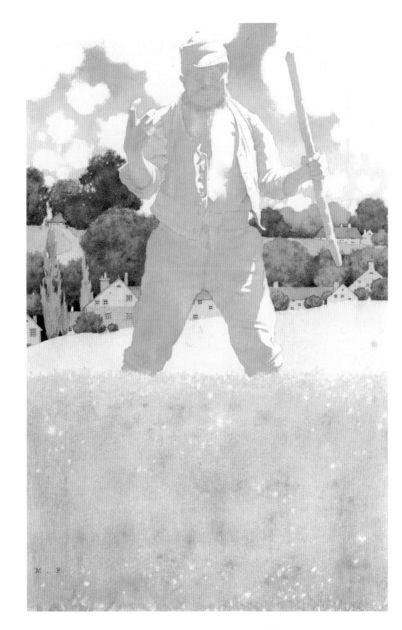

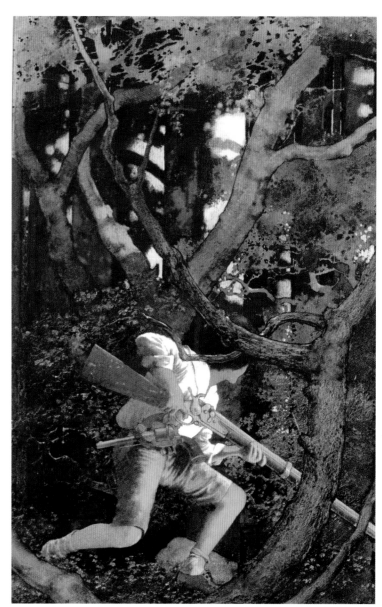

FAR LEFT
The Golden Age (The Blue Room), 1899
Pencil and gouache on paper, 13 x 9in (33 x 23cm). Kenneth Grahame. John Lane: The Bodley Head, 1899.

'The procession passing solemnly across the moon-lit Blue Room...'

LEFT
Dream Days, 1898
Book cover. John Lane: The Bodley Head, 1898.

Dream Days (Mutabile Semper, Chocolate), 1900–01
Oil on board, 18 1/2 x 14in (47 x 36cm). Kenneth Grahame. John Lane: The Bodley Head, 1902.

Dream Days (Mutabile Semper,
Chocolate), 1900–01
Pen and ink on board, 8¹/₂ x 12¹/₄in
(22 x 31cm). Tailpiece.

Dream Days (Dies Irae), 1900
Oil on board, 12 x 8¹/₂in (30 x 22cm).

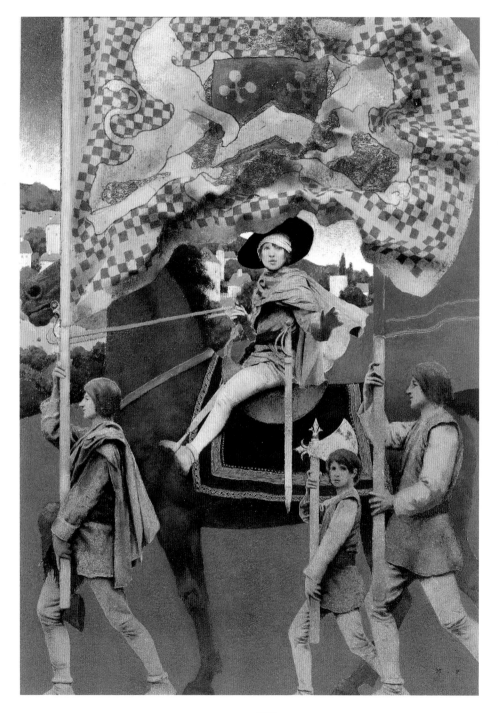

Dream Days (Dies Irae), 1900
Pen and ink on board, 10 x 13³⁄₄in
(25 x 35cm). Tailpiece.

RIGHT
Dream Days (The Walls Were As Of Jasper), 1900
Oil on board, 15 x 11$\frac{1}{2}$in (38 x 29cm).

OPPOSITE LEFT
Dream Days (The Magic Ring), 1901
Oil on board, 16 x 12in (41 x 30cm).

OPPOSITE RIGHT
Dream Days (The Magic Ring), 1901
Pen and ink on board, 10 x 11in (25 x 28cm). Title page.

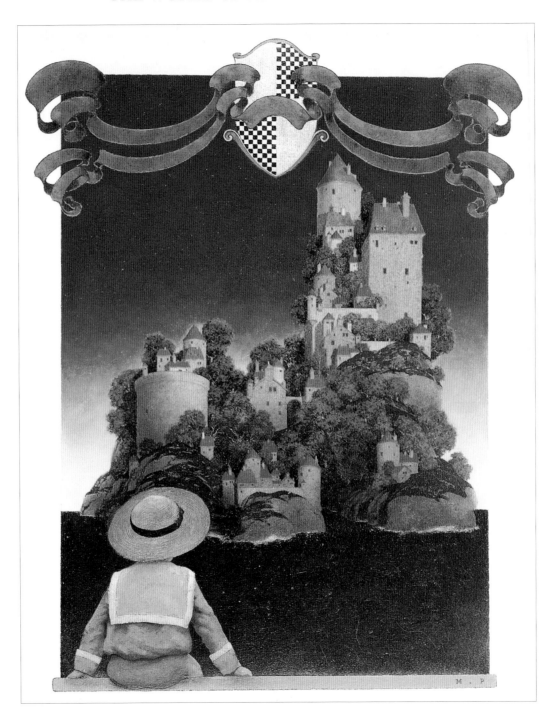

Head piece for "The Magic Ring"

Dream Days (The Reluctant Dragon), 1902

Oil on board, 12 x 8³/₄in (30 x 22cm).

Dream Days (The Reluctant Dragon),
1902
Tailpiece.

Dream Days (A Departure: Man in the Moon), 1902
Oil on board, 12 x 8¹/₂in (30 x 22cm).

Dream Days (A Departure: Man in the Moon), 1900
Oil on board, 5³/₄in (15cm) diameter.
Tailpiece.

Dream Days (Dolphins), 1901
Pen and ink on board. Tailpiece.

Dream Days (Saga of the Sea), 1901
Oil on board, 12¹/₂ x 8¹/₂in (32 x 22cm).

Dream Days (The Twenty-First of October), c.1902
Oil on board.

RIGHT
Italian Villas and Their Gardens, 1904
Cover for the book by Edith Wharton.
The Century Company, 1904.

FAR RIGHT
Italian Villas and Their Gardens, 1904
Title page.

FAR LEFT
Italian Villas and Their Gardens
(Vicobello, Siena), 1904

LEFT
Italian Villas and Their Gardens
(Villa Gori, La Palazzina, Siena), 1903
Oil on panel, 17 x 11¹/₂in (43 x 29cm).

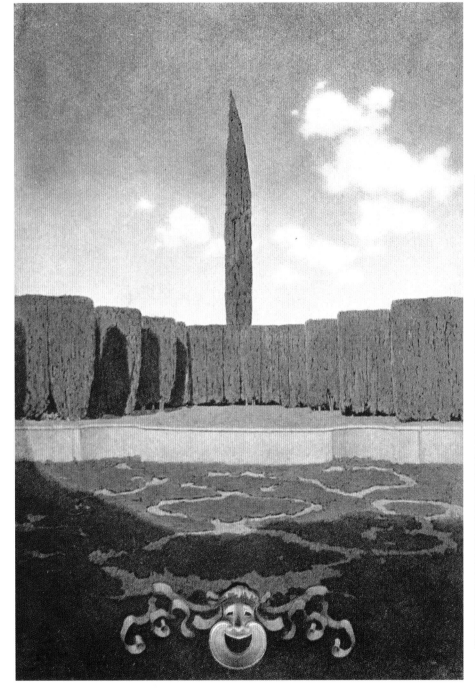

RIGHT
Italian Villas and Their Gardens
(Theatre at La Palazzina), c.1903–04

FAR RIGHT
(Villa Lante, Bagnaia), c.1903–04
Oil on paper mounted on board, 28 x 18in
(71 x 46cm).

OPPOSITE LEFT
(Villa Corsini, Florence), 1903
Oil on paper, 28 x 18in (71 x 46cm).

OPPOSITE RIGHT
(Villa Medici, Rome), c.1903–04
Vintage print.

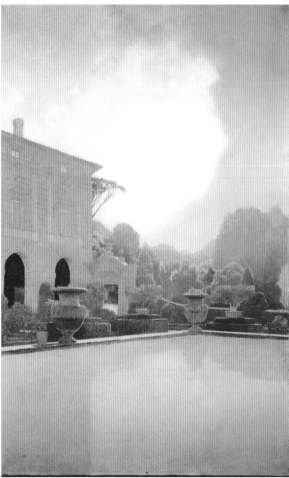

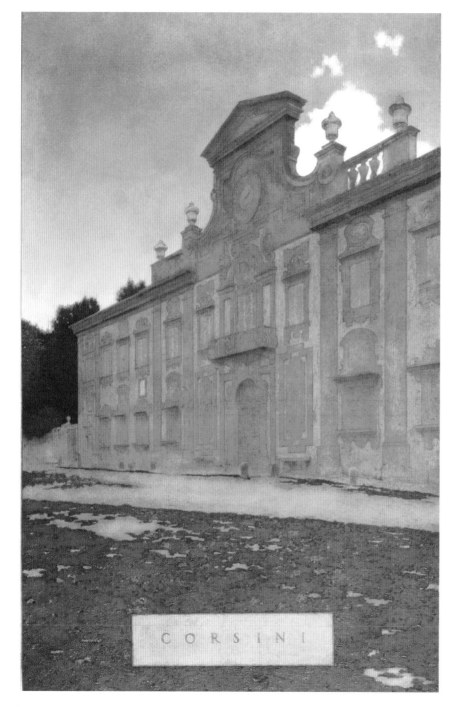

RIGHT
Italian Villas and Their Gardens
(Villa Campi, Florence), 1903–04
Vintage print, frontispiece.

FAR RIGHT
(The Pool, Villa d'Este, Tivoli), 1903–04
Print.

OPPOSITE LEFT
(Villa Gamberaia), 1903
Oil on canvas, 28 x 18in (71 x 46cm).

OPPOSITE RIGHT
(Villa Chigi, Rome), 1903–04
Oil on paper, 28 x 18in (71 x 46cm).

RIGHT
***Italian Villas and Their Gardens
(Villa d'Este, Tivoli) c.1903***
*Oil on paper on board, 28 x 18in
(71 x 46cm).*

FAR RIGHT
***(Reservoir at Villa Falconieri, Frascati),
c.1903***
Oil on paper, 28 x 18in (71 x 46cm).

OPPOSITE LEFT
***(Gateway of the Botanical Gardens,
Padua), c.1903***
*Oil on paper mounted on a stretcher,
$16^7/8$ x $11^1/2$in (43 x 29cm).*

OPPOSITE RIGHT
(Villa Cicogna, Bisuschio), c.1903
Oil on paper, $27^3/4$ x $17^3/4$in (70 x 45cm).

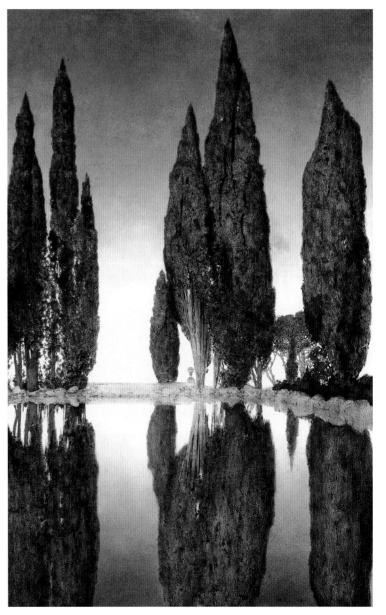

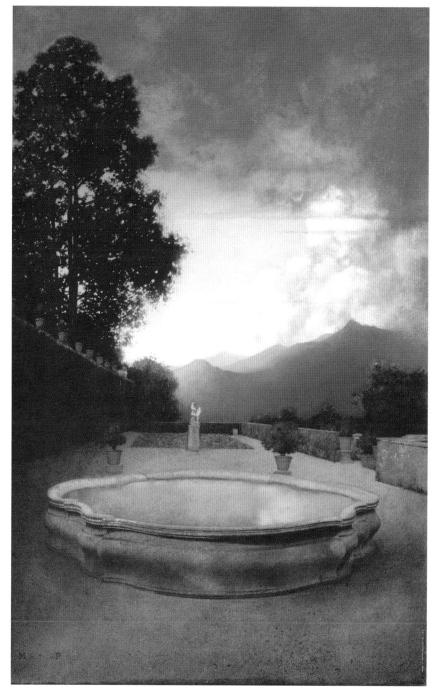

RIGHT
Italian Villas and Their Gardens
(Villa Scassi, Genoa), 1903
Oil on paper, 11 x 16in (28 x 41cm)

FAR RIGHT
(Boboli Gardens, Florence), c.1903–04
Vintage print.

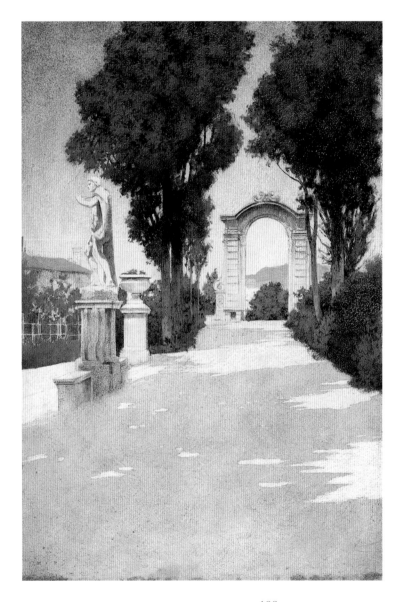

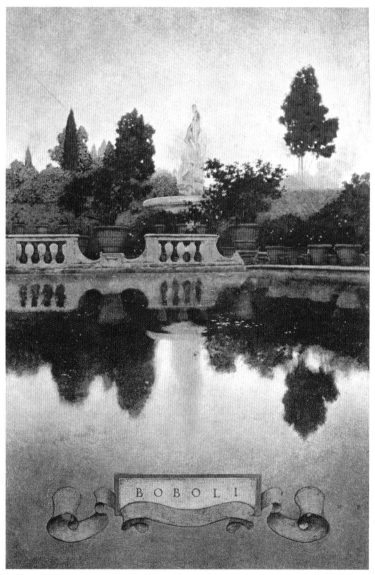

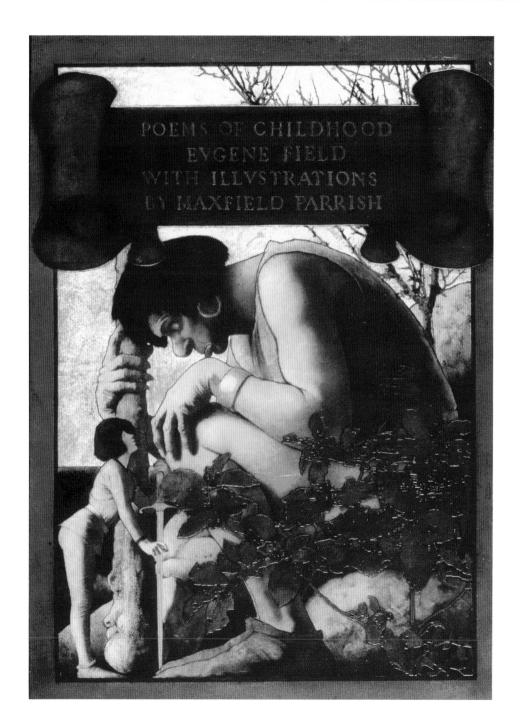

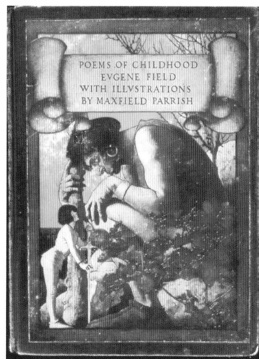

FAR LEFT
Poems of Childhood, 1904
Book cover for Poems of Childhood *by Eugene Field. Charles Scribner's Sons, 1904.*

LEFT
Poems of Childhood (Giant Seated with Jack at His Feet), 1904
Oil on stretched paper with collage, 21¹/₄ x 15¹/₄in (54 x 39cm). Illustration for book cover.

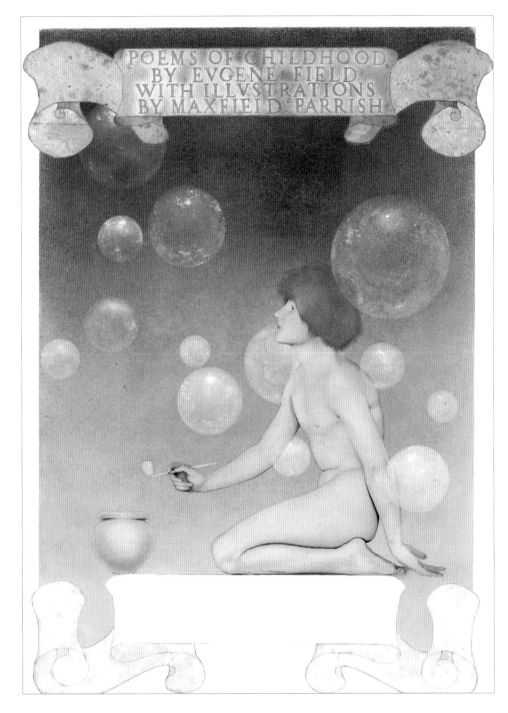

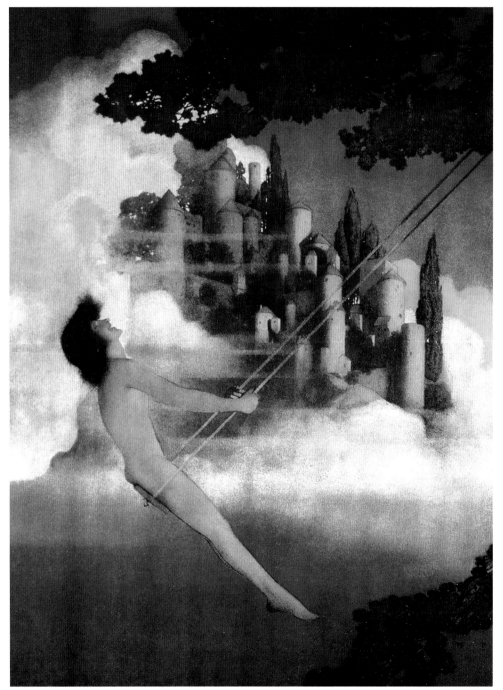

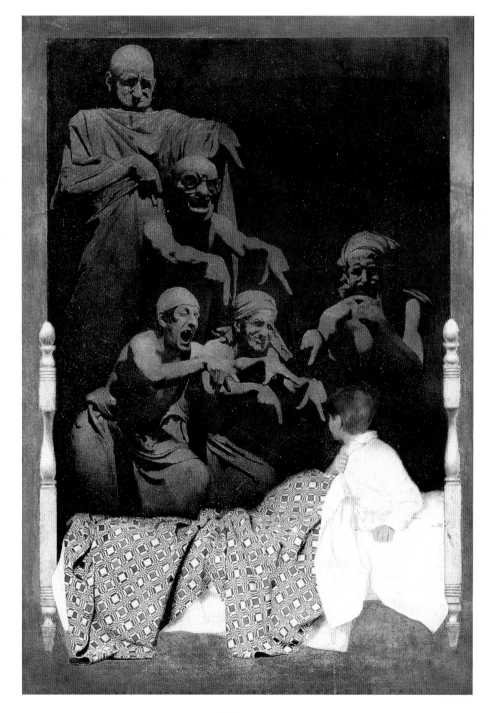

OPPOSITE LEFT
Poems of Childhood, 1904
Title page.

OPPOSITE RIGHT
Poems of Childhood (The Dinkey Bird), 1904
Vintage print, 16 x 11in (41 x 28cm).

LEFT
Poems of Childhood (Seeing Things at Night), 1904
Oil on paper, 21¹/₄ x 14³/₄in (54 x 37cm).
Illustration.

RIGHT

Poems of Childhood (The Little Peach), 1904

Oil on stretched paper, 21¹/₄ x 14³/₄in (54 x 37cm). Originally published in the Ladies' Home Journal, March 1903, and in 1904 by Charles Scribner's Sons.

FAR RIGHT

Poems of Childhood (The Sugar-Plum Tree), 1904

Vintage print.

OPPOSITE LEFT

Poems of Childhood (The Fly-Away Horse), 1904

Oil on stretched paper mounted on board, 28¹/₄ x 20¹/₂in (72 x 52cm).

OPPOSITE RIGHT

Poems of Childhood (Shuffle-Shoon and Amber Locks), 1904

Vintage print, 21 x 15¹/₄in (53 x 39cm). Published by Ladies' Home Journal and Charles Scribner's Sons.

RIGHT
Poems of Childhood (With Trumpet and Drum), 1905
Vintage print.

FAR RIGHT
Poems of Childhood (Wynken, Blynken and Nod), 1904

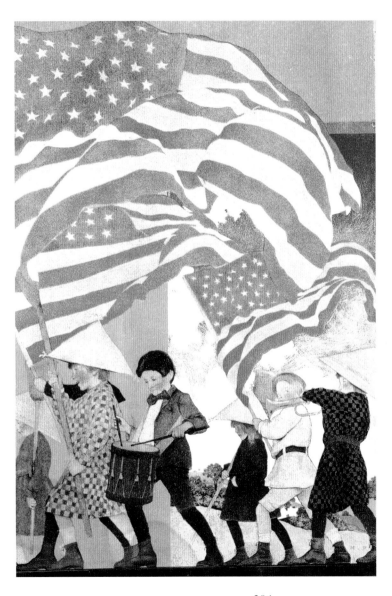

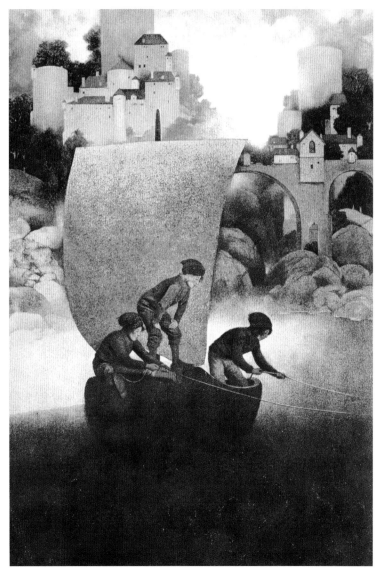

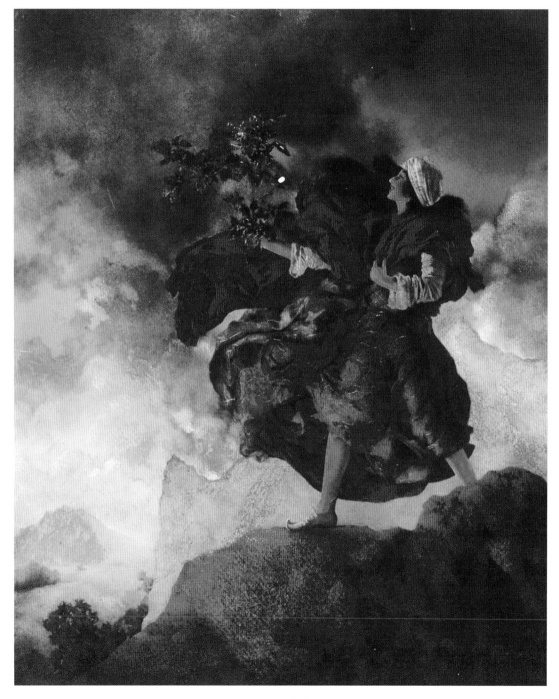

The Arabian Nights: Their Best Known Tales (Princess Parizade Bringing Home the Singing Tree or The Talking Bird), 1906
Oil on composition board, $20^{1}/_{16}$ x $16^{1}/_{16}$in (51 x 41cm). Collier's magazine illustration, 1906, Charles Scribner's Sons, 1909, Sunshine Calendar, Dodge Publishing Company.

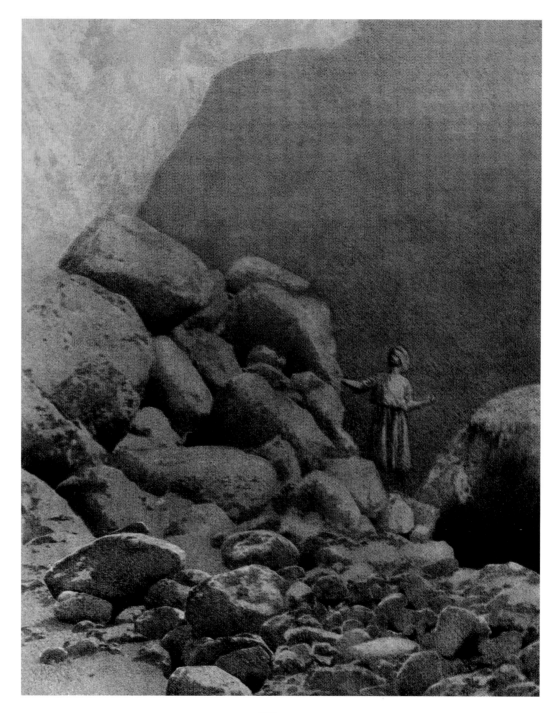

The Arabian Nights: Their Best-Known Tales (The Second Voyage of Sinbad), 1909
Book edited by Kate Douglas Wiggin and Nora A. Smith. Vintage print, Charles Scribner's Sons.

'The spot where she left me was encompassed on all sides by mountains that seemed to reach above the clouds, and so steep that there was no possibility of getting out of the valley'.

A Wonder Book and Tanglewood Tales,
1910
Cover for a book by Nathaniel Hawthorne.
Duffield and Company, New York.

RIGHT
A Wonder Book and Tanglewood Tales (Atlas), 1910
Vintage print. 'The Three Golden Apples'.

FAR RIGHT
A Wonder Book and Tanglewood Tales (The Fountain of Pirene), 1907
Oil on canvas mounted on wood panel, 40¹/₄ x 32in (102 x 81cm).

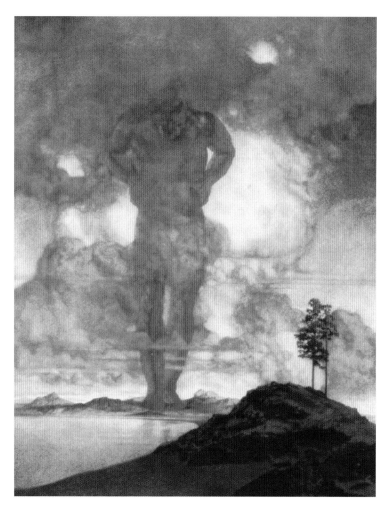

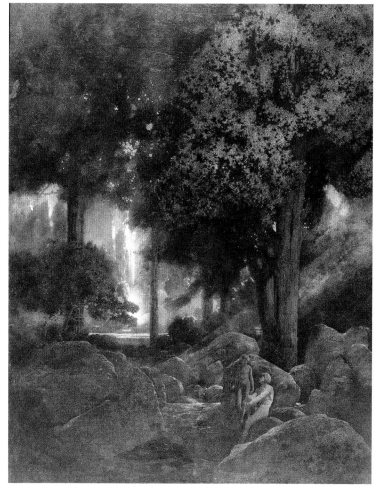

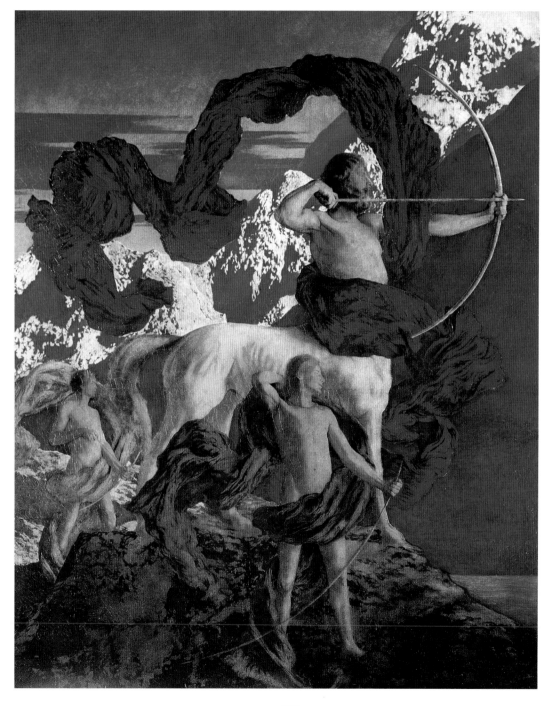

A Wonder Book and Tanglewood Tales
(Jason and His Teacher), 1908
Oil on canvas board, 38 x 32in
(96 x 81cm). Collier's, 23 July 1910.

RIGHT
**A Wonder Book and Tanglewood Tales
(Head of Pandora), 1908**
*Study. Collier's, The National Weekly,
16 October 1909, Duffield and Company.*

OPPOSITE LEFT
Susan Lewin poses for Pandora.

OPPOSITE RIGHT
Pandora, 1908
Vintage print.

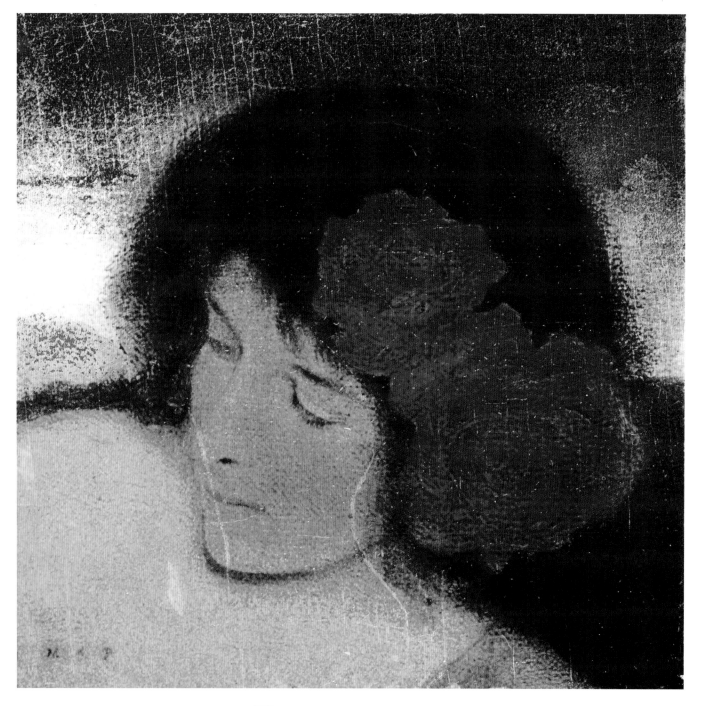

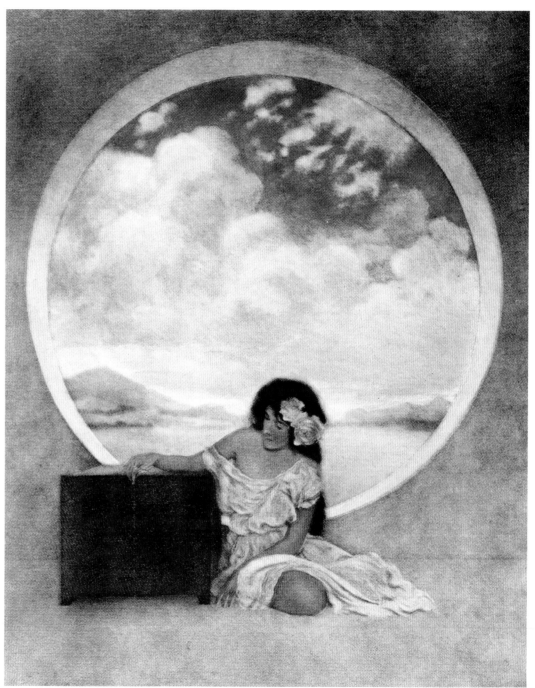

RIGHT

RIGHT

Seven Green Pools at Cintra, 1910
Florence Wilkinson. Century magazine,
August 1910.

OPPOSITE LEFT
Susan Lewin posing for Griselda
*(*Seven Green Pools at Cintra*), at The*
Oaks, Plainfield, New Hampshire in
August 1910. Photograph taken by
Maxfield Parrish.

OPPOSITE RIGHT
Griselda (Seven Green Pools at Cintra),
1910
Oil on canvas mounted on a wood panel,
40 x 32in (102 x 81cm). Century, August
1910.

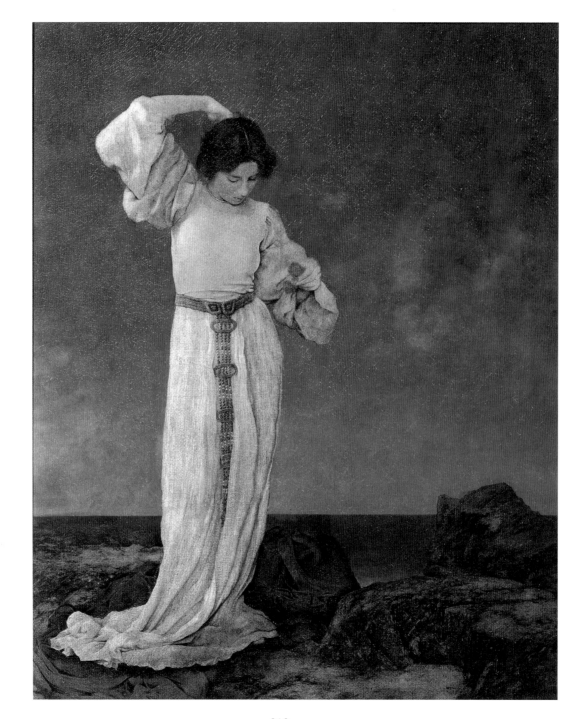

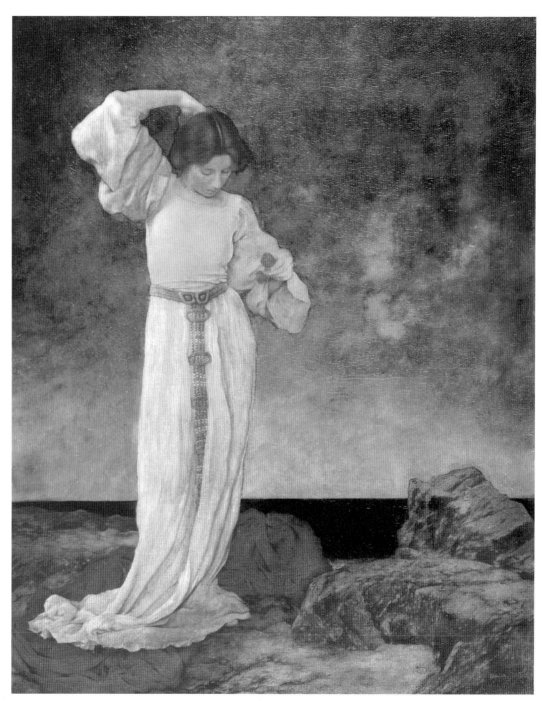

RIGHT
The Knave of Hearts, 1923–25
Cover for a book by Louise Saunders.
Charles Scribner's Sons.

FAR RIGHT
The Knave of Hearts, 1923–25
Title page.

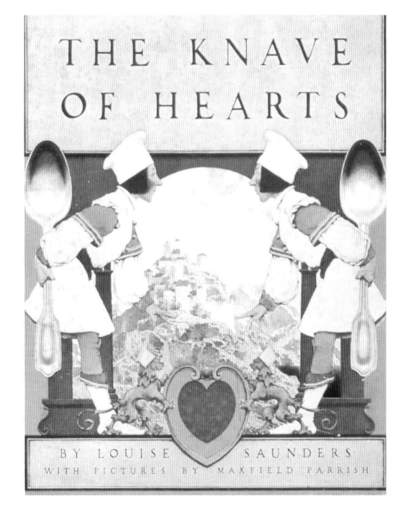

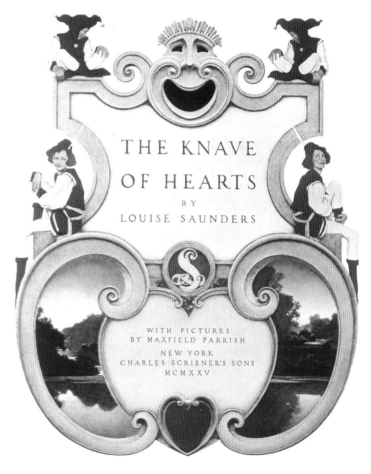

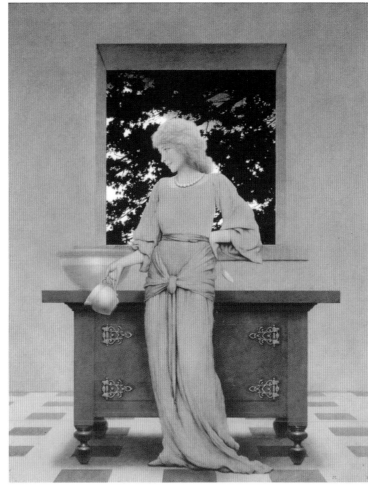

FAR LEFT
The Knave of Hearts, 1924
The Characters. Vintage print.

LEFT
The Knave of Hearts (Lady Violetta About to Make the Tarts), 1924
Oil on board, 22 x 18in (56 x 46cm).

RIGHT
RIGHT

The Knave of Hearts (Two Pastry Cooks: Blue and Yellow Hose), 1924

Oil on paper laid down on panel, 20¹/₈ x 16¹/₄in (51 x 41cm). Cover for Collier's magazine, 30 November 1929 and Charles Scribner's Sons, New York, 1925.

FAR RIGHT

The Knave of Hearts (Violetta and the Knave Examine the Tarts), 1925

Oil on board, 19¹/₄ x 15in (49 x 38cm).

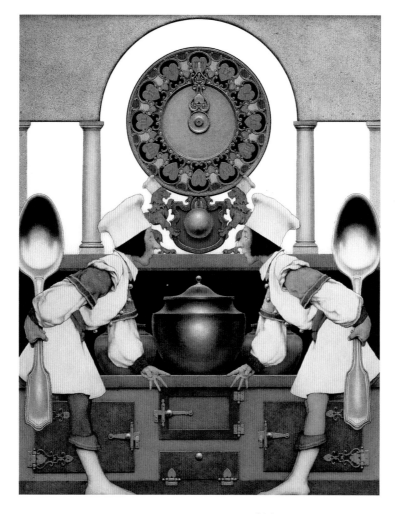

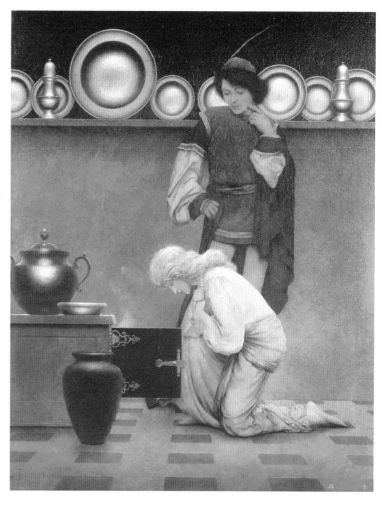

The Knave of Hearts (Two Chefs at a Table), 1925
Oil on panel, 9¼ x 20in (23 x 51cm).

RIGHT
The Knave of Hearts (The Knave of Hearts Watching Violetta Depart), 1924
Oil on panel, 20^1/$_8$ x 16^3/$_8$in (51 x 41cm).

FAR RIGHT
The Knave of Hearts
Study for the above.

OPPOSITE LEFT
The Knave of Hearts (Lady Ursula Kneeling Before Pompdebile), c.1925

OPPOSITE RIGHT
The Knave of Hearts (The King and the Chancellor at the Door), 1924
Oil on paper, 20^1/$_8$ x 16^3/$_8$in (51 x 41cm).

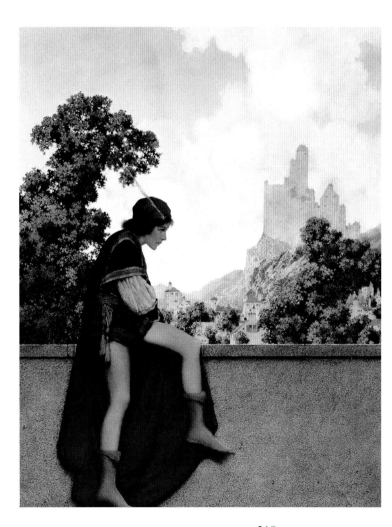

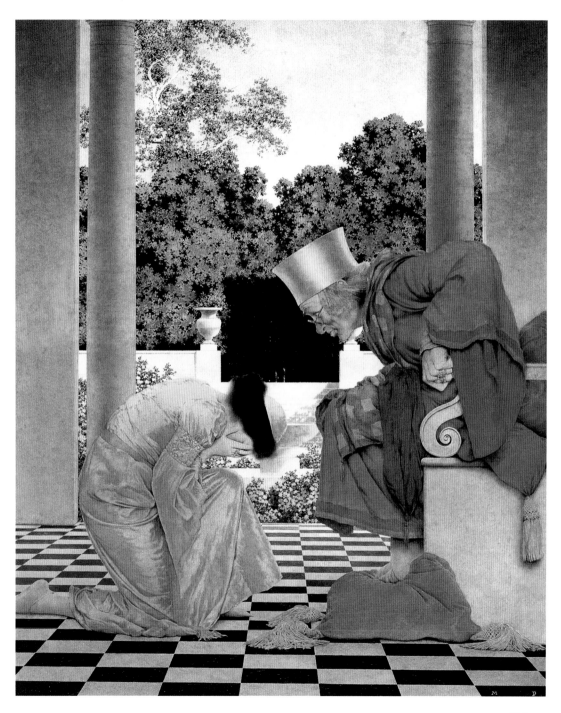

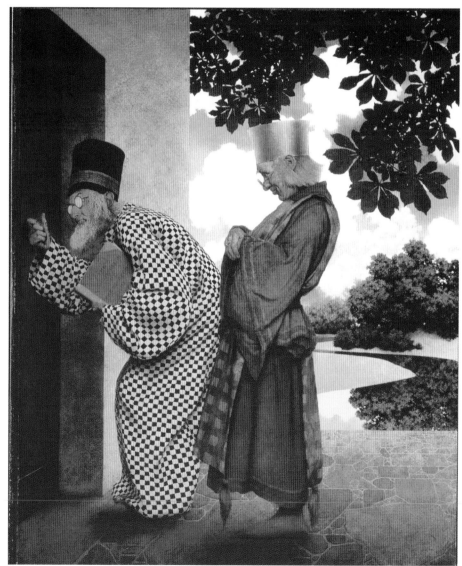

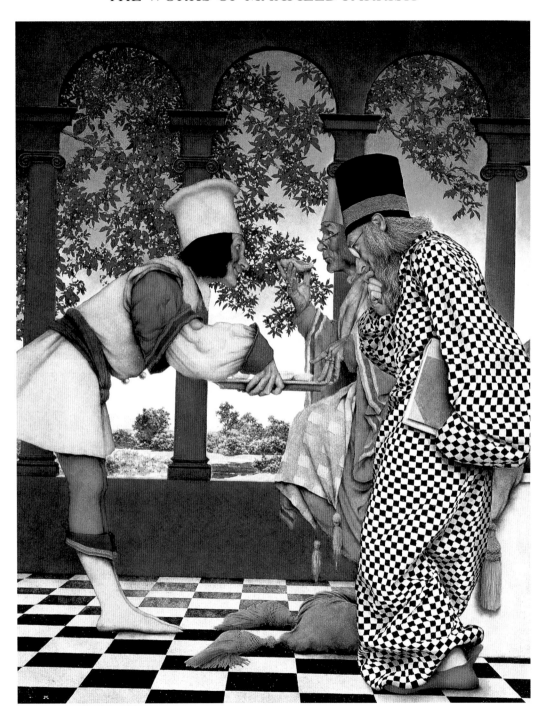

The Knave of Hearts (The King Samples the Tarts), 1924

Oil on paper laid down on panel.
19¹/₂ x 15³/₄in (49 x 40cm).

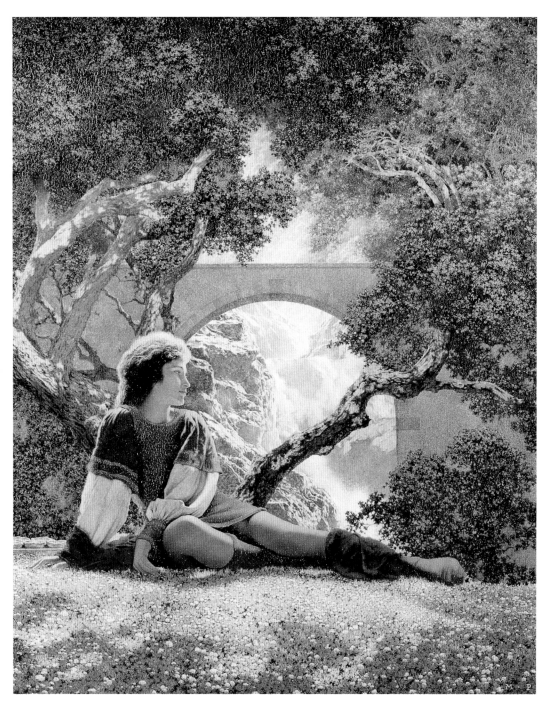

LEFT
The Knave of Hearts (The Knave), 1925
Oil on board, 20 x 16in (51 x 41cm).

ABOVE
Jean Parrish posing as The Knave.

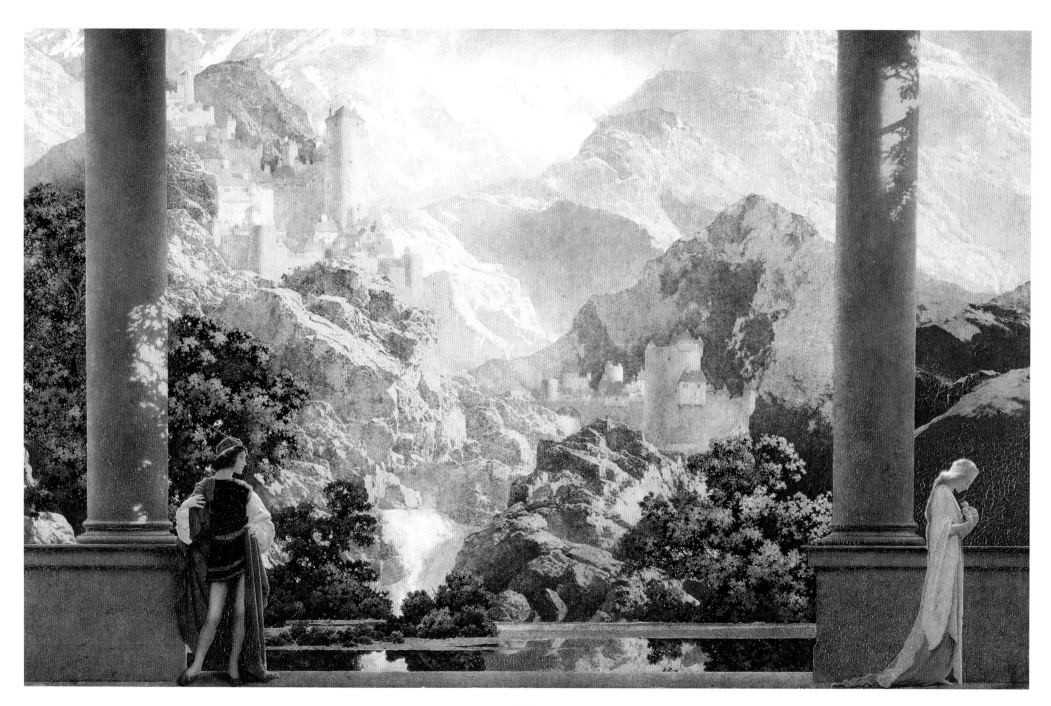

The Knave of Hearts (Romance), 1922
Oil on board, 21¹/₄ x 36¹/₂in (54 x 93cm).
End papers.

LEFT
Romance, 1925
Vintage print, 23³/₄ x 14in (60 x 36cm).
House of Art print, 1925.

The Knave of Hearts (Entrance of Pompdebile, King of Hearts), c.1925
Vintage print.

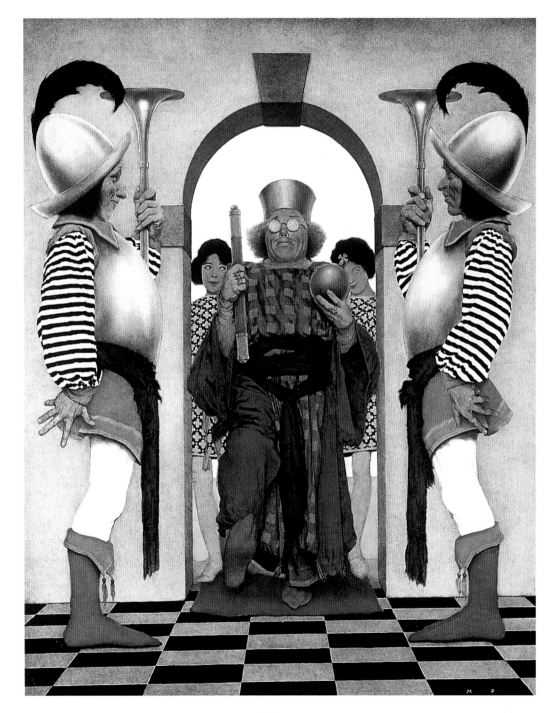

FAR LEFT
The Knave of Hearts (The Manager Takes His Final Bow), 1925
(The End).

LEFT
The Knave of Hearts
The play by Louise Saunders.

THE ILLUSTRATIONS: ART PRINTS, POSTERS, ADVERTISEMENTS & OTHER MISCELLANEA (1917–1939)

I would much prefer to paint … away from the actual place, because I feel that the most important qualities of such scenes are their sense of vastness, space, color and light, fleeting qualities which can best be portrayed in retrospect.

Art Prints and Posters

Perhaps Parrish's greatest claim to fame during his lifetime came from his art prints and posters. The public almost always recognized Parrish's work, to the extent of cutting it out of magazines and keeping it. Anything with a Parrish image became collectible. Today, there are clubs, journals and newsletters devoted to collecting his work, with avid fans loyal to the point of religious fervour constantly seeking anything by Parrish – even something he may have touched.

One can only imagine an age when printed matter was the only source of images: posters, magazines, books, billboards, leaflets and the like. Then, the public literally papered the walls of America with Parrish images. Today, animated and computer-manipulated images are a feature of our times, in stark contrast to bygone days when human talent was a unique commodity. The proliferation of images from new media has caused a new perspective on life, as well as overloading it with trivial images. It is hard to imagine the Victorian age, when individual craftsmen were still valued. Yet paradoxically, Parrish art prints and posters are still in demand across the world and continue to be re-published today, in China, the Netherlands, Indonesia, Japan, Germany and England, with reproductions offered in many qualities and sizes. The phenomenon seems likely to continue.

At the time that Parrish art prints and calendars were originally produced, they were offered to the public in different sizes. Edison Mazda calendars were printed in only two, but some art prints distributed by the House of Art came in three sizes, framed or unframed. This made them more or less suitable to hang on the wall over a sofa or to pin on a wall. They were all 'open-edition' printings, meaning that they were not limited by production to a set number. This is the opposite of 'limited edition', whereby the publisher establishes the total which he will publish in advance of printing them. Parrish never authorized limited-edition prints during his lifetime, which is when a certain number of prints are offered to the public and the buyer is assured that no others will ever be published and issued. In such cases, the prints are numbered and sometimes signed by the artist. A pencilled number on the print indicates which copy it is; for example, 42/1,000 indicates that it is the 42nd in a total publication run of 1,000 copies. After the designated printing run, the printing plates are destroyed to ensure that the agreement to limit the run is upheld.

This suggests that the limited-edition print may hold its value, as is usually suggested by the confident publisher. No guarantees are given, but over the years most such prints are expected to retain their original value at least and a number to increase. One must be careful when sourcing art prints and always distinguish between vintage pieces, which were published during the artist's lifetime, and contemporary prints published since 1966. In many cases the newer prints are better since they are more faithful to the original and unlikely to fade, being printed on acid-free paper; many publishing processes today are truer to the image and ensure the longevity of the print.

As a boy, Parrish made posters for events at the schools he attended, Swarthmore Preparatory School, then Haverford College. Perhaps his first real poster was for the *Bryn Mawr College Lantern*, in 1891. Parrish designed a number of school programme covers and accompanying posters for the University of Pennsylvania, the Jefferson Theatre of Portland, Maine, the American Watercolor Society and John Wanamaker's Department Store. He always referred to advertisements as 'posters', since that was how they all started – an old-fashioned word applied to a whole new way of looking at things.

After receiving the commission for the Mask and Wig Club Old King Cole mural in

1894, and related works at the University of Pennsylvania, Parrish was commissioned to produce its programme covers and posters for theatrical performances for the next four years. In 1896 he won the competition for the Columbia Bicycle poster in competition with 550 other young artists, and also won the PAFA competition, his poster used to advertise an exhibition entitled, 'Paintings of the Glasgow School' (page 234) at the academy. It created quite a stir, since the boldness of its graphics overwhelmed all the other entries, which naively and simply used gaudy colours to create an effect; Parrish's more sophisticated use of colour and design was apparent even then.

The same year, a professor at the Pennsylvania Academy of the Fine Arts, Robert W. Vonnoh, offered the school 'an exhibition of the posters recently brought from Europe with others to be obtained here'. The exhibition was considered to be of 'rare excellence'. Professor Vonnoh included seven Maxfield Parrish posters and for the cover of the exhibition catalogue selected another Parrish image, which was to cause something of a furore. Entitled 'Poster Show: Academy of Fine Arts', Maxfield Parrish signed a number of the posters in pencil, just beneath the image, at the request of the printer. After Vonnoh's exhibition, a protest letter was sent to PAFA by the Academy for Social Purity Alliance, 'objecting to the recent exhibition of posters on moral and artistic grounds'. Parrish's nude figures were the target of its disgust, but nothing more was said regarding the matter. Parrish's erotic design was being exhibited at the very peak of the so-called Artistic Poster Movement in the U.S.A., at a time when exploration of design, art and technology was more important to designers than content. A year later, another of his successful poster designs was also considered too erotic, the *Scribner's* fiction number for August 1897.

In 1896, the *Century* Poster Contest was held to decide the popular magazine's next cover, the *Century* midsummer holiday number, August. Along with 750 other artists, Maxfield Parrish entered and was awarded second prize to J.C. Leyendecker, having violated the competition rules by using more colours than allowed, disqualifying him from

first place. Once again the Parrish image was a naked woman; his wife Lydia posed for him (page 113), seated on the grass with her hands on her knees and a thicket of emerald-green foliage with a sky of cobalt blue glowing in the background. The image was greatly admired. The *Inland Printer* published it as a poster and it became the most reproduced poster of the decade. Parrish proudly included the names of the three famous judges on the bottom of the poster, Elihu Vedder, F. Hopkinson Smith and Henry J. Hardenbergh. It was reproduced several times over, first as the magazine cover for *Century*, then as a stand-alone poster and later in the French magazine, *Maître de l'Affiche*, opposite a painting by Henri de Toulouse Lautrec. Finally, and perhaps most importantly, the original painting was seen by the art director who later commissioned Parrish's first book cover for *Mother Goose in Prose*. Such recognition of a young artist was unusual at a time when society valued age and wisdom.

Advertising

One must remember that advertising as a profession was in its infancy when Parrish's career was beginning, with the result that old marketing traditions were quickly set aside. The use of posters, as a means of announcing events and products, began in France and many young American artists brought the concept back to their own shores. Consequently, posters were soon being slapped onto walls to announce anything from prizefights to bicycles for sale, while smaller posters were stuck to the sides of news-stands describing the next issue of *Hearst's* magazine. It took off from there and advertising was soon regarded as crucial to the success of any business. The J. Walter Thompson Archive comprises a collection of advertisements dating from 1910 until 1955. Not much existed prior to 1910.

Parrish received several small commissions for advertisements for such items as linen and box labels for men's clothing for the John Wanamaker Department Store in Philadelphia

between 1894 and 1897. To keep busy he took whatever other assignments he could get, including restaurant menus (1893), the seal for the Civic Club of Philadelphia (1896), Columbia Bicycle posters (1896) and Sterling Bicycle posters (1897), a no smoking poster, No-To-Bac (1896), the packaging for Royal Baking Powder (1897), greeting cards for the Bartram Hotel of Philadelphia (1897), and a souvenir menu for Sherry's in New York, marking a dinner in honour of Theodore Roosevelt in 1910. He also designed toy soldiers for a children's game as well as its packaging. In some ways he was an illustrator, easel painter, graphic designer and industrial designer all rolled into one before some of these professions existed or were even perceived to be necessary.

Parrish completed more significant advertising commissions in the form of posters for Djer-Kiss cosmetics (1916), Fisk Tires (1917), Colgate & Co's Cashmere Bouquet toilet soaps (1897–1902), D. M. Ferry's Seeds (1918) and Oneida Silver (1918). He produced other posters from magazine covers for which he had painted the images, including *Harper's Weekly*, *Life*, *Scribner's* and *Success*. In later years, advertising commissions were a source of more income rather than simply attempts at recognition, and he undertook full advertising campaigns for Hires Root Beer (1920), Jell-O for the Genesee Pure Food Company (1921), Swift's Premium Ham (1921), the Broadmoor Hotel (1925), Maxwell House Coffee (1926) and later the famous twin posters (1936 and 1939) to help his state of New Hampshire Scenic Planning and Development Commission promote tourism. New Hampshire, still a bastion of conservatism, its licence plates reading, 'Live Free or Die', began to refer to the artist as its 'native son'.

Advertising was accepted as part of mainstream marketing from the late 1890s and Parrish illustrations were germane to bringing this revolution about because of the popularity of his work. In fact, poster art reached such proportions that an artist's fame was nearly as important as the advertising message itself. The name 'Maxfield Parrish' was already a valuable commodity, even to an oblivious State Government agency, so the New Hampshire tourism posters became extremely valuable and desirable and the advertising campaign did its job.

Parrish's advertisements sometimes included logo designs, although when they were completed, neither the client nor the artist considered them anything more than artistic renditions for an immediate purpose. For Crane's Chocolates, he painted a long and slender crane posed before a rugged mountain, with billowing cumulus clouds in the sky as a backdrop. The crane was obviously symbolic of the family name, but it was Parrish's idea; prior to that, the company did not have a logo, an easily recognizable device that characterized the company, its reputation and its products. Ultimately, Crane's Chocolate became the most popular in the nation due to its connexions with Parrish and his artworks. Likewise, the introduction of Colgate's Dutch Boy, a symbol of cleanliness, first used for the Cashmere Bouquet soap advertisements, became Colgate's logo ten years later. Parrish therefore virtually created Colgate's brand image before branding became the special science that it is today.

There was more than a touch of irony in Parrish's last assignments for the Vermont Association for Billboard Restriction, issued as a postcard and then as a poster in 1939. It read, 'Buy Products Not Advertised on our Road Sides'.

Maxfield Parrish was not above making money from the commercial exploitation of his artworks. A poignant example is when 'Little Boy Blue', from *Mother Goose in Prose*, was used in an advertisement for Pettijohn's Breakfast Food, the Pettijohn Company offering free copies of Parrish's book with three coupons and an 8 cent stamp. Promotions, posters, special offers, all made a contribution to his career, made his name, and brought products to the attention of the public; as modest as Parrish reputedly was, he thoroughly enjoyed all the fame and recognition he received.

The public had fallen in love with collecting during the Gilded Age. First came etchings, an immediate sensation as modern printing processes made it possible for the middle classes to collect signed, hand-pulled prints. Printing then progressed to such an extent that products could be produced inexpensively in four colours, which was particularly popular. Everyone who was anyone had to own a colour art print and be able to ask his neighbour if he was a 'collector' too? Liking a particular image, or the work of a

particular artist, often formed the bases of their collections. The publishers of magazines soon realized that offering a print on high-quality paper in a large format greatly appealed to its readers. Magazines began to offer reproductions of their most popular images, either individually or in portfolios, some offering the original images painted by the illustrators, but never those of Maxfield Parrish. Where once the public collected etchings and block prints, they now collected coloured lithographic art prints.

The most sought-after artist, the most collectible of all, was Maxfield Parrish, which is hardly surprising, since his art prints were beautiful, clear and bold, with uncomplicated subjects that were easy to understand and had short, meaningful titles. There may have been subliminal meanings in his romantic images but they managed to remain non-controversial.

Many tried to collect art prints before they became generally available. Books were torn apart, magazines cannibalized and anything in colour was framed and hung on the wall. Scribner's began to offer Maxfield Parrish art prints in 1903, the first being *Aucassin Seeks for Nicolette* (page 118), in an $11^1/_2$ x 17-in (29 x 43-cm) version, obviating the need to rip it out of a beautifully bound book. A year later, *Ladies' Home Journal* released *Air Castles* (page 169) to its subscribers as an incentive to subscribe to the magazine. In 1904 *Century* offered a special hard-cover portfolio entitled, 'Six Color Plates of Italian Villas From Paintings by Maxfield Parrish', reproduced from *Italian Villas and Their Gardens* (page 190 et seq.), just released.

Scribner's bought the rights to some Parrish images and in 1909 published four-colour prints from *Poems of Childhood*. They were described as 'Maxfield Parrish's Pictures in Colors …Each picture 11 x 16 inches on mounts 19 x 24 inches. Price for the set, $5.00 net. These four beautiful and fanciful pictures by Maxfield Parrish were inspired by the Poems of Childhood of Eugene Field and are executed in Parrish's most popular manner. They are symphonies of color and show vivid imaginative power. These four subjects are the only reproductions of Parrish's work in large size in full color. The lithographs retain all the fascinating qualities and richness of the originals.'

In 1909, P. F. Collier & Son published *Cadmus Sowing the Dragon's Teeth* (page 134) as a 13 x 11-in (33 x 29-cm) art print, and scenes from Parrish's stage set for Shakespeare's *Tempest* were released under different names as art prints by the Dodge Publishing Company. In 1914, Collier's issued a collection of Maxfield Parrish's 'Four Best Paintings'. Maxfield Parrish watched the proceedings with fascination, but gained little financially from all this activity. He collected few royalties on art prints taken from his work up until the 1920s, having then sold the rights to the book publishers with no controls on future use. *Scribner's* realized this and paid him some royalties, but it was unique in this respect.

In 1916, Parrish was commissioned by Clarence A. Crane of Crane's Chocolate to design a box cover for one of his tasty products, which was a whole new direction for Parrish. The following year, excited by its success, Crane sent his son, the author Hart Crane, to Cornish to commission Parrish to paint yet another box top for a Christmas gift package, with the result that Parrish's *Rubaiyat* was born (page 248). Eastern themes, inspired by Omar Khayyam, were popular at the time and many stores, such as Wanamaker's in Philadelphia, were using them in store and window dressings. Parrish's version, however, was totally sublime. It was so popular that Crane gave his customers the opportunity to buy poster reproductions of the painting for 10 cents. This met with an overwhelming response and 1,000 were ordered within two weeks. Crane eagerly ordered 2,000 more, reproduced in the same size as the original, and they too immediately sold out. From then on, order forms were placed in every chocolate box. Parrish produced two other successful paintings for Crane, *Cleopatra* (page 250), in the context of a Hollywood movie set, and the fabulous *Garden of Allah* (page 254), both sensationally popular.

In 1918, Parrish received over $50,000 in royalties from these three paintings alone, which made him realize that harsh scheduling and book commissions were now a thing of the past. He knew that he had a successful formula for painting and that it would bring immense financial rewards in the future.

THE WORKS OF MAXFIELD PARRISH

Daybreak

In 1922, Maxfield Parrish produced what he referred to as, 'the great painting', for Reinthal and Newman, a publisher of art prints, which it distributed through its internal distribution arm, the House of Art. This painting, *Daybreak*, became one of the most successful art prints of the decade and secured Parrish's position as America's most popular illustrator after the First World War, where it is perhaps the most reproduced art image ever, surpassing even those of Andy Warhol.

In composition it resembles a stage set, which is appropriate, since Parrish loved the theatre, had dallied with Ethel Barrymore, and had designed a number of sets for masques in Cornish as well as for a New York performance of Shakespeare's *The Tempest*. After the House of Art began to distribute the ever popular *Garden of Allah*, for Crane's chocolate boxes, Parrish found the business opportunity too tempting to be ignored. He gave *Daybreak* everything that the public loved best. It was laid out according to dynamic symmetry using photographs of Kitty Owen, his daughter Jean and Susan Lewin as models, having first made a montage to structure the composition, which included architectural elements, columns and urns, with a typical Parrishscape as a background. It was Parrish at his best, and by 1924 he had earned over $75,000 in royalties from this one work. The print was the sensation of the decade and was displayed in every middle-class American home. The next year, Parrish's royalties rose to over $100,000, at a time when the average house was selling for $5,000. By this time, having no more use for the original, Parrish sold it for an unprecedented $10,000. In 1996 it was sold for a third time, for $4,292,500.

After his death, the following poem by H.M. Jalonack was found among Parrish's personal effects, though it is not sure if it was written by someone inspired by the painting or whether the painting was inspired by the poem.

Daybreak

Awake, my playmate, from your gentle slumber,
Beside the restful quiet of the sea,
Awake, the morning draws the veil asunder,
The sunshine sends its call to you and me.

Look, my own, while still the foliage shadow
Across your face, in flitting beauty lies,
Our own blue sea, with its warm arms received me
And now would wash the sleep from your blue eyes.

Shines not the distant hills with purple splendor?
Paints not the blue-gold light our cliffs so dear?
Does not the golden sun light up the pillars?
Lift up thy head, Oh Comrade, day is here.

This great, wide wondrous world – Sky's palest blue,
The gold that crowns our heaven – Sea so deep
All beckon for another day of life,
Ere once again night lulls us into sleep.
Awake, my playmate, from your gentle slumber,
Beside the restful quiet of the sea,
Awake, the morning draws the veil asunder
The sunshine sends its call to you and me.

Daybreak: the Study

Parrish's writings suggest that he used a system called dynamic

symmetry and inspection of his works confirm this, but for some odd reason art historians mention it fleetingly or ignore it altogether. However, he considered it integral to his work. The lines of dynamic symmetry can clearly be seen laid out in thick pencil in the study for *Daybreak*, which is a watercolour montage and one of the few known works with lines of intersection locating the major design elements. While *Daybreak* measures 26 x 45inches, the study for it is about half that size at $14^1/2$ x $23^1/2$in. The mountains and the locations of the columns frame the setting, while the girls and their positions are fixed according to the geometric precepts laid down by Hambidge. It can now be said that the final *Daybreak* is geometrically exact and this may well be a factor in its great popularity. Hambidge thought that people were most comfortable with organically-based, geometrical positions, the concept being the determining factor for producing symmetry, the interrelationship between various areas around the painting's centre of balance rather than the relative length of its lines. This is a result of the relationships of mathematically symmetrical sub-areas within the structural pattern.

In reviewing the study for *Daybreak*, it is possible to see a third girl pictured at the right who does not appear in the final version. Some have incorrectly said that she was removed from the final painting due to her incompatibility with dynamic symmetry, but she is actually placed rather well according to the rules, though her overall scale is incorrect. She simply does not relate well to the reclining girl and was probably removed and the standing girl added for better balance. The two girls were applied to the picture by projecting their photographic images onto the surface; the total balance of the composition was achieved only when the third was removed.

The original photographs of the girls posing for these positions have also been found and the relationships and scale of the three of them are incompatible with a harmonic layout, although the artist could have adjusted them quite easily.

In 1926, Maxfield Parrish painted *Stars*, with *Hilltop* (page 262) in 1927. While neither of these matched the sales of *Daybreak*, by any other standard they were great successes. It is important to note that most vintage prints of *Daybreak* are in various tones of blue, including the one on Coy Ludwig's book jacket. The true colours are those printed here, which are true reproductions from the original painting. The vintage art print colours differ due to fading, which causes the orange, red and yellow tones to disappear, with blue tones remaining. This phenomenon has nothing to do with 'Parrish Blue'.

Parrish was now focusing all his energies on art prints, while posters and advertising were of diminishing interest. He produced a poster now and again for his church and one for a toy show at Madison Square Garden, and certainly helped the War Relief efforts, but generally speaking he now avoided them like the plague.

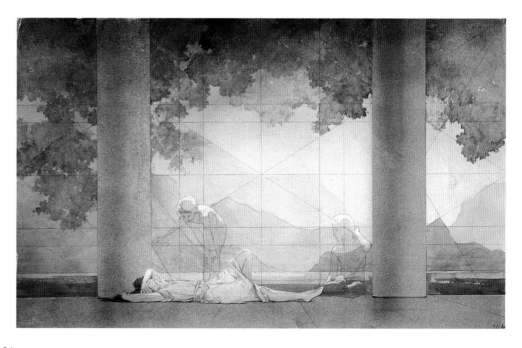

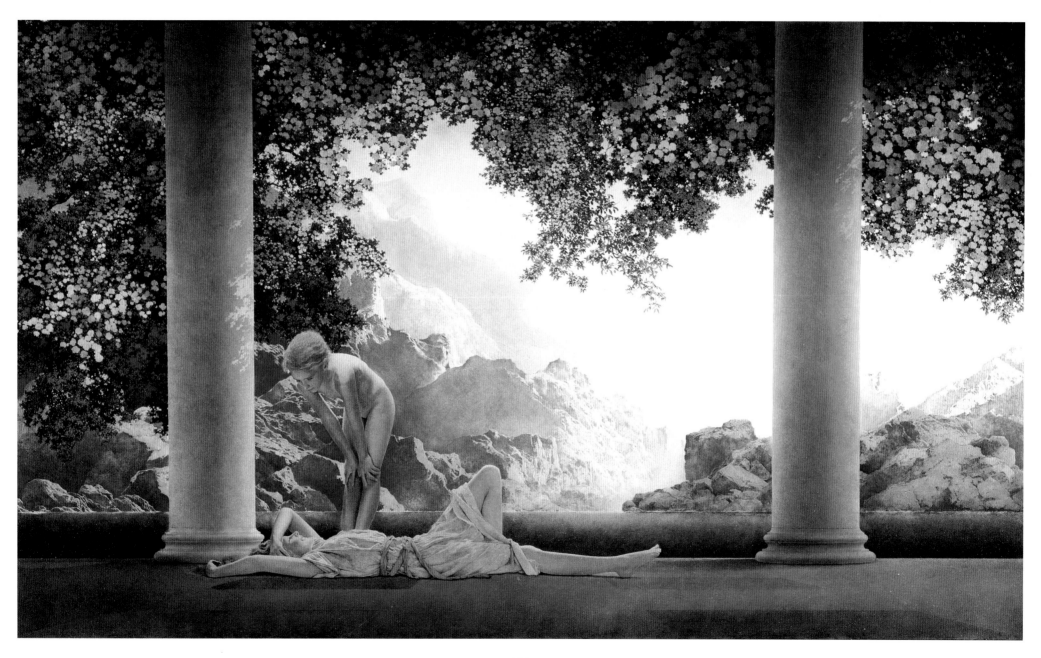

PAGE 231
Daybreak, 1922
Study
Watercolour and collage, 14¹/₂ x 23¹/₂in
(37 x 60cm).

OPPOSITE
Daybreak, 1922
Oil on panel, 26 x 45in (66 x 114cm).

FAR LEFT
The Chaperone, 1892
*(Doorknocker painted on door of a
sail loft)*
Oil on panel, 28¹/₂ x 21¹/₈in (72 x 54cm).

LEFT
Standing Female Nude, 1892–94
Pencil on paper, 24³/₄ x 18³/₄in
(63 x 48in).

RIGHT
Watching in the Woods, Midsummer's Eve, c.1893
Water-based paint on brown paper, 17 x 14³/₄in (43 x 37cm).

FAR RIGHT
Pennsylvania Academy of the Fine Arts original poster, 1896, 44 x 28in (112 x 71cm).

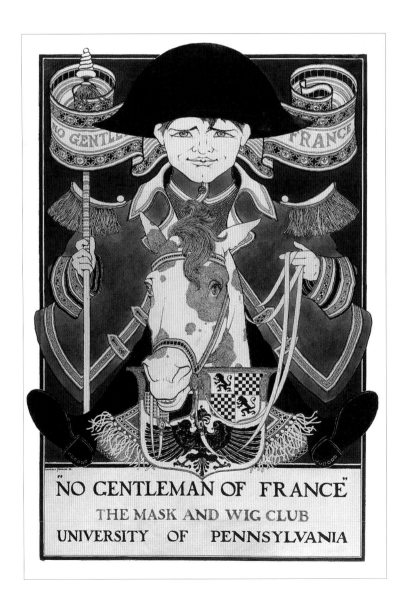

FAR LEFT
No Gentlemen of France, 1886
Oil and pen and black ink on paper,
19¹/₂ x 13¹/₂in (49 x 34cm).
Drama poster for the Mask and Wig Club,
University of Pennsylvania.

LEFT
The Young Gleaner, 1886
Oil on canvas, 42 x 28¹/₄in (107 x 72cm).
Possible advertisement for a brewing
company.

OPPOSITE
The Sandman, 1896
*Oil on canvas on board, 22 x 28in
(56 x 71cm).*

LEFT
*Pennsylvania Academy of the Fine Arts
programme cover, 1897.*
Oil on paper, 14 x 14in (35 x 36cm).

RIGHT
Mask and Wig Club decennial anniversary
poster, c.1898. Watercolour and ink on
paper, 15³/₈ x 11¹/₂in (39 x 29cm).

FAR RIGHT
Architectural study. Photograph courtesy
of Gary Meyers.

FAR LEFT
Memento of Augustus Saint-Gaudens,
1902. Envelope/engraved stamp with pen
and ink drawing on paper, printed with
return address, 4¹/₂ x 5³/₄in (11 x 15cm).

LEFT
A Christmas Toast, c.1910
Oil on board, 14 x 10in (36 x 25cm).

RIGHT

Bronze casting of a comic mask, 7 x 5in (18 x 13cm), by the sculptor Augustus Saint-Gaudens and his wife Augusta, based on a design by Maxfield Parrish for use during a performance of 'A Masque of Ours' staged in Cornish, New Hampshire, 22 June 1905. The celebration was in honour of the 20th anniversary of the founding of the Cornish Colony.

FAR RIGHT
Clowns, c.1897–1905
Mixed media, 18 x 13in (46 x 33cm).

Funnigraph for Collier's Express, 1905
Oil and collage on paper, 19 x 24in
(48 x 61cm).

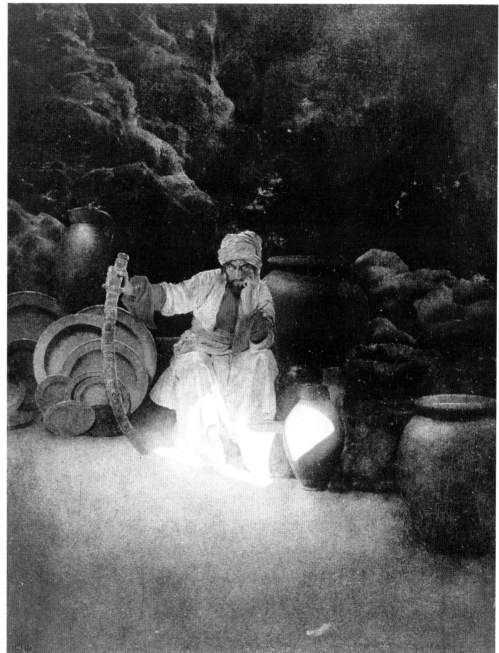

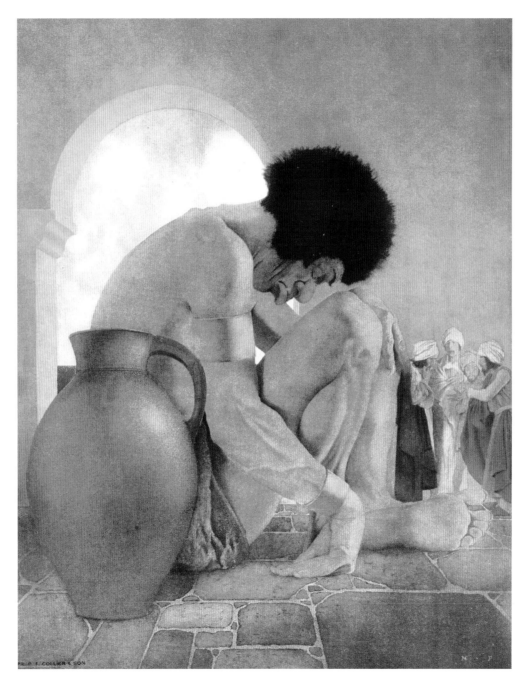

OPPOSITE LEFT
The Arabian Nights: Their Best Known Tales (The Fisherman and the Genie), c.1929
Vintage print.

OPPOSITE RIGHT
The Arabian Nights: Their Best Known Tales (The Story of Ali Baba and the Forty Thieves), 1929

LEFT
The Arabian Nights: Their Best Known Tales (The Third Voyage of Sinbad), 1929

RIGHT
Just a Moment, Please, c.1935
Oil on panel, 39 x 24in (99 x 61cm).
Sign which Parrish placed on his studio
door when he wasn't in.

FAR RIGHT
Parrish posing for Just a Moment, Please.
Photograph taken by Maxfield Parrish at
The Oaks, Plainfield, New Hampshire,
circa 1935. Courtesy of Special
Collections, Baker Library, Dartmouth
College.

Wooden toy sailing boat, 4³/4 x 7¹/2 x 11¹/2in (12 x 19 x 29cm), carved in 1915 and bearing the legend: 'This boat was made by Maxfield Parrish for his children to play with in the water'. Maxfield Parrish Jr. added the rigging and sails in 1936 and painted the boat.

RIGHT
Parading Soldier with Musket, 1912
Cutout. Oil on paper, 9 x 6in (23 x 15cm).
Collier's magazine cover, 16 November
1912.

FAR RIGHT
Lute. Length 37 x base 17¹/₈ x neck 5in
(94 x 43 x 13cm).

OPPOSITE
Mermen, 1916
Oil on panel with cutout reliefs,
19¹/₂ x 35¹/₄in (49 x 89cm).

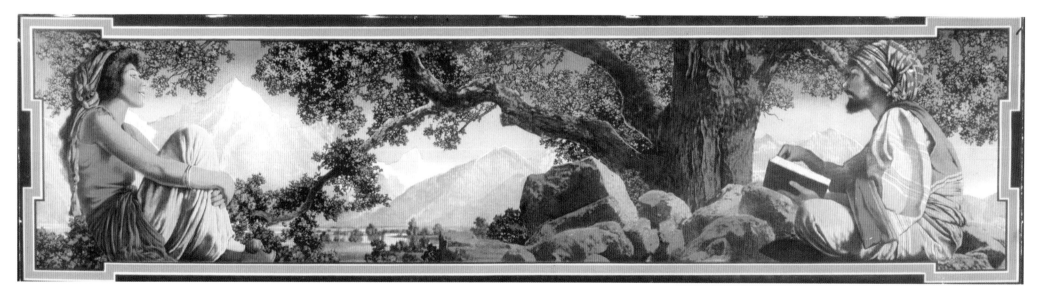

Rubaiyat, 1916
Oil on panel, 8 x 30in (20 x 76cm).
Crane's Chocolates Christmas gift box.

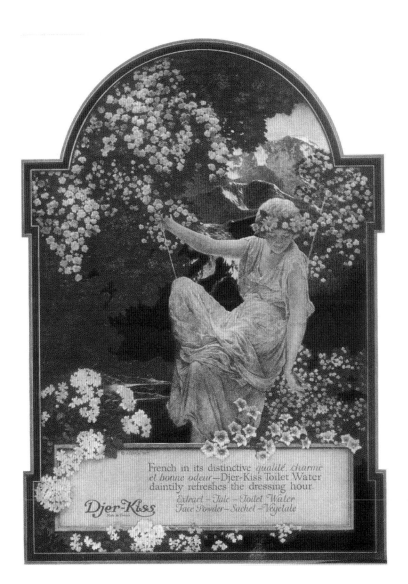

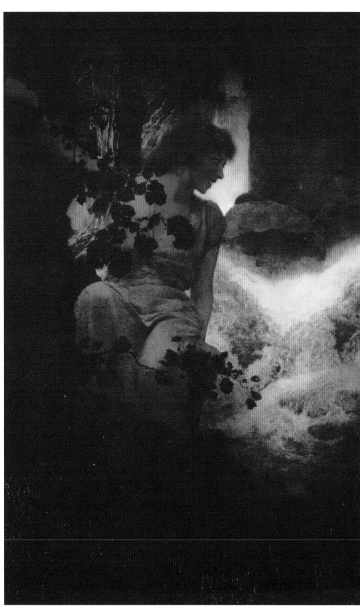

FAR LEFT
Djer-Kiss, c.1916
Vintage print. Djer-Kiss magazine advertisement.

LEFT
Deep Woods, Moonlight, 1916
Oil on Masonite, $21^{1/4}$ x $13^{3/4}$in (54 x 35cm).

Cleopatra, 1917
Oil on board, 25$^{1}/_{2}$ x 29$^{1}/_{4}$in
(65 x 74cm). Decoration for a Crane's
Chocolates Christmas gift box.

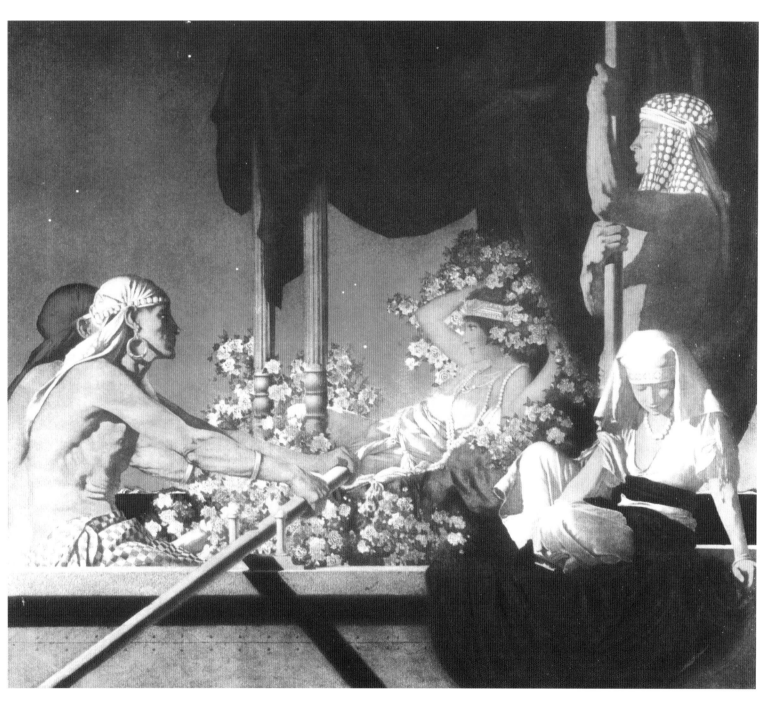

Peter Peter pumpkin eater
Had a wife and couldn't keep her
He put her in a pumpkin shell
And there he kept her very well

USE FERRY'S SEEDS

Mary Mary quite contrary
How does your garden grow?
PLANT

FERRY'S SEEDS

FAR LEFT
Peter, Peter the Pumpkin Eater, 1917
Poster advertising Ferry's Seeds.

LEFT
Mary, Mary, Quite Contrary, 1921
27 x 19³/₄in (68 x 50cm).
Vintage print advertising Ferry's Seeds.

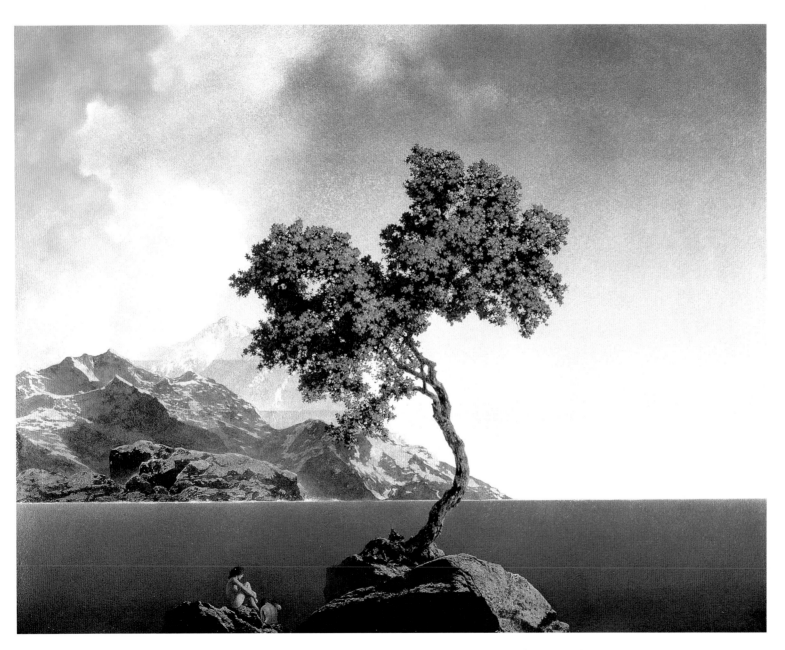

OPPOSITE LEFT
Jack and the Beanstalk, 1923
(Plant Ferry's Seeds)
Vintage print, original poster 25 x 25in
(64 x 64cm). D.M. Ferry Seed Company
advertisement.

OPPOSITE RIGHT
Girl by a Lake, 1918
Oil on board, 10 x 8in (25 x 20cm).

LEFT
Aquamarine, 1917
Oil on panel, 15$^{1}/_{2}$ x 19$^{1}/_{4}$in (39 x 49cm).

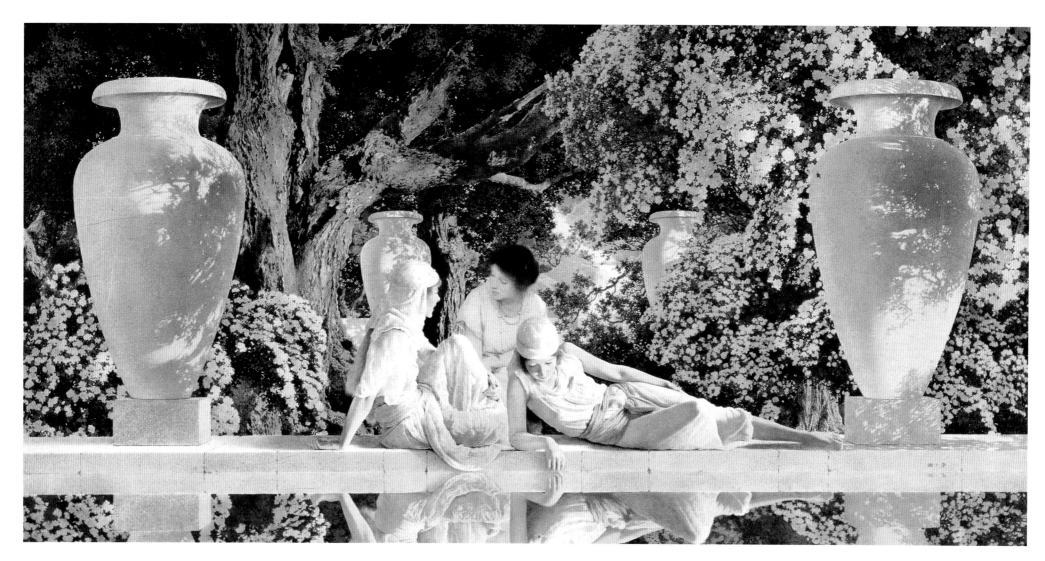

OPPOSITE
The Garden of Allah, 1918
Oil on panel, 15 x 30in (38 x 76cm).
Illustration used to decorate gift boxes of
Crane's Chocolates.

LEFT
The actual chocolate box, decorated with
the Garden of Allah.

RIGHT
Jack Sprat, 1919
Vintage print, original poster,
15³/4 x 10in (40 x 25cm).

FAR RIGHT
Advertisement for Edison Mazda Lamps.
Oil on metal, 26 x 21¹/2in (66 x 55in).

OPPOSITE ABOVE
There Was on Old Woman Who Lived in a
Shoe, c.1920
Oil, 24 x 58³/4in (61 x 149cm).
Proposed advertisement for Fisk Tires
(unpublished).

OPPOSITE BELOW
Mother Goose, 1919
Wallpaper border. Fisk Rubber Company.

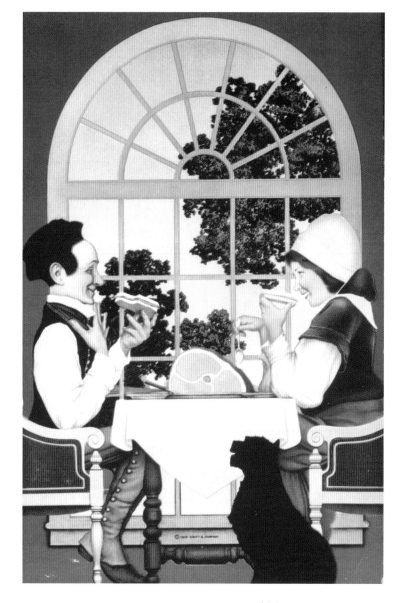

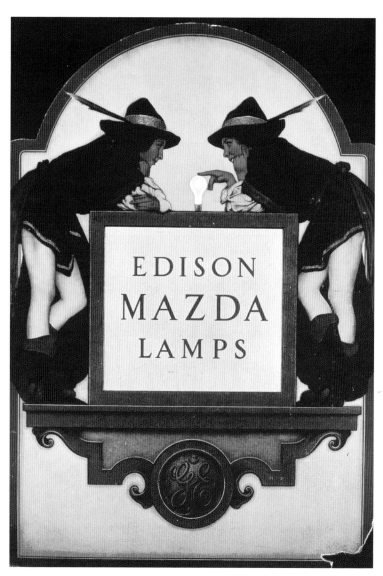

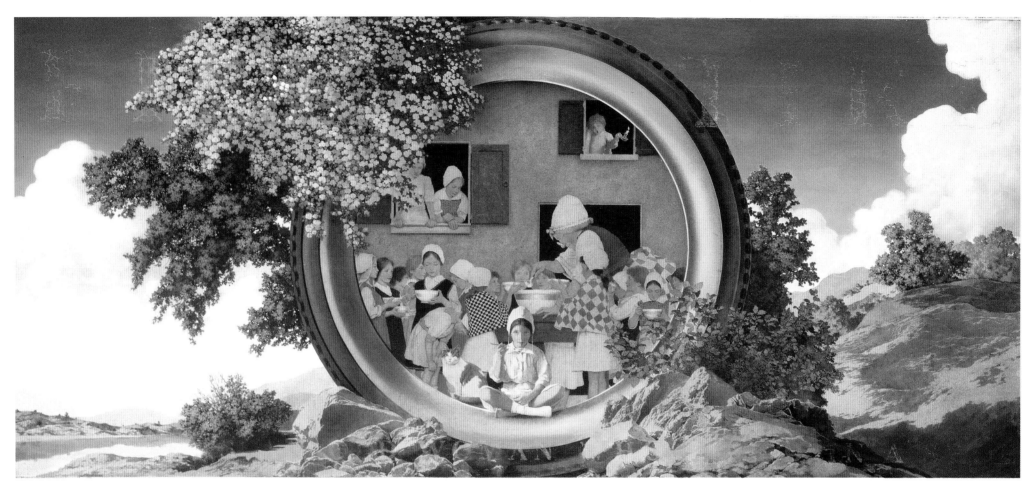

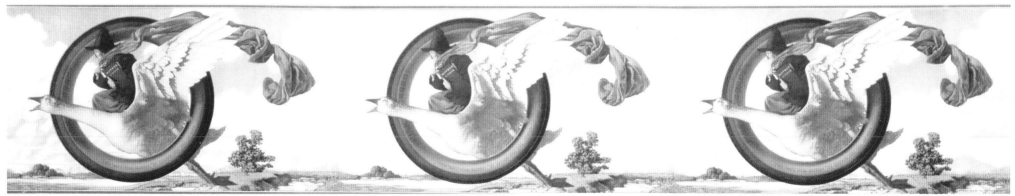

RIGHT

Jell-O advertisement, 1921. Vintage print.
The Genesee Pure Food Company
introduced this advertisement in 1921.

FAR RIGHT
Humpty Dumpty, 1921
Oil on paper, 16¹/₂ x 12in (42 x 30cm).
Life magazine cover, 17 March 1921.

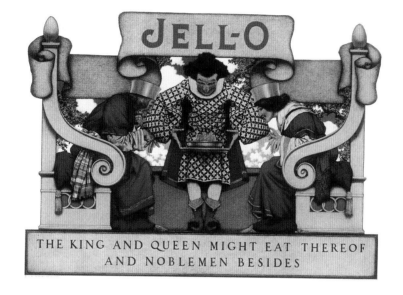

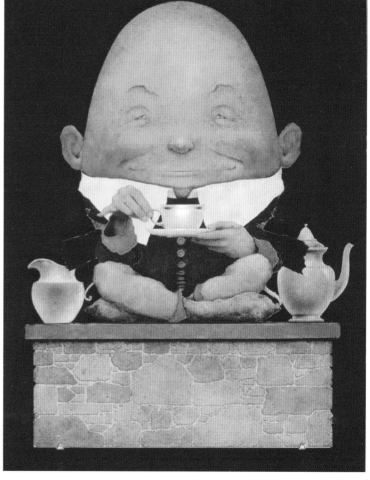

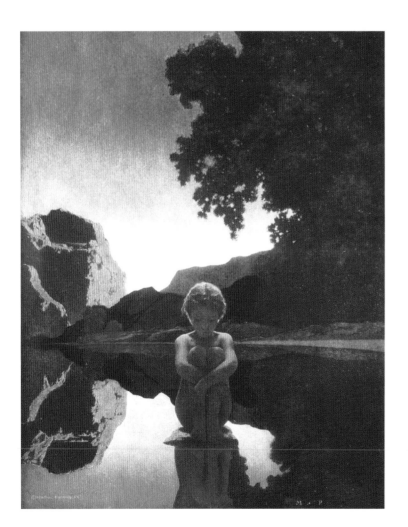

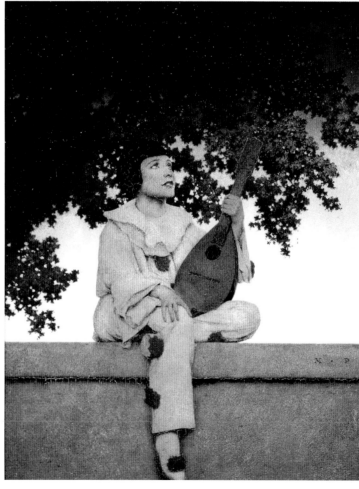

FAR LEFT
Evening, 1922
15 x 12in (38 x 30cm).
House of Art print.

LEFT
Her Window, 1922
Oil on panel, 14³/4 x 11¹/2in (37 x 29cm).

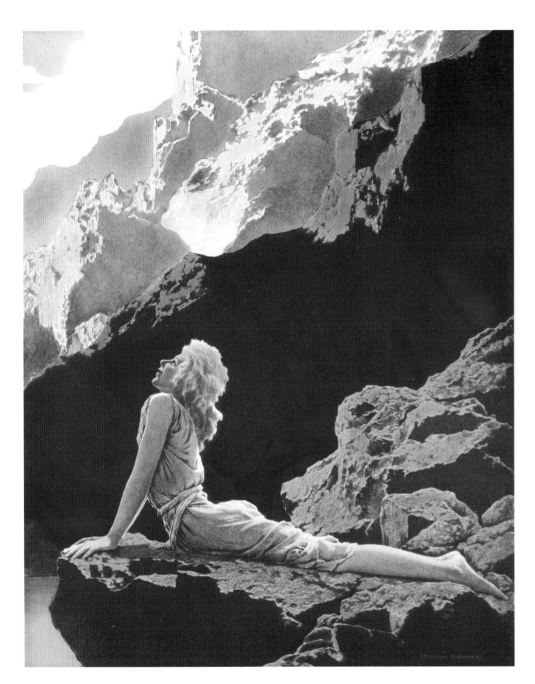

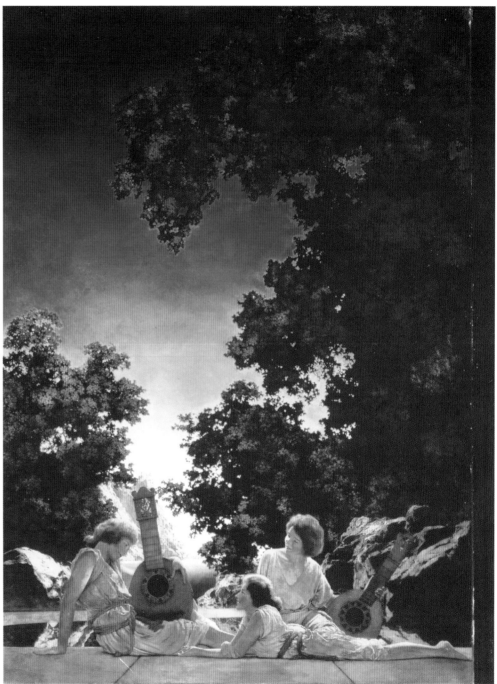

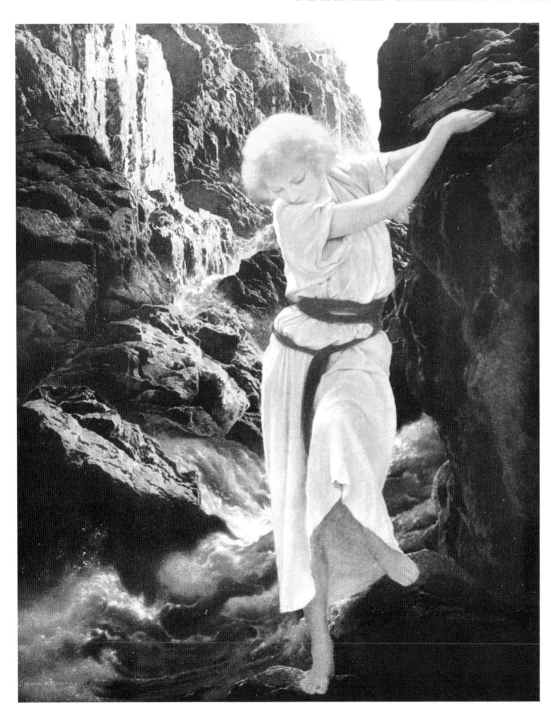

OPPOSITE LEFT
Wild Geese, 1923
Oil on panel, 19³/4 x 15in (50 x 38cm).
House of Art print, 1924.

OPPOSITE RIGHT
Interlude (The Lute Players), 1922
Oil on canvas, 6ft 11in x 4ft 11in
(2.11 x 1.50m). House of Art print of an
original mural for the University of
Rochester Eastman Theatre, 1924.

LEFT
The Canyon, 1924
Vintage print, 15 x 12in (38 x 30cm).
House of Art print.

RIGHT
Hilltop, 1926
Oil on panel, 35³/4 x 22¹/8in (91 x 56cm).
The House of Art (Reinthal and Newman).
Thomas D. Murphy Company calendar,
1942.

OPPOSITE
Dreaming (October), 1928
Print.

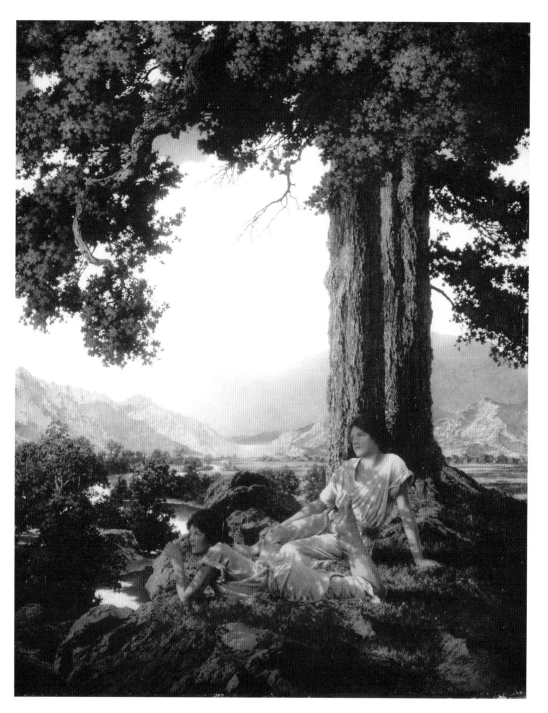

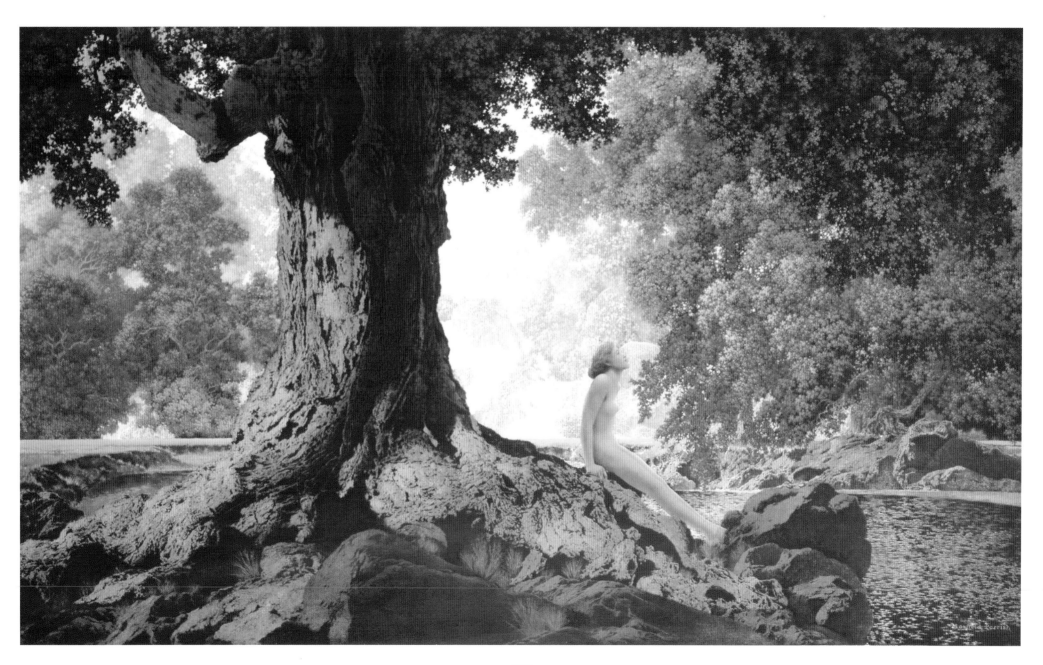

THE ILLUSTRATIONS: CALENDARS & LANDSCAPES (1918–1963)

'Only God can make a tree'. True enough, but I'd like to see Him paint one.

Maxfield Parrish was 48 when Forbes Lithograph Manufacturing of Boston brought him to the attention of the Edison Mazda Lamp Division at General Electric, with the result that he was immediately contracted to produce an advertising campaign to which General Electric had already given considerable thought. Forbes had previously printed Parrish's art images, and was well aware of their quality. They realized that the artist's unusual knowledge of printing processes was a significant factor in their success.

For the first calendar project, Parrish was paid $2,000, with fees rising to $5,000 due to its immediate popularity. After a few years Parrish wished to terminate the contract, but thought twice about it when the fees rocketed to $10,000 each, with one-time printing rights only. The first image painted for Edison Mazda was *Dawn* (page 268), which pictured a girl seated on rocks and consolidated Maxfield Parrish's long career with General Electric. Between the years 1918 and 1934, Parrish produced annual calendar illustrations for the Edison Mazda Company which forged an irrevocable link between artist and company in the minds of the public; many millions of calendars were distributed worldwide.

Years later, when General Electric was pondering the growth of its massive public corporation, much of its early success was attributed to the Parrish calendars, which had been responsible for making its name a household word. The better part of an immense advertising campaign had been achieved through these ubiquitous calendars, where they hung, all year long, in lawyers' and dentists' offices, in kitchens, at local banks and in automobile repair shops. A light bulb was usually suspended in a cartouche as part of a flowing ribbon decoration, in celebration of the blessings electricity had bestowed on mankind. Different applications of light were explored in *Golden Hours* (page 272) and *Contentment* (page 275), *Primitive Man* (page 269) and *Ecstasy* (page 273). Light as a

natural phenomenon was explored to the full, from spectacular sunrises and glowing sunsets to reflections in water. Girls seated on rocks at various times of the day enabled Parrish to carry the concept to its fullest potential. He embellished the borders with architectural details and delicate filigree patterns and named the pieces in his usual simple fashion: *Solitude, Moonlight, Reverie*, and so on.

Maxfield Parrish increasingly used landscapes as backgrounds in his paintings for Edison Mazda. Ultimately, some of these paintings were reworked into stand-alone landscapes by removing the figures altogether. *Moonlight* (page 278) is one such example, and there are other instances, when he would give the work a new title and resell the reproduction rights to another client years after the original had first been used.

The Edison Mazda calendars were exquisitely printed, with nothing spared in the process, 14 colour separations being used. In the end, General Electric boasted that hundreds of millions of potential customers had seen and digested the message and that it had all been well worthwhile. The first electricity promotion had been less than 25 years earlier and Parrish, a visitor to the World's Exposition as a youth, was now a partner with General Electric in this worldwide force for good.

Parrish enjoyed painting images for calendars, because far more people were going to see them, and rather more sooner than magazine or book readers. People loved his lush colour effects and extraordinary attention to detail, and though modern technology can now offer some competition, few have achieved the imaginative designs that Parrish assembled so creatively.

Parrish decided that it was more trouble than it was worth to work on art prints, posters, advertisements, books and periodicals and turned to calendars and landscape painting for the remainder of his life. Although he enjoyed tackling the technical problems of everything he ever created, the amount of dealing and corresponding with city people required to keep them happy was too much of an effort for a man, now in his 60s and growing weary. He had grown tired of certain themes, such as the subject of light in his Edison Mazda works, but

he was especially disenchanted with the never-ending demand for more paintings of 'girls on rocks'. He now preferred peaceful landscapes that he could sell to collectors or license out for calendars to ensure a steady income.

Parrish was so fond of landscapes that somehow or other he always managed to include them in his work, no matter what the assignment, adding even an imaginary landscape whenever the opportunity arose. When questioned about 'realism' in his landscapes, he replied: 'My theory is that you should use all objects in nature, trees, hills, skies, rivers and all, just as stage properties ... on which to hang your idea ... you cannot sit down and paint such things; they are not there or do not last but for a moment. "Realism" of impression, the mood of the moment, yes, but not the realism of things. The colored photograph can do that better.'

Parrish's landscapes were exercises in the use of saturated colour and exquisitely articulated detail and were his true forte. They were usually composites, constructed from photographs and achieved by juxtaposing images from his travels with the familiar New England scene, which to a large extent included the great oak trees in his estate in Plainfield. When studying his collection of glass slides, it is immediately noticeable that the same images and the same trees repeatedly occur. Sometimes the images are reversed, sometimes they are shown as more distant than they really are or on a different scale. The colours draw the viewer's eye – rich autumn oranges and contrasting aquamarine skies – to idealized views, places that essentially belong to the world of make-believe.

In 1931, the Associated Press announced that 'Maxfield Parrish will disregard "Girl-on-the-Rock ideas in art" '. Parrish added to that announcement, 'I'm done with girls on rocks. I have painted them for thirteen years and I could paint them and sell them for thirteen more. That's the peril of the commercial art game. It tempts a man to repeat himself. It's an awful thing to get to be a rubber stamp. I'm quitting my rut now while I'm still able.'

At that time he was in the process of finishing his last girl on a rock painting and had used a 17-year-old Cornish local, Arlene Jenney, as the model. Then and there, Parrish decided to devote himself to his beloved landscapes. Besides, Susan was now over 40 and her figure had matured to the extent that she was no longer suitable as a model. The businessman in him was aware that he could sell the landscapes to Brown & Bigelow for calendars and that his income would always be secure. He gave the reasons for his bold decision to a news reporter: 'Magazines and art editors – and the critics too – are always hunting for something new, but they don't know what it is. They guess at what the public will like and, as we all do, they guess wrong about half the time. My present guess is that landscapes are coming in for magazine covers, advertisements and illustrations. Shut-in people need outlets for their imaginations. They need windows for their minds. Artists furnish them. There are pretty girls on every street, but a city man can't step out of the subway and watch the clouds play tag with the top of Mount Ascutney. It's the unattainable that appeals. Next best thing to seeing the ocean or the hills or the woods is enjoying a painting of them.'

Parrish admitted that it was possible, just barely possible, that he would paint another girl on a rock, just to keep his hand in and that if he did he would 'do the job more painstakingly than ever before' and would keep the finished canvas and hang it in a place of honour at The Oaks.

Brown & Bigelow

From 1931, therefore, with a few exceptions, Parrish kept his promise and painted only landscapes until he stopped painting altogether. In 1935, he signed a contract with the Brown & Bigelow Publishing Company of St. Paul, Minnesota, to produce illustrations for calendars, playing cards and greeting cards. Many millions of calendars, three million greeting cards and one million prints later, and his relationship with the publisher was quite secure. It is said that the calendar with his *Peaceful Valley* (1934) – also known as *Elm, Late Afternoon* – and *Tranquility* – was the first time a landscape had been the most popular image in the entire range, a fact which Parrish relished. The reason for the several titles was

that the image was often used in other applications, on greeting cards or on different calendars when another name was chosen so as not to confuse. Over the years, however, it has caused more confusion than anyone would have imagined.

When Brown & Bigelow once suggested that he inject more excitement into a farm scene, Parrish was annoyed, retorting that the only way to make it more exciting would be to set the barn on fire.

However, these landscape paintings never achieved the same degree of popularity as the girls on rocks, neither did they come even close to equalling Parrish's best-selling art print, *Daybreak*, even though they were beautifully executed and much coveted today.

Brown & Bigelow had their art director visit Parrish to select images for calendars and greeting cards. Over the years, from 1937 until 1942, Parrish re-released many previously painted images, for example, to the Thomas D. Murphy Company for use on its calendars. Suddenly, in the late 1930s, however, when the Murphy relationship was well established, Parrish's creativity took a dive. He began to brood on the people who were copying his work, which made him thoroughly depressed as a result. This coincided with the fact that the public had almost had enough of his work. As with the Murphy calendars, the Brown & Bigelow images were earlier paintings or images Parrish simply felt like doing, rather than works created specifically for the purpose. Brown & Bigelow re-released some of these much later, giving them new titles. It simply reused the images under licence from Parrish and later from his estate through Maxfield Parrish, Jr.

It was uncanny the way Maxfield Parrish was echoing his father when he turned to landscape painting in 1931. Although his popularity had waned with the proliferation of art prints and calendars, a key element in this had been the advent of copyists imitating his style. The market was now saturated with both Parrish and pseudo-Parrishes, in fact, there was a veritable flood. Meanwhile, Parrish was remarking more and more often how important it was to have a view of nature on one's wall.

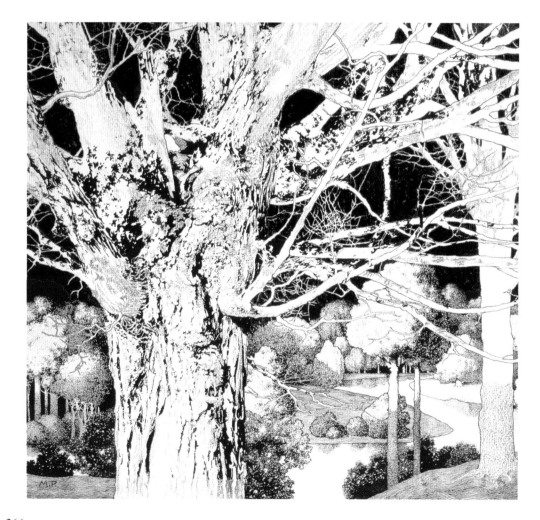

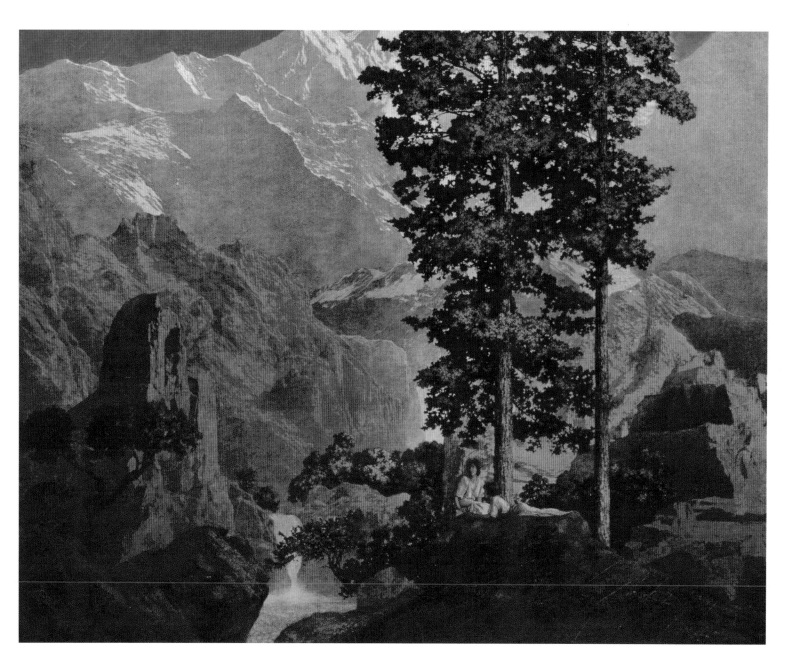

OPPOSITE
Solitude (Trees), c.1906
Ink, gouache and charcoal on board,
16 x 17in (41 x 43cm).

LEFT
Solitude, 1911
Oil on board, 32 x 40in (81 x 102cm).

RIGHT
Dawn, 1918
Vintage print. General Electric Mazda
Lamps calendar.

FAR RIGHT
Spirit of the Night, 1919
Lithograph–progressive proof of calendar,
overall size 22 x 21¹/₂in (56 x 55cm).
Original 1919 Spirit of the Night
illustration was in oil on panel.

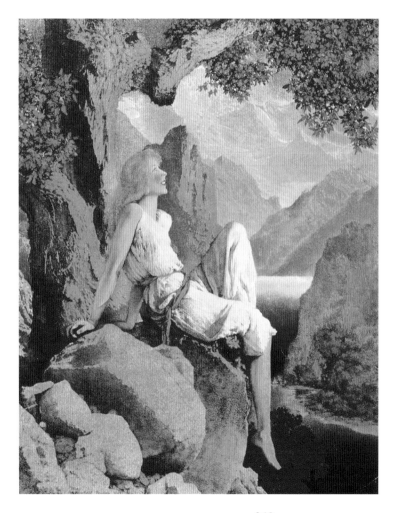

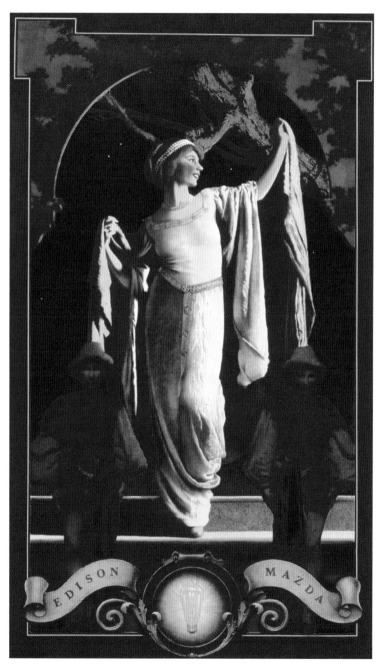

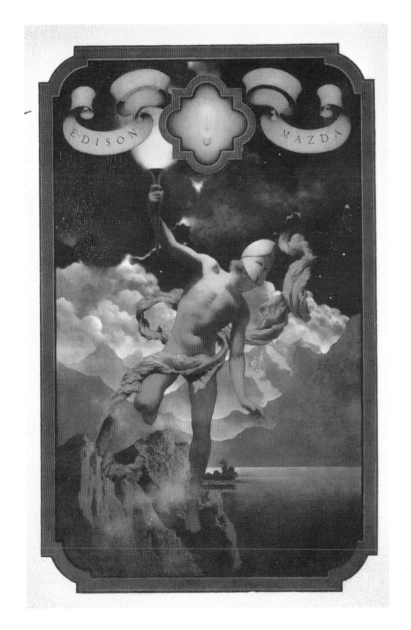

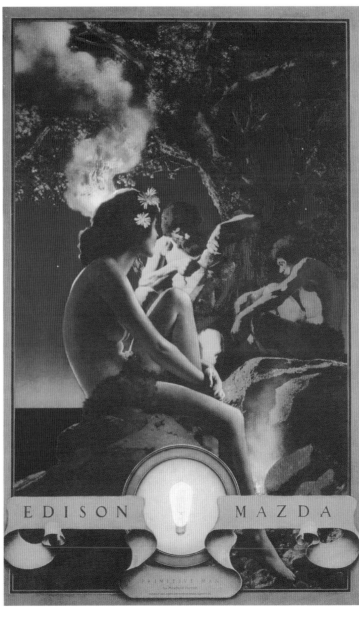

FAR LEFT
Prometheus, 1919
Vintage print. General Electric Mazda Lamp calendar, 1920.

LEFT
Primitive Man, c.1919
General Electric Mazda Lamp calendar.

Little Sugar River at Noon, 1930
Oil on panel, 15^1/$_2$ x 19^3/$_4$in (39 x 50cm).

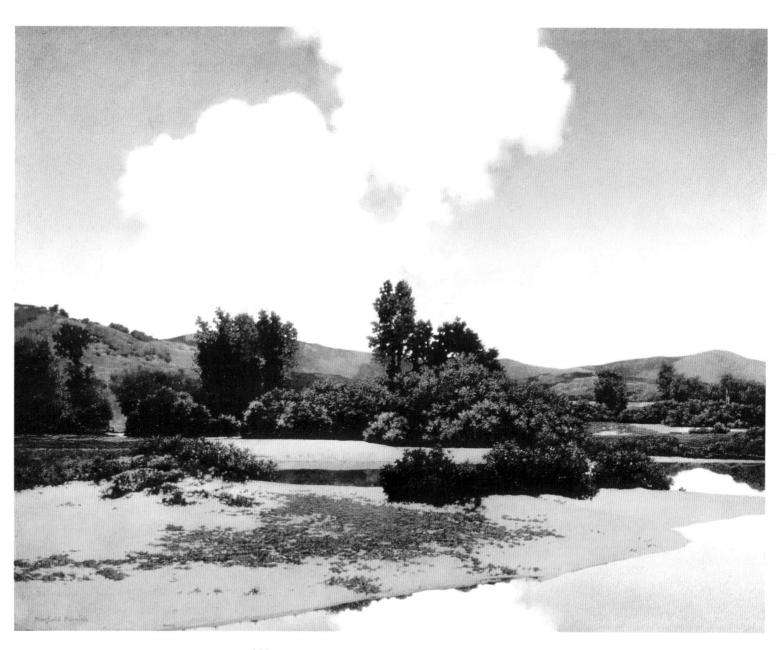

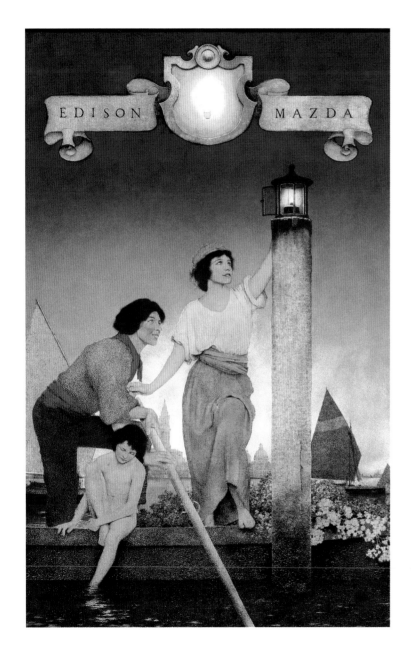

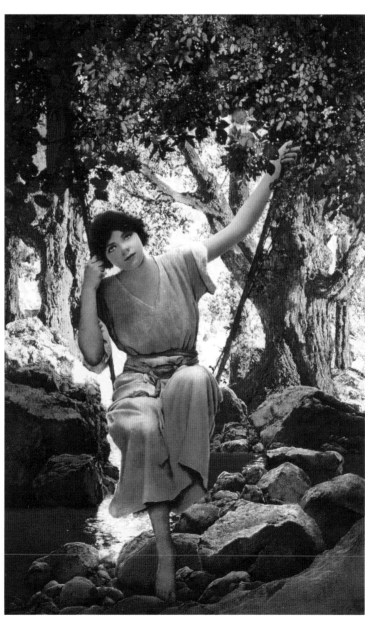

FAR LEFT
Venetian Lamplighters, 1922
Oil on panel, 28³/4 x 18³/4in (73 x 48cm).
General Electric Mazda Lamps calendar
illustration, 1924.

LEFT
Dream Light, c.1925
General Electric Edison Mazda Lamps
calendar.

271

RIGHT
Golden Hours, c.1929
General Electric Edison Mazda Lamps calendar.

CENTRE RIGHT
Reverie, 1927
General Electric Edison Mazda Lamps calendar.

FAR RIGHT
Ecstasy, 1930
General Electric Mazda Lamps calendar.

OPPOSITE LEFT
Reverie, 1926
Oil on panel, 35 x 22in (89 x 56cm). Illustration for General Electric Edison Mazda Lamps calendar.

OPPOSITE RIGHT
Ecstasy, 1929
Oil on board, 36 x 24in (91 x 61cm). Illustration for General Electric Mazda Lamps calendar.

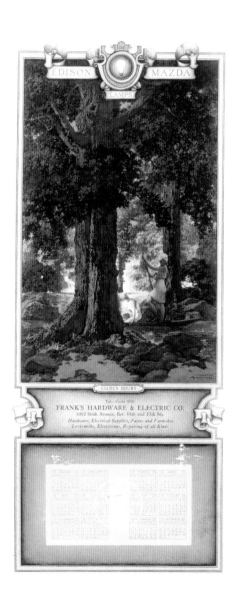

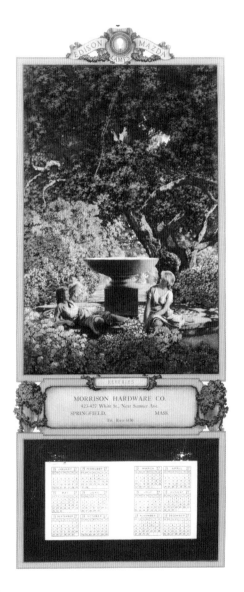

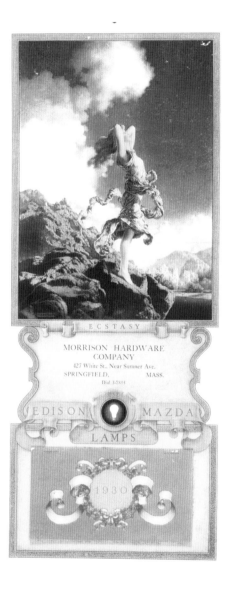

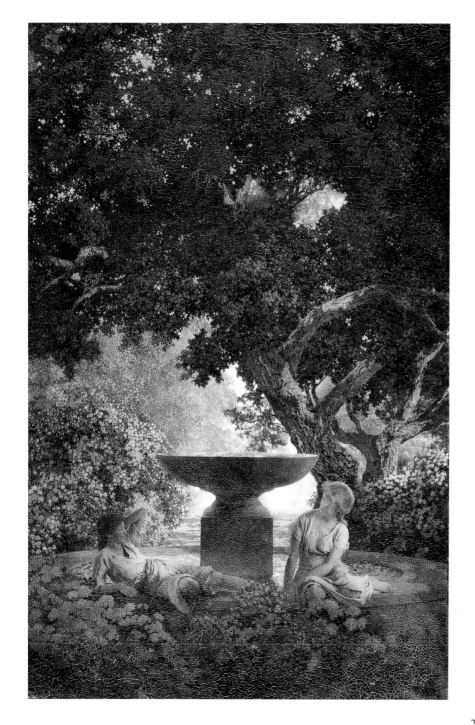

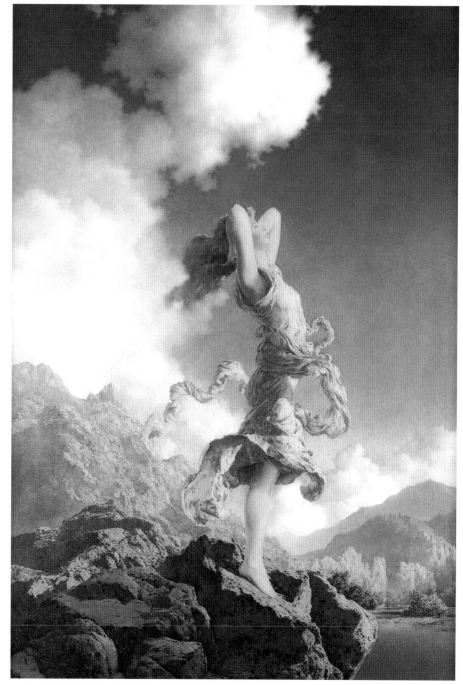

RIGHT
Cinderella (Enchantment), 1913
Oil on panel, 30 x 24in (76 x 61cm).
Harper's Bazaar cover, 1914, General
Electric Mazda Lamps calendar 1926.

OPPOSITE LEFT
Contentment, 1927
Oil on panel, 36 x 22$\frac{1}{2}$in (91 x 57cm).
Illustration for Edison Mazda Lamps
calendar 1928.

OPPOSITE RIGHT
Waterfall, 1930
Oil on panel, 32 x 22in (81 x 56cm).
Illustration for General Electric Mazda
Lamps calendar, 1931.

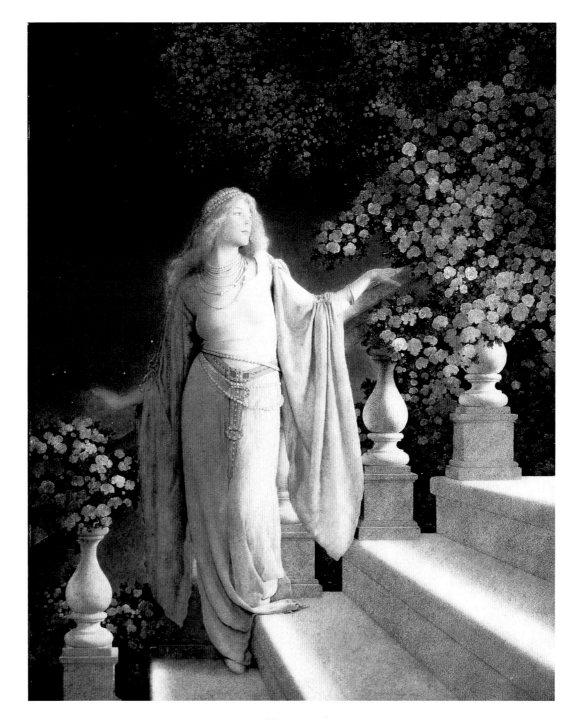

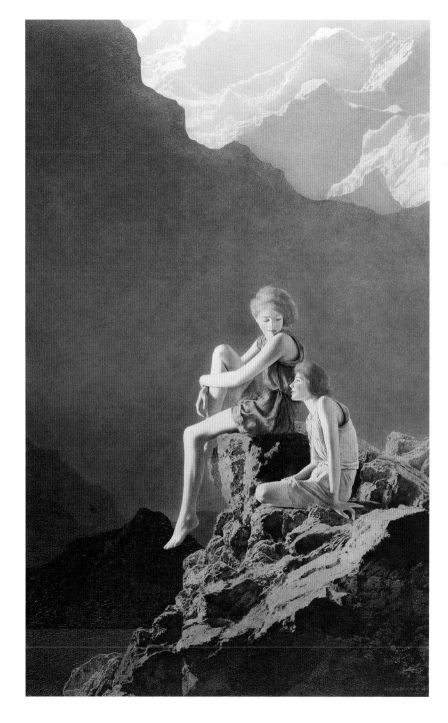

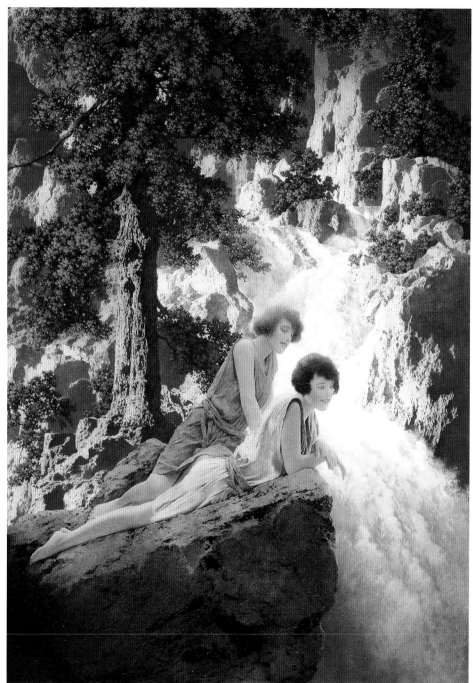

RIGHT
Sugar Hill, Late Afternoon, 1930
Oil on board, 25 x 30in (63 x 76cm).

OPPOSITE LEFT
White Birch, Winter, 1931
Oil on panel, 25 x 20in (63 x 51cm).

OPPOSITE RIGHT
Sunrise, 1931
Oil on panel, 31³/4 x 22¹/2in (81 x 57cm).
Illustration for General Electric Mazda
Lamps calendar, 1933.

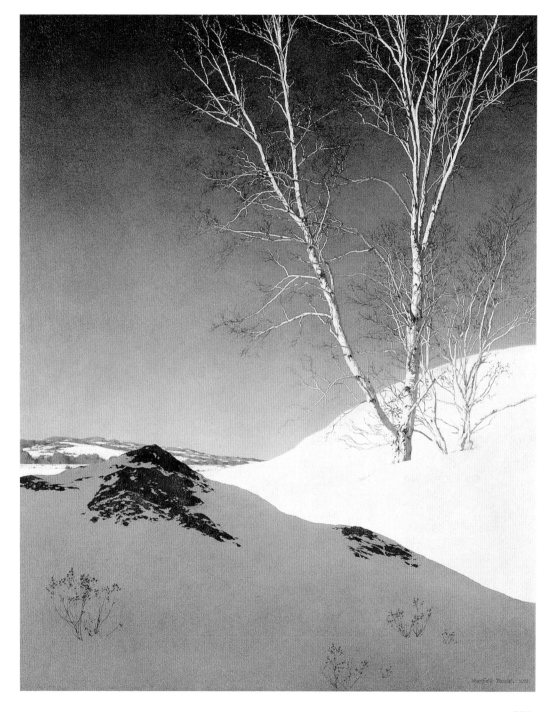

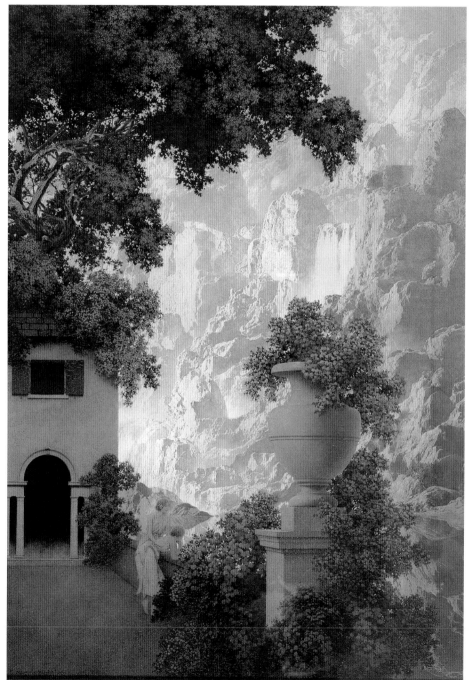

RIGHT
Solitude, 1932
*Vintage print. Original illustration used
for a General Electric Edison Mazda
Lamps calendar in 1932.*

FAR RIGHT
Moonlight, 1932
*$32^5/8$ x $22^3/4$in (83 x 58cm).
Illustration for General Electric Edison
Mazda Lamps calendar, 1934.*

OPPOSITE LEFT
New Hampshire Hills, 1932
Oil on panel, 23 x $18^5/8$in (58 x 47cm).

OPPOSITE RIGHT
The Enchanted Prince, 1934
Oil on board, 24 x $22^3/4$in (61 x 58cm).

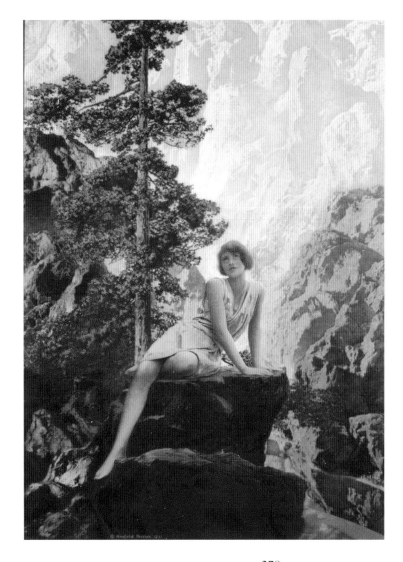

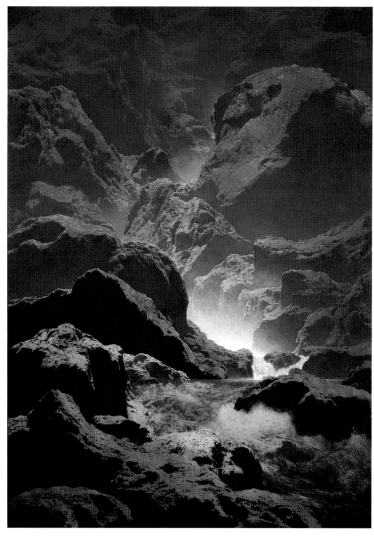

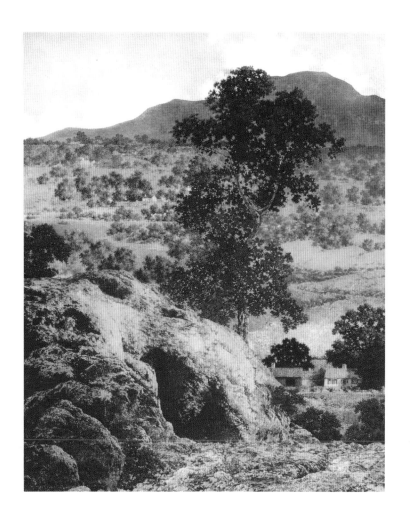

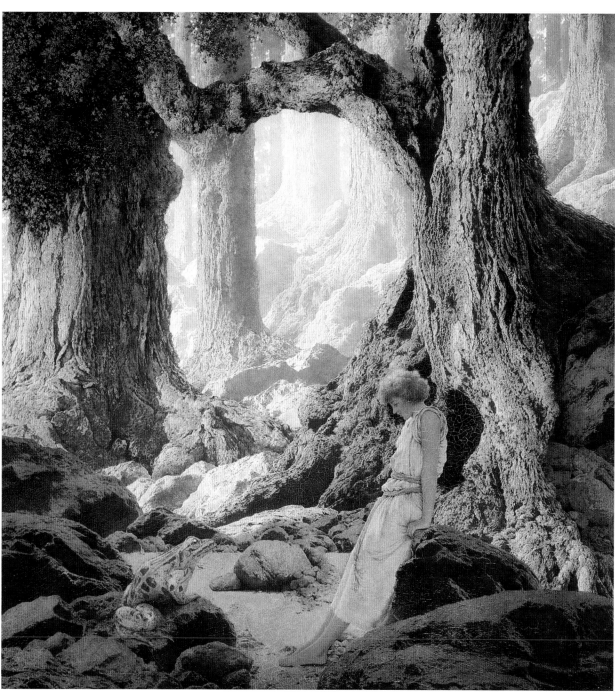

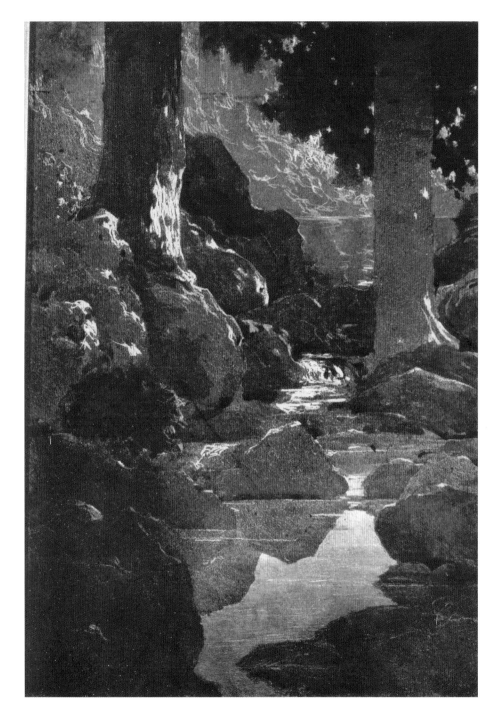

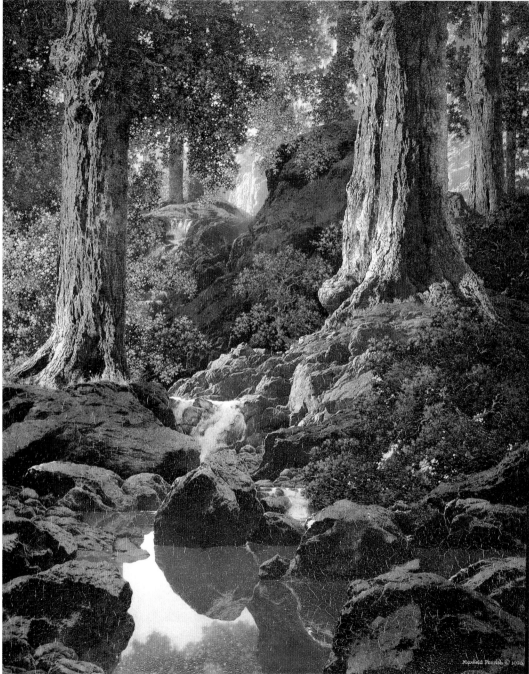

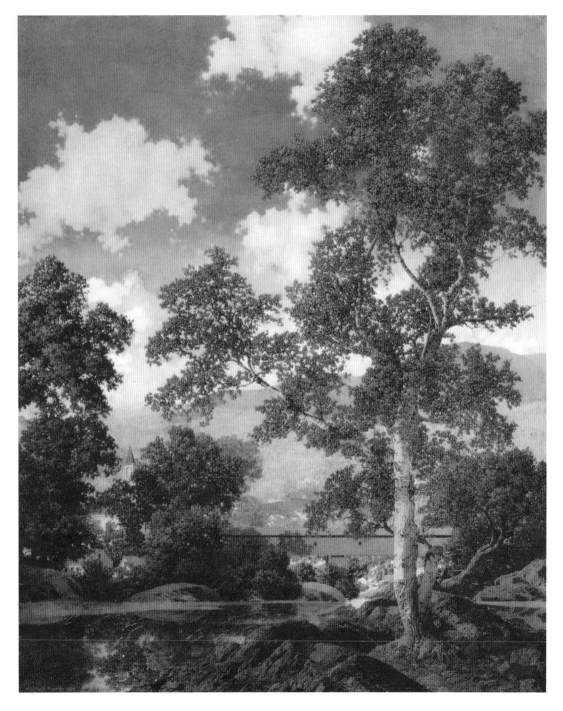

OPPOSITE LEFT
The Glen, c.1936
Study for Brown & Bigelow calendar,
1936.

OPPOSITE RIGHT
The Glen, 1936
Oil on Masonite, 33¹/₄ x 28in (84 x 71cm).
Brown & Bigelow calendar, 1938.

LEFT
Early Autumn (White Birch), 1936
Oil on panel, 31 x 25in (79 x 63cm).
Brown & Bigelow calendar, 1939.

RIGHT
County Schoolhouse (Village Schoolhouse), 1937
Oil on panel, 30 x 24in (76 x 61cm).

FAR RIGHT
New Hampshire: The Winter Paradise, 1939
Original promotional poster for The New Hampshire Scenic Planning and Development Commission, 1939.

OPPOSITE LEFT
River Bank, Autumn, 1938
Oil on panel, 17 1/2 x 20in (44 x 51cm).

OPPOSITE RIGHT
June Skies (A Perfect Day), 1940
Oil on panel, 23 x 18 1/2in (58 x 47cm). Illustration for Brown & Bigelow calendar, 1943.

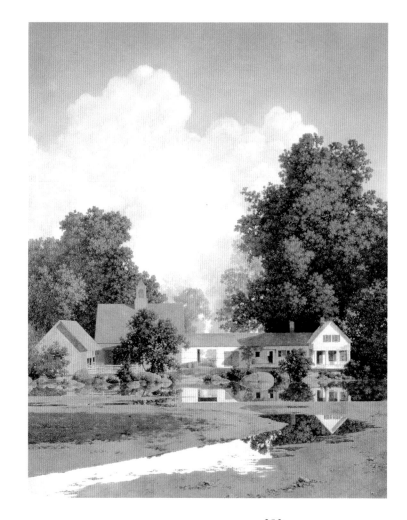

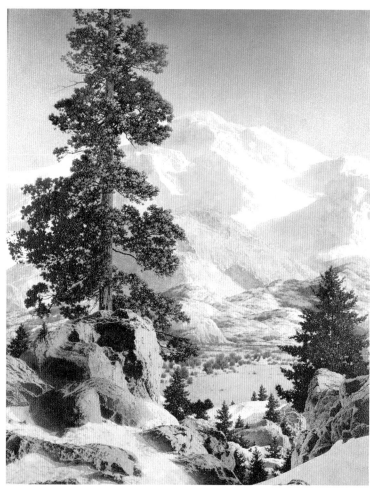

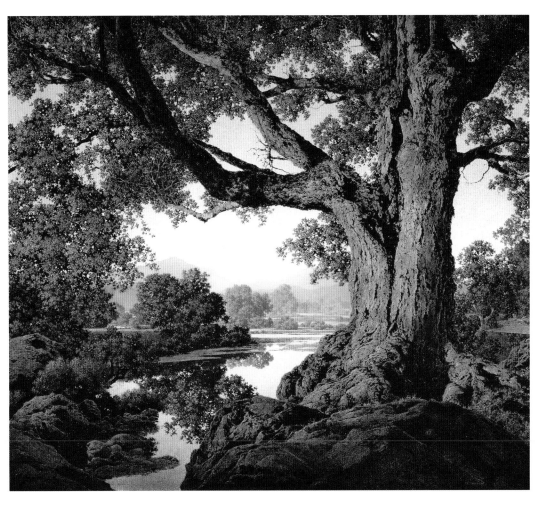

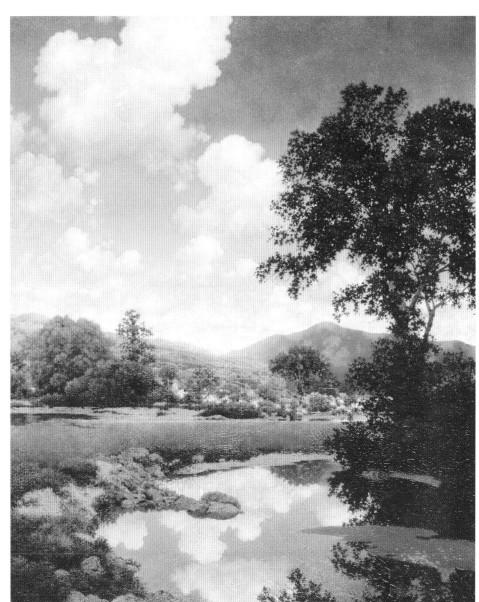

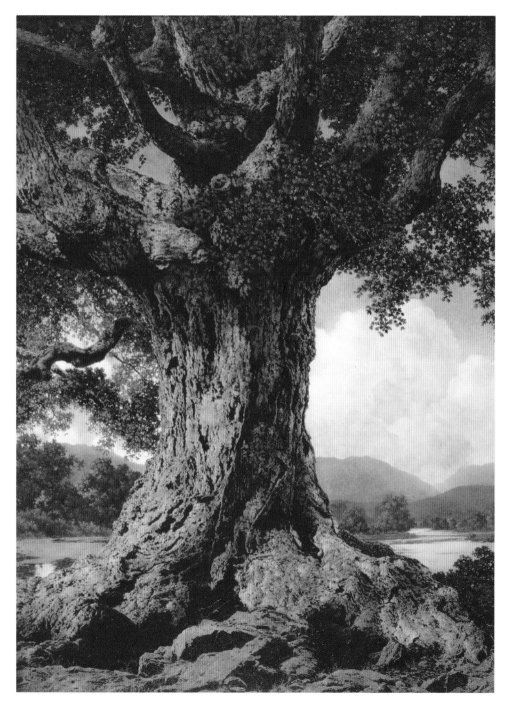

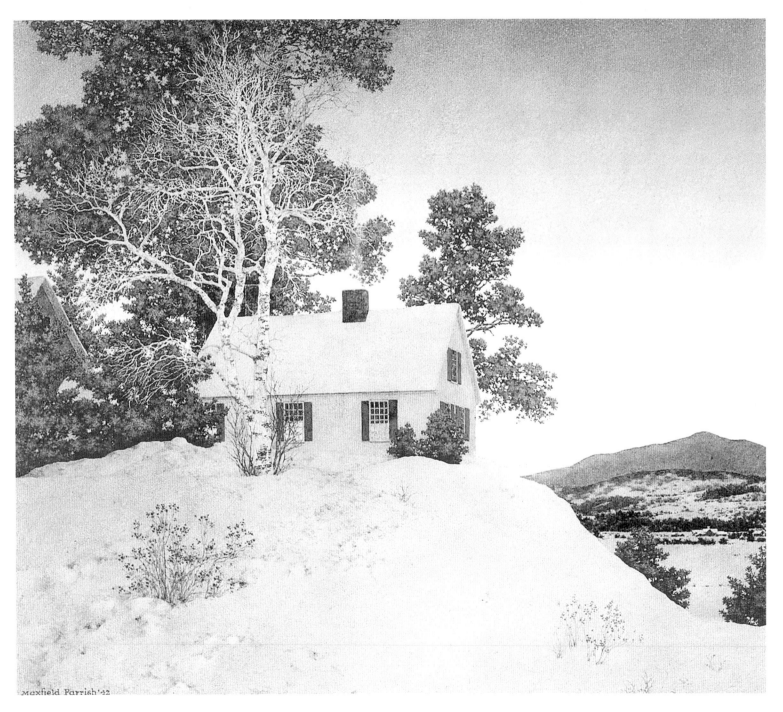

Maxfield Parrish '42

OPPOSITE LEFT
Ancient Tree, 1941
Oil on board, 23 x 18⁵/₈in (58 x 47cm).
Illustration for Brown & Bigelow
calendar, 1952.

OPPOSITE RIGHT
River at Ascutney, 1942
Oil on panel, 23 x 18¹/₂in (58 x 47cm).

LEFT
Dusk, 1942
Oil on Masonite, 13¹/₄ x 15¹/₄in
(34 x 39cm). Photograph courtesy of New
Britain Museum of American Art.

RIGHT

Road to the Valley, 1943

Oil on Masonite, 23 x 18⅝in (58 x 47cm).

FAR RIGHT

Good Fishing, 1945

*Oil on paper laid down on Masonite,
23 x 18½in (58 x 47cm).*

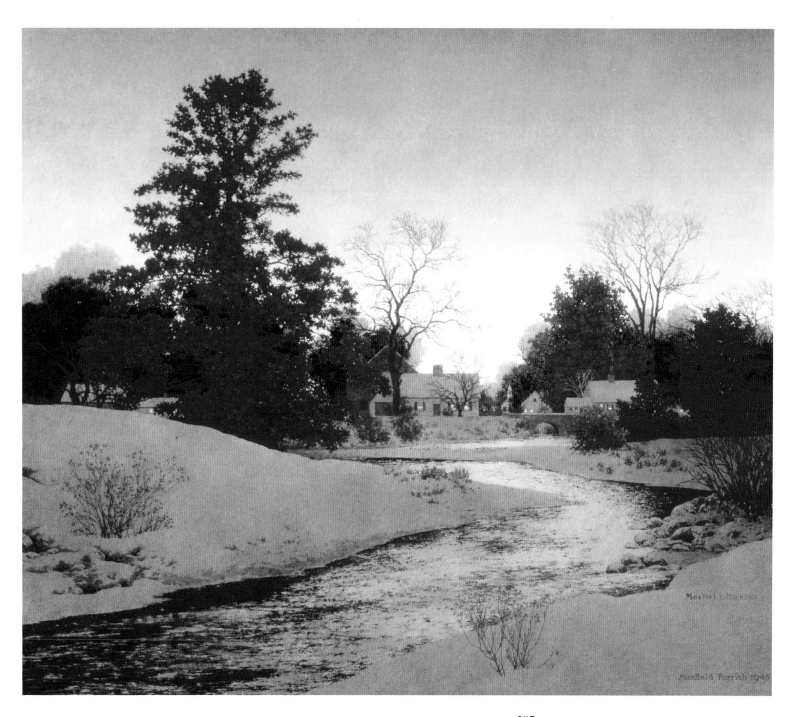

Lull Brook, Winter, 1945
Oil on board, 13^1/$_2$ x 15^1/$_2$in (34 x 39cm).
Illustration for Brown & Bigelow
executive print, 1947.

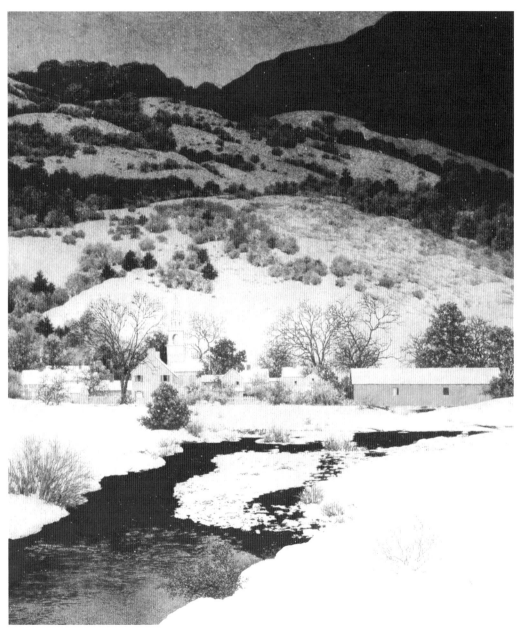

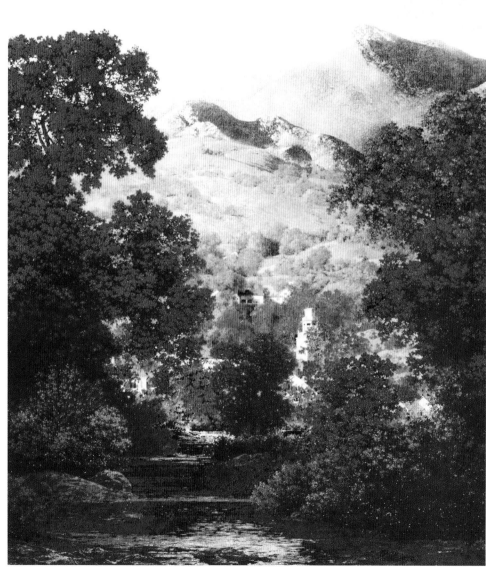

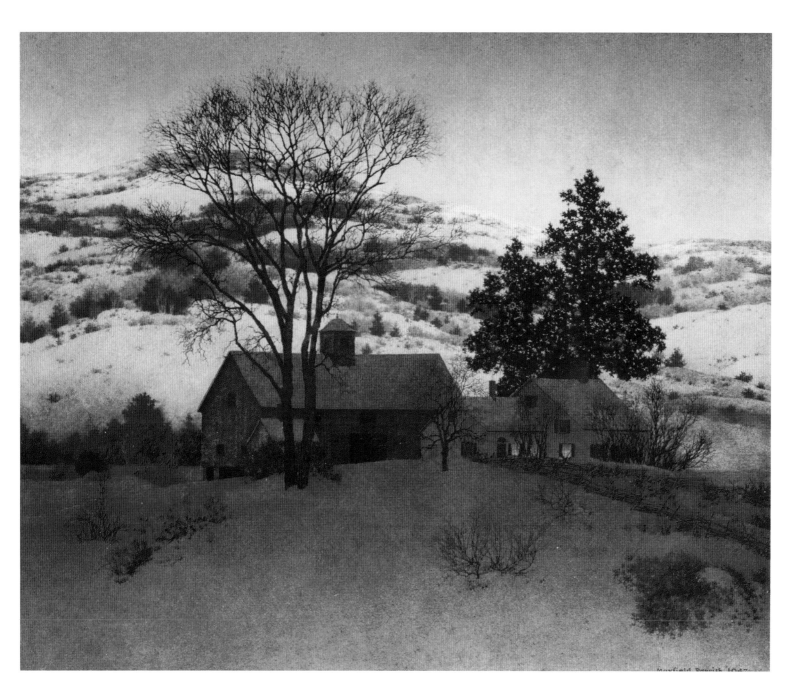

OPPOSITE LEFT
Christmas Eve (Deep Valley), 1946
Oil on panel, 15¹/2 x 13¹/2in (39 x 34cm).
Illustration for Brown & Bigelow
calendar, 1948.

OPPOSITE RIGHT
Sunlit Valley, 1947
Oil on panel, 23 x 19in (58 x 48cm).
Illustration for Brown & Bigelow
calendar, 1950

LEFT
Afterglow (A New Day), 1947
Oil on panel, 13¹/2 x 15in (34 x 38cm).
Illustration for Brown & Bigelow
calendar, 1950.

RIGHT
Church at Norwich, Vermont, 1950
Oil on panel, 21¹/₂ x 17¹/₂in (55 x 44cm).
Illustration for Brown & Bigelow
calendar, 1953.

FAR RIGHT
Glen Mill, 1950
Oil on panel, 23 x 18¹/₂in (58 x 47cm).

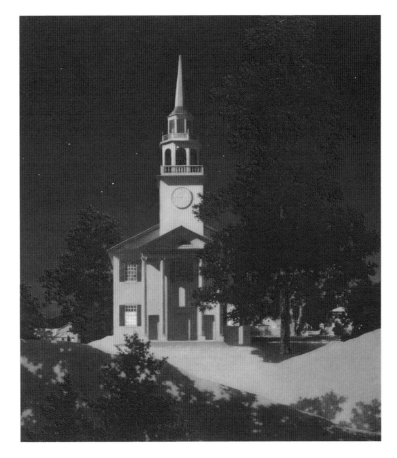

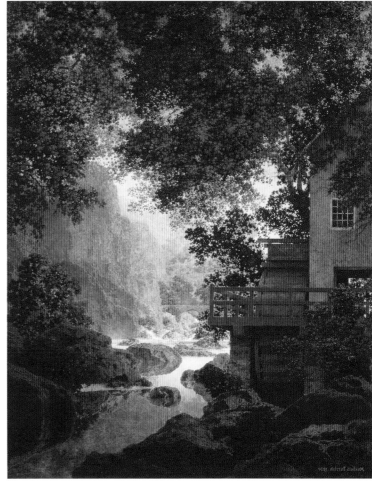

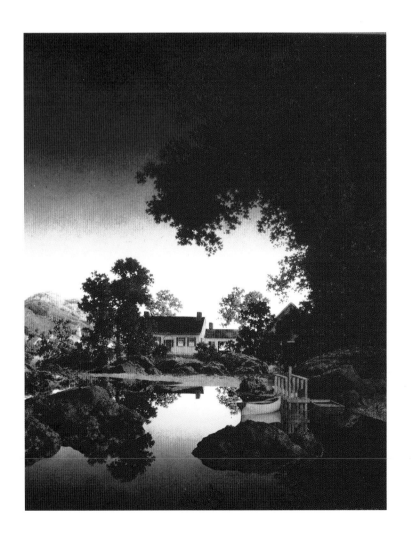

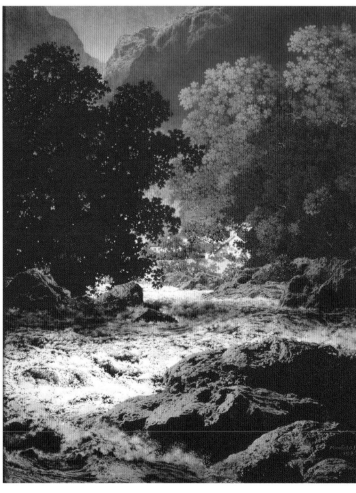

FAR LEFT
Peace of Evening (Evening Shadows), 1950
Oil on panel, 23 x 18³⁄₄in (58 x 48cm).
Illustration for Brown & Bigelow calendar, 1953.

LEFT
Swift Water (Misty Morn), 1953
Oil on panel, 23 x 18¹⁄₂in (58 x 47cm).
Illustration for Brown & Bigelow calendar, 1956.

Hilltop Farm, Winter (Lights of Welcome), 1952
Oil on panel, 13¹/₂ x 15¹/₂in (34 x 39cm). Illustration for Brown & Bigelow calendar.

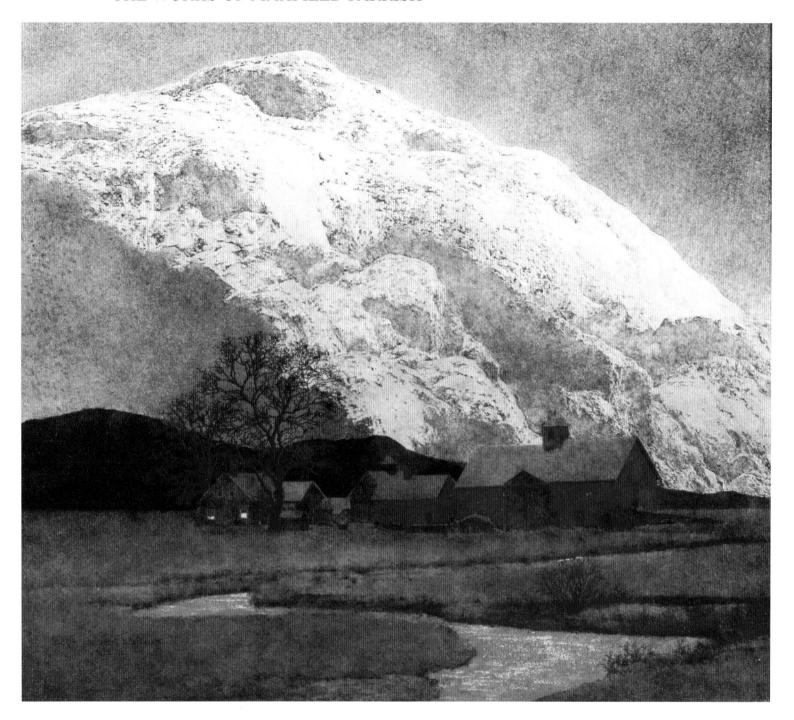

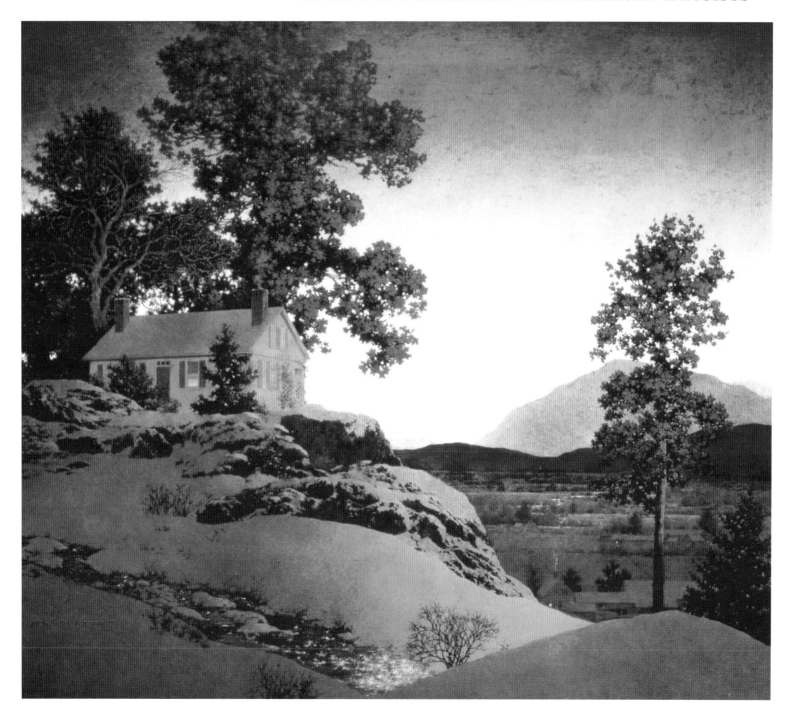

Evening (Winterscape), c.1956
Oil on artist board, $13^{1}/_{2}$ x $15^{1}/_{2}$in
(34 x 39cm). Brown & Bigelow executive
print, 1956.

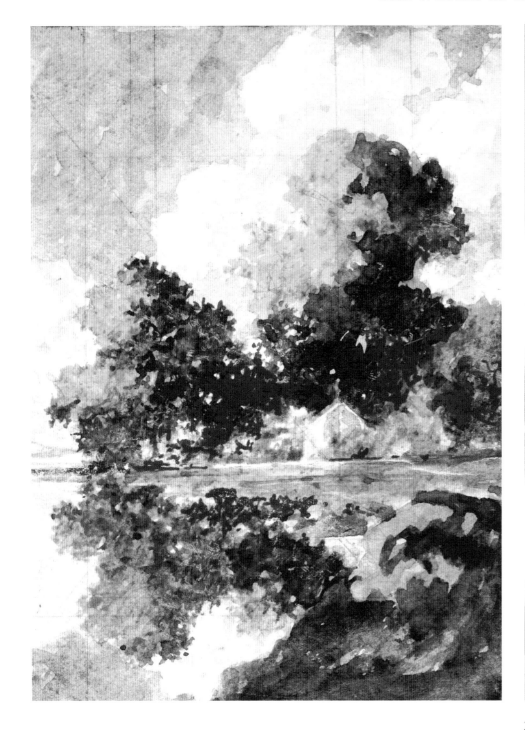

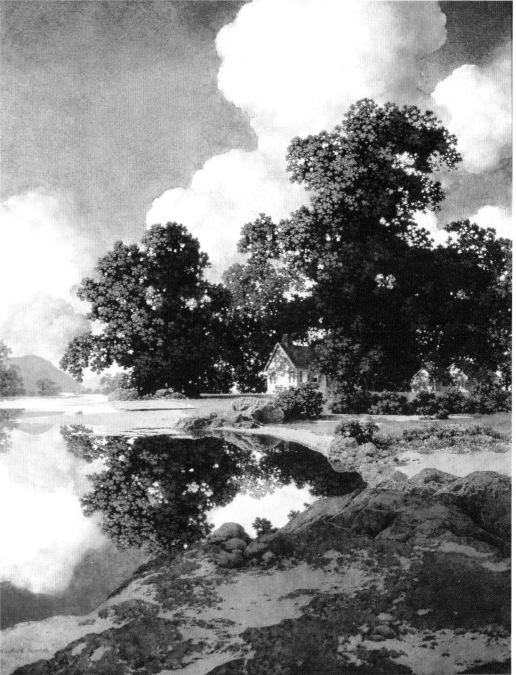

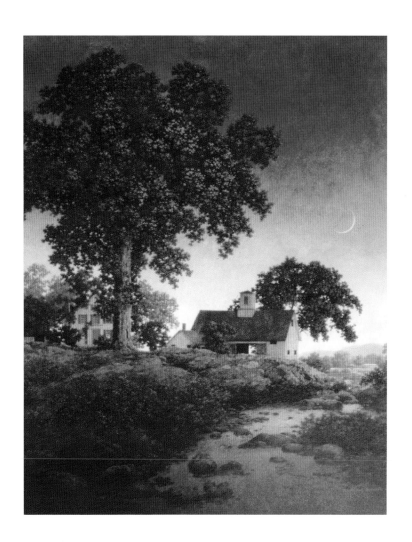

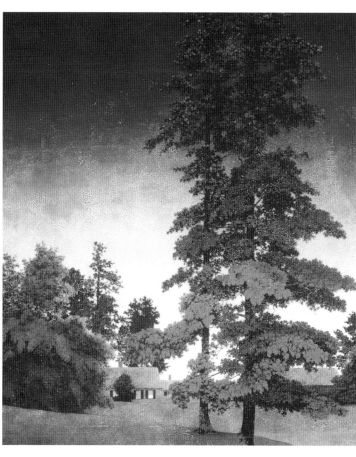

OPPOSITE LEFT
Sheltering Oaks (A Nice Place to Be), 1956
Watercolour on paper, 5³/4 x 4¹/2in (15 x 11cm).
Study for Brown & Bigelow calendar, 1956.

OPPOSITE RIGHT
Sheltering Oaks (A Nice Place to Be), 1956
Oil on board, 23 x 18¹/2in (58 x 47cm).
Illustration for Brown & Bigelow calendar, 1956.

FAR LEFT
New Moon, 1958
Oil on panel, 23 x 19in (58 x 48cm).
Illustration for Brown & Bigelow calendar, 1958, Brown & Bigelow playing cards, 1962.

LEFT
Winter Night Landscape (Two Tall Pines), c.1957
Oil on board, 18¹/2 x 16in (47 x 41cm).
Study.

MURALS, STAGE SET DESIGNS & PHOTOGRAPHY (1894–1918)

I've always considered myself strictly a 'popular' artist.

Maxfield Parrish combined the spirit of the Pre-Raphaelites with a photographic vision of romantic images, which he flooded with pure colour. Possibly the best way to appreciate his work, beyond a printed image on a page held in one's hands, is to see his murals or one of his set designs, or to study one of his extraordinarily sensitive photographs. None of these artworks was created to be reproduced as an illustration, yet they demonstrate the genius of a true artist.

Although Parrish was paid to produce unique artworks for each commission, the real mainstay of his career lay in the prolific and profitable illustrations designed to be reproduced in periodicals, books, advertising, calendars and art prints. But his dimensions as an artist permitted him to go beyond all this. He was able to create vast murals with a quality of timelessness, set designs which inspired dramatic performances, and photography as precise and ordered as that of a contemporary fashion photographer with a digital camera. Ever since the World's Columbian Exposition, murals had begun to be recognized as a viable and legitimate means of expression for artists. Murals are usually considered a part of illustration art, for they tell a story and many of them have even been reproduced as art prints. In 1895, the National Society of Mural Painters was incorporated to educate the public regarding murals and their use as decorations for public spaces. The year prior, at the age of 24, Parrish completed his first mural, Old King Cole, for the University of Pennsylvania. A decade or so later, he took on several other commissions, including the Curtis Florentine Fête murals, which Coy Ludwig considered to be among his most significant achievements.

Maxfield Parrish created artworks on totally different scales, yet they always seemed the appropriate size, whether reduced to fit on a book page or enlarged to fill a billboard or a backdrop on a stage. People could identify with his characters, even though they belonged to a world of fantasy. These unique compositions were superbly executed, first as scale models, and it was only when they were enlarged as stage sets or murals that one recognized how well they suited their specific purpose.

Parrish began as an architect and became an artist later on, which is evident in the sense of scale and proportion he manages to convey. Unlike most illustrators bound to working within a small dimension, say, for a magazine cover, Parrish always envisaged these creations in three dimensions and at scales larger than life. Consequently, each of his murals seems perfectly placed in its respective location. There is a strong sense of physical movement which grasps the attention before it slides towards the details – a sensation difficult to describe; it is necessary to actually see them to understand.

As mentioned earlier, illustrators during the Golden Age were primarily trained as fine artists. Parrish had more exposure than most to the painting styles of the European masters, so it was hardly surprising when forward-thinking clients considered him for commissions other than illustrative works. These unique commissions were as rewarding for the artist as anything he ever endeavoured in the realms of illustration. He was a perfectionist and worked tirelessly towards the perfection of his vision. He was possibly the most versatile of artists.

The Murals
Old King Cole, 1895

In the fall of 1894, on returning to the Pennsylvania Academy from Cornish, Maxfield Parrish was contacted by Wilson Eyre, Jr., architect of his father's house, Northcote. The architect wondered if Parrish would be interested in a commission to paint a mural, a few posters and other decorative works for a theatrical club. Eyre felt he owed Stephen Parrish a favour for the Cornish project and was reciprocating. He suggested that the 24-year-old art student produce some murals for a stable being converted by him into a clubhouse for the University of Pennsylvania's Mask and Wig Club at 310 Quince Street. Thus Parrish began his career in art.

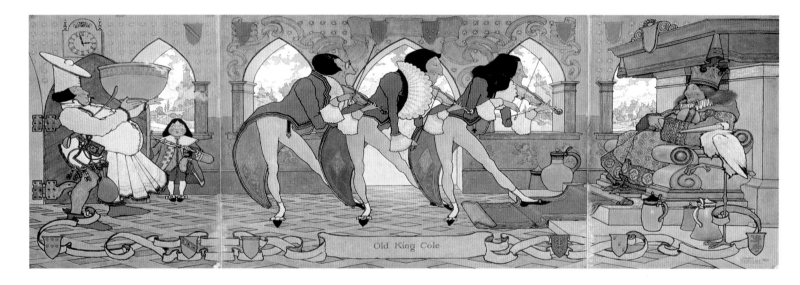

Old King Cole, 1895
Oil on canvas, 44 x 132in (1.2 x 3.35m).
Painted for the Mask and Wig Club of the
University of Pennsylvania.

Parrish's first commissioned work was the study for a comic mural featuring Old King Cole in a 5 x 12-ft (1.5 x 3.6-m) wide strip to be placed over the bar at the club. In the scene, each figure is over-characterized, in fact they are caricatures of a typically stout chef with a ladle under his arm, a trio of long-haired musicians playing for the merry old soul, and of King Cole himself, seated on his throne, having downed several tankards of beer which are lying about the floor. Parrish was enthusiastic about the commission, while letting his father know that the members of the club were not so happy with Wilson Eyre, Jr., due to the renovation costs of their clubhouse having overrun their target.

The club members were delighted with their mural and decorations when they were completed. In December, the watercolour study for the mural was purchased by the Pennsylvania Academy of the Fine Arts for its collection and it remains there to this day.

In his log book recording his artworks and sales, Parrish's first entry reads: 'Preliminary Sketch for Old King Cole. Painted in November 1894 at no. 320 so. Broad St. Water Color Drawing on manila paper with here and there pieces of paper of various colors cut out and pasted on thus making many different qualities of tone. Between the glass and drawing is a sheet of transparent celluloid upon which is painted the sky. EXHIBITED in the Pennsylvania

THE WORKS OF MAXFIELD PARRISH

Academy of the Fine Arts in Dec. 1894. Sold to same for its permanent collection for $100. Framed by self*. Reproduction as it appeared in catalogue of Architectural Dept. on page 11. *Made at Windsor, Vermont.'

The study-sketch of Old King Cole was later reproduced in *Harper's Weekly* on 2 March 1895 and gave rise to the following descriptive narrative – the first piece of national publicity received by the young artist and the first comment on his 'brilliant blue'. Reading this review and seeing its impact on the viewing public possibly inspired Parrish to use the colour more and more in the years to come until it became something of a personal trademark.

'Maxfield Parrish, of the School of Industrial Art, Philadelphia, sends a very clever drawing of a decoration for the club room of the Mask and Wig Club, the amateur dramatic association of the University of Pennsylvania, which is quite remarkably quaint, reminding one, both in drawing and coloring of Walter Crane or William Morris. The subject is taken from the old nursery rhyme of King Cole and his fiddlers three, and shows those interesting personages in an apartment of the palace, which is rendered in dull green tones. Through the arched openings in the background, one sees a bright green landscape and a sky of brilliant blue, with white, fleecy clouds.'

Nothing was more important to Maxfield Parrish than his work, and he consequently preserved every article and critique ever published. Like his father before him, he kept impeccable records of transactions, reviews and other documentation for provenance, posterity and simply for fun.

The Pennsylvania Academy loaned the study for exhibition at the Architectural League of New York, where it attracted the attention of a young, up-and-coming architect, Thomas Hastings (1860–1929) of Carrère & Hastings, designers of Vernon Court and venue in 1998 for the National Museum of American Illustration. Hastings organized the Architectural League exhibition and also wrote an article describing it.

An important visitor to the exhibition, whose purpose was to see Parrish's work at the suggestion of Howard Pyle, was Thomas W. Ball, art director of *Harper's Bazaar*. Ball, suitably impressed, asked Parrish to submit a design for the 1895 Easter number of *Harper's*, to which he submitted two designs, both of which were accepted for publication, the second published in *Harper's Young People*.

The 44 x 132-inch mural of Old King Cole was inscribed by Parrish, 'Painted for the Mask and Wig Club of the University of Pennsylvania by F. Maxfield Parrish, 1895', where it made an impressive sight until a few years ago when it was sold by the club. Because of the mural's popularity with the club's members and their guests, other assignments were immediately forthcoming, including the ornamental decorations on the grill-room walls, decorations over the proscenium, designs above a bulletin board in the entrance hall, graphic designs for various posters and programme covers, and charming caricatures of the members on the grill-room wainscoting over the pegs for their respective beer mugs.

The original Old King Cole created an agreeable setting for Mask and Wig productions for over 100 years. It was such a strong statement of the two-dimensional arts, combining as it did with the theatre arts to draw everything together, that it set a subtle direction, if not a tone, for each performance. The decision as to which plays and musicals should be performed was obviously made in the very halls decorated and embellished by Parrish; moreover, he was also responsible for designing the theatre programmes, using his original bold graphics, which could not have failed to set his seal on the proceedings. The influence of Maxfield Parrish was therefore all-pervasive and affected everything that occurred within the club's walls.

The study is quite notable as it was his first work to be sold outright. The mural was his first formal commission, he received his first critical review as a result of it, and invitations for further commissions came from *Harper's* following the first exhibition of his art, all of which made Parrish as proud as a peacock.

'My Duty Towards My Neighbor' and 'My Duty Towards God' (1898)

These are not large-scale murals but twin panels, each 33 x 24in (84 x 61cm), and are installations mounted above a fireplace. Created for the Mrs. Parsons Memorial Chapel at the Trinity Episcopal Church in Lenox, Massachusetts, a jewel of a building, they can be seen a few miles from the Norman Rockwell Museum at Stockbridge, where the Maxfield Parrish Retrospective exhibition was held (November 1995–January 1996). Coy Ludwig said of these small murals, executed on pine boards, that they 'have the interesting Pre-Raphaelite quality sometimes seen in the products of the Arts and Crafts Movement in America'. There is no doubt that the faces and costumes are reminiscent of Rossetti and Waterhouse, but most of the entire frame, with its design, colours and lettering, all executed by the artist, is also derivative of the Arts and Crafts Movement. Parrish obviously felt that such a commission deserved the full treatment, and that if he had left the framing up to the congregation he would have lost control of the total effect he wished to create.

Old King Cole (1906)

In 1906, Parrish repeated his very first commission by recreating Old King Cole in a more sophisticated version for the indomitable John Jacob Astor at his Hotel Knickerbocker. Today, the mural is located at New York's St. Regis Hotel in the bar/lounge named for the mural, 'The Old King Cole Room'. The three mural panels were moved there in 1935 after their first home, the Knickerbocker Hotel, was converted into an office building. Since then the mural has become an important New York City landmark and is mentioned in guidebooks, news articles and Broadway shows. It is now as much a part of New York as the Statue of Liberty and a must-see for visitors.

The Old King Cole theme was updated by Maxfield Parrish, and is a rather less humorous, albeit larger version than the earlier mural at Pennsylvania. However, the story behind the image is worth repeating and also has its funny side. It was said that Parrish did not want to accept this commission, since he was busy building his studio in Cornish and had several lucrative commissions to complete. In 1905, Nicholas Biddle, an old friend of Parrish from Philadelphia and an associate of Astor, offered the artist $5,000 to complete the mural. The immensely wealthy John Jacob Astor felt that for that amount of money he should be immortalized as the king himself, a suggestion that the artist found somewhat annoying. Moreover, his Quaker upbringing made him less than thrilled that his painting was to be hung in a bar. Parrish felt that his integrity had been assailed, but Stephen Parrish intervened, persuading Maxfield that it was unwise to thwart a powerful man like Astor, that his future career might be affected, and that the sum was hardly trifling in any case. Parrish agreed to the commission on condition that he had total control of the project, while agreeing to portray Astor as Old King Cole.

But it was a pyrrhic victory, for the king looks as though he is passing wind, his face contorted with the effort, leading Coy Ludwig to refer to him as 'the flatulent monarch', while the pained expressions on the faces of the other figures tell their own story. The two knights guarding the throne seem ready to abandon their posts as they hold their noses for as long as they possibly can, while the musicians look on in a state of shock. Astor made no comment whatsoever and the work was hung without further ado. But the story naturally got about and soon the Hotel Knickerbocker was so thrilled with the interest created that it printed the mural on its brochure cover with the legend, 'Painted For Hotel Knickerbocker by Maxfield Parrish (eight feet by thirty feet)'. The whole country seemed to be talking about the king with a digestive problem, who just happened to resemble John Jacob Astor. In 1909, the Pyraglass Company began to sell licensed tie racks from the hotel news-stand, embellished with the image of Old King Cole.

Old King Cole, c. 1906
Oil on canvas, 8 x 30ft (2.5 x 9m).

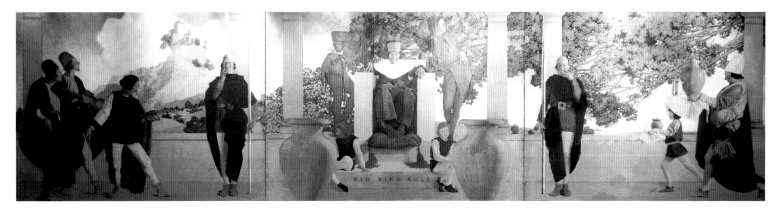

The Whitney Murals (1909–18)

In 1909, Maxfield Parrish was asked to paint some decorative murals for Gertrude Vanderbilt Whitney, but the commission was delayed for some time due to indecision regarding their ultimate location, whether they should be placed in her sculpture studio at Old Westbury or in her apartment in Manhattan. Once the decision was made to place the murals in the studio, the brief for the actual commission could be decided. There were to be four paintings (6-ft high by 19-ft long/1.8 x 5.8-m), designed to fit above the doors of the reception room. After they had been completed, however, it was discovered that the measurements for the wall panels had been incorrect. Moreover, the location's natural lighting was insufficient and artificial lighting would be required, which was a source of aggravation to Maxfield Parrish. 'The idea is simply this: don't light the decorations at all, but let them get what light they can after the

room is lighted to suit living requirements. To my mind decorations should decorate and they should not have attention called to them by specially directed light any more than wallpaper or a rug or a piece of furniture.'

When the project was finally completed, some nine years later, Parrish was mortified by what he saw; the panels related badly to one another, the scale of one being totally out of proportion with the others. He offered to return his fee so that he could destroy them, but Whitney, however, decided to keep them. This incident was a severe blow to his confidence, something he had never experienced before and would never in the future; it was his most unhappy commission.

To make matters worse, the murals were fixed to the walls with white lead, as was the custom of the time, and when they were removed to be sold in about 1999, they were in serious need of

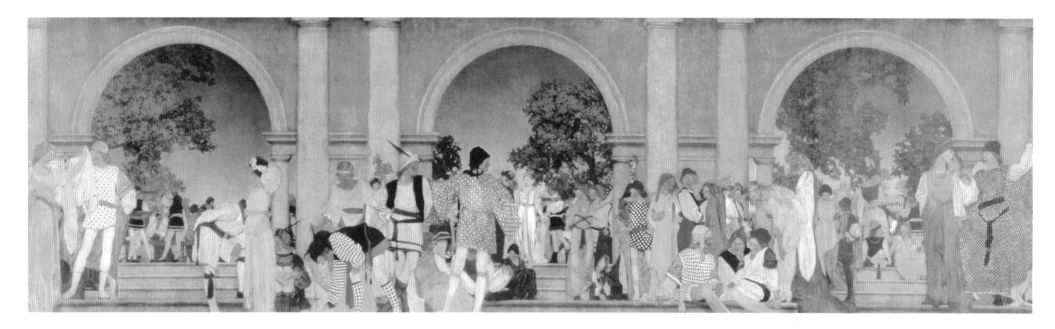

restoration. In a letter to Mrs.Whitney's secretary in 1926, Parrish wrote, '… I had a chance to study it longer than anything I had ever done, but to this day I do not know just why it is a failure.' He never quite got over this disaster and brooded on it for ever more.

The Pied Piper (1909)

This 7 x 16-ft (2 x 5-m) mural was painted for the bar of the Palace Hotel (now the Sheraton Palace) in San Francisco, which is called 'Maxfield's Bar' in homage to the artist. As usual, Susan

Lewin was the model for most of the male and female figures, although Max, Jr. is portrayed as a boy (right side looking at the viewer, and again just below the Piper). Parrish worked from photographs and used the camera as a kind of tool to help him achieve the correct effect of foliage or drapery on models' bodies. Trained as an architect, he also used scale models and props so that the perspective would be as accurate as possible. All this, and his unique way of applying paint, combined to produce a result that was magical indeed.

The Gertrude Vanderbilt Whitney
Murals, 1918
Oil on canvas, 5ft 4in x 18ft 6in
(1.6 x 5.6m). North wall panel.

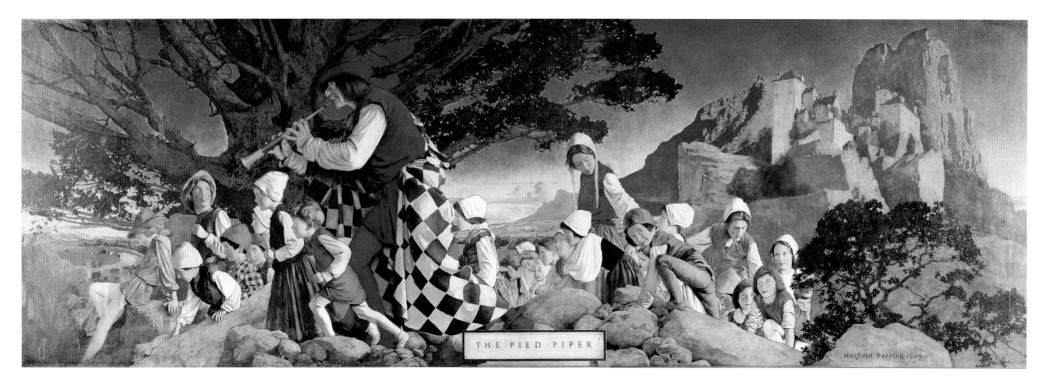

ABOVE

The Pied Piper, 1909

Oil on canvas, 7 x 16ft (2 x 5m)
Mural painted for the former Palace
Hotel's men's bar, San Francisco.

OPPOSITE

Sing a Song of Sixpence, 1910

Sketch in oil.

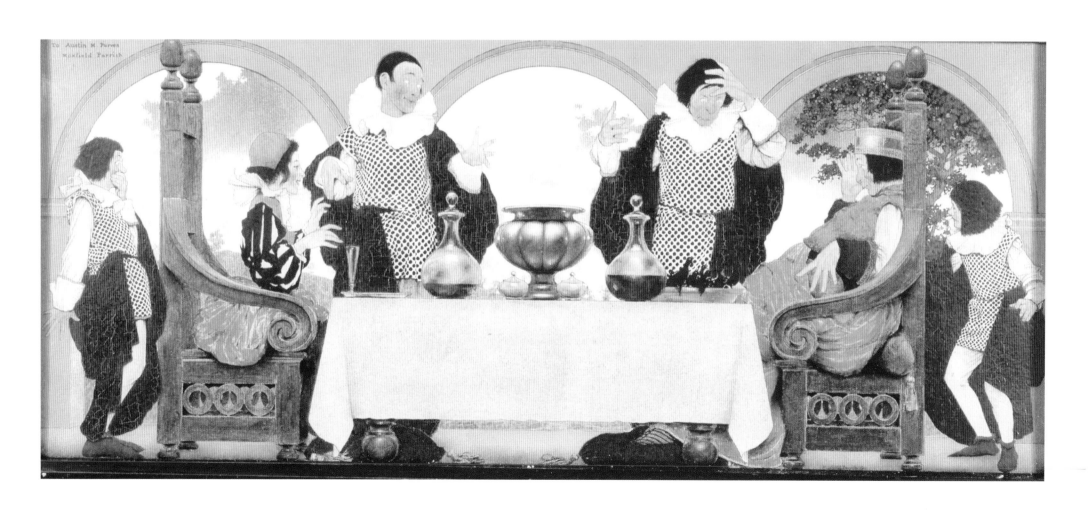

THE WORKS OF MAXFIELD PARRISH

Sing a Song of Sixpence (1910)

Maxfield Parrish painted this mural for the Sherman House Hotel in Chicago, while new clients appeared daily at his door with a seemingly inexhaustible thirst for his illustrations, and now murals. Among these clients was *Ladies' Home Journal*.

A Florentine Fête (1910–16)

Ladies' Home Journal was published in Philadelphia and its editor, Edward W. Bok, had long been aware of Parrish's worth from the work Parrish had previously done for the magazine and from Bok's own days at The Players Club. Parrish produced his first illustration for *LHJ* in 1896 and in 1904 won a competition for a cover image with his *Air Castles* (page 169). More illustrations for magazine articles were to appear before Bok commissioned the decorations for the Girls' Dining Room at the brand-new Curtis Publishing Company building. The result was Parrish's A Florentine Fête, a series of fabulous murals which experts agree is Parrish's greatest single artwork. Images of it were also reproduced in covers for *Ladies' Home Journal,* when the reader could also buy a triptych art print of the murals for 25 cents if they signed up to a subscription, a ploy to enlarge the readership.

The murals were commissioned by the Curtis Publishing Company in January 1910, and Parrish started work in September, working directly from photographs of his favourite model and a few others whom he also included. He also used photographs of the Rocky Mountains, which is why they bear so little resemblance to Tuscan hills. It is interesting to note that most Parrish landscapes are a composite of scale models, small rocks photographed and enlarged, images of the Rocky Mountains in Arizona and waterfalls in North Conway, New Hampshire. They are fantasy landscapes, yet admirers sometimes claim to recognize their location, as if they had visited them personally. Perhaps they had – in their dreams.

The publishing magnate, Cyrus Curtis, was the founder of the most perfectly equipped publishing establishment for periodicals in the world, located adjacent to the Liberty Bell and Independence Hall in Philadelphia. The appointments throughout the building were the finest, from the furnishings to the decorative elements, which included gold-plated spittoons in the lobby. Curtis' right-hand man was the legendary editor of *Ladies' Home Journal*, Edward Bok (1863–1930), a practical and frugal Dutchman who was determined that the artists hired should give their best efforts to the task of decorating the building. The two largest commissions were the Girls' Dining Room on the top floor, and a massive backdrop on a wide wall in the building's main lobby entrance. Bok felt that if he used popular artists, whose illustrations also sold well, he could kill two birds with one stone, for he would be able to use images taken from the wall decorations as later magazine covers. The decorative paintings were commissioned for 17 locations between windows, and an 18th for one end wall of the large room. He eventually issued them as art prints to give or sell as incentives to subscribers and also used them as *LHJ* covers. It all worked. The murals Parrish created for Curtis were perhaps his most successful ever, even though they had the same theme as the Whitney commission – a party in Renaissance Florence.

Maxfield Parrish wrote to Bok in 1911 and described the theme of the main painting thus: 'All the people are youths and girls; nobody seems old. It may be a gathering of only young people, or it may be a land where there is youth, and nobody grows old at all …what is the meaning of it all? It doesn't mean an earthly thing, not even a ghost of an allegory: no science enlightening agriculture: nobody enlightening anything. The endeavor is to present a painting which will give pleasure without tiring the intellect: something beautiful to look upon: a good place to be in. Nothing more.'

Bok was born in Den Helder, Holland, having come to the U.S.A. with his family at the age of seven, in the same year that Parrish was born. As a youth, Bok wanted to be a journalist, but started out as the advertising manager for *Scribner's Magazine*. Later, he became editor of the *Brooklyn Magazine* and in 1886 founded the Bok Syndicate Press, which ultimately led to *Ladies' Home Journal*. He was appointed editor in 1889, and used the

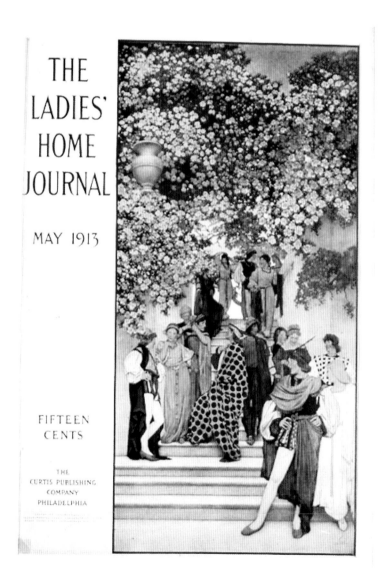

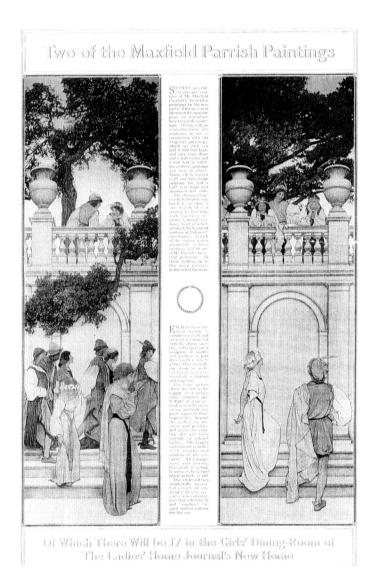

FAR LEFT and LEFT
Ladies' Home Journal
Cover and inside page with an article featuring Parrish's Florentine Fête, May 1913.

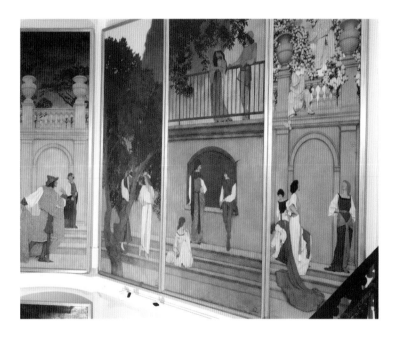

Florentine Fête installed at the National Museum of American Illustration in Newport, Rhode Island.

platform to campaign for social issues, including women's suffrage, prenatal care, sex education and pacifism, as well as environmental issues including conservation and public health. America's first magazine devoted exclusively to women, it continued to grow and by 1900 had achieved the highest circulation in the nation, being the first magazine in the world to have over a million subscribers. A Pulitzer prize-winning author, Bok retired in 1919, but kept active writing and was a noted philanthropist, establishing a system of awards to encourage citizens to take an interest in their communities. In 1921,

he funded the American Peace Award, which provided $100,000 for the best plan whereby the U.S.A. could cooperate with other nations to achieve peace in the world. In 1923, he created the Harvard Advertising Awards, bestowed by the Harvard University School of Business Administration to raise the standard of advertisements, and in 1926 established the Woodrow Wilson Professorship of Literature at Princeton University. Bok died in 1930 and is buried at the Tower at the Sanctuary, which he founded in Lake Wales, Florida.

The Curtis murals were begun in 1910 and were completed and installed in 1916, although the 17 small panels had been finished within the first three years. The largest panel took an additional three years to complete, mainly because it was not a part of the original commission. Parrish's $45,000 fee turned out to be a small sum, given the size of each panel, having been based on square footage.

Maxfield Parrish was loath to give descriptions, and especially titles, to his paintings and considered it 'a very difficult matter'. Bok approached him time and time again for names for the various panels, in order to distinguish one from the other in copyright applications, to which Parrish retorted, 'I am the last one in the world to invent titles for pictures ... the panels are really sections of one large picture, technically what are known as fragments, and what to call each one – why, it's nigh impossible... Could one be Opus No. 4 like in music? "A pair of vases"... "Another pair"..."Still another pair"... "Even two more"...Could the "study" idea be worked? "A Study in Polka Dots"... "A Study in Lavenders"…As to sentimental titles, for Heavens sake let's not have that …I can think of nothing better than

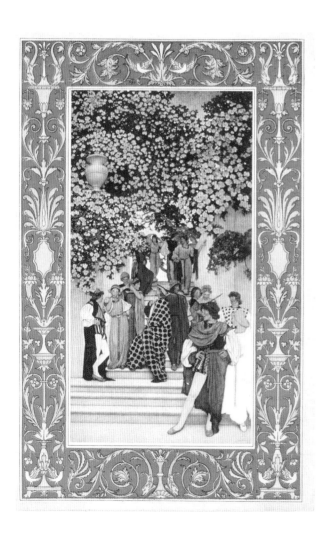

"The Masquerade" for the big picture to be, at the south end, and have all the other panels called "The Masquerade: no. so and so." Remember there will be about 18 all together. How is it possible? I don't wonder you appealed to me. A dictionary might be procured and a hunt made for the given names of males, and the most conspicuous party in each picture named. John: Edward: Seth: etc. But seriously, it is beyond me. If they can be copyrighted properly by the "fragment no. 8," I should strongly advise it.' Due to the artist's intransigence, that was not what happened. In fact, Bok ultimately took it upon himself to name the paintings and made a fine job of it in the process. Indeed, most people think that they were named by the artist but are far longer than Parrish would have used, being more in the tradition of the day. Some examples are: *A Rose for Reward*, *Buds Beneath the Roses* and T*he Stairway to Summer*.

As already mentioned, Susan Lewin was the model for most of the figures, with Parrish himself here and there, while his cousin, Anne Bogardus Parrish, is the attractive woman wearing the brown gown in the right foreground of the largest panel. There were a few other people portrayed, but all in all the mural is all Susan, wherever one looks. Parrish's granddaughter said of the mural, 'There was a six-paneled screen of a Japanese House and Garden Party (as my father referred to it) on the huge sliding wooden stage door of Granddad's music room. Throughout my childhood visits, I often sat at Granddad's grand piano and played, the fine old Chickering standing on the floor just in front of and below the

307

THE WORKS OF MAXFIELD PARRISH

FAR RIGHT
A Florentine Fête
Susan Lewin posing for Sweet Nothings.

OPPOSITE from LEFT to RIGHT
A Florentine Fête (Shower of Fragrance), 1911
Oil on canvas, 126 x 39in (3.2 x 1m).

A Florentine Fête (Love's Pilgrimage), 1911
Oil on canvas, 126 x 39in (3.2 x 1m).

A Florentine Fête (A Call to Joy), 1911
Oil on canvas, 126 x 39in (3.2 x 1m).
Mural for the Girls' Dining Room, Curtis Publishing Company, Philadelphia.

A Florentine Fête (Lazy Land), 1911
Oil on Masonite, 126 x 39in (3.2 x 1m).

closed stage door and the painted screen thereupon. I gazed up at the strolling men and women, some conversing, some sitting and taking tea together. Much later, I wished I had asked Granddad if the screen gave him ideas for the eighteen panels he created between 1910 and 1916 for the Curtis Publishing Company, Philadelphia, Pennsylvania. These murals decorated the dining room for young women with scenes of beautiful young men and women entertaining each other in dreamy, lavish settings … The variety of expressive faces and personalities revealed the guests' feelings about each other, like affection, jealousy, longing, amusement. Words were as unnecessary to explain Granddad's Curtis murals as they were to the party taking place on the Music Room screen ... in places, a fluffy golden cloud floated over the roofs of the Japanese houses, obscuring parts of the buildings and some of the partygoers. Therefore, though I was looking up at the graceful scene from Granddad's piano bench, my point of view was really looking down from the sky, a "god's eye view" from some heavenly perch. As I get farther away from those happy summer visits, I have thought that my eighteen year view into Granddad's life with its not always clear view of his life is beautiful and graceful and tantalizing, as the view into the party on his Japanese screen.'

The last mural was installed in 1916, and they remained in the Girls' Dining Room until the Curtis building was sold by John Merriam in 1984 to the Kevin Donahue Company. Merriam retained ownership of the murals and just before close of sale had them removed from the walls and put into storage.

On the cover of the *Ladies' Home Journal* of May 1913, and in an article entitled 'Two of the Maxfield Parrish Paintings – Of Which There Will be 17 in the Girls' Dining-Room of The Ladies Home Journal's New Home', the magnificent paintings were announced to the public. They were described as having been placed in the dining room 'in which 500 girls may lunch at one time, is one hundred and seventy-six feet long, with fourteen immense Colonial

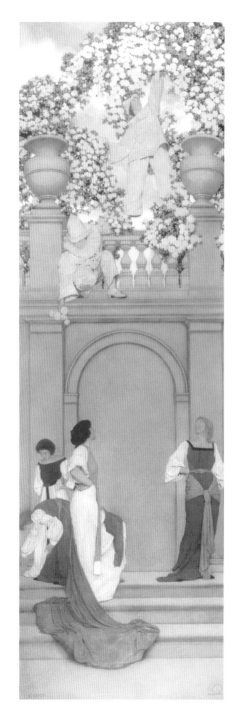
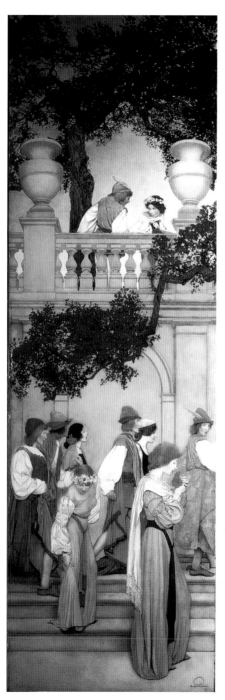
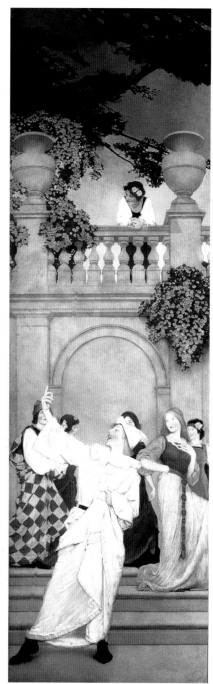
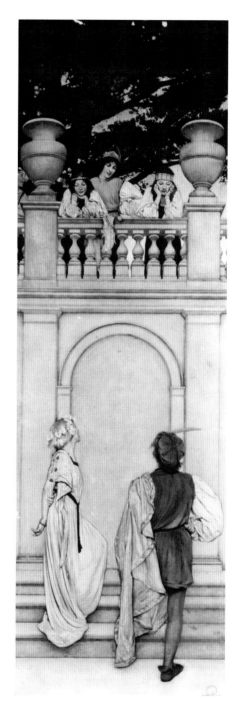

RIGHT
RIGHT

A Florentine Fête (Buds Below the Roses), 1912

Oil on canvas, 126 x 65in (3.2 x 1.65m).

FAR RIGHT

A Florentine Fête (Journey's End), 1912

Oil on canvas, 126 x 65in (3.2 x 1.65m).

OPPOSITE

A Florentine Fête (The Garden of Opportunity), 1913

Oil on canvas, 126 x 65in (3.2 x 1.65m).

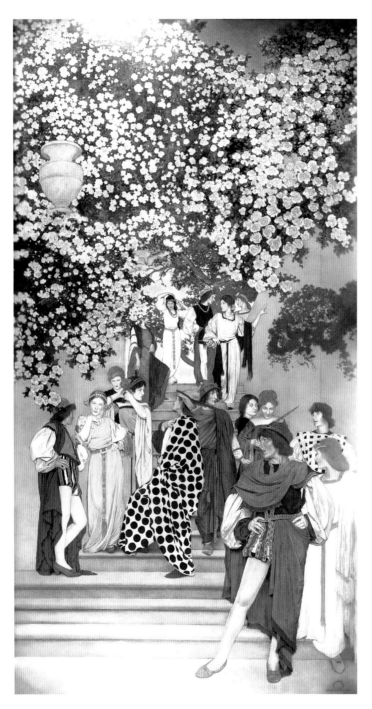

windows, most of which overlook the beautiful verdure of Independence Square. In each of the sixteen spaces alongside of these windows will fit one of Mr. Parrish's beautiful paintings – all these leading up to the main picture, at the end of the room.' It goes on to report, 'Each of these sixteen panels is complete in itself, and yet each is connected with the others, since they will represent a company of youths and maidens in gala dress on their way to a fête. They are walking along an architectural terrace; everybody is chatting and laughing.

'The large picture shows the fête in the loggia of a palace some centuries ago …All is happiness and beauty. Everybody is young. It seems to be a land where no one is old …The whole will be a wonderfully successful result of the artist's idea to present a series of paintings that will refresh and "youthen" the spirit and yet will not tire the eye.'

Sometimes referred to as 'the Maxfield Parrish Dining Room', it is described as 'the most beautiful dining-room in America'.

In 2003, the murals were all finally restored and reinstalled in the National Museum of American Illustration. The first eight had been set in place earlier, just in time for the museum's opening to the public on 4 July 2000. The remaining artworks were still being restored and were soon to be placed on the grand staircase, known as the 'Romance Staircase', but the task was enormous. A scaffolding 30-ft (9-m) high had to be constructed with a bridge leading from the second-floor landing to the staircase walls. A large table was constructed in the second-floor hallway, 12-ft wide by 20-ft long

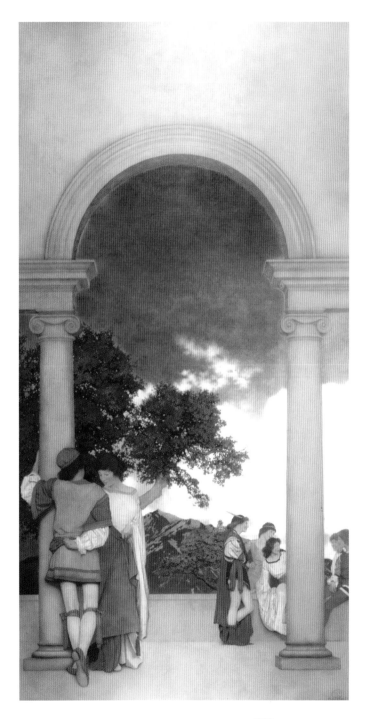

RIGHT

***A Florentine Fête (An Arch Encounter),
c.1911***

Oil on canvas, 126 x 65in (3.2 x 1.65m).

FAR RIGHT

***A Florentine Fête (Boughs of Courtship),
1911***

Oil on canvas, 126 x 56in (3.2 x 1.4m).

OPPOSITE, from LEFT to RIGHT

***A Florentine Fête (A Word in Passing),
1911***

Oil on canvas, 126 x 56in (3.2 x 1.4m).

***A Florentine Fête (Rose for Reward),
1911***

***A Florentine Fête (Roses of Romance),
1911***

Oil on canvas, 126 x 56in (3.2 x 1.4m).

A Florentine Fête

Susan Lewin posing for Rose for Reward.

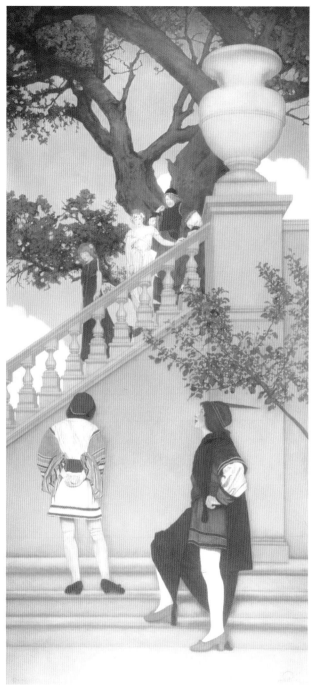

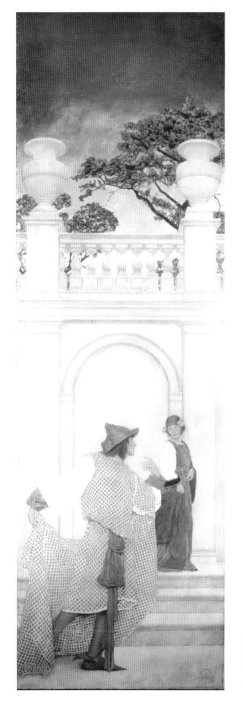

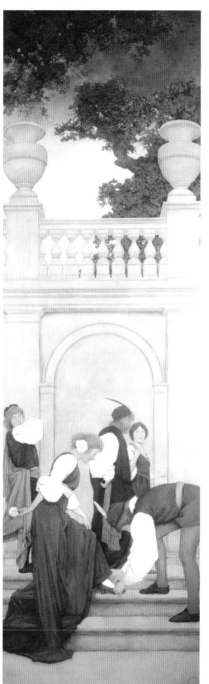

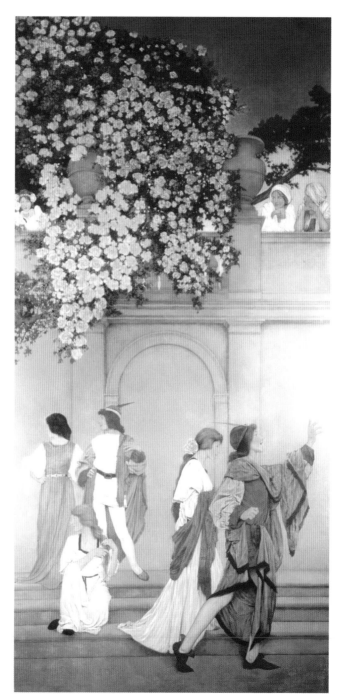

RIGHT
A Florentine Fête (Whispering Gallery), 1911
Oil on canvas, 126 x 64in (3.2 x 1.6m).

FAR RIGHT
A Florentine Fête
Susan Lewin posing for Whispering Gallery.

OPPOSITE LEFT
A Florentine Fête (Sweet Nothings), 1913
Oil on canvas, 126 x 64in (3.2 x 1.6m).

OPPOSITE RIGHT
A Florentine Fête
Print.

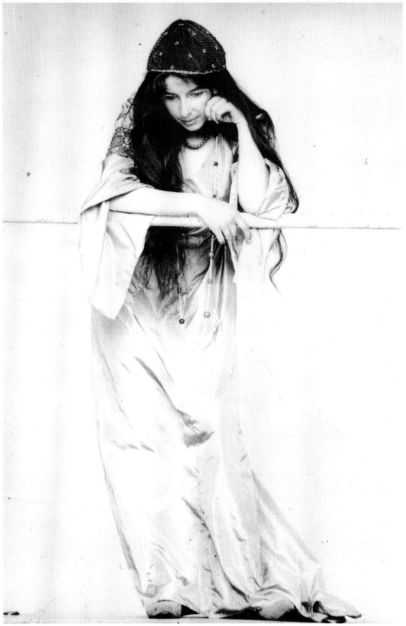

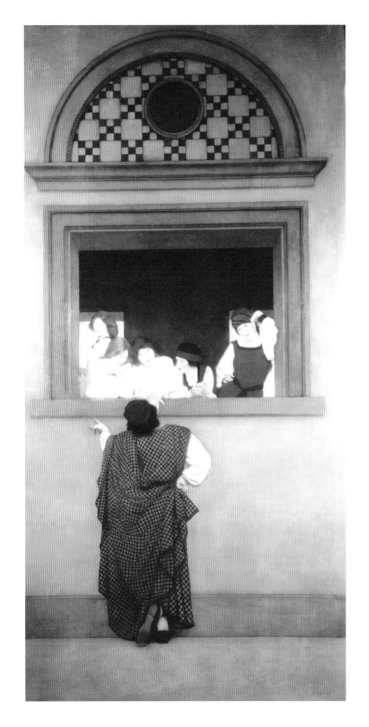

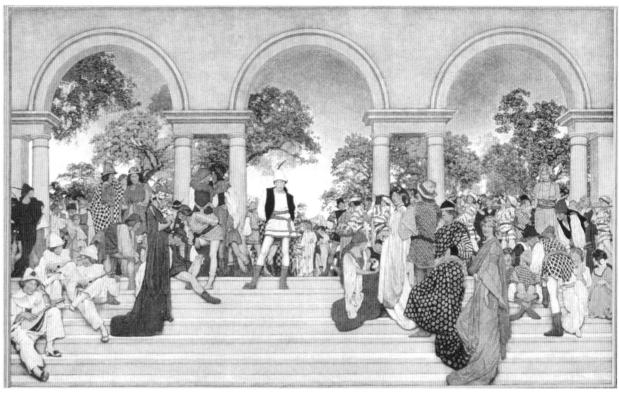

(3.7 x 6m) in order to varnish the painting on-site after it had been
stretched to fit the frame properly. A team of four restorers arrived
at Vernon Court to prepare the paintings, while three other teams of
carpenters, masons and electricians were on site for a full week to
assist in the installation of Maxfield Parrish's greatest work. For
Parrish to have handled these paintings, literally for years, must
have been a Herculean task, even though he must have had helpers.

At about the time that Parrish was finishing the last of the
largest of the 18 Florentine Fête murals, he was commissioned to
design a stage set to be used as a backdrop for the Plainfield Town
Hall. Parrish had used repeat images taken from other works in
Florentine Fête, which he had completed earlier. One can spot
'Griselda' in *Buds Beneath the Roses*, while 'The Lantern Bearers'
are clustered in the lower left corner of the largest mural, *A
Florentine Fête*, and *The Garden of Opportunity* has a partial view

of the same water scene used in the Plainfield stage set. The water, as offered to the viewer in a one-point perspective just under the woman's left arm in *Garden of Opportunity*, is exactly the same setting and view as in the stage set. In many ways, these murals are a composite of the first half of Parrish's career, a grand finale well in advance of his declining days which were not to come until nearly half a century later.

Not all of Parrish's murals and stage sets were reproduced as

Twilight, 1897

Stained-glass window
134¼ x 123½in (341 x 314cm). Signed:
'Tiffany Glass and Decorating Company,
New York. Copyright 1897'.

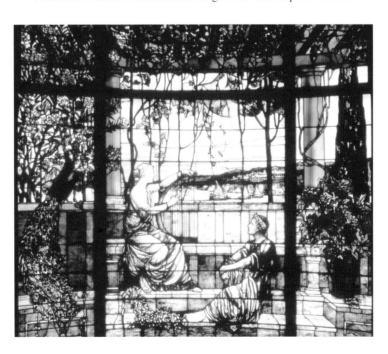

illustrations. The Whitney murals were never considered good enough to reproduce and of course were stashed away in a Long Island studio, where only a few people ever saw them. The Plainfield Town Hall stage set was likewise never reproduced as an illustration. The original painting for *Dream Garden* was issued as an art print and is extremely rare, while Florentine Fête was reproduced a number of times and is consequently much more popular and familiar to the public, so much so that they have become beloved images.

Parrish and Tiffany

Parrish collaborated only once throughout his long career, and that was with Louis Comfort Tiffany for the favrile-glass mosaic executed by Tiffany Studios and derived from Parrish's *Dream Garden* at the Curtis Building. Yet, they did in a sense come together again, albeit posthumously, when the Florentine Fête murals were installed in the Rose Garden Loggia at the National Museum of American Illustration. The ceilings and walls had been covered with murals produced by Tiffany Studios, but they had long since been destroyed, due to water damage, and were removed in the 1970s. However, the Tiffany Studios paintings in the large archways were still in good condition, and the Parrish murals were now installed on the walls between each archway, where they look as though they have been painted for the purpose and seem perfectly compatible with the location.

Each of the two loggias at Vernon Court is decorated with

ceiling and wall murals and also within the window archways. The South Loggia's Tiffany murals remain and are in the process of restoration. Originally, both loggias were open to the elements, but after some years they were closed in with glass doors, which were covered with trellis on the south and clear glass on the north end at the Rose Garden Loggia. The archway paintings remain today, just as Tiffany Studios executed them. They beautifully complement the Parrish murals in colours of burnt sienna, beige and cream and are Renaissance in style, with *putti*, garlands, fruits and flowers.

Dream Garden **(1914)**

Cyrus Curtis and Edward Bok arranged the collaboration between Maxfield Parrish and Louis Comfort Tiffany, two of the giants of the art world at the time, to create a mosaic for the Curtis lobby. By taking Parrish's painting of 2ft 1$^{1}/_{2}$in x 6ft 6in (0.65 x 2m) and enlarging it into a 15 x 49-ft (4.6 x 15-m) mosaic, they created perhaps the most beautiful glass artwork that exists – *Dream Garden*. It is made up of over 100,000 pieces of favrile glass in 275 different colours. The mosaic was fabricated in 24 separate sections to make it easy to erect.

Edward Bok originally hired Edwin Austin Abbey (1852–1911), an illustrator, to paint a mural for the lobby of the Curtis building. Abbey, a member of The Players Club, was born in Philadelphia and studied art for a short time at the Pennsylvania Academy, though he was largely a self-taught muralist. Abbey had been on the staff of *Harper's Weekly* since he was 19, and had had a brilliant career as a sensitive but dramatic illustrator. In the late 1870s, Abbey emigrated to England to pursue a career as a so-called 'history painter'. While in England, he joined the Pre-Raphaelite Brotherhood, the group of artists so admired by Maxfield Parrish. In 1890, Abbey was invited by sculptor Augustus Saint-Gaudens to produce the mural *The Quest for the Holy Grail* for architects McKim, Mead and White (Players Club members) for their design for the Boston Public Library (1901), after which he was awarded his largest commission to decorate the Rotunda, House and Senate Chambers, and the Supreme and

Superior Court Rooms in the Pennsylvania State Capitol at Harrisburg (1909). Realizing the significance of this, he turned his energies to producing a personal tribute to his home state. Abbey was finishing some of his Pennsylvania State murals when Edward Bok commissioned him to paint a mural for the Curtis project.

In 1911, just as he had begun his work on the mural for Curtis, Abbey suddenly died, and Howard Pyle suggested that Violet Oakley be asked to complete Abbey's works for the State of Pennsylvania and Abbey's friend, John Singer Sargent, the Curtis commission. Sargent refused and Bok next approached Howard Pyle himself, who died while he was considering the request on 9 November 1911. Several Cornish artists were approached, some foreign, and then the American illustrator Albert Herter was asked, but rejected it on the grounds that he was too busy. The next artist to be selected was Boutel de Monvel, who also died shortly after accepting the commission. It seemed that the hand of Fate was resting on the project and in order to outwit her this time Bok asked both Parrish and Tiffany to submit ideas. By late 1913, Tiffany and Parrish had both produced sketches for the wall, though Parrish's was accepted; however, a compromise was reached whereby the two artists would work together, thus making a unique collaboration.

When asked to explain the meaning of the work, Parrish, as usual, described the mural in his own blunt fashion: '... You can tell them you have it on good authority, it's a dream garden, a genuine dream, not a real thing in it.' Tiffany, in contrast, went into greater detail: 'When Maxfield Parrish's painting was shown to me, with all its beauty of suggestion, I saw the opportunity of translating it into a mosaic which would bring, to those who could see and understand, an appreciation of the real significance of this picture ...Never before has it been possible to give the perspective in mosaics as it is shown in this picture, and the most remarkable and beautiful effect is secured when different lights play upon this complete mosaic ... it will be found that the mountains recede, the trees and foliage stand out distinctly and, as the light changes, the purple shadows will creep slowly from the base of the mountain to its

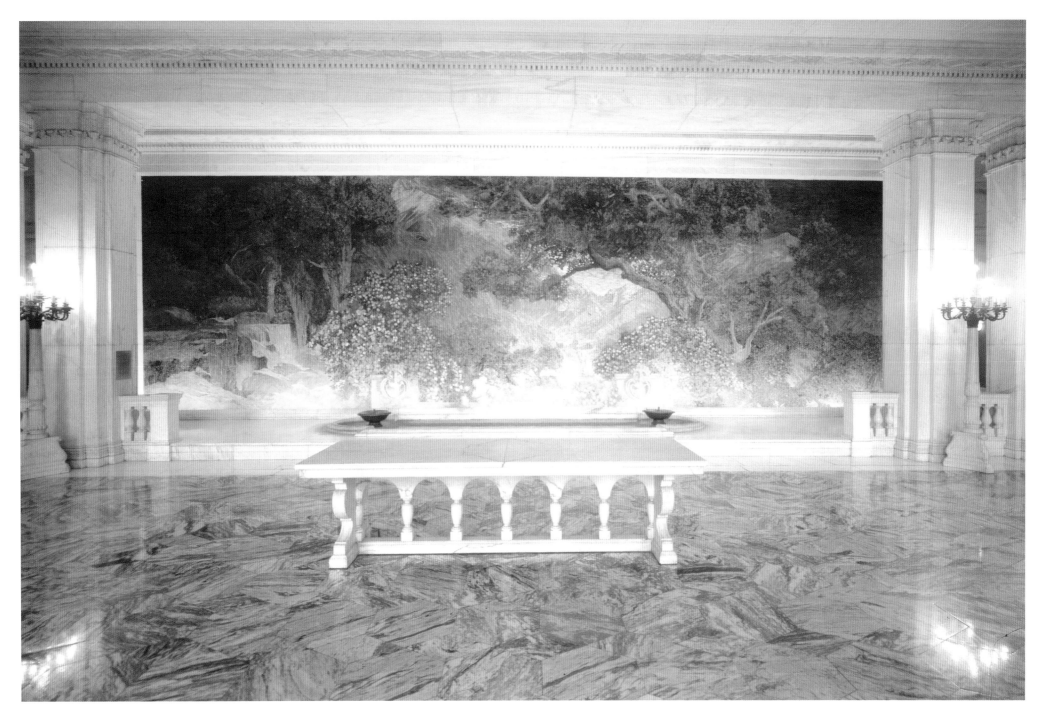

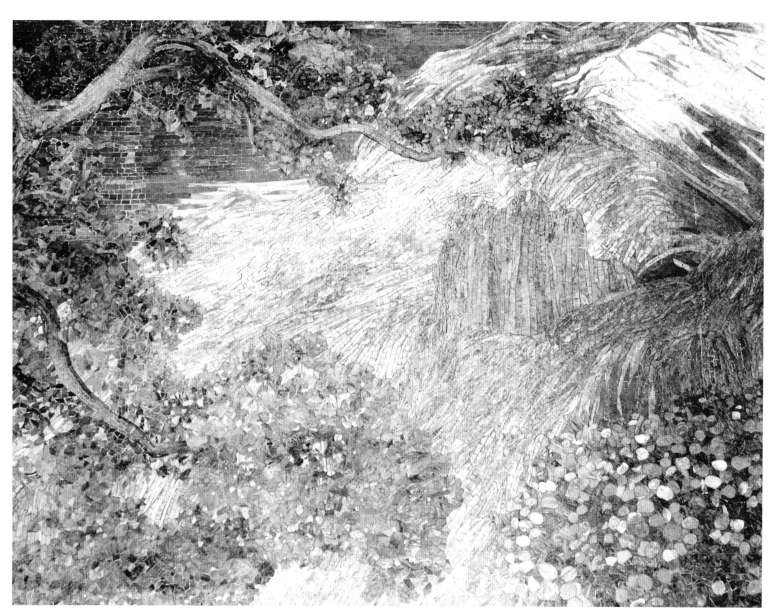

OPPOSITE
Dream Garden, 1915
Favrile glass mosaic, 15 x 49ft
(4.6 x 15m), executed in favrile glass by
Louis Comfort Tiffany, Tiffany Studios.
Situated in the lobby of the Curtis
Publishing Company, Philadelphia.

LEFT and ABOVE
Dream Garden, 1915
Details.

RIGHT

The Tempest (Prospero in Golden Sands), c.1909

Painted for Winthrop Ames' and Hamilton Bell's production of The Tempest *by William Shakespeare at the New Theatre, New York City, in 1909.*

FAR RIGHT

The Tempest (Prospero in Golden Sands), c.1909

Vintage print, 7 x 7in (18 x 18cm).

OPPOSITE

The Plainfield Town Hall stage set, 1916. Watercolour on paper, 12 x 8¹/₂in (30 x 22cm). One of five pieces representing the six wings which formed the scenery at the Plainfield Town Hall in New Hampshire.

top; that the canyons and the waterfalls, the thickets and the flowers, all tell their story and interpret Parrish's dream.'

The mosaic mural by Louis Comfort Tiffany based on Maxfield Parrish's painting was completed and installed in 1915. This favrile-glass mosaic (Tiffany's patented technique by which a particularly

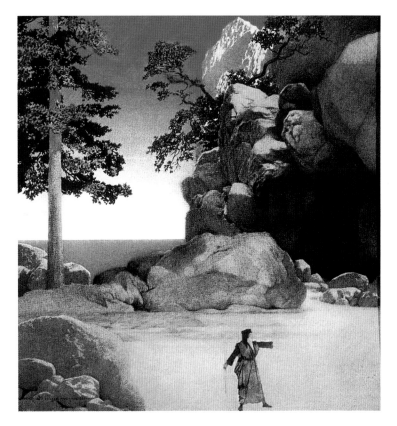

radiant mosaic glass and gold leaf was used) was installed in the Curtis Publishing building to resounding acclaim as, 'a veritable wonderpiece'.

Interlude/ Lute Players/Music **(1922)**

In 1922, Maxfield Parrish painted yet another mural which, although only 6ft 11in x 4ft 11in (2.1 x 1.5m), was designed for a staircase landing in the George Eastman Theater in Rochester, New York. It has several titles, *Music* being the first given by the artist. But it is more popularly known as *Interlude* and/or *Lute Players*, having appeared in art prints under those names with different croppings, and is a favourite vintage print with many collectors.

Stage Designs

Among his more unique commissions, Parrish designed the Town Hall stage set (1916) for his beloved Plainfield, New Hampshire. This was not such an outlandish request for Parrish as it seems, although it was an unusual one for this artist. He had only designed two other stage sets: one for Shakespeare's *The Tempest* (c.1909), in a production in New York City at the New Theatre and the other for *Snow White*, a production by William Wanger (1917) which was never realized due to the onset of the First World War.

Although Parrish was accustomed to creating artworks for small posters (13¹/₂ x 8³/₄/34 x 22cm) and other images for use on magazine covers or in books, the originals usually measuring 28 x 18in (71 x 46cm), or even paintings for a small advertisement layout, such as that for Jell-O, the act of creating the large-scale artwork required posed the kind of problem he particularly enjoyed. Whatever he was creating had to be enlarged in any case, so he was always sensitive to scale; it had to work well in a small context to be successful in a larger version

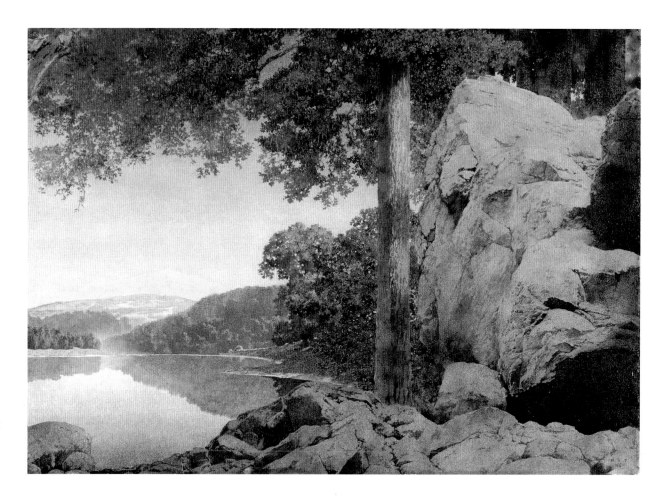

RIGHT
Studies for Plainfield stage set, 1917
Watercolour on paper, 12 x 8¹/₂in
(30 x 22cm) each. A set of five scenes.

OPPOSITE
Once Upon a Time, 1916
Forest drop: oil on canvas, 32 x 40in
(81 x 102cm). Scenery for Walter Wagner's
production of Snowdrop (Snow White)
and the Dwarfs), *1917, which was*
abandoned.

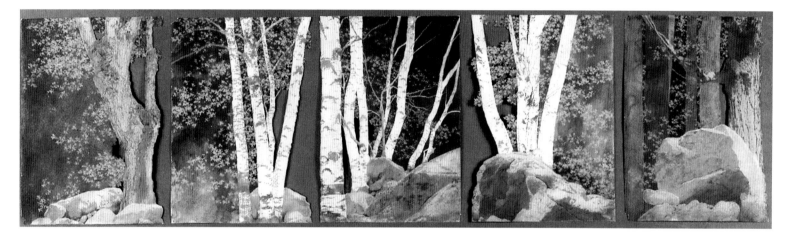

of the same image. Parrish understood scale and size better than most, since he was well versed in dynamic symmetry and had been trained as an architect. This enabled him to enlarge or reduce his images for applications as murals, stage designs or mosaics at will. The final use of the image was always the most important criterion.

Plainfield: *The Woodland Princess* (1916)

William Howard Hart (1853–1937), a New Yorker and summer resident of Plainfield, was an active member of the Cornish Colony and a well-known scenery designer, who in 1916 commissioned Maxfield Parrish to design a stage set for the Plainfield Town Hall. Parrish received the commission after completing the last of the Florentine Fête panels and when the *Dream Garden* mosaic had just been installed.

Housed in a typical New England white clapboard building, Plainfield Town Hall had a long history of service to the town and is still seen by the community as its most prized possession. One can readily compare the real world with Parrish's idealized stage set by looking through the Town Hall's front door. Although one cannot see the Connecticut river from the stoop, one can easily see Mount Ascutney and there are views of the river as one drives along the highway. The state of New Hampshire recently named this segment, 'The Maxfield Parrish Highway'.

Hart requested that the town should put $300 towards adding a stage in the Town Hall so that amateur plays could be performed. At the same time, he promised to provide everything else needed for local performances. The town agreed while requiring that Hart include the building foundation, stage equipment, scenery and the

stage set itself, including decorative elements. Hart further agreed to pay professional scenery painters to come from New York to construct and paint the scenery and stage set designs.

Parrish proceeded to design a small-scale mock-up of the set in order to study it in three dimensions, alternating the locations of the six wings and getting a perspective on the final configuration of the overhead drapes. From the small-scale model, he prepared paintings of each section and overlaid them with a grid. This enabled the scenery painters to enlarge the design accurately with another corresponding grid on the full-sized canvas sheets. Parrish hired the Indian Head Mills in Nashua, New Hampshire, to provide all the canvas necessary for the project. The stage set canvases are most likely not by Parrish, for he was extremely busy with many other commissions at this time.

While Parrish's work was progressing, the town completed Hart's shed-like addition to the Town Hall, which facilitated the installation of the stage and two dressing rooms at the rear. The first Town Hall building had been built in 1804, but was torn down 40 years later and rebuilt from the original materials. There have been three additions since, including the stage shed, which was approximately one third the size of the original building. In 1915, the year after electricity came to the area, the old kerosene lanterns were replaced with electrical fixtures. The Parrish scenery designs were totally completed in 1917, after two full summers of painting. The excitement must have been palpable when the residents came to see the set in action for the first time. The new electrical lighting was used to show Maxfield Parrish's woodland scene under many

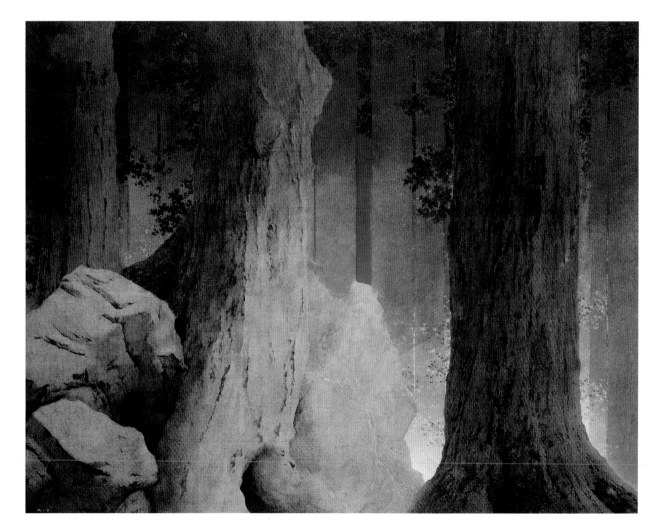

conditions, the effect of different times of day achieved by adjusting its intensity. The end result was dynamic and exciting and quite revolutionary for its time.

Hart worked with Parrish on the project in respect of practical design details. The set designer determined the configuration of the wings and the depth of the overhead drapes, but they both apparently supervised the scenic artists who painted each section according to mock-ups fabricated by Parrish. When completed, it was decided that the scenery sections should serve as a 'near-permanent' decoration rather than be used for just one show, *The Woodland Princess*. Parrish rose to the challenge and selected his favourite landscape subject, Mount Ascutney, as the focus for the stage set, the very image he had used in the recently completed Florentine Fête murals, in *The Garden of Opportunity*. No one locally had seen the mural, however, and it now became the central focus of the stage, while precisely the same water scene was taken and used again by Parrish. Maxfield Parrish could once again brag, 'when I sell a painting I sell it more than once'.

Once the scenery canvases had been installed, the Plainfield Town Hall was said to possess the 'best stage north of Boston'. Consequently, it soon became the venue for other plays, including performances by the Howard Hart Players with their own repertoire, while the Cornish Colony contributed a number of fine actors over the years. The performances were well executed, well attended and at one time the Hart troupe was heralded as one of the best theatre groups in New England.

After 70 years of use and abuse, the set became rather dusty and grimy, with clear signs of wear and tear throughout. There were areas where the paint had fallen off or had been rubbed off during school assemblies or a boisterous play, not to mention the many public meetings. In 1993, the entire set of canvases was professionally cleaned and restored and the building itself was renovated in 1995. New lighting was installed so that no one would miss the important artwork. Today, the stage set stands, thoroughly refreshed and as handsome as it ever was in its delightful historic setting.

With several murals and a theatrical set under his belt, Maxfield Parrish was still endeavouring to meet his commitments for illustrations. There was more than enough work to go around, what with the plethora of up-and-coming publications, and Parrish received more than his share, his creativity and popularity being as great as ever.

While he was enjoying daunting commercial success, with both book and magazine commissions on the horizon, Parrish was seeing New York in a new light. For some time he had been making frequent excursions to the city to meet publishers, art directors and other clients, and was spending a great deal of time at The Players Club. But as the years rolled on, his life was becoming something of a dichotomy; his modest life as an artist, tucked away in the hills of New Hampshire, was in stark contrast to his new role of *bon vivant* and 'man about town'. His lifestyle in New York City was now very different: he could carouse with actress Ethel Barrymore at the Algonquin, lounge in smoke-filled parlours at the Players Club with Harrison Fisher and spend untold hours at the adjacent National Arts Club.

In 1917, Parrish finally decided to rent a studio apartment in New York City and within months brought the 29-year-old Susan Lewin 'down from the hills' for a nine-month stay in the city. It was at this point that he received his greatest advertising commission, the Edison Mazda calendars for the fledgling General Electric Company, which ran continuously until 1932. He was now flush with success, money and fame. He was a few years short of 50 and Susan was in her prime.

The New York scene offered even more to the middle-aged artist, it offered him a promise of immortality unobtainable at Cornish. He was winning medals of honour from the Architectural League of New York, and art collectors were clamouring to buy his original illustrations. A new vogue for images to release as art prints had begun and larger royalties than ever before were arriving weekly. All the while, Susan was longing for the great northern woods and feeling most uncomfortable in the New York crowds. Finally, Susan managed to entice Parrish away from that glittering world of society and persuade him to return to a simpler world of fireside chatter and quiet evenings in the studio at The Oaks.

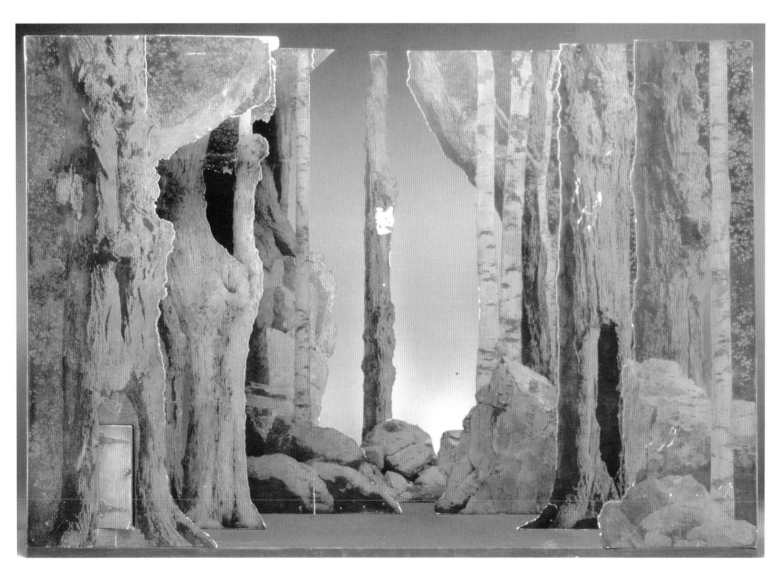

Stage set model for woodland scene, c.1915. Oil on panel, 10½ x 32in (27 x 81cm).

Susan Lewin posing.

Photography

Maxfield Parrish first used photography as a tool for his work while a student at the Pennsylvania Academy in 1891. The academy actively encouraged its draftsmen to use photographs as a form of shorthand to avoid long and expensive sessions with live models. Howard Pyle also suggested the same to Parrish, for it was obvious to him that Parrish's talents as an artist were exemplary.

Parrish realized early in his career that photography saved large amounts of time and money and that using it would make him more prolific and earn him more money. Thereafter, it was his clear and rational decision to use photography whenever possible. Other artists saw the medium as a 'crutch' for talentless artists who 'could not draw their way out of a paper bag'. Parrish, however, was not lacking in talent and he could draw better than most.

In 1897, while working on *Mother Goose in Prose*, he accepted an advertising commission from the Adams and Westlake Company to promote its new product, the Adlake camera. The camera cost $12 and was capable of taking 12 pictures in a 4 x 5-in (10 x 13-cm) format. The client placed different versions of its camera in varying prototype stages at the disposal of the artist, giving him several sizes from which to choose. The results of his research, like everything else he did, were documented and catalogued in minute photographic detail. Parrish catalogued his every artwork, numbering and labelling them before storing them away in flat files, making sure that he noted the medium and materials used, together with date, title(s) and size; he also kept a ledger of purchasers and the prices they had paid.

Likewise with his photography, he catalogued the individual glass photographic plates as to location (mountains, lakes, clouds, trees); scale models (farms, houses, walls, urns, balusters); people (models, age, sex, costume, pose position); setting (lighting, shade, shadow, grain). He set up a part of his studio strictly for photography with home-made props, such as a lute made from a bedpan, period costumes skilfully stitched by Susan, and a whole array of hats, shoes and other accoutrements.

Once he had achieved the image he sought, he would project it using a magic lantern onto a surface of canvas or paper attached or pinned to the studio wall. By simply moving the lantern forwards or backwards, he could control the size of the image and get everything to work in its proper scale. Parrish traced around the magic lantern's projected images on the surface fixed to the wall and in this manner could create the design layout for a painting in no time at all.

Photorealism or Superrealism (detailed visual representations in art, like those obtained in a photograph) was popular in the 1960s and still is, and its origins can be seen in the early works of Maxfield Parrish. It was mostly used to portray the humdrum, people having a meal, urban street scenes, automobiles, mobile homes, pinball machines, and other everyday images familiar to viewers. The Photorealists created images as precise as those produced by a camera lens, all faithfully recorded and in composite form. They magnified the ordinary, with Parrish in particular pinpointing everyday occurrences as occasions to be relished. The public never condemned him for using the camera.

Parrish never painted over a photograph and never used it as an easy way out. In fact, he deplored the idea, even in the form of an exercise. The use of a camera was considered to be cheating during the period of Abstract Expressionism, but in Parrish's hands it was a tool to be reckoned with.

In some of his photographs, Maxfield Parrish manages to catch his own figure on camera (see page 145), in others he can be seen purposely photographing himself by pulling on a long wire attached to the shutter. In many cases he created synthetic landscapes by using mirrors for ponds and reflecting pools. He never used professional models, the only time he did being as a student at the Pennsylvania Academy, when he completed a number of charcoal studies. Otherwise, he used himself, Susan Lewin, family and friends, and painted from their photographs, all of which he took himself.

PART II
CHAPTER THREE
THE AMERICAN IMAGISTS

Illustrators combine personal expression with pictorial representation in order to convey ideas. For the most part they are trained at schools as fine artists and are destined for professional careers.

Illustration is art created to be reproduced in books, advertisements, periodicals, the new media, in murals and the like. Unlike other more personal forms of art, illustration has a whole range of parameters to be satisfied: they must give pleasure, while complying with deadlines, and the subject matter and the specified dimensions are usually established beforehand by the client.

Illustration is a communicative tool, clarifying and defining our understanding of the world. Because of its use in mercantile, military and political applications, illustration also serves as a reservoir of our social and cultural history – a visual record of our civilization. Illustration is therefore a significant and enduring art form.

After the Civil War, society was far less complicated than it is today and could be easily understood through what was available. As literacy improved, so also did printing processes, while decreasing in cost, and the chief source of entertainment was a good book. Artists occupied an important place in society when illustration was at its height and it was used to maximum potential in all forms of printed matter. As industrialization spread across America, thousands of new periodicals came into being. Distribution systems expanded to meet the growing demands and also permitted massive and widespread circulation. A more literate public gave publishers and the press the opportunity of becoming powerful instruments for social change and even politics. As new printing technologies developed, so the field of illustration expanded, with the result that illustrators became major celebrities, on a par with today's sportsmen and movie stars. They entertained and informed the public and in practising their art reflected the changes in the world around them.

The heyday of illustration in America was known as the Golden Age of American Illustration, and it coincided with the Gilded Age in architecture, a period which really started at the end of the Civil War (1865) and declined quite abruptly with the 1929 stock market crash. While the Gilded Age became tarnished thereafter, illustration's Golden Age continued, albeit to a lesser degree and with fewer talented illustrators, until the mid-1960s. The incursions of film and television dramatically changed the publishing industry, the demise of *Saturday Evening Post* signalling the point when new technologies finally transformed visual communications: the Golden Age truly ended in 1965.

Illustrators from the period of the Golden Age had the opportunity to create iconic images that have stayed the course: they are a visual record and a mythology of American history, which in some cases has percolated throughout the world. These images captured a national persona and temperament and in the process created internationally recognized icons that have promoted American culture abroad.

The best known and loved American Imagists from the Golden Age are Maxfield Parrish (most popular illustrator of the first half of the 20th century), N.C. Wyeth (adventure book illustrator), Howard Pyle ('Father of American Illustration'), J.C. Leyendecker (illustrator of 322 *Saturday Evening Post* covers), Howard Chandler Christy (creator of the Christy Girl, which set the criteria for the 'Miss America' pageant), Charles Dana Gibson (the Gibson Girl), Harrison Fisher (the American Girl), Jessie Willcox Smith (children's book illustrator), and many others popular in the history of illustration.

For all of these reasons the collection of illustrative art at the National Museum of American Illustration is named the American Imagist Collection. It is a national cultural treasury of art and architecture in which Americans can see their heritage lying before them in this most American of American arts.

For over 100 years, some art critics have defined 'art' as having been executed by certain artists, or as paintings hanging in museums, but without meaning all artists or all museums. In fact, it is often down to which critic is being asked to define art at which moment in time. These same critics define 'illustration' as something that the public can understand and

which is therefore not worthwhile. While this is annoying, it is also easy to establish one's own definitions. For example, it can be said that art is all painting, be it 'illustration' or 'decoration'. Illustrations are images which tell a story and decorations are simply paintings which enhance an environment – interior or exterior. Ken Stuart, art editor of the *Saturday Evening Post* made the point in 1951 that the *Post* had a readership of 20,000,000 people per week, and that visitors to the Metropolitan Museum of Art exhibited their fine art to a very few. In fact, this is still true, for in the year 2004 the attendance at the Met is approximately 6,000,000 per annum or only about 115,000 per week.

Illustrative art is critical to the documentation of American history today. Illustrations not only freeze moments in time for posterity, they also add the psychological dimension of how people see themselves. George Lucas put it well in the March 2004 issue of *Architectural Digest* when he said, 'Illustrations carry so much cultural weight with them …they're cultural artifacts infused with the sensibility of a particular time.'

THE NATIONAL MUSEUM OF AMERICAN ILLUSTRATION

A Brief History

In 1897, Mrs. Richard Gambrill (née Anna van Nest, 1865–1927), a young widow with an eight-year-old son, commissioned the architectural firm of Carrère & Hastings to design a 'Newport cottage' that she could use for entertaining during the social season. The van Nests were a wealthy Dutch-American family who made their fortune in the harness industry during the Gilded Age. The Gambrills considered the Vanderbilts nouveau riche and would not allow their daughters to be bridesmaids in an 'upstart Vanderbilt wedding'. Anna's sister, Jane van Nest, married Giraud Foster in 1892, bringing with her an $18 million dowry, and three years later he hired Carrère & Hastings to design Bellefontaine, an estate comprising 200 acres (80 hectares) in Lenox, Massachusetts. Completed in 1897, Bellefontaine so delighted Anna Gambrill that she hired the same architects to design her own summer cottage

– Vernon Court. She selected Newport's Bellevue Avenue, considered 'the most elegant street in America', as the site for her mansion in order to 'avail the family of "the season" in both Lenox and Newport'. It was said that Anna was 'shrewd, invested well and lived up to the hilt in Newport'. Her reputation as a hostess at formal dinners, high teas and harpsichord concerts was unrivalled, even by the Astors, Belmonts, Berwinds and Vanderbilts. Vernon Court was completed in 1898 and received much praise in *Town and Country*, *Architectural Record*, and other magazines of its type. The magazine articles and her own reputation for entertaining established Mrs. Gambrill's social eminence for years to come.

Provenance

The Gambrills owned Vernon Court until 1956 when, after more than a half-century of family ownership, Anna's daughter-in-law, Edith Blair Gambrill, sold it at auction to the Hatch Preparatory School. Interestingly, Carrère & Hastings also designed Blairsden (1902) for DeWitt Clinton Blair, 'King of the Western Railroads'. Blairsden was the daughter-in-law's family estate, located nearby in Peapack, New Jersey, the Gambrill winter home.

In 1963, Vernon Court became Vernon Court Junior College, which functioned as the college's administrative headquarters until 1972, when it fell into bankruptcy. At that time, Vernon Court, in fact all the college buildings, had been allowed to fall into serious disrepair. Ceiling murals had been destroyed by water; decorative elements were crumbling and falling from the façade; trellis work had rotted away; the building had not been painted in years and broken windows were everywhere; sculpture, furniture, doré wall sconces, chandeliers and other contents had been auctioned off and the property had been left to become a derelict shell.

Over the next two decades, five different owners did little more than stick their thumbs into leaks. None of them had the resources or knowledge to conserve the structure. One owner replaced the 40-ft (12-m) circular reflecting pool, with its iron stork and *putti* fountain, with a swimming pool and installed twin tennis courts on the sites of twin bowling greens,

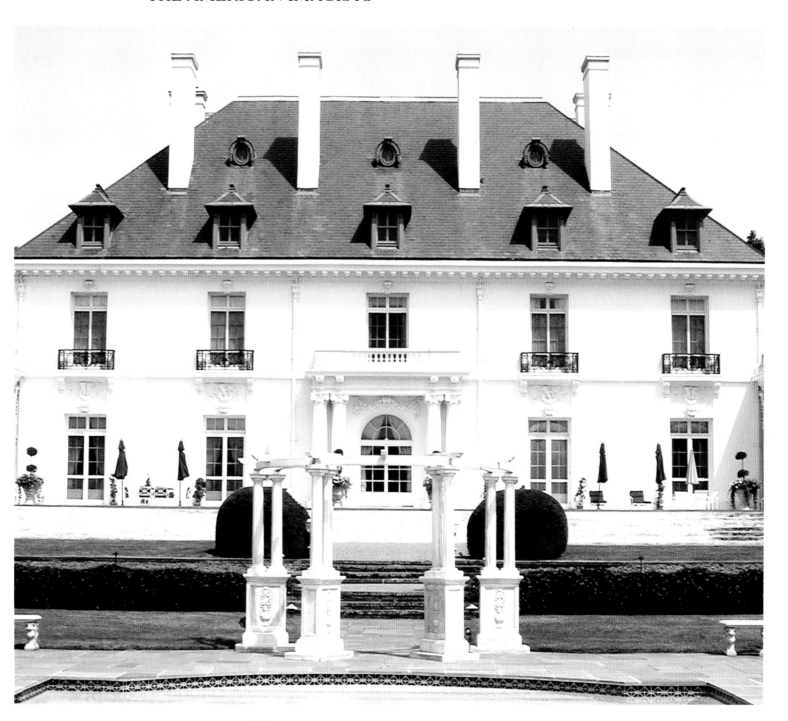

Vernon Court, the west façade, home of the National Museum of American Illustration.

while another tried desperately to restore structural elements but did not have the experience to tackle such an undertaking and inferior materials were used. British entrepreneur Peter de Savary proposed a private club for the property. His plans were to gut the interior, add an indoor pool and health spa, and convert Vernon Court into a boutique hotel, which did not endear him to the rest of the neighbourhood, who banded together to defeat his proposals.

In 1998, exactly 100 years after its completion, the property was saved from destruction when Judy Cutler and her husband, Laurence, purchased it. The Cutlers' plan was to restore the building to its original splendour and use it for cultural purposes as well as a home to live in. However, the same few neighbours who had fought de Savary also opposed the Cutlers who, after referring the matter to the Superior Court, ultimately won the battle.

While they were still undergraduates at the University of Pennsylvania, Laurence gave Judy a book on art history which coupled with an existing interest in American history set her on the road to become a collector of original illustrations. Penn is located in Philadelphia, once the national hub of magazine and book publishing, with the result that many illustrations wound up in local antiques shops and galleries. Starting as a hobby, Judy began to collect in the early 1960s when the fine arts establishment still considered illustration to be 'commercial art'. She recognized the important links between illustrative art and America's history and soon developed a keen eye for the very best masterworks of illustration, in the process becoming the leading dealer in this area. What had been an interest soon became a vocation, however, when Judy founded the American Illustrators Gallery in New York City, with the result that over a period of 40 years or so, she has been building collections for Fortune 100 corporations, art museums, Steven Spielberg, Malcolm Forbes, George Lucas, Ross Perot and other famous collectors.

It became apparent to the Cutlers that what they had was not only the largest, but also the most important milestone collection of artworks from the Golden Age of American Illustration, a period which coincided with the Gilded Age in architecture. This led to their search for a fitting place where they could keep the collection together and share it with the public. To this end the Cutlers decided to establish the non-profit-making American Civilization Foundation as an independent, educational and aesthetic organization to endow and administer their American Imagist Collection. Once they had seen Vernon Court, however, they saw at once what a perfect museum it would make.

On 4 July 2000, the National Museum of American Illustration opened to the public. It features the masterpieces of illustrative art and is the single, largest collection of its kind in the U.S.A.

The Architecture of Carrère & Hastings

In 1886, John Merven Carrère (1858–1911) and Thomas Hastings (1860–1928) left the firm of McKim, Mead and White and formed their own architectural practice. The partners had been classmates at the Ecole des Beaux-Arts in Paris and shared an identical vision of what architecture should be. Their firm was particularly known for the way it applied French architectural models to its new American designs. At the time, Americans had not yet developed their own styles of architecture and clients were looking for inspiration elsewhere, particularly to Europe, to show their sophistication and to manifest their wealth in opulent surroundings. Carrère & Hastings were far less eclectic and rather more restrained than their contemporaries, McKim, Mead and White, Richard Morris Hunt and others, who adopted many types and periods of architectural styles to satisfy the egos of their Gilded Age clients.

Vernon Court is a perfectly proportioned structure and is arguably the best building in Carrère & Hastings' repertoire. It is widely reputed to be the 'most beautiful mansion in Newport'. It was based on the Château Haroué (1721), near Nancy, France, designed by Germain Boffrand and reinterpreted by Carrère & Hastings for Mrs. Richard Gambrill.

In 1888, Carrère and Hastings made their name with their Hotel Ponce de León in St. Augustine, 'the world's finest hotel', which was designed for the industrialist and realtor

Henry Morrison Flagler. They were also the architects of Flagler's mansion, Whitehall, now the Flagler Museum (1902), the U.S. Senate and House Office Buildings (1906), Alfred I. DuPont's mansion, Nemours (1909), Daniel and Murry Guggenheim's residences (1890 and 1903), Lord Duveen of Millbrook's New York art gallery and, 14 years after Vernon Court, and the design of a New York City mansion for Henry Clay Frick, with the view to convert it into an art museum. The original plan for the Frick Collection (1912), its orientation, massing, circulation system, and much of the detailing, was taken directly from Vernon Court. But the architects are possibly best known for their New York Public Library, described by *Architectural Record* as 'the most perfect Beaux-Arts building in America'. Having used Tiffany Studios for the successful loggia murals at Vernon Court, completed in 1898, the same year in which the firm won the competition for the library, they suggested that Tiffany design the lighting and other elements of the New York Public Library project.

Thomas Hastings recommended that Jules Allard and Sons undertake the interior design of Vernon Court. Allard had made his reputation as the decorator of The Breakers, The Elms, Rosecliff and Marble House, as well as dozens of other mansions in New York City and Old Westbury, Long Island. Mrs. Gambrill then cast her favourite florists, Wadley & Smythe, in the role of landscape architects by asking them to design the gardens, with the brief that they 'undertake an enlargement of the Pond Garden at Hampton Court Palace constructed by King Henry VIII for Anne Boleyn for application in Newport'. Following this first commission for a garden design, Wadley & Smythe went from strength to strength with many other projects of the kind throughout Westchester, including the Saratoga racecourse and the Averill Harriman family estate, Arden House, on 9,000 acres (3600 hectares) in Harriman, New York.

John Carrère died in 1911 in the first recorded automobile accident, while Hastings lived on to receive a Gold Medal from the Royal Institute of British Architects in 1926, for services to modern architecture as seen in Vernon Court, whose floor plan is considered to be one of the earliest examples of Modernism. Hastings considered that a building 'must function', a

simple example being that food preparation should be near or adjacent to the place where it is to be consumed. While the outward appearance of Vernon Court may be reminiscent of a French château, Hastings designed a house that actually 'worked' in modern terms. Up until this time, most floor plans, whether for mansions or ordinary houses, did not place great value on functionality. In mansions, of course, it did not matter much if servants had to walk long distances, so it was something of an innovation to see a logical plan for domestic architecture, be it large or small.

The Architecture of Vernon Court

The play of light and shade on Vernon Court's stark white façades emphasizes all aspects of its proportion and geometry. More perfect than its exemplar in France, Vernon Court boasts exactly the right balance of decorative relief to flat surface area. The fenestration is precisely placed within the composition and is subtly accentuated with low, black wrought-iron railings, which were influenced by the work of Jean Lamour, creator of the ironwork at Haroué. The façades are ultimately counter-balanced by eight slender 85-ft high (26-m) white chimneys, casting long black shadows on the splendid steeply-sloped, grey slate roof. These vertical elements are the tour de force of the composition, giving the building its noble appearance. They contrast perfectly with the staccato rhythms of scrolls, corbels and elegant garlands, creating a symphony of positives and negatives beneath a dramatic horizontal edge. The loggias, with their symmetrical arches, are evocative of Boffand's work with de Cotte and Hardouin-Mansart at the Place Vendôme (1698). Vernon Court is therefore a manifestation of Parisian elegance with a touch of French country vigour, but with a unique American identity.

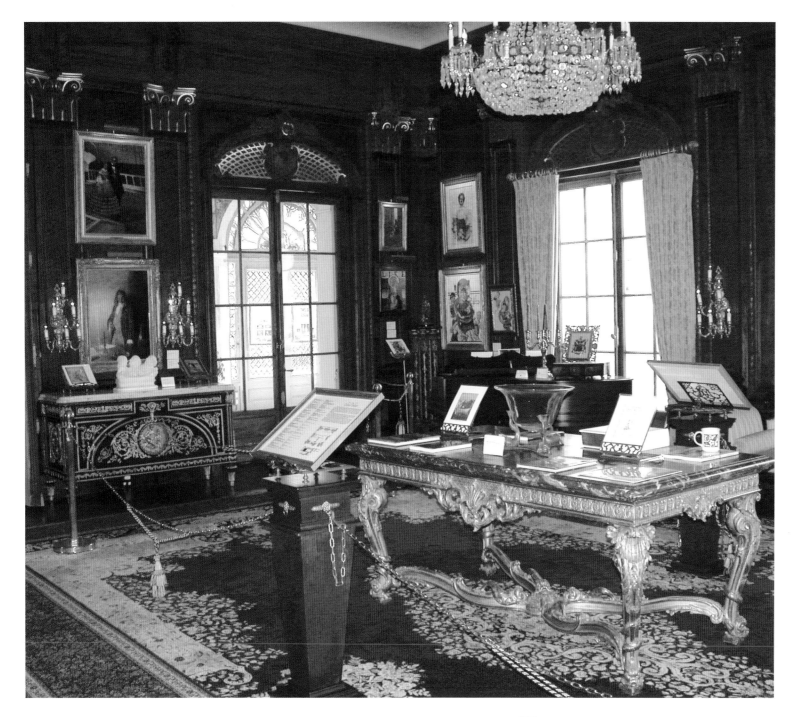

Vernon Court, the Grand Salon.

CHAPTER FOUR
MAXFIELD PARRISH'S CIRCLE

Illustration is indeed 'the most American of American art' for a variety of reasons, the most important being that it traces the history of a nation, encapsulating whole stories in a single image. Whether it is recording an obviously historical moment, is an expression of American culture, or because of the date on which it was created, or for whom it was created, all make the art form particularly relevant to Americans and their view of themselves as a nation.

The question 'Which elements constitute American art?' is not difficult to answer. Lloyd Goodrich, of the Whitney Museum of American Art, has the answer to this question: 'There have to be common elements of adherence to facts, an avoidance of subjective emotion, directness and simplicity of vision, clarity, solidity, and traditionalism.' This statement outlines the basic elements of illustrative art as a publisher might specify the requirements of an assignment given to an artist-illustrator. The publisher would also have stipulated other parameters such as the need for a cover for Veterans Day. In planning the design, the illustrator would eventually arrive at an image which best expressed the feelings and opinions of the public at large.

Today, it is difficult to appreciate the pre-eminent position the media of print occupied in the world prior to television, movies and computers. Illustrators became the cultural heroes of their day to a public eager for the next newspaper or magazine to 'see' what was happening in the world.

The men and women artists who were professional illustrators in the Golden Age had a great deal in common. Most of them were influenced by or had studied under Howard Pyle, and had become illustrators in order to earn a living. They were talented and their work reflected American culture and held up a mirror so that ordinary people could see their reflection – how they were supposed to look and act, and how they would react to different situations, gaining a measure of insight in the process. Through reading their biographies and examining their artworks, one can readily see the relationships between the artists, the sources of their art and its expression, and their circle of friends, competitors and colleagues, all of whom had very similar goals in common. There follow brief biographies of the most American of these American artists.

McClelland Barclay (1891–1943)

Born in St. Louis, Missouri, Barclay studied at the Art Institute of Chicago, moving to New York City in 1912 to make his way in the art world. He quickly became known in the city as a colourful character and according to *Life* magazine was 'talented and seen all around the town'. Tom Fogarty and George Bridgeman were his influential teachers at the Art Students League and encouraged him to be an illustrator. Barclay badly needed income after having refused help from his family in St. Louis. He simply wanted to 'make it on his own', but his family could not understand his attitude. After a single year of study he received a couple of important commissions and soon his work was appearing on the covers of national publications. One commission led to another and his career took off. During the 1920s and '30s, McClelland Barclay's images were selected for the nation's most popular periodicals, including *Colliers, Country Gentleman, Redbook, Pictorial Review, Coronet, Country Life, Saturday Evening Post, The Ladies' Home Journal, Cosmopolitan,* and a host of movie magazines.

In 1930, the General Motors Company selected McClelland Barclay's *Fisher Body Girl* for a series of advertisements, and she quickly became as popular as the Gibson Girl and the Christy Girl. He used his wife, just 19-years-old, as the model for the iconic Fisher Autobody image. She later appeared in magazine advertisements and her shapely body could soon be seen plastered on billboards all over the country. Barclay also illustrated advertisements for the A. & P. Eaton Paper Company, Elgin Watches, Humming Bird Hosiery and Lever Brothers, among others.

In the late 1930s, Barclay set up a small company to make jewellery and utilitarian

McClelland Barclay
Whoa, c.1935
Oil on canvas, 28 x 38in (71 x 96cm).

LEFT
McClelland Barclay
Woman Checking for Rain, c.1935
Oil on canvas, 40 x 20in (102 x 51cm).
Advertisement, possibly for Davenport Hosiery, c.1935.

figures for ashtrays, bookends, desk sets, lamps, and other articles for home and office. These products were fabricated out of cast grey metal with a thick bronze plate finish and retailed for just a few dollars. He appropriately, if unimaginatively, named the company the McClelland Barclay Art Products Corporation, and although one can still find these artifacts in flea markets, they never brought the artist/illustrator much in the way of income. In some ways, this is reminiscent of Maxfield Parrish's notion of a 'businessman with a brush', as though Barclay were seeking to emulate Parrish. Whereas Parrish was careful to license his images for one-time use, McClelland Barclay did not, but preferred to be his own client and

product designer as well as manufacturer, but without the requisite experience.

McClelland Barclay later began to illustrate movie posters and became even better known as one of two artists who first painted Betty Grable, the most famous of all the Second World War pin-up girls. He produced posters for Paramount Pictures and Twentieth-Century Fox and was well-known in Hollywood during the late 1930s and early '40s, primarily for his portraits of beautiful starlets. After enlisting in the navy, his posters and camouflage designs for the armed forces earned him a commission of which he was quite proud. Unfortunately, Lt. Commander McClelland Barclay was reported missing in action in the Solomon Islands, when the LST he was on was torpedoed by the Japanese navy.

OPPOSITE
McClelland Barclay
Young Woman Swimming, 1930
Oil on canvas, 22 x 38¹/₂in (56 x 98cm).
Campaign advertisement.

FAR LEFT
McClelland Barclay
Woman in Yellow Dress, 1926
Oil on canvas, 39¹/₂ x 16in (100 x 41cm).
Advertisement, possibly for Davenport Hosiery.

LEFT
McClelland Barclay
Young Woman Playing Tennis, c.1930
Oil on canvas, 20 x 30in (51 x 76cm).
Campaign advertisement.

FAR RIGHT
Anna Whelan Betts
Bedtime, 1913
Oil on canvas, 25 x 17in (63 x 43cm).
Harper's Monthly, January 1913.

Anna Whelan Betts (c.1878–1952)

There is precious little known about Anna Whelan Betts, and even less about her illustrator sister, Ethel Franklin Betts. What is known, however, is that Anna was a superb artist, a devoted craftswoman, and a respected teacher of art. She first studied at the Pennsylvania Academy with one of Maxfield Parrish's favourite teachers, Robert Vonnoh. After her early studies in Philadelphia, she left for Paris and studied under Courtois, an academic painter from the Académie Julian. Upon her return to the United States, she was given the opportunity of joining the first illustration class taught by Howard Pyle at the Drexel Institute, in the same class as Maxfield Parrish, Elizabeth Shippen Green and Jessie Willcox Smith. Because her work was so exemplary, Howard Pyle invited Anna to join his Chadds Ford summer school in the Pennsylvania countryside in the summer of 1899. It was there that she met her good friend, illustrator Sarah Stillwell Weber.

Anna Betts' first published illustration was for *Collier's* magazine in 1899, a commission most probably recommended by Howard Pyle, since he knew many art directors and was always searching for new talent to feed hungry magazines. Pyle's classes were composed of approximately 50 per cent females and Pyle took pride in getting commissions for them all, be they male or female. That first commission launched Anna Whelan Betts' career, and from then onwards her works were published in *Century Magazine*, *Harper's*, *The Ladies' Home Journal* and *St. Nicholas*, among others. However, Anna was proudest when her work was published in book

FAR LEFT
Anna Whelan Betts
Gold Coins, c.1910
Oil on canvas, 26 x 17¼in (66 x 44cm).

LEFT
Anna Whelan Betts
Spinning Wool (Spinning Yarn), c.1900
Oil on canvas, 22 x 17¼in (56 x 44cm).

form and in 1901 her first book illustrations were published in *Nancy's Country Christmas* and then in *Janice Meredith*. She is best known for her images of Victorian women in romantic settings and moods. Anna Whelan Betts was later honoured as a fellow of the Pennsylvania Academy and won several medals for her work in various competitions and exhibitions, including a bronze medal at the 1915 Panama/Pacific Exposition.

In 1925, Anna began to have problems with her sight and retired from illustration. However, she was fortunate to be able to join the faculty of Solebury School, a small private boys' school and was thereafter involved in all aspects of administration, including teaching art courses, which she enjoyed immensely. Anna stayed at Solebury School for more than 20 years and eventually retired in 1948 when her health began to wane. She moved in with her sister in New Hope, Pennsylvania, having spent almost the whole of her life in the Delaware Valley.

Ethel Franklin Betts (c.1880–1956)

The sister of illustrator Anna Whelan Betts, Ethel Franklin Betts followed the example of her talented sibling, first studying art at the Pennsylvania Academy of the Fine Arts and later enrolling in Howard Pyle's illustration classes at the Drexel Institute, continuing his classes in Wilmington, Delaware at the Howard Pyle School of Art in 1900. Ethel, her sister Anna, and art student Dorothy Warren, shared a studio and living quarters in Wilmington for two years during their period with Howard Pyle.

OPPOSITE
Ethel Franklin Betts
Easter Bonnet, 1904
Oil on canvas, 21¹/4 x 16¹/2in (54 x 42cm).

FAR LEFT
Ethel Franklin Betts
Couple with Peacocks, c.1900
Oil on canvas, 22 x 15in (56 x 38cm).

LEFT
Ethel Franklin Betts
Little Johnts' Christmas, 1906
Oil on canvas board, 17 x 10³/4in
(43 x 27cm). From While the Heart Beats
Young, *1906 by James Whitcomb Riley,*
Little Johnts' Chris'mus.

Ethel was not prolific, neither was she confident enough to gain many commissions; therefore, her illustrations have become quite prized when they come to light. She did, however, have good contacts with magazines through Howard Pyle's introductions, and produced illustrations for *St. Nicholas*, *Reader*, *McClure's Magazine* and *Collier's*. Successes with those notable publications invariably generated more work, particularly from book publishers, and between 1904 and 1909 she illustrated a number of books, such as *The Complete Mother Goose*, *Favorite Nursery Rhymes*, *Fairy Tales from Grimm*, *The Raggedy Man* and *While the Heart Beats Young*. Like her sister, she also won a bronze medal for illustration at the Panama/Pacific Exposition in 1915, the award being for the story, *The Six Swans*.

Ethel Franklin Betts' work was quite graphic in its bold layout and she attracted many fans for the delicate yet strong impact of her images, especially in children's book illustrations. In many ways, the work of the talented Betts sisters is not dissimilar.

Ethel married in 1909 and produced precious little thereafter, although she was invited frequently to exhibit, which she was happy to do during this dormant part of her life, offering her tattered portfolio of originals well into the 1930s for scholastic exhibitions.

Howard Chandler Christy (1873–1952)

Howard Chandler Christy had come a long way from his early days in Ohio, where he had watched steamboats on the Muskingum river. Now he was painting presidents, the grandes dames of society,

THE SAME OLD YARN

OPPOSITE LEFT
Ethel Franklin Betts
The Hired Girl, 1906
Oil on canvas board, 17³/₈ x 12in (44 x 30cm). While the Heart Beats Young by James Whitcomb Riley.

OPPOSITE RIGHT
Ethel Franklin Betts
The Lisper, 1906
Oil on canvas board, 17¹/₄ x 11¹/₈in (44 x 28cm). While the Heart Beats Young by James Whitcomb Riley.

LEFT
Howard Chandler Christy
The Same Old Yarn, 1918
Watercolour, gouache and pencil on board, 35 x 25¹/₄in (89 x 64cm).

Hollywood stars and army generals. Christy arrived in New York in 1890 to attend the Art Students League, where he studied with William Merritt Chase. At that time, great technological advances were being made in publishing and Christy witnessed the unfolding of new and lucrative opportunities for providing illustrations for the new periodicals that were appearing on the scene. Reproduction technologies had evolved to the point where engraving was no longer the only means of reproducing a painting. Consequently the needy young artist decided to turn his hand to illustration as a profession. His first project was to illustrate *In Camphor*, a book by Frank Crowninshield, which inspired other commissions when completed.

Christy's patriotic feelings were stirred by the explosion of the battleship *Maine*, and he decided to cover the Spanish-American War. Accompanying the Rough Riders under fire, he illustrated articles published by *Scribner's*, *Harper's*, *Century*, and *Leslie's Weekly*, to the utter delight of readers back home. In the meantime, Christy got to know Col. Theodore Roosevelt and developed an even broader interest in patriotic subjects. By the time he returned home in 1898 he was a celebrity, his fame and reputation thoroughly secured with *The Soldier's Dream*, published in *Scribner's*, where he portrays a beautiful girl known as the Christy Girl. Like the Gibson Girl, she was a prototype for the ideal American woman, 'High bred, aristocratic and dainty though not always silken-skirted; a woman with tremendous self respect'. From that point onwards, Christy painted beautiful women for *McClure's* and other popular magazines.

OPPOSITE
Howard Chandler Christy
The Puritan Girl, 1911
Oil on canvas, 63 x 44in (160 x 112cm).
Liberty Belles: Eight Epochs in the
Making of the American Girl, The
Courtship of Miles Standish *by*
Earl Stetson Crawford, 1912, published by
the Bobbs-Merrill Co.

LEFT
Howard Chandler Christy
Couple in the Woods, 1910
Watercolour, 40 x 28in (102 x 71cm).

Howard Chandler Christy
Miss America, 1925
Bronze over plaster (galvano), on original
marble base, 14^1/2in (37cm) high.

There were calendar and book illustrations, some with articles that Christy had written himself, and which expanded his audience. Consequently, his idea of a beautiful girl was adopted by everyone thereafter.

In 1908, he returned to the Muskingum river and enlarged his childhood home, The Barracks, by adding a studio, where, in spite of being so far from the beaten track, publishers continued to compete for his illustrations and by 1910 he was earning an astounding $1,000 per week. In 1915, Christy returned to New York and continued his career doing magazine commissions. As war once again appeared on the horizon, he decided to assist the war effort by painting posters for government war bonds, the Red Cross, the armed forces, and in support of civilian volunteer organizations. His famous poster of a young woman dressed in a sailor's uniform with the caption, 'If I were a man, I would join the Navy', is a classic of the period.

The 1920s was an era that was particularly lucrative for illustrators. New directions, styles and music were combining with the business boom to create a huge market for portrait artists, in particular, as the wealthy and famous sought immortality on canvas. Christy turned his back on illustration and began to paint notables, including Benito Mussolini, Crown Prince Umberto of Italy, Captain Eddie Rickenbacker, U.S. presidents Franklin Roosevelt, Coolidge, Hoover, Polk, Van Buren and Garfield; the humourist Will Rogers, aviator Amelia Earhart, General Douglas MacArthur and William Randolph Hearst. Exhibitions, commissions, trips to Europe and

Howard Chandler Christy
Stand by Your President, 1933
Oil on canvas, 60 x 40in (152 x 102cm).
National Recovery Act poster.

FAR RIGHT
John Clymer
Backyard Baseball, c.1951
Oil on canvas, 35 x 28³/₄in (89 x 73cm).
Saturday Evening Post cover, 21 April 1951.

OPPOSITE
John Clymer
Central Park Zoo, 1953
Oil on board, 34 x 27in (86 x 69cm).
Saturday Evening Post cover, 25 July 1953.

hobnobbing with the rich and famous engaged him completely for the rest of the 1920s. In 1925, after his earlier successes with his American girls, he was commissioned to make a sculpture, which he called, *Miss America* (page 345), after he was the judge in the Miss America Pageant in Atlantic City.

In 1934, Christy painted some magnificent murals of female nudes at the Café des Artistes in New York, a restaurant on the ground floor of his studio building. This heralded a new kind of recognition and a new kind of commission for allegorical works depicting historical events and commemorative posters. Christy painted illustrations again, but of a wholly different kind.

The 1940s saw the appearance of mainly historical pieces, such as *The Signing of the Constitution* (Christy's most famous mural, which hangs in the Rotunda of the United States Capitol Building), *Signing the United Nations Charter*, and his portrayal of Thomas Edison in *Dawn of a New Light*. Howard Chandler Christy died peacefully at the age of eighty in 1952, in his beloved studio apartment at the Hotel des Artistes in New York City.

John Clymer (1907–89)

Famous for documenting the American frontier, Western history and wildlife, John Ford Clymer was born in Ellensburg, Washington. He was interested in art from an early age, having taken correspondence art courses from the age of 13. Although they were unsolicited, by the time he was 16 he had sold his first two illustrations to the Colt Firearms Company in Hartford, Connecticut. He was amazed that an

art director should purchase these illustrations, since he had had no formal training, but his work was clearly suitable for publication. The ingenuity and raw talent of the young man was recognized by everyone who saw his work, and was driving him towards illustration as a profession. The Colt illustrations were used not only for advertisements, but were also published and republished over and over again.

After graduating from high school, Clymer moved to Canada and produced illustrations for billboards. He was a sign painter in Vancouver, where he took art classes at night school until he was 23. He studied at the Vancouver School of Fine Art and later at the Ontario College of Art. As he matured, Clymer travelled throughout Canada where he became immersed in the north-western environment which he loved to paint best: wildlife, mountain men, trappers, Indians, and the flora of the region, his region.

In 1927, Clymer worked on a Yukon river steamboat and visited gold mines, river trading posts and logging camps, creating a visual encyclopedia of memories of the changing times and recorded the scenery as the landscape was altered by encroaching civilization. In 1930, John Clymer attended the Wilmington Academy in Delaware, where he was strongly influenced by N.C. Wyeth and Wyeth's students, Gayle Hoskins, Stanley Arthurs, and Douglas Duer. In 1932, he married, and a few years later moved to Westport, Connecticut to join the artist colony there, where he studied further with Harvey Dunn and later at the Grand Central School of Art in New York City.

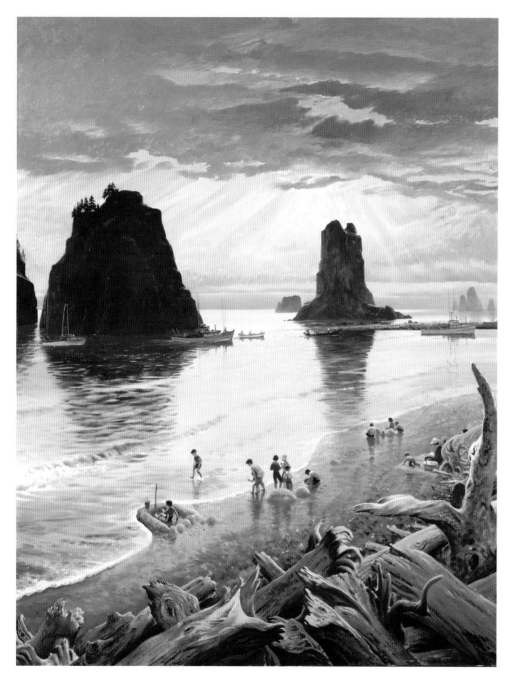

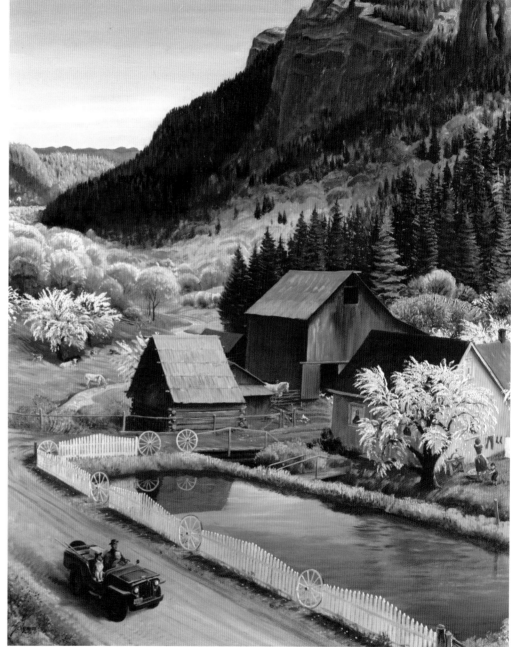

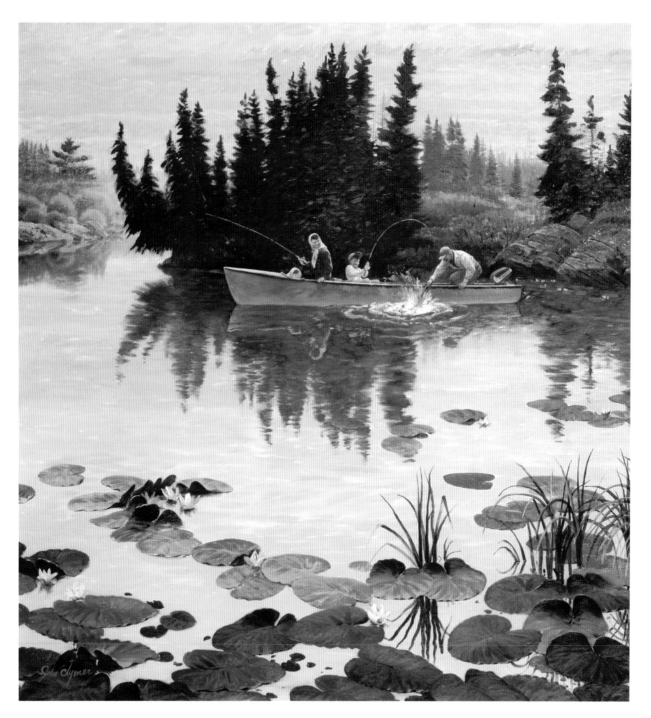

OPPOSITE LEFT
John Clymer
Coast, Lapush, Washington, c.1957
Oil on board, 34 x 27in (86 x 69cm).
Saturday Evening Post, 27 July 1957.

OPPOSITE RIGHT
John Clymer
Western Farm Scene, 1957
Oil on board, 33 x 27in (84 x 69cm).
Cover of Saturday Evening Post, 23
March 1957.

LEFT
John Clymer
Family Fishing (First Catch, Fly
Fishing), 1959
Oil on canvas, 30 x 28in (76 x 71cm).
Cover of Saturday Evening Post, 13 June
1959.

FAR RIGHT
Dean Cornwell
Desert Healer, 1922
Oil on canvas, 36 x 28in (91 x 71cm).
The Desert Healer *by E.M. Hull for*
Cosmopolitan Book Corporation, October
1922 to March 1923.

'Hour after hour Carew lay motionless,
his ears in the warm sand, the blood
beating in his brain on fire'.

OPPOSITE
Dean Cornwell
The House of Nazareth, 1926
Oil on canvas, 38 x 29in (96 x 74cm).
City of the Great King *by William Lyon*
Phelps, 1926, Cosmopolitan Book
Corporation, New York.

Illustrator Walt Louderback was his hero, although he was also impressed by Dean Cornwell and N.C. Wyeth. Clymer's illustrations were published in the *Saturday Evening Post, True, Field and Stream*, and he painted calendars for 28 years for the American Cyanamid Company, and produced advertising material for the New England Life Insurance Company for more than a dozen years. During the Second World War, John Clymer and the illustrator Tom Lovell joined the Marines together and were stationed in Washington State. They spent the war producing illustrations for the *Marine Corps Gazette* and *Leatherneck* magazine. When Clymer was discharged in 1945, he resumed contact with the *Post* magazine and began to do covers once again; he painted as many as 90 covers in all.

In 1966, John Clymer and his wife, Doris, moved to Jackson Hole, Wyoming, to indulge his passion for painting local people, indigenous wildlife and flora, and to once again create a visual record of changing times and losses to the environment. John Clymer said that he always tried to take the viewer of his art 'to an actual place and make him feel that he was really there'.

Dean Cornwell (1892–1960)
Dean Cornwell began his career as an illustrator in 1914 and worked on steadily until his death at 68. His work appeared regularly in popular magazines and important books written by a number of outstanding authors, including Pearl S. Buck, Lloyd Douglas, Edna Ferber, Ernest Hemingway, W. Somerset Maugham and Owen

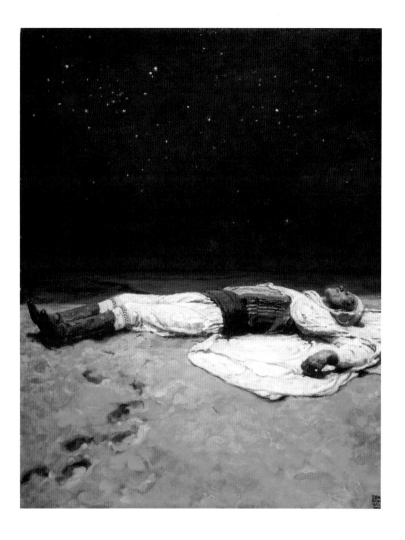

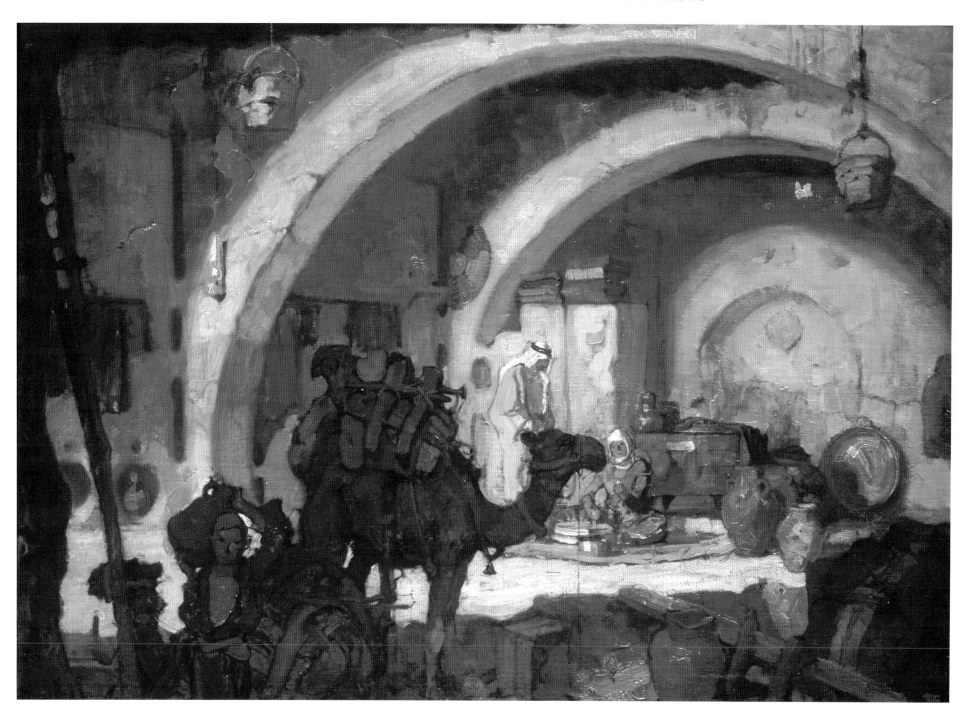

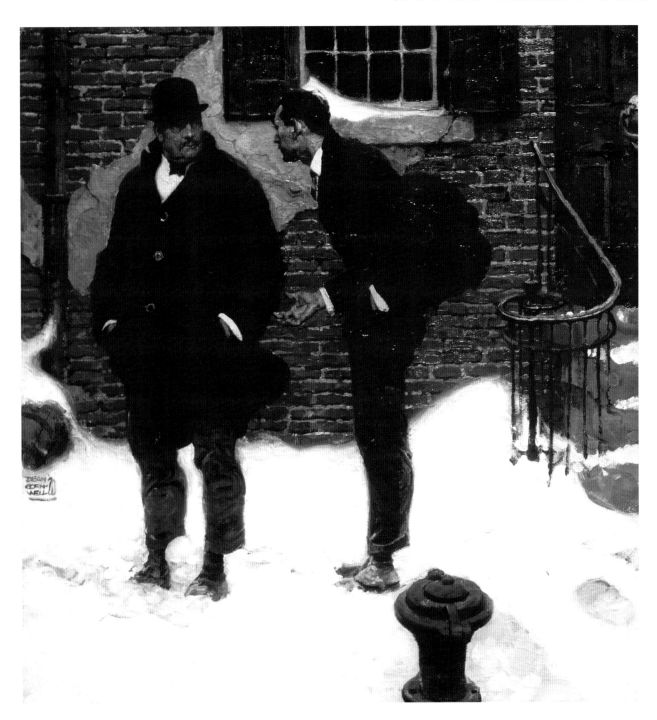

Wister. This left-handed illustrator painted more than 20 murals for various public institutions and in the process became one of the nation's most popular muralists.

Cornwell was born on 5 March 1892 in Louisville, Kentucky and his father, Charles L. Cornwell, a civil engineer, largely fostered the young boy's interest in drawing. Because of his father's engineering career, there were always sketches of bridges and railroads lying around the Cornwell house and they intrigued young Dean, who was amazed that anything could be drawn so exactly. A similar influence on his career was the nearby Louisville and Portland Canal, constructed during the Industrial Revolution. As a result of its magnetic attraction for the young boy, one of Cornwell's earliest drawings, at the age of 13, is entitled *Tell City*, a sketch of a steamboat passing through the Louisville and Portland Canal.

Like so many other illustrators of note, Dean attended the Art Students League in New York in 1915, where he met Charles Chapman and studied under Harvey Dunn, a disciple of Howard Pyle. Harvey Dunn proved to be a great influence on Cornwell in respect to colour theory and composition. Dean was also lucky enough to study under Frank Brangwyn, a distinguished English muralist.

Dean Cornwell's work reveals a magnificent combination of dynamic colours within a formal composition of the elements he wished to capture within a limited space. He was known to create countless studies on paper before finally committing an image to canvas. This ongoing process of refinement created magnificent results, and his works were promptly accepted by art directors and

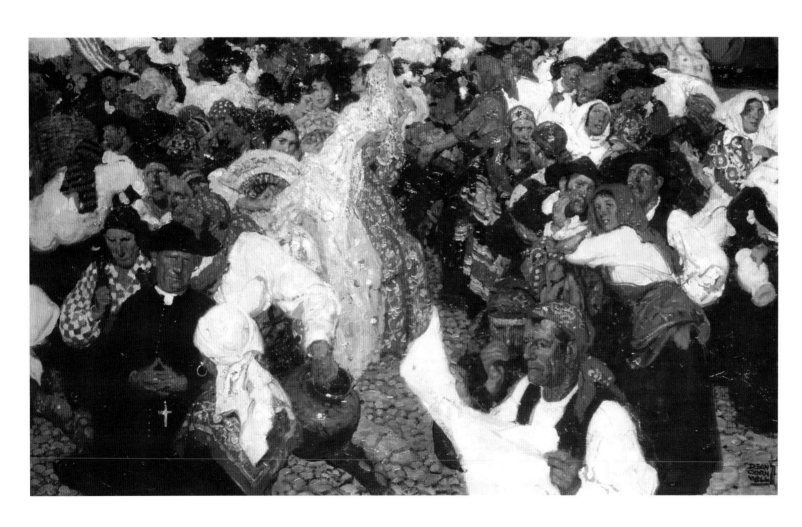

OPPOSITE
Dean Cornwell
In Front of the New York Athletic Club,
1920
Oil on canvas. 30 x 28in (76 x 71cm).

LEFT
Dean Cornwell
Street Scene, Gypsies, 1921
Oil on canvas, 24 x 40in (61 x 102cm).
Cosmopolitan magazine illustration for
The Torrent *by Vicente Blasco-Ibañez.*

Dean Cornwell
Who Hired You? (1924)
Oil on canvas, 30 x 46in (76 x 117cm).
For The Enchanted Hill *by Peter B. Kyne,*
a story for Cosmopolitan, 1924.

'In hysterical Spanish and English the
killer began babbling a confession. "Who
hired you?" demanded Purdy.'

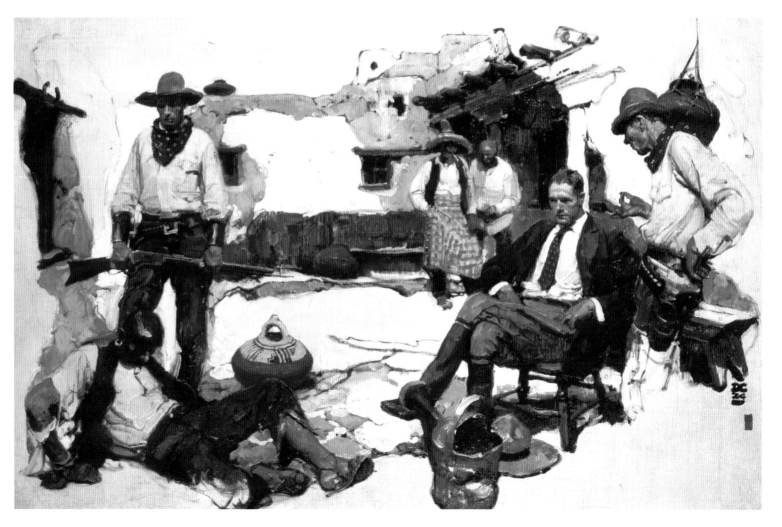

publishers for the finest magazines, including *Harper's Bazaar*, *Cosmopolitan*, *Redbook*, *Good Housekeeping* and the *American Magazine*. In *Desert Healer* (page 352), Cornwell's composition reveals both the gravity of the situation and the structure of the painting, giving the viewer a tactile sense of the atmosphere created. The vastness of the sky above represents infinity, counter-balanced by the sandy waste below, while the hero of E.M. Hull's story lies across the canvas and delicately divides it in half.

By the 1930s and '40s, Cornwell became known as the 'Dean of Illustrators'; his patriotic images and war posters were to be seen everywhere, as were his advertisements for blue chip companies such as Seagrams, Palmolive Soap, Scripps-Howard newspapers, Coca-Cola and General Motors. Cornwell painted a series of advertisements for Wyeth Laboratories, which commemorated milestones in the history of medicine as, for example, in *Conquerors of Yellow Fever*. His commissioned advertisements became collectibles, if one could be found which was not badly faded from having been displayed in a drugstore window.

Paintings by Cornwell have been exhibited in the Whitney Museum of American Art, the Pennsylvania Academy of the Fine Arts, the Chicago Art Institute and the National Academy of Design. He taught and lectured at the Art Students League in New York City and at museums and art societies throughout the United States. James Montgomery Flagg paid him a tribute when he said, 'Cornwell is the illustrator par excellence – his work is approached by few and overtopped by none ... he is a born artist.'

Stevan Dohanos (1907–94)

A proponent of simplicity as a virtue, Stevan Dohanos once said that 'a clean, strong, uncluttered image forms the basis of a good picture'. Born in the steel town of Lorain, Ohio, Stevan Dohanos, called the 'American Realist', was a founder of the Famous Artists School in Westport, Connecticut. One cannot discuss the illustrative art of Dohanos without

mentioning Norman Rockwell, as their *Saturday Evening Post* cover images are invariable compared. Whereas Rockwell was noted for idealizing the American way of life, Dohanos had an all-consuming love of the common everyday things in life. He remarked: 'As an artist I have always gloried in finding beauty in the ordinary things of life.'

Dohanos was influenced by 'The Eight' (Henri, Sloan, Glackens, Shinn, Prendergast, Davies, Lawson, Luks) and the realistic depictions they painted, and claimed that 'the truth and quality of the art could not be long denied'. He was more true to fact and form than Rockwell, who had a tendency towards exaggeration. However, the difference between the two illustrators is more obvious in their choice of subjects rather than their techniques. It is said that Dohanos focused more on the environment of the people he portrayed than the people themselves, making him more objective than Rockwell. Norman Rockwell once described the privilege of painting for the *Post* as 'the greatest show window in America for an illustrator. If you did a Post cover, you had arrived'. The proof of Dohanos' success was that he painted over 125 *Saturday Evening Post* covers during the 1940s and '50s, illustrating scenes of American life that included baseball games, eating ice cream, mobile homes, gas stations, children with toys or butterfly collections, barns and, of course, Harley-Davidson motor bikes. Dohanos also worked for *Esquire*, among other magazines, and designed 46 stamps for the U.S. Postal Service.

Stevan Dohanos studied art in night school, like many other talents who could neither afford the time nor tuition at a full-time or better-known institution, and then later at the Cleveland School of Arts. However, he was able to get a job painting signs and lettering and learned more through work experience about colour, scale, texture, composition and other basics than he did in art school. Later in his career, he accepted advertising commissions using still life subjects rather than lifestyle images, showing people engaged in various occupations. He completed an advertisement for Dunham's shoes and used techniques he had acquired as a billboard artist in its preparation.

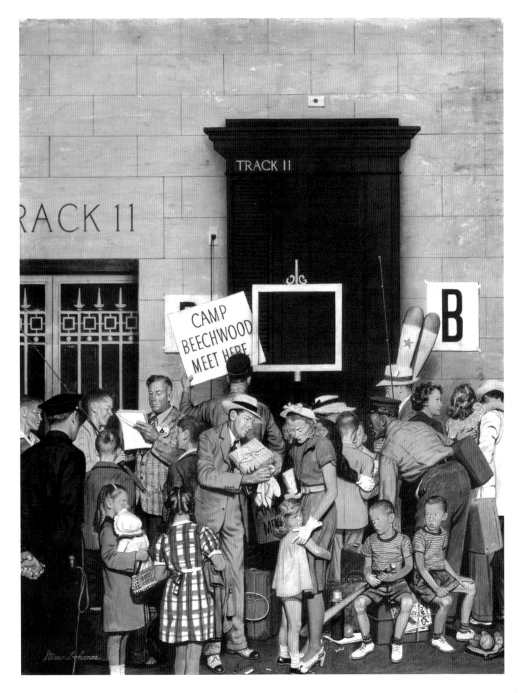

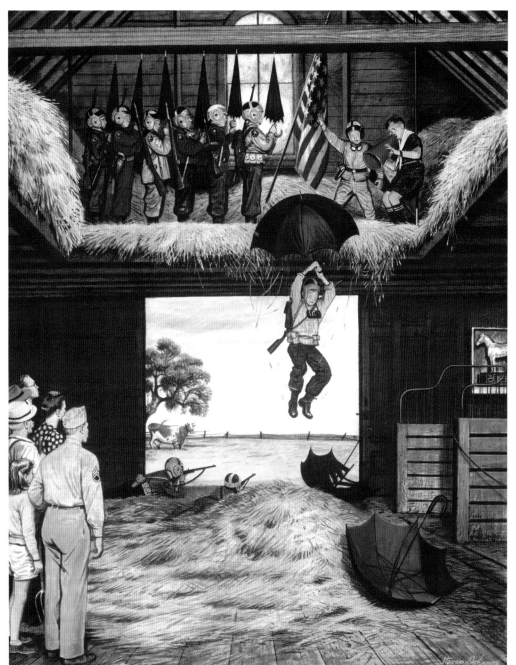

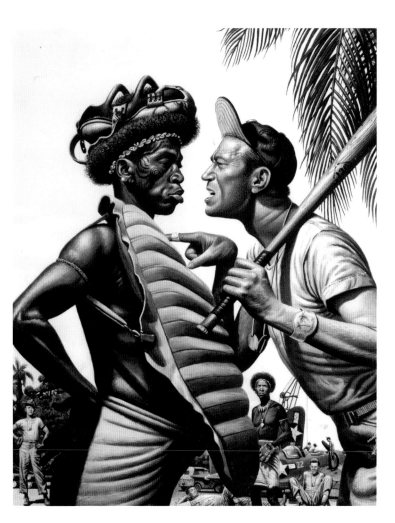

Dohanos was considered to be the cultural spokesman for the *Saturday Evening Post* because of his clear visual images and the poignant glimpses of Americana that they revealed. He cherished his relationship with the *Post*, while relishing the differences between his work, Rockwell's and other *Post* favourites. Often, he would use images from Westport, Connecticut, and local readers were able to catch sight of their neighbours in the backgrounds of scenes depicting everyday activities.

Dohanos, along with Rockwell, came to represent the quintessence of American magazine illustrators. His images were generally slightly humorous, optimistic, and reflected the best of American ideals. He has been referred to as the 'Delineator of the Heart of America'. His paintings are in the collections of the Avery Memorial of Hartford, The Cleveland Museum, New Britain Museum of American Art, the Pennsylvania Academy of the Fine Arts and the Whitney Museum of American Art.

Harvey Dunn (1884–1952)

Harvey Dunn was born in the Red Stone Valley in the Dakota Territory in a shanty on a land claim just off a major buffalo trail. While sounding more romantic than it really is, the area where he was born had been the 'frontier' a few years earlier. His parents were homesteaders who insisted that he help on the farm, while he had bigger ideas in mind, and wanted to become an artist. In 1901, he abandoned the farm and enrolled at the South Dakota Agricultural College, but soon left for the Art Institute of Chicago (1902–04). Just

RIGHT
Harvey Dunn
The Silver Horde, 1909
Oil on canvas, 36 x 24in (91 x 61cm).
For The Silver Horde *by Rex Beach, a*
ten-part series for Hampton's magazine,
1908–09.

FAR RIGHT
Harvey Dunn
The Woodsman, 1909
Oil on canvas, 36¼ x 24in (92 x 61cm).
Outing Magazine cover, October 1909.

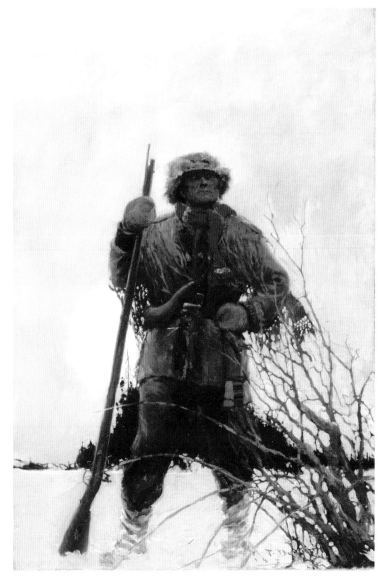

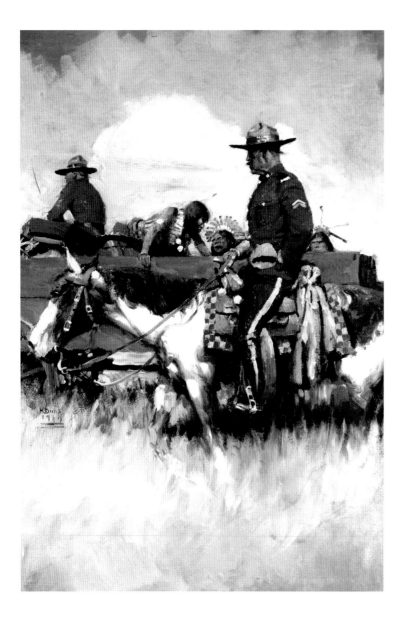

two years later, Howard Pyle met Dunn after a lecture at the AIC, looked at his work and invited him to join the summer programme in Chadds Ford, Pennsylvania (1904–06). Dunn accepted and studied with Pyle, becoming deeply influenced by his mentor and noting that 'Pyle's main purpose was to quicken our souls so that we might render service to the majesty of simple things'.

In 1906, at the age of 22, and with Pyle's active encouragement, Harvey Dunn opened his own studio to begin a career as an illustrator. Dunn, a large bull of a man with country manners, was almost an immediate success, even though he did not fit the usual prototype of an artist. He sold his first illustration to the Keuffel and Esser Company of New York for an advertisement and other commissions rolled in afterwards from magazines such as *Century, Collier's, Harper's New Monthly, Scribner's* and *Outing*. In all, Harvey Dunn painted over 250 illustrations for the *Saturday Evening Post*, an indication of his great prowess, talent and popularity.

Harvey Dunn married in 1908, with N.C. Wyeth acting as his best man. He stayed in Wilmington until 1914, when he and his wife moved to Leonia, New Jersey. There, he met another artist, Charles S. Chapman, and they co-founded the Leonia School of Illustration while continuing to commute to clients in New York City. Among his first students were Dean Cornwell and Arthur Fuller. Dunn instilled in all his students the thought that 'art schools teach complexities, while I teach the simplicities. The only purpose in my being here is to get you to think pictorially'. Dean

FAR LEFT
Harvey Dunn
The Prisoners, 1914
Oil on canvas, 35¹/₂ x 23¹/₄in (90 x 59cm).
Elgin Watch advertisement, 1914.

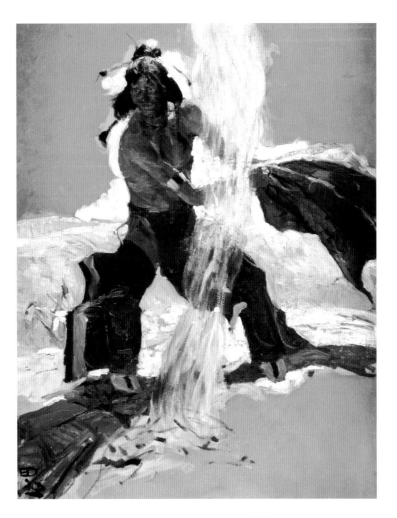

Harvey Dunn
Brave Sending Smoke Signals, 1923
Oil on board, 32 x 24in (81 x 61cm).
Collier's Weekly, 10 March 1923.

Cornwell remembered his days as Dunn's student and said, 'I gratefully look back on the time when I was privileged to sit at Harvey Dunn's feet ...he taught art and illustration as one ...as religion ...' The influence of Pyle on Dunn was obvious and it did not lessen when he passed what he had learned from Pyle onto his own students. The legacy continued when he went to teach at the Grand Central School of Art, where his students included John Clymer, Amos Sewell, Harold von Schmidt and Saul Tepper. Dunn greatly influenced his friends, N.C. Wyeth and Frank Schoonover, with his own interpretations of Pyle's teachings, while continuing to speak of his mentor. He once said that 'art can not be taught, Pyle did not teach art, any more than life can be taught, but Pyle lay constant stress upon the proper relationship of all things'.

During the First World War, Dunn was commissioned a captain and was one of eight war artists assigned to the American Expeditionary Forces in France, where he suffered deep emotional trauma from his experiences. It was while he was recovering that he turned to painting fond reminiscences of his youth on the plains.

In 1919, after the war had ended, he turned many of his paintings over to the Smithsonian Institution and moved back to New Jersey, where he built a large studio and attempted to revitalize his pre-war career. Once again he blossomed, turning out paintings so fast that his art editors were astonished. Nostalgically, he made many trips to South Dakota and began to earnestly paint the prairies as he had known them as a youth before the advent of wholesale development and highways.

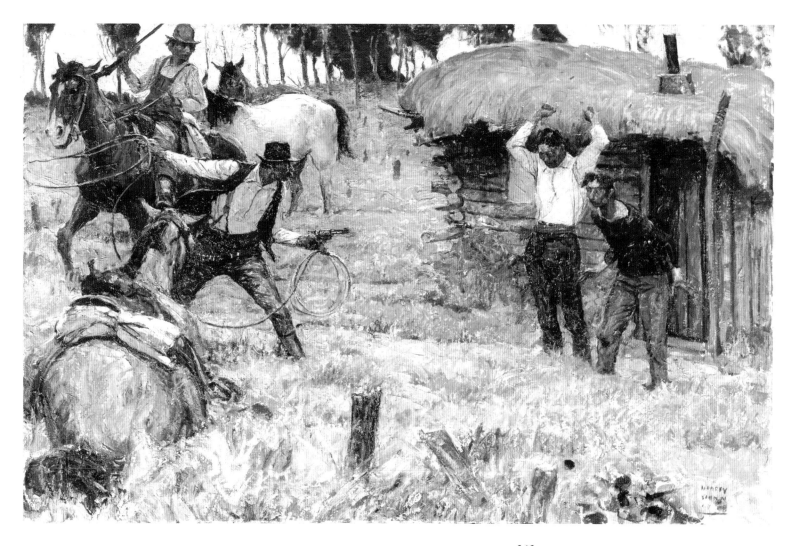

Harvey Dunn
Apprehending the Horse Thieves, 1938
Oil on canvas, 26 x 40in (66 x 102cm).
Saturday Evening Post, 30 April 1938.

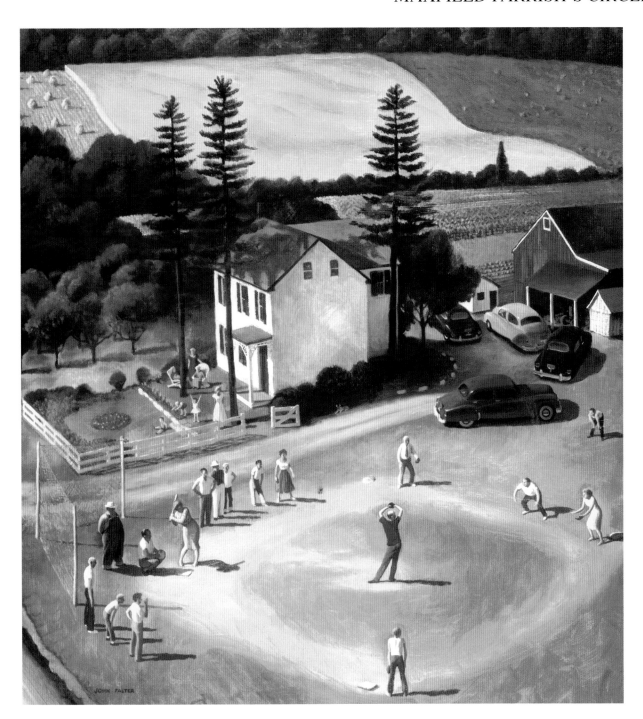

The early influence of Howard Pyle on Harvey Dunn may be seen throughout his work, especially in Dunn's treatment of dramatic moments. He went on to paint murals, his illustrations appeared on many magazine covers, and in 1950 he donated his collection of prairie paintings and archives to South Dakota State College, where they can now be seen at the South Dakota Art Museum in Brookings, on Harvey Dunn Street.

John Falter (1910–82)

John Falter was born in Plattsmouth, Nebraska, although the family homestead was in Atchison, Kansas. He started his career as an illustrator when he was rather young, selling his first artwork when he was 20 to *Liberty*, a pulp magazine. The commission, however, gave him the exposure he needed to gain further clients, including the Gulf Oil Company, Four Roses Whiskey and Arrow Shirts. His career flourished, from his time on pulp magazines until he became a noted cover illustrator for the most famous magazine in America, the *Saturday Evening Post*.

Falter studied art at the Kansas City Art Institute and later moved to New York to 'get the right exposure and make career contacts', and matriculated at the Art Students League. He later attended classes at the Grand Central School of Art, where he studied under George Wright (1873–1951), an illustrator for *Century*, *Harper's*, *Scribner's* and *Saturday Evening Post*. Wright was a fine role model, for before becoming an illustrator he had been a reporter and was strict in his teaching methods, encouraging students to make

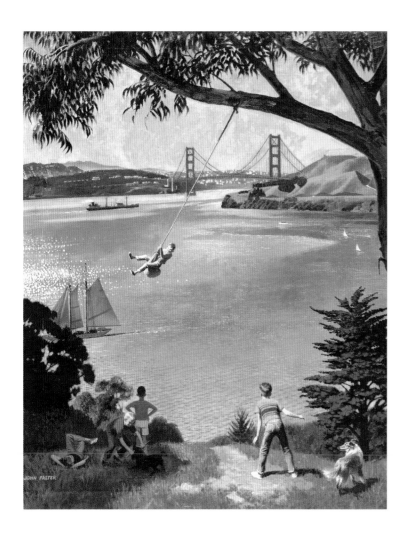

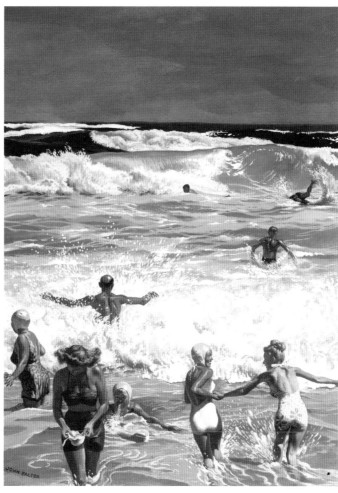

John Falter
The Family Picnic (Baseball), c.1950
Oil on canvas, 26¹/8 x 24¹/8in (66 x 61cm).
Saturday Evening Post cover, 2 September 1950.

FAR LEFT
John Falter
Golden Gate Bridge, 1956
Oil on canvas, 28 x 24in (71 x 61cm).
Saturday Evening Post cover, 26 May 1956.

LEFT
John Falter
Maine Surf, 1948
Tempera on board, 23 x 17¹/4in (58 x 44cm). Saturday Evening Post cover, 14 August 1948.

John Falter
June Wedding, 1950
Oil on canvas, 24 x 22in (61 x 56cm).
Saturday Evening Post cover, 24 June 1950.

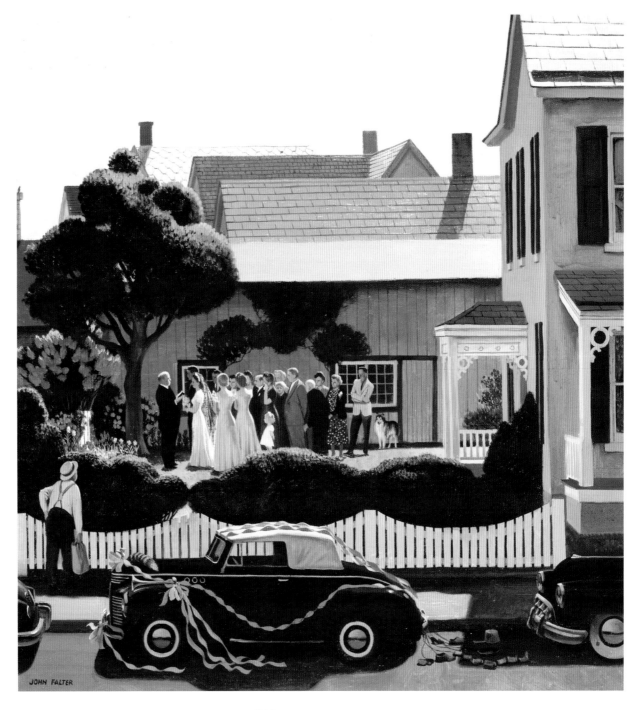

preliminary studies and organize themselves well in advance. Wright also believed in showing artists all the ways of getting a better grasp of what the client expected. Falter took all this to heart and passed similar ideas on to others. He is reputed to have shown Ken Stuart, art editor of the *Post*, a series of sketches as ideas for a cover, which caused Stuart to remark, 'If the idea is right, it takes only a few simple lines for one artist to explain it to another.'

Falter went on to illustrate 47 books for *Reader's Digest* and 187 covers for the *Saturday Evening Post*. Interestingly and prophetically his businessman father, George H. Falter, once said, 'You won't be an artist son, until you've put a cover on the Saturday Evening Post.' Over his many years with the *Post*, John Falter painted mostly scenes he had experienced as a youth growing up in Nebraska and Kansas. He was also a portrait artist, and painted jazz idols Louis Armstrong and Art Tatum. He delighted in introducing images of real people into his compositions, sometimes including himself, which seemed to cause consternation on occasions and reminds one of the way cartoonist Al Hirschfeld hid his daughter's name, 'Nina', in his caricatures. Viewers made a point of looking for Falter's image, usually complete with a pipe and standing in a crowd waiting to be found out. In his later years, Falter painted a number of famous people, although not for magazines: they included actress Olivia De Havilland, actor James Cagney and Admiral Halsey.

With the onset of the Second World War, Falter joined the navy as a chief boatswain's mate and when it was learned that his artwork had been published, he was designated 'lieutenant with special art

John Falter
Political Convention, 1948
Watercolour on paper, 20 x 19¹/₄in
(51 x 49cm). Saturday Evening Post cover,
19 June 1948.

duties'. During his 72 years, Falter's paintings covered a wide range of themes, from episodes in American history, such as *Charging San Juan Hill* to *Country Boy and Collie*, a reminiscence of his childhood. He recorded special locations across America, from the Golden Gate Bridge to Gramercy Park. He once said, 'If you are not in love with what you are trying to put on canvas, you had better quit.' One indisputable fact that was obvious from his work was his deep love for America.

Harrison Fisher (1875–1934)

At one time, Harrison Fisher's Fisher Girl was as well known as the Gibson Girl. Likewise, his American Girl was recognized as the epitome of feminine beauty during the first quarter of the 20th century. She was lithe and elegant, but also athletic, independent and intelligent, eventually eclipsing the Gibson Girl. Fisher's place in the history of American illustration was secured by his ability to paint beautiful women. In the 1920s, *Cosmopolitan* magazine called him, 'The World's Greatest Artist', remarking that 'There is an underlying ideal that dominates his paintings. His ideal type has come to be regarded as the type of American beauty: girls, young with the youth of a new country, strong with the vitality of buoyant good health, fresh with clear-eyed brightness, athletic, cheerful, sympathetic, and beautiful'. They went on to say that 'The American Girl is practical, adventuresome, active, and above all, attractive. No one can portray more of this attractiveness than Harrison Fisher'.

Harrison Fisher
At the Opera, 1901
Watercolour on illustration board, 27¼ x 19½in (69 x 49cm).

RIGHT

Harrison Fisher

A Winter Promenade, 1905

Watercolour on illustration board, 37 x 22in (94 x 56cm). Illustration for a calendar cover in 1906. Also used in Scribner's Magazine in 1907.

OPPOSITE LEFT

Harrison Fisher

Her Eyes Were Made to Worship, 1909

Watercolour and gouache on board, 17 x 12in (43 x 30cm). From American Beauties, *November 1909, Grosset & Dunlap, also used for cover of Saturday Evening Post, 10 October 1908.*

OPPOSITE RIGHT

Harrison Fisher

Woman at the Piano (Oh! Promise Me), 1910

Watercolour, 25¼ x 16¾in (64 x 42cm). The Saturday Evening Post cover, 15 January 1910. Also used in Fair Americans *by Harrison Fisher for Charles Scribner's Sons, 23 Sept and Harrison Fisher's* American Girls in Miniature, *Charles Scribner's Sons, 24 August 1912.*

Harrison Fisher was born in Brooklyn, the son of Felix Xavier Fisher and grandson of Hugo Antoine Fischer (sic), both artist immigrants from Bohemia. In 1886, the family left New York and moved to Alameda, California, not far from San Francisco, Harrison's mother dying two years later. In 1893, Antoine Fisher's art was shown at the World's Columbia Exposition in Chicago, giving him the confidence to open a studio on Battery Street in San Francisco. Felix Fisher had already started to teach his two sons to sketch and paint as soon as they arrived in California, taking them on camping trips up and down the Pacific coastline so that they could record the magnificent scenery. Harrison had shown promise quite early on, having excelled at drawing from the age of six. Coupled with his father's training and natural talent, he enrolled at the Mark Hopkins Institute of Art, and as a teenager sold illustrations to local newspapers. The popular national magazine, *Judge*, was soon publishing Harrison's works, creating the need for a separate studio in which to concentrate. Those early commissions brought him to the attention of the *San Francisco Call*, and he was hired as a staff artist to illustrate society functions, sporting meets and news items. After a couple of years he joined the *San Francisco Examiner*, the largest newspaper in William Randolph Hearst's stable, and sketched news events. In 1897, Fisher was given a requested transfer to Hearst's *New York American*, where, barely two weeks later, he landed a job as in-house cartoonist and illustrator with the fabulously famous *Puck* magazine.

By 1900, Fisher was doing freelance assignments for the

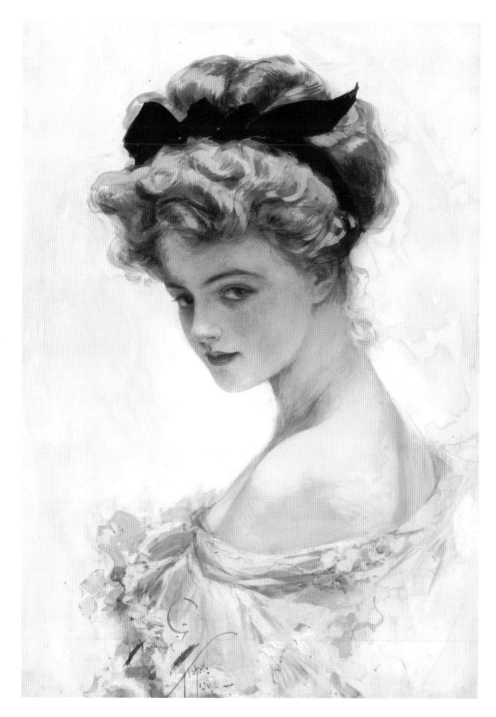

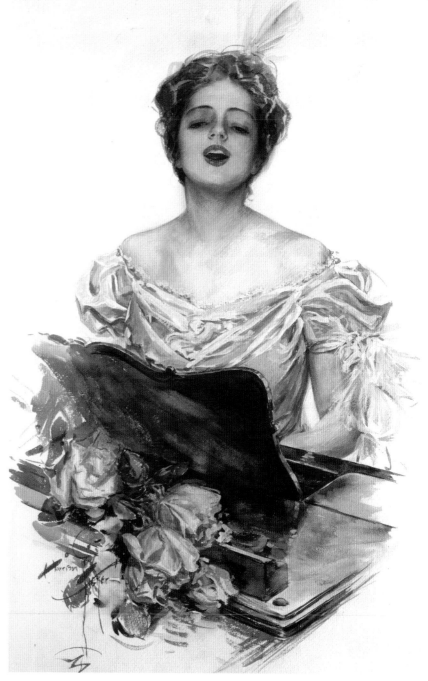

Saturday Evening Post and was receiving more commissions from other respected journals, including *McClure's*, *Life*, *Scribner's*, *Ladies' Home Journal* and *Cosmopolitan*. Hearst kept him as busy as he could to prevent others from poaching this now-famous illustrator. Hearst's newly renamed magazine, *The American Weekly*, gave Harrison more assignments than a normal illustrator could have possibly completed, yet he was able to accept freelance work in advertising from Armour's Beef, the Warren Featherbone Co. and Pond's Soap, but the *Saturday Evening Post* kept him busiest with more work. In spite of this disparate array of clients and the clamour for illustrations of all kinds, his greatest successes continued to be vibrant drawings of beautiful American girls, which he immodestly dubbed 'The Fisher Girl(s)', which surpassed all other idealizations of the American female. His commissions at the turn of the century amounted to $75,000 in a single year, an amount equivalent to $1,500,000 in present-day terms.

In March 1908, *Success* magazine published a milestone piece by Fisher illustrating an article by Oliver Opp entitled, 'The American Girl', which caused quite a pandemonium and led to demands for more of Harrison Fisher's beautiful girls. The article appeared at a time when the average wage for a woman was $5 per week in contrast to Fisher's girls, who lived lives of luxury in Newport mansions, playing tennis or travelling with 'our motoring millionaires' between one country club and another. The article states quite boldly, that 'since Charles Dana Gibson has given up his pen and ink work for oil paintings, Mr. Fisher has become his

natural and popular successor'. Gibson retired in 1905, leaving the stage clear for Fisher, and his Gibson Girl could no longer compete. The American Girl was now everywhere and in colour, a 'well-bred and healthy minded American girl is delightfully free from pose: mistress of herself she looks out upon the world with a frankness and an assurance born of the realization that she is an accepted ornament of society and quite sure of respectful consideration'.

In June 1910, an article published in *Cosmopolitan* entitled, 'The Father of a Thousand Girls', ensured that Harrison Fisher had that nickname for ever more. That same year, the Fisher Girl exceeded all competitors in popularity. By 1913, *Holland* magazine mentioned the fact that Fisher was making more than $75,000 a year, and there was no limit to his success, which continued with illustrations published in literally dozens of books, with articles on the artist appearing in *Vogue* and periodicals everywhere. His 'Fisher College Girls' appeared in both *The Ladies' Home Journal* and *Scribner's* at the same time, with no complaints from either. Between 1907 and 1914, the 'Fisher American Belles' was published in the form of more than a dozen different variations as art books. By 1920, the efforts of Fisher's earlier competitors, Gibson, Christy, Hutt and Boileau, had been all but forgotten.

The artwork of Harrison Fisher appeared on over 80 covers of the *Saturday Evening Post*, and he created almost every cover for *Cosmopolitan* magazine from 1913 until his death in 1934. In his later years, Harrison Fisher restricted himself to portraits of famous personalities and performers. In 1927, he painted F. Scott Fitzgerald

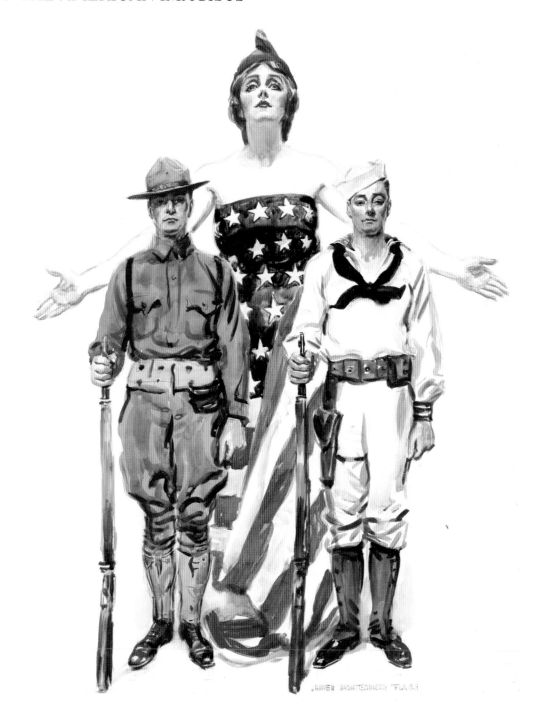

and Zelda, which seems fitting when one thinks how they all contributed to define the era in which they lived.

When he died in 1934, Harrison Fisher's estate was valued at $297,061, excluding real estate in Westport, Connecticut, and in California. The paintings had already been paid for and were published and therefore 'are practically of very little value', and Fisher himself believed that they had little resale value. Some 113 pictures were valued at $565 and 53 pen and ink drawings at $159. After his death, a relative kept a few paintings and burned over 900 of his remaining artworks, at Fisher's own request.

James Montgomery Flagg (1877–1960)
Flagg produced an immense and varied number of illustrations during a long and fruitful career. A gregarious man, always the life and soul of the party, Flagg was constantly sketching friends, celebrities and politicians and seemed to be constantly in the company of beautiful models. As well as his talents as an illustrator, he also seems to have been a gifted humorist and satirist.

His talent was precocious, for he was selling drawings and cartoons to *St. Nicholas* magazine when he was 12, and by the age of 15 was a staff artist on both *Judge* and *Life* magazines, two of the nation's most successful periodicals. Flagg grew up in the period when pen and ink was predominant and printing technology was very limited. Once half-tone printing was established as a reproduction process, the images of beautiful women that Flagg created surpassed those of the portrait artists of the previous

James Montgomery Flagg
Presenting a Bouquet, c.1909
*Watercolour on board, 23 x 19in
(58 x 48cm). Life cover, 16 September
1909.*

Life

generation. It is true that Gibson created a sensation with his early notion of the beautiful American girl, but Christy, Fisher, Hutt and Flagg did likewise, setting the scene for a whole new world of fashion, style and beauty. John Singer Sargent's society beauties were beginning to seem rather staid as Victorian values were thrown aside and a newer, more liberal way of life was coming into view.

Flagg studied at the Art Students League in New York City (1894–98), then went to England to further his studies at the Herkomer School in Bushey, Hertfordshire, an art school founded by Professor Hubert von Herkomer, the art critic who praised Maxfield Parrish's work in his reviews of 1896. On returning from Europe, Fisher created a comic strip, 'Nervy Nat', which gained immediate popularity, winning him a commission to illustrate P.G. Wodehouse's Jeeves stories. The first book he illustrated was *Yankee Girls Abroad* (1900), with pretty gals galore that were not dissimilar to the Christy Girl and Fisher's American Girl – yet more examples of idealized American women.

Flagg's commissions ranged from cartoons, posters, advertisements, magazine covers and inside illustrations to serious portraits exhibited in the Paris Salon of 1900 alongside those of the academic painters of the Académie Julian. Magazines that featured his work included *Collier's, Cosmopolitan, Hearst's International, Judge, Liberty, Life, McClure's, Photoplay, Redbook, Saturday Evening Post, The American Weekly, Women's Home Companion,* and many others, while books illustrated by him included *An*

Orchard Princess, Simon the Jester, City People, Brinkley Manor, The Adventures of Kitty Cobb, and in 1932, the seminal pin-up work, *Virgins in Cellophane*.

Flagg was a favourite illustrator of publishing tycoon William Randolph Hearst, who helped him to get numerous other illustrative commissions, including humorous short stories (which he enjoyed doing most), and rapid portrait studies of Hearst's friends. Most of his sitters were celebrities of one sort or another and included actor John Barrymore and his sister, Ethel, cartoonist Ham Fisher, humorist Rube Goldberg and illustrator Charles Dana Gibson. He was an active member of the Society of Illustrators, the Players Club, the Dutch Treat Club and the Lotos Club – where his cartoons can be seen to this day. He often sought out the company of Maxfield Parrish at The Players Club and the two lunched there together on many occasions.

James Montgomery Flagg remains best known for a single painting, however, his iconic portrait of Uncle Sam proclaiming, 'I Want You'. This U.S. Army Recruiting poster is still remembered by a vast majority of Americans, and the image is used over and over again. Mayor Rudy Giuliani's face was substituted for Uncle Sam's just after 9/11, when New York City was asking for help after the World Trade Center tragedy.

Between the years 1917 and 1919, Flagg produced 46 posters for the United States Government, including the companion watercolour to *I Want You*, entitled *Miss Columbia*. He published his autobiography, *Roses and Buckshot*, in 1946.

FAR LEFT
James Montgomery Flagg
Man Crazy, 1927
Watercolour, 28 x 21in (71 x 53cm).

FAR RIGHT

Charles Dana Gibson

His First Love, 1897

*Pencil on board, 18¹/₄ x 26¹/₂in
(46 x 67cm). Illustration for Life
magazine, c.1898; also appeared in
Sketches & Cartoons, 1897, Life Publ. Co.
and The Gibson Book, Vol I, R.H.
Russell, 1907.*

Charles Dana Gibson (1867–1944)

Charles Dana Gibson was born into a wealthy New England family
from Roxbury, then a suburb of Boston. He first became interested in
art as a boy, watching his father make silhouettes of the family. An
enterprising lad, he began to make similar silhouettes at the age of
eight, and by the time he was 12, was actually selling them. When he
was 14, Charles was apprenticed to the sculptor Augustus Saint-
Gaudens, founder of the Cornish Colony and a friend of Maxfield
Parrish. After nearly a year in the Saint-Gaudens studio, he decided
that sculpture was not his main interest and took up pen and ink
drawing instead.

His parents, having already recognized his precocious talent,
enrolled him in the Art Students League, but in 1885, due to financial
setbacks in the family, he was forced to leave and seek a career. He
was unable to find a job, but happened on *Life*, a new magazine in
competition with the already well-established *Puck* and *Judge*. *Life*
magazine, impressed by his talent and enthusiasm, hired Gibson on a
trial basis to produce editorial cartoons of political figures. However,
his interests lay elsewhere; he much preferred to poke fun at high
society and satirize its idiosyncrasies. *Life* magazine was well aware of
Gibson's value, right from the start, and that his drawings sold the
magazine. His trial monthly salary started at $33, but it was increased
each month until in the third month it had reached the sum of $185.
He also worked for another magazine, *Tid-Bits*, later re-named *Time*
magazine. Eventually, Gibson was illustrating articles not only *Life*
and *Tid-Bits*, but also for *Scribner's Magazine*, *Century* and *Harper's*.

In 1890, Charles Gibson produced his first 'Gibson Girl',
undoubtedly based on his wife, Irene Langhorne Gibson, and
featured her in his first independent portfolio of drawings in a
variety of different poses and situations. By 1904, his popularity
and that of the Gibson Girl had grown so large, that Robert Collier
and his partner Condé Nast, tried to sign him up as a member of
their team at *Collier's Weekly*, in much the same way as they had
recruited Pyle, Remington and Parrish before. Gibson refused,
wishing to remain loyal to *Life*, but Collier and Nast persisted,
before coming to a complicated arrangement whereby they would
share him with *Life*. It was tantamount to signing a major league

baseball player and letting him pinch hit for two teams but in different leagues. The contract was worth $100,000 for 100 illustrations over a four-year period, an amount staggering in modern-day terms.

By 1905, Gibson was longing to relinquish his pen and ink drawings for painting in oils, to follow other artists whom he admired and respected, such as Abbey, Frost, Remington and Parrish. Yet he was still at the height of his career and realized that it was the wrong time for self-indulgence, especially as his salary had now reached $75,000 per annum, with side deals still in place, including the original *Life* commission.

The time of Charles Dana Gibson's greatest popularity was between 1900 and 1910, although he was productive well into the 1920s. His best-known subject was, of course, the legendary Gibson Girl, the personification of young American womanhood – a modern woman, athletic, smart, stylish and desirable – and she sold magazines. The moment Gibson decided to give her a different style of hat or gloves or belt, a whole new fashion would erupt overnight – whatever the Gibson Girl wore, every female desired. The new style would be the immediate talking point of the whole country and sweat shops would hum with activity struggling to satisfy the new demand. This was a time when the nation was reinventing itself, creating new styles in art and architecture and searching for a uniquely American identity; the Gibson Girl was completely of her time and could have belonged to no other era.

FAR LEFT
Charles Dana Gibson
Inseparable, 1943
Oil on canvas, 37 x 31in (94 x 79cm).

FAR RIGHT
Charles Dana Gibson
The Market Basket, 1918
Pen and ink, 29⅞ x 24in (76 x 61cm).

In 1917, after he had founded the Society of Illustrators, Gibson rallied a small group of illustrators who pledged their efforts to help win the war: they included James Montgomery Flagg, J.C. Leyendecker, Howard Chandler Christy and others. Gibson had the foresight to set the group up formally as the Division of Pictorial Publicity in the U.S. Office of Public Information, with himself as head. After the defeat of the Germans, Gibson continued to make it his personal mission to preserve Western civilization by illustrating and issuing propaganda posters, but the public was far more interested in forgetting war. They now wanted the Charleston, jazz music, fast cars and booze, and the Gibson Girl had had her day.

In 1920, Charles Dana Gibson, heading a syndicate of illustrators, writers and staff members, bought *Life* magazine at auction, with Gibson holding the largest number of shares. Unfortunately, new competition from the *New Yorker*, *Fortune* and *Time* was giving *Life* a hard time, and it slumped into near demise. Gibson sold the magazine in 1932, and at 65 retired and finally took up painting. Although not as successful artistically as his pen and ink drawings of earlier times, the American Academy of Arts and Letters exhibited his paintings, causing a *New York Times* critic to exclaim, 'Make no mistake about it, Charles Dana Gibson is a painter.' However, the public at large only remembered his earlier work and soon forgot him. Yet, the Gibson Girl lives on and Gibson's name endures, mainly because of her, his most important creation. Charles Dana Gibson died of a heart attack in Maine in 1944.

Phillip R. Goodwin (1882–1935)

As a youngster in Norwich, Connecticut, art was the most important thing in Goodwin's life. Like other child prodigies who grew up to became professional illustrators, Goodwin sold his first drawing almost without trying, selling an illustration to *Collier's* magazine when he was only 11. His proud parents, pleased with this success, wished to encourage his talents and enrolled him at the prestigious Rhode Island School of Design and later at the Art Students League in New York. Still later, Goodwin realized that he wanted to become a professional illustrator and that the best place to study was under his idol, Howard Pyle, at the Drexel Institute in Philadelphia (1899–1900).

Pyle was quite impressed with Goodwin and invited him to study further in Wilmington (1901–03). Howard Pyle's influence upon Goodwin was predictable and Goodwin agreed with the master that the artist should visit the actual places he was illustrating in order to have true empathy with that environment. Pyle also considered that models should be in authentic costume, where appropriate. During his time in Wilmington, Goodwin grew very close to Pyle, and was one of Pyle's most exemplary students. As a reward for his loyalty and devotion to illustration, Goodwin was invited to Pyle's 50th birthday party – a great honour indeed.

Although he grew up in New England, like many young men of his generation, Goodwin was particularly inspired by scenes of the Wild West – cowboys and Indians, wildlife and hunting, and fly-fishing in particular. When Goodwin launched his career, he opened a studio in New York City at a time when it seemed something of a

Phillip R. Goodwin
Bear Hunting, c.1916
Oil on canvas, 21 x 14^{1}/$_{8}$in (53 x 36cm).
Illustration for Adventures In Beaver Stream Camp: Lost in the Northern Wilds.

OPPOSITE LEFT
Phillip R. Goodwin
Lucky Catch, 1910
Oil on canvas, 36 x 25in (91 x 63cm).
Horton Steel Fishing Rod advertisement.

OPPOSITE RIGHT
Phillip R. Goodwin
The Right of Way, 1902
Oil on canvas, 26 x 18in (66 x 46cm).
Outing Magazine cover, December 1903.

LEFT
Phillip R. Goodwin
Unexpected Game, c.1915–20
Oil on canvas, 24 x 33in (61 x 84cm).
Advertisement for Winchester Firearms.

FAR RIGHT

Elizabeth Shippen Green

The Masquerade, 1909

Oil and charcoal on illustration board, 24 x 14¹/₂in (61 x 37cm). From Dorinda Dares, *Harper's Monthly, July 1909.*

paradox to love the outdoor life while settling in the nation's busiest metropolis. Nevertheless, his talent, integrity and perseverance sustained him and soon his illustrations were being published in the popular magazines, which included *Everybody's, Harper's Monthly* and *Harper's Weekly, Outing, Persimmon Hill Magazine,* and *Scribner's.*

Brown & Bigelow, the nation's largest publisher of calendars, took Goodwin's calendars and he received advertising commissions from major firearms companies, including the two biggest manufacturers, Winchester and the Marlin Firearms Company. His success in this field brought him to the attention of the best book publishers for whom he illustrated *Call of the Wild,* by Jack London, and Theodore Roosevelt's *African Game Trails.*

Elizabeth Shippen Green (1871–1954)

Elizabeth Shippen Green was inspired to become an illustrator by Howard Pyle's drawings in *St. Nicholas* magazine and studied fine art under Thomas Eakins, Thomas Anshutz and Robert Vonnoh at the Pennsylvania Academy of the Fine Arts. After graduation, she travelled to Europe to complete her formal studies by visiting the museums and galleries. Upon her return, Green illustrated several small, inconsequential articles for the *Philadelphia Times* and the *Public Ledger,* which was rather disappointing, given the perfect education and elaborate preparations she had made for her chosen career. She received only 50 cents for her first *Times* illustration, but it was her first official commission and the experience meant more

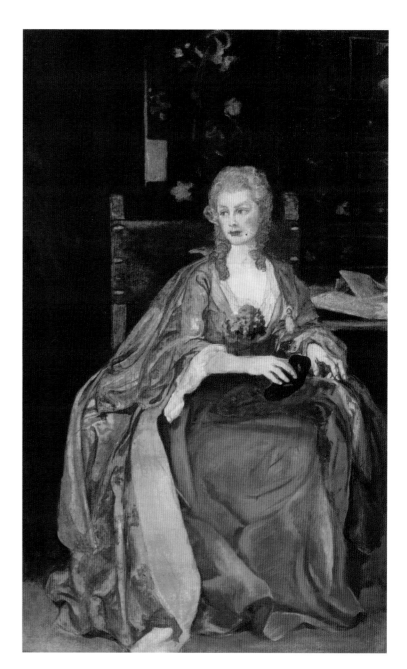

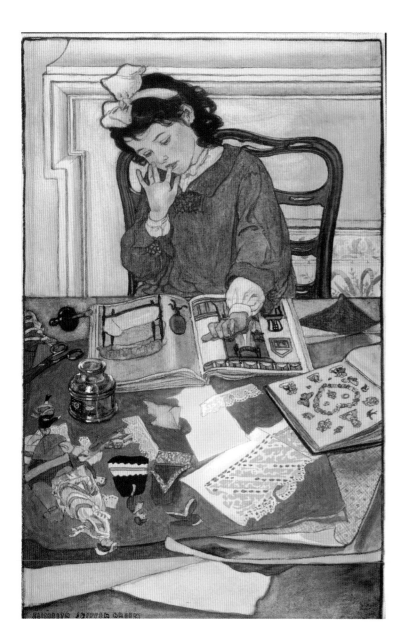

to her than money. However, later in 1897, she was able to study illustration with Howard Pyle at the Drexel Institute (Pyle, Anshutz and Vonnoh were the very same teachers who had influenced Maxfield Parrish at these same institutions.)

On returning to Philadelphia, Green undertook advertising commissions for department stores and later illustrations for various articles, serial stories and magazines – particularly the children's pages for periodicals such as *Saturday Evening Post*, *St. Nicholas*, *Ladies' Home Journal* and *Women's Home Companion*. She was quite proud of her new-found progress when an article by a noted critic described her as an 'exciting new illustrator', which was a godsend and the true start of her career. In 1901, she signed an exclusive contract with *Harper's* and her work for the magazine lasted for more than 23 years thereafter. In fact, she was the first woman staff member at *Harper's Weekly*.

During her studies with Pyle, Green met Violet Oakley and Jessie Willcox Smith to whom Pyle suggested a possible mural commission to replace Edwin Austin Abbey, following his sudden death. The mural required the talents of all three young artists due to its formidable size, and is the reason why the three women decided to share a rented house, the Red Rose Inn. From that point, the three lady illustrators were life-long friends and came to be known as the 'Red Rose Girls'. Green was known individually for her artwork for *Ladies' Home Journal*, *Harper's*, *Saturday Evening Post* and a number of imaginatively illustrated children's books, including *Five Little Pigs*, one of many tales that became part of the American

FAR LEFT
Elizabeth Shippen Green
Paper Doll Books, 1906
Watercolour and charcoal, 23 x 14¹/₂in (58 x 37cm).
From 'The Mind of a Child', article for Harper's Monthly, December 1906 by Edward S. Martin.

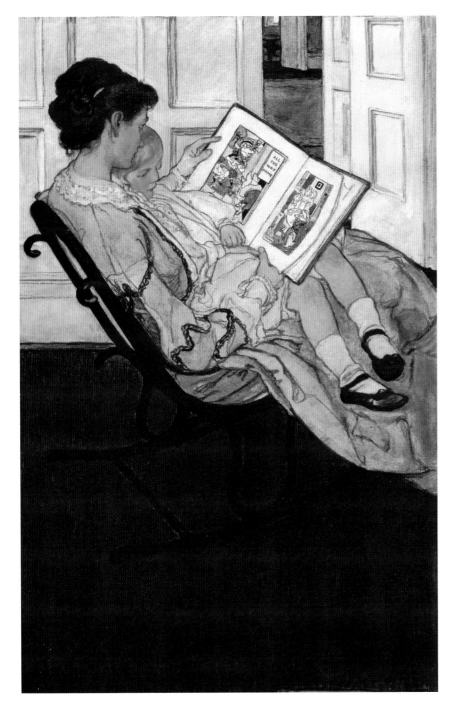

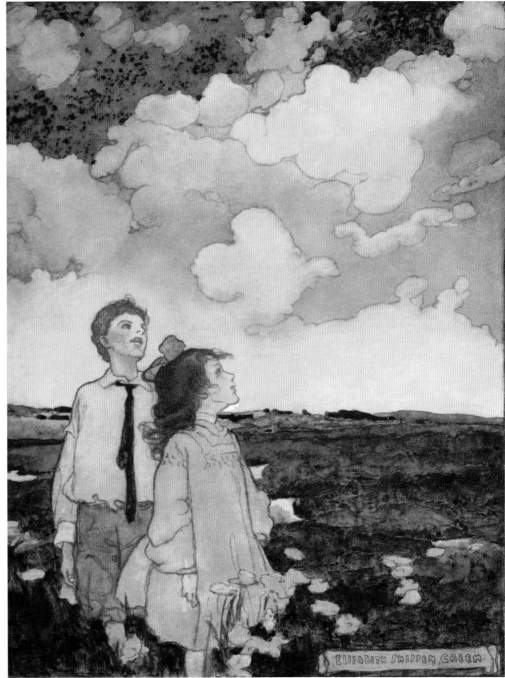

tradition. She illustrated a number of other books including *The Book of the Child*, *Book of the Little Past*, *Tales of Shakespeare*, *Daughter of the Rich* and *Torch*.

One can clearly see the influences of her contemporary and friend Maxfield Parrish in her work. Her painting, 'Foreign Children' from *A Child's Garden of Verses* (1905), pictures a young boy in a sailor's outfit wearing a large straw hat with a broad rim, with his back to the viewer. It is strongly reminiscent of Parrish's image of a similarly placed and dressed boy in 'Its Walls Were as of Jasper' from *Dream Days* (1900). Another image strongly influenced by Parrish is 'I Can Build a Castle' in her *Dream Blocks* (1908), with what appears to be a Parrish-like castle in the clouds.

Green married in 1911 and moved to Rhode Island, then Boston, then back to Philadelphia and on to New York City. Finally, her husband was appointed director of the Philadelphia College of the Arts, which prompted yet another move back to Philadelphia, though they ultimately returned to New York. All this time, however, Green continued to illustrate whatever commissions came her way. In 1951, just after her husband's death, Elizabeth Shippen Green returned to her clique of illustrator friends in Villanova and died there a few years later.

Albert Herter (1871–1950)

Albert Herter was one of the famous Herter family of craftsmen, furniture makers and artists of distinction. Albert was the son of Christian Augustus Herter, who, with his brother, were

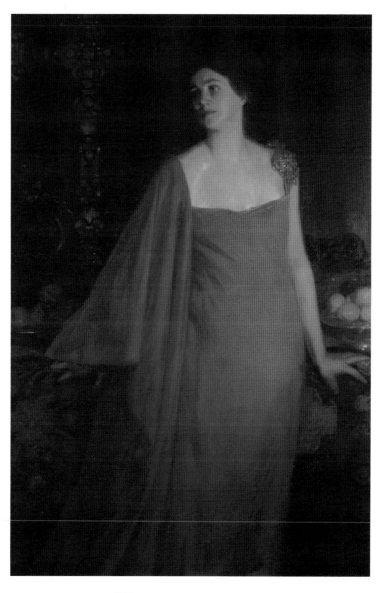

OPPOSITE LEFT
Elizabeth Shippen Green
Five Little Pigs, 1905
Watercolour and charcoal on board,
27 x 16¹/₂in (69 x 42cm).
'Mistress of the House', August 1905
'A Song Set to Five Fingers' in One
Thousand Poems for Children *by George*
W. Jacobs, 1920.

OPPOSITE RIGHT
Elizabeth Shippen Green
Two Children Watching Clouds in a Field, c.1905
Charcoal and watercolour (varnished),
20 x 15¹/₄in (51 x 39cm).

LEFT
Albert Herter
Portrait of a Woman, c.1900
Oil on canvas, 17¹/₂ x 11¹/₂in (44 x 29cm).

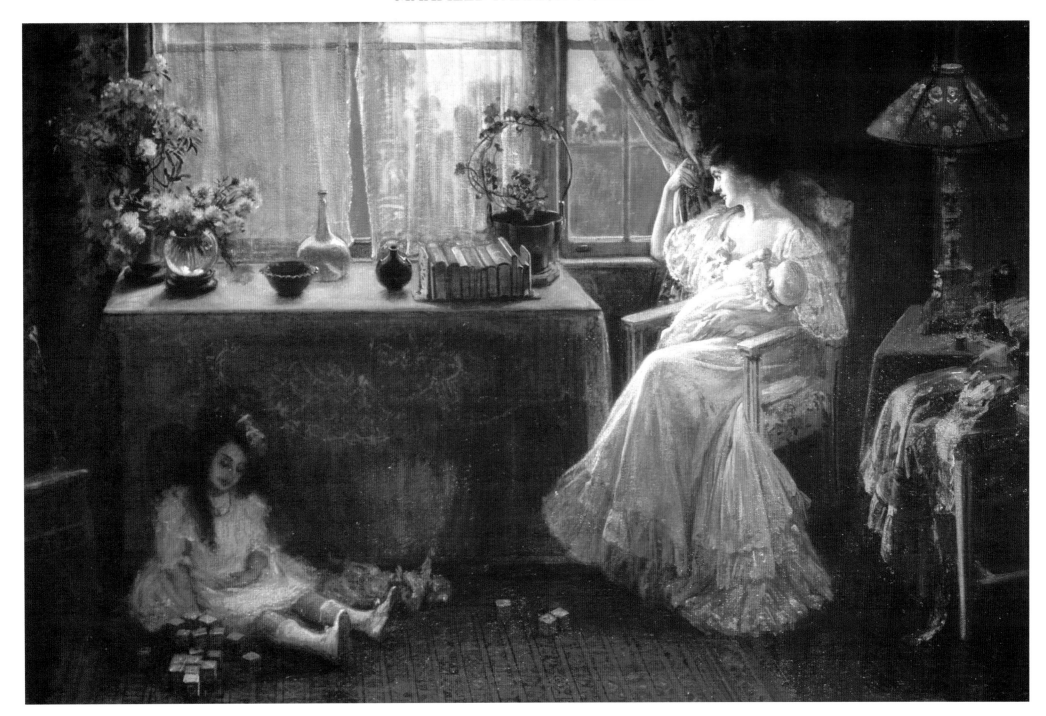

cabinetmakers to the Gilded Age millionaires and among the first interior designers in the nation. The Herter brothers took on assignments to create whole spaces, entirely of their own making and conception, in styles derived or invented by themselves.

Having been brought up in such a family, which had contributed so much to American taste, Albert Herter's interest in the practical side of crafts and the fine arts was hardly surprising. His father enrolled him in the Art Students League and later arranged for him to study in Paris at the Académie Julian. It was his time in Paris, under the legendary J.P. Laurens, that finally inspired Albert to become a painter.

When Herter returned from Paris, he taught for a time at the Chicago Art Institute while seeking commissions in illustration, a rising new profession and a branch of the arts in which it was possible to earn a decent living. His artworks soon won him the Evans Prize from the American Water Color Society in 1899, a medal at the Paris Exposition in 1900, and an exhibition at the Pan American Exposition in 1901. His style as an illustrator was sometimes described as similar to that of Maxfield Parrish with elements of N.C. Wyeth, and Herter himself often professed to emulate them. For this reason, it is interesting to note that the Century Company published a book entitled, *Romantic America* in 1913, which featured Maxfield Parrish's painting, *The Grand Canyon of the Colorado*, as its frontispiece. The book, with approximately 80 illustrations, included paintings by Joseph Pennell, George Inness, Jr., Winslow Homer and Albert Herter (*San Gabriel*,

San Diego, *San Luis Rey*, and *San Juan Capistrano*). Herter and Parrish's illustrations were in a book purporting to be a 'substitute for the look and feel, the sound and human atmosphere of Romantic America'.

A book and magazine illustrator and a muralist, Herter gained additional fame as a portrait painter of New York society as well as of a few Russian noblemen. His murals hang in the state capitals of Connecticut, Wisconsin and Massachusetts, as well as in the Academy of Science in Washington, D.C., and in banks and hotels across the U.S.A. Having lost a son in World War I, Albert Herter painted a majestic mural in his son's memory, which hangs in the Gare de l'Est in Paris. His second son, Christian, was Secretary of State under President Dwight D. Eisenhower and governor of Massachusetts.

Albert's father appointed his son head of Herter Looms, a textile, curtain, upholstery and tapestry company based in New York City, which catered to the wealthiest families in New York. He successfully ran the company while carrying on with his career as an illustrator.

Herter and his wife Adele bought a home in Santa Barbara, California, travelled in Europe, and lived during the summer months in East Hampton – an idyllic existence. Almost all of his inherited and earned wealth went into the physical enhancements of his beloved estate, The Creeks, in East Hampton, Long Island, where he designed lavish gardens with ponds complete with a Venetian gondola, and added parterres, boxwood hedges and a profuse assortment of flowers. Albert Herter died in Santa Barbara in 1950.

OPPOSITE
Albert Herter
Where Love Abides, 1909
Oil on canvas, 24 x 36in (61 x 91cm).

FAR RIGHT

W.H.D. Koerner

Expecting Trouble, 1922

Oil on canvas, 15 x 13¹/₂in (38 x 34cm).
Saturday Evening Post cover, 8 April
1922. Illustration for The Covered Wagon
by Emerson Hugh.

W.H.D. Koerner (1878–1938)

William Henry Dethlef Koerner is renowned as one of the master illustrators of America's Wild West, along with Frederic Remington, Charles M. Russell, Phillip R. Goodwin and Harvey Dunn. Koerner's illustrations are known for their bold brushwork and a vibrant colour palette which resulted in vigorous depictions of an untamed landscape.

Born in Lunden, Holstein, Germany, Koerner's parents emigrated to Clinton, Iowa, when he was three years old. Although he had little art training as a youth, his raw talent had always been obvious to his parents as it was to anyone who saw his sketches. At the age of 20, Koerner was hired by the *Chicago Tribune* as a staff artist at $5 per day, quite a respectable sum in 1898. Shortly after, he married and accepted a job as art editor for a brand-new newspaper, the *United States Daily*. Unfortunately, that newspaper was shortlived, and the young couple moved east, deciding that New York could not survive without them.

Once established in New York, Koerner was hired by *Pilgrim Magazine* to cover the 1904 St. Louis Exposition; it was then that he realized that he needed proper instruction before he could progress in his chosen field. He enrolled at the Art Students League for a two-year programme between 1905 and 1907, under the venerable George Bridgeman, Norman Rockwell's teacher. A student colleague later persuaded Koerner to apply to Howard Pyle's illustration school in Wilmington. Koerner's time with Howard Pyle was significant, but his student colleagues also had much to offer and he and N.C. Wyeth,

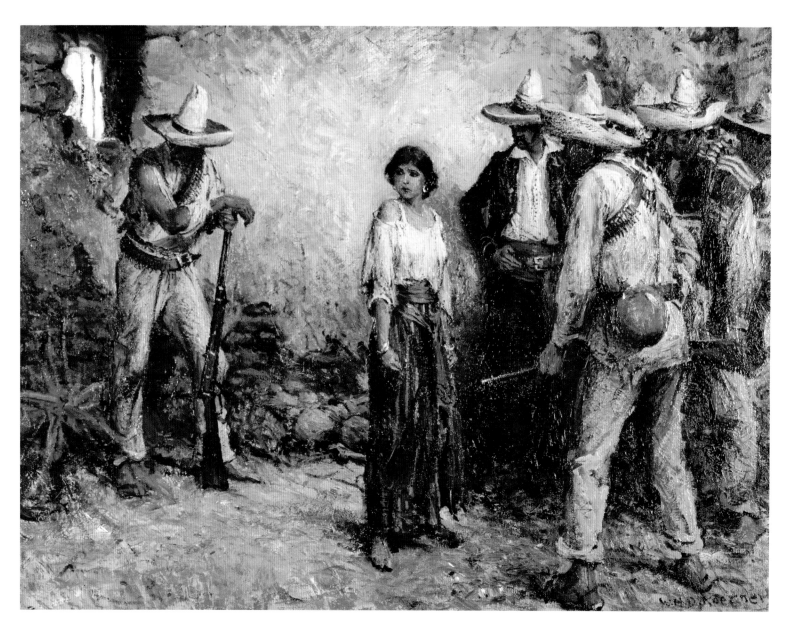

W.H.D. Koerner
Her Demand for Revenge, c.1919
Oil on canvas, 27 x 36in (69 x 91cm).
Saturday Evening Post cover,
13 December 1919. Illustration for Mad
Hack Henderson *by Peter Clark*
McFarlane.

W.H.D. Koerner
The River's Rising, 1929
Oil on canvas, 36 x 30in (91 x 76cm).
Illustration for Texas Queen *by Gordon*
Malherbe Hillman for the American
Magazine, July 1929.

Harvey Dunn, Frank Schoonover and Stanley Arthurs all compared notes. While still a Pyle student, he rented a studio adjacent to Anton Otto Fischer and William Foster and the interaction between them was of mutual benefit to all.

Howard Pyle died in 1911, and Bill Koerner was given the job of writing the eulogy, which was published in the *New Amstel Magazine*. A year later, the first exhibition by Pyle's students was presented to the public and Koerner's works figured prominently, distinguishing themselves among strong competition. In 1919, the art editor of *Saturday Evening Post* invited Koerner to illustrate two articles with Western themes, which proved to be a major turning point in his life. However, the articles, 'The Covered Wagon' and 'Traveling the Old Trails', required a measure of authenticity, which, up to that point, eluded him. Koerner immediately thrust himself into researching the subjects properly, with the result that the history of the West, its tools and weapons, livestock and wildlife, architecture and buildings and the eccentric characters who inhabited the plains and mountains, entered into his imagination and captivated his soul. He learned more about these visual elements than most seasoned cowboys would ever know and made trips with his family to the very locations he would later paint, just as Pyle had taught him.

From 1922 onwards, Koerner illustrated more than 250 stories with Western themes and painted over 600 pictures for periodicals. He illustrated a number of books, including some by Zane Grey (*The Drift Fence* and *Sunset Pass*) and Eugene M. Rhodes's classic, *Paso Por Aqui*. Overall, it is assumed that he completed nearly 2,000

W.H.D. Koerner
The First Riders, Horn-Blowers, 1922
Oil on canvas, 22 x 36in (56 x 91cm).

FAR RIGHT
John LaGatta
Bathing Beauties, 1933
Oil on canvas on board, 37 x 28in
(94 x 71cm). Saturday Evening Post cover,
8 July 1933.

illustrations of which about 1800 were for magazines, as well as advertisements for C.W. Post's Grape-Nuts and Postum cereals.

In 1924, the Koerner family took a trip to Montana, where Bill's fame for Wild West paintings had spread; he was received 'home' as a local cowboy. Americans had always loved the notion of the frontier and a lifestyle of rugged independence. Koerner was one of the first to portray it accurately and for mass consumption.

It is not surprising to learn that Maxfield Parrish was a great influence on Koerner and his use of colour, when one sees Parrish's illustrations of 'The Great Southwest' articles by Raymond Stannard Baker, which appeared in *Century Magazine*. In these Western landscapes, Parrish burst forth with bold colours used in a way which had not been attempted before. The colours seemed unreal, even surreal: pure oranges, cobalt blue and purple skies, red suns with cadmium streams of light – all captivating to Bill Koerner.

A prolific and versatile artist-illustrator, 'Big Bill' Koerner's work received considerable exposure through his cover and story illustrations for *Saturday Evening Post, Ladies' Home Journal, Harper's, McClure's Magazine* and *Red Book*. He died in 1938 aged 58, having been seriously ill and unable to paint for the previous three years.

John LaGatta (1894–1977)

LaGatta enjoyed painting women above all else, which worked well for him as an illustrator and allowed him and his wife to have a very comfortable lifestyle. His women inhabited a world full of romance

dressed in beautiful clothes. His images appeared in the nation's most famous publications: *Life*, *Ladies' Home Journal*, *Cosmopolitan*, *Delineator*, *Women's Home Companion* and the *Associated Sunday Magazine* and his advertising accounts were with a number of the nation's important corporations: Ajax Rubber Company, Andrew Jergens Co., Fleishmann's Yeast, International Silver Company, Lucky Strike cigarettes, Laros Lingerie, Ivory Soap and Resinol Soap, all of which financed luxurious travel, eating out at popular restaurants and other signs of success.

John LaGatta arrived in the U.S.A. as a poor Italian immigrant, though with a lineage he described as illustrious. The family lived quite modestly on Long Island, where his father was unsuccessful in business due, no doubt, to racial discrimination and a slowness to assimilate. It was a tough existence, but John was undoubtedly talented, studying under Frank Parsons at the New York School of Fine and Applied Arts, after which time he gained his first commission for *Life* magazine and worked for N.W. Ayer, one of the earliest and largest advertising agencies. His images were unique and seductive, even risqué, but art directors were willing to take a chance as long as they could sell magazines and products by using them. Soon, he was commissioned to produce a cover for the *Post* and was then hired by the U.S. Rubber Company, his first big breaks as an illustrator.

Unlike Rockwell, Pyle and Parrish, LaGatta did not use photography as a preliminary to his work. He rather enjoyed the exchange of banter during his sessions with the models and felt that

John LaGatta
Brunette in Pink Négligée, c.1935
Oil on canvas, 23¹/₂ x 19¹/₂in (60 x 49cm).

FAR RIGHT
John LaGatta
Couple Embracing, 1940
Oil and charcoal on board,
26³/4 x 20¹/2in (68 x 52cm).
Illustration for No Scarlet Woman *by*
Thelma Strabel for the American
Magazine, February 1940.

he could paint them better if he knew them personally. Sometimes, confused by an array of beautiful models, he was unable to choose between a blonde, a brunette or a redhead. So he would often do a composite of all three girls in one image, leaving it to the reader to decide which they liked best.

One critic described LaGatta's glamorous creatures as 'LaGatta's Chromium-Plated' women, and few illustrators felt that they could compete with him when it came to bathing beauties. At the beginning of his career during the roaring twenties, it was fashionable for women in America to have flattish bosoms and narrow hips with long slim legs. These girls were called 'flappers', and liked to think they were flouting convention. However, John LaGatta preferred another kind of beauty and his girls were very different, being curvaceous, full-bodied and with plenty of sex appeal. He remarked, 'Women are aware of the psychological effect they possess over men, and regardless of the degree of modesty they pursue, they play it up to suit the occasion – often with charming and ingenious bits of innocence and varying, subtle ways of flirtation. Often women demurely reveal fragments of their anatomy. It is their strength and surely one of man's incorrigible weaknesses. In most cases I believe it is simply devilry for the sake of identity.'

LaGatta moved to California at the beginning of the Second World War and started a new career teaching at the Art Center School in Los Angeles and easel painting for his own pleasure. He died in 1977 in Santa Monica, California.

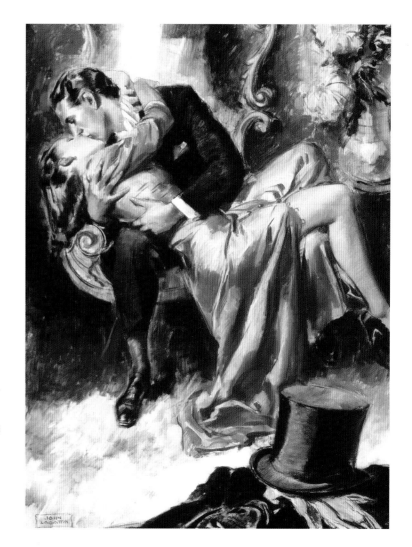

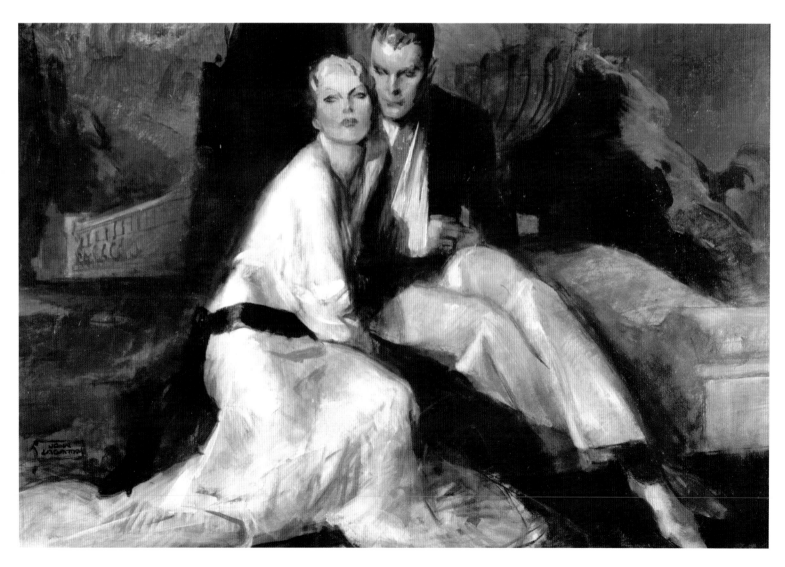

John LaGatta
Sweet Consolation, c.1930
Oil on board, 25 x 17in (63 x 43cm).

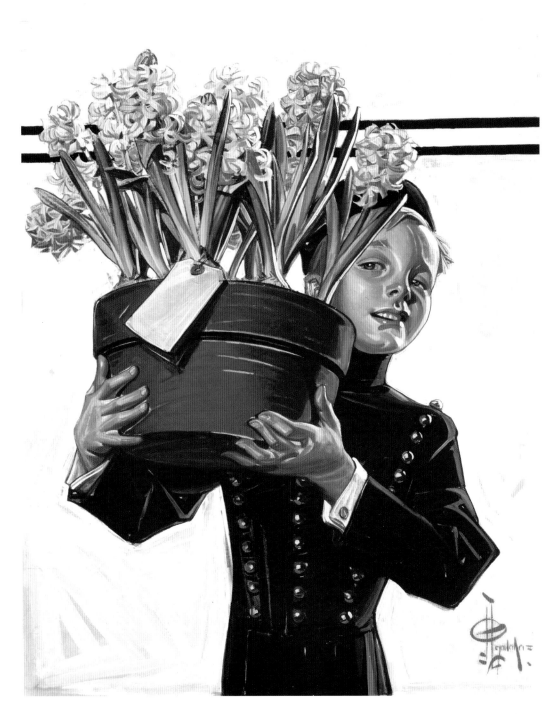

Joseph Christian Leyendecker (1874–1951)

J.C. Leyendecker developed as a major talent towards the end of the 19th century and became the most sought after and fashionable illustrator of his day, reaching the peak of his fame and productivity in the 1930s. Leyendecker was talented where self-promotion was concerned and quickly established an easily identifiable style. His approach to his own career influenced an entire generation of younger artists, most notably Norman Rockwell, who began his own career by specifically emulating Leyendecker.

Between 1896 and 1950, J.C. Leyendecker produced more than 400 magazine covers, of which 322 were for the *Saturday Evening Post* alone. No other artist, until the arrival of Norman Rockwell two decades later, would be so solidly identified with one publication.

J. C. Leyendecker and his younger brother, Francis Xavier, were born in Montabour, Germany, and emigrated to the U.S.A. in 1882. Joe and Frank (also an aspiring illustrator) studied in Paris at the famous Académie Julian, where they developed their artistic styles. Joe Leyendecker became swiftly famous because of a specific and readily identifiable signature style. With his broad, deliberate brushstrokes, executed with authority and control, he seldom overpainted, preferring to intrigue the viewer as much with his omissions as his inclusions. His three most memorable creations, which survive to this day, were the iconic images of the Arrow Collar Man, the New Year's Baby, and the first Mother's Day cover created for the *Post*, a painting which single-handedly gave birth to the flower delivery industry.

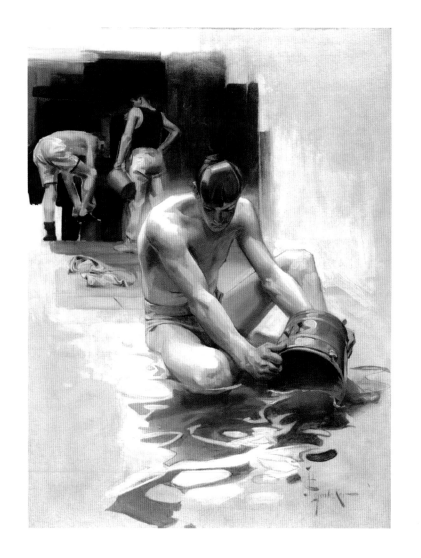

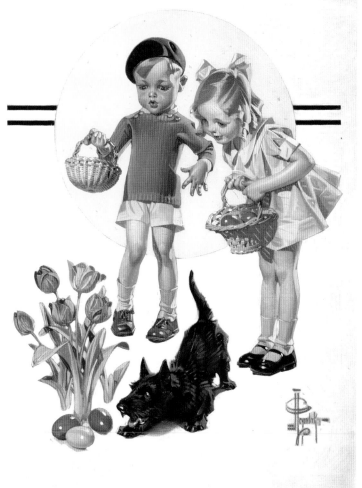

OPPOSITE
Joseph Christian Leyendecker
Bellhop with Hyacinths, 1914
Oil on canvas, 28 x 20in (71 x 51cm).
Saturday Evening Post cover, 30 May
1914.

FAR LEFT
Joseph Christian Leyendecker
In the Yale Boathouse, 1905
Oil on canvas, 28 x 21in (71 x 53cm).
Illustration used in Century and
Scribner's magazines, c.1905. Illustration
for A Victory Unforseen *by Ralph D.*
Paine.

LEFT
Joseph Christian Leyendecker
Easter Egg Hunt, c.1933
Oil on canvas, 32 x 24in (81 x 61cm).
Saturday Evening Post cover, 15 April
1933.

FAR RIGHT
Joseph Christian Leyendecker
New Year's Baby, 1914
Oil on canvas, 20 x 14in (51 x 36cm).
Cover of Saturday Evening Post,
3 January 1914.

OPPOSITE LEFT
Joseph Christian Leyendecker
Interwoven Socks, 1927
Oil on canvas, 39 x 28³⁄₄in (99 x 73cm).
Illustration used as an advertisement for
Interwoven Socks, 1927, and in Saturday
Evening Post, 27 December 1930.

OPPOSITE RIGHT
Joseph Christian Leyendecker
Marching Brass Band, 1933
Oil on canvas, 31 x 24in (79 x 61cm).
Saturday Evening Post cover, 1 July 1933.

In 1905, Leyendecker received his most important commission from Cluett, Peabody & Co. to advertise its Arrow brand of detachable shirt collars. Leyendecker created the 'Arrow Collar Man', handsome, smartly dressed, the symbol of fashionable American manhood. Through his advertising illustrations, Leyendecker boosted sales for the company to over $32 million a year, and defined the ideal American male: a dignified, clear-eyed man of taste and discernment.

As *Saturday Evening Post*'s most important cover artist, J.C. Leyendecker illustrated all the holiday numbers as well as many in between. His Easter, Independence Day, Thanksgiving and Christmas covers were annual events for the *Post*'s millions of readers. Leyendecker gave us what is perhaps the most enduring New Year's symbol and for almost 40 years, the Leyendecker Baby featured on the *Post*'s New Year cover.

Leyendecker also specialized in American heroes, both sporting and on the battlefield, designing patriotic posters for both world wars, while his sports posters to promote Ivy League football, baseball and crew teams were widely collected by college students. Throughout his career, his favourite model was his companion of 50 years, Charles A. Beach, a Canadian whom Leyendecker met in 1901 and immortalized as the Arrow Collar Man.

The broad range of J.C. Leyendecker's oeuvre encompassed advertisements for the House of Kuppenheimer, Ivory Soap and Kelloggs, and there were magazine covers for such publications as *Collier's* and *Success*. In many ways, J.C. Leyendecker was the personification of the American Imagist, an illustrator whose images became an integral part of American civilization.

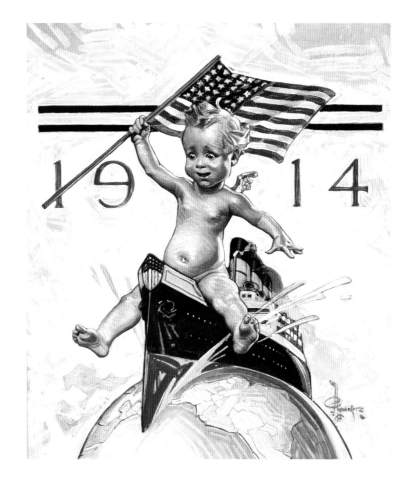

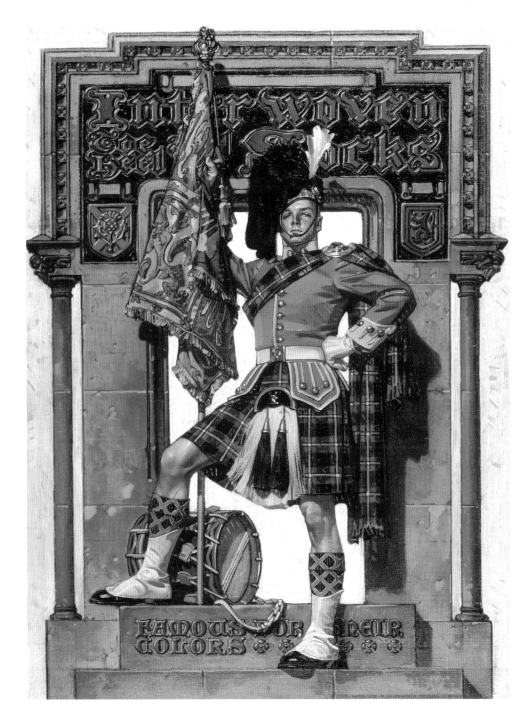

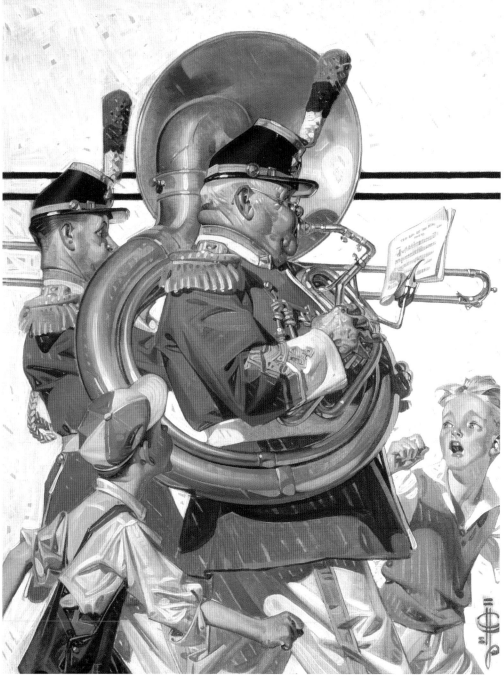

FAR RIGHT
Violet Oakley
Woman Curtsying before Rising Colonial Man, c.1897
*Ol on canvas, 18¹/₄ x 11in (46 x 28cm).
Book illustration for Maud Wilder
Goodwin's* White Aprons, *1897. Little
Brown and Company.*

Violet Oakley (1874–1961)

Unlike many other illustrators, Violet Oakley came from a family of mostly fine artists. Consequently, as a young lady in Bergen Heights, New Jersey, there was no question that she should study art. With both grandfathers members of the National Academy of Design, she described her infatuation with illustration as 'hereditary and chronic'. She was encouraged to attend the Art Students League, where her studies were followed with trips to Europe.

In 1896, Violet Oakley returned to the U.S.A. and enrolled at the Pennsylvania Academy of the Fine Arts, but within a year had changed her focus to illustration and transferred to the Drexel Institute to study under Howard Pyle. It was while at Drexel that she met her soulmates, illustrators Elizabeth Shippen Green and Jessie Willcox Smith. Like Maxfield Parrish, the Pre-Raphaelites were also a major influence on her style, with Howard Pyle her mentor and teacher. Pyle immediately recognized her talent, her sense of colour and composition and her deft handling of large-scale artworks, where he felt her greatest ability lay; he encouraged that pursuit even though the result would be few illustration commissions. Oakley may have been the only one of his students whose work Pyle admired, but whom he encouraged in a different direction, trying, wherever possible, to get her commissions for large-scale murals and stained-glass windows. Oakley did get such commissions, yet she never abandoned illustration, accepting it when the opportunity arose. Both Oakley and Pyle argued that murals were simply larger-scale illustrations, for the murals also told a story.

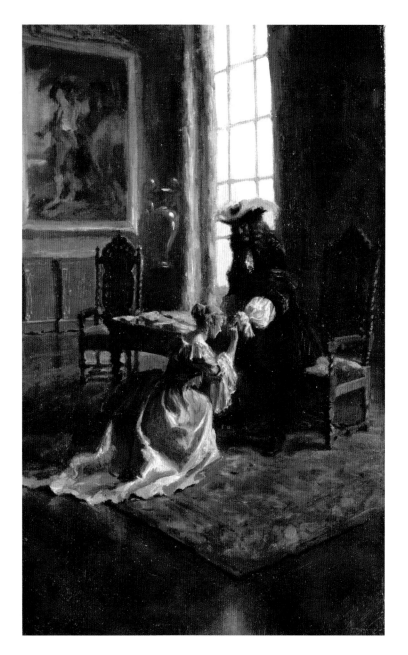

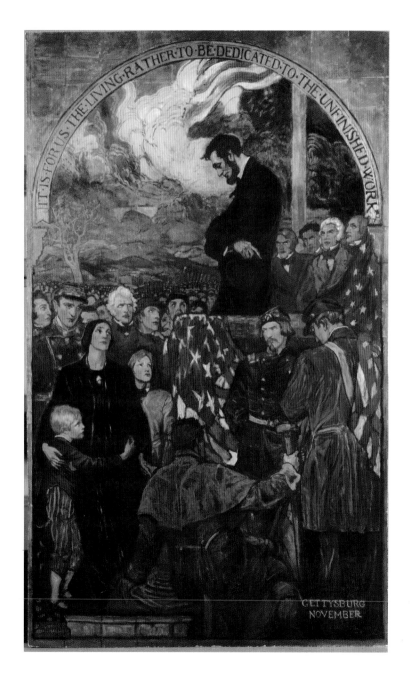

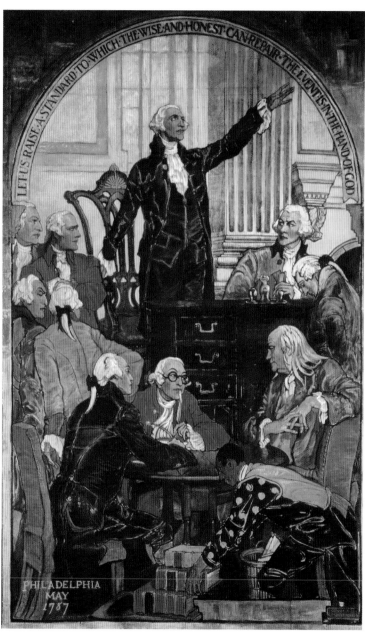

FAR LEFT
Violet Oakley
The Creation and Preservation of the Union, 1902
Oil on printed board, 40 x 24in (102 x 61cm).
Abraham Lincoln delivering the Gettysburg Address.

LEFT
Violet Oakley
The Creation and Preservation of the Union, 1902
Oil on printed base, 39³/₄ x 24in (101 x 61cm).
George Washington at the constitutional convention.

Violet Oakley
Penn Preaching at Oxford, 1903
Oil on printed paper mounted on
pulpboard, 24¹/₂ x 37³/₄in (62 x 96cm).

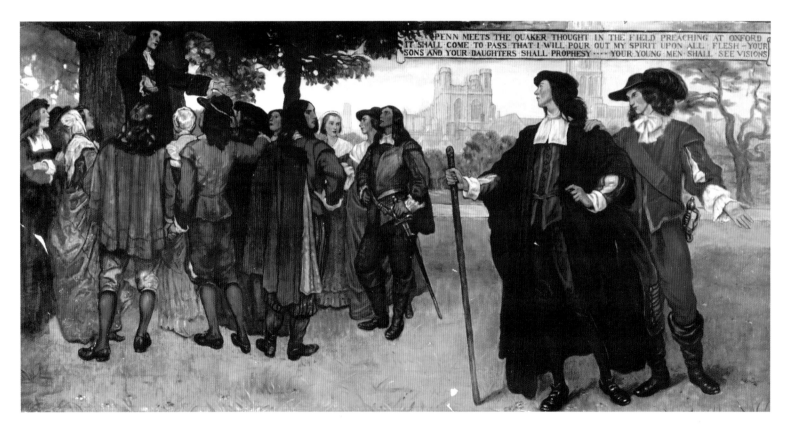

Violet Oakley completed one of her most significant commissions in 1902, *The Creation and Preservation of the Union*, which consisted of a series of large murals for the walls of the governor's reception room in the State Capitol Building in Harrisburg, Pennsylvania. The extraordinary working drawings for the murals were issued in a portfolio as limited-edition art prints, while the finished work was a magnificent expression of Oakley's love of history and her talent as a pioneering female illustrator in a

mostly male-dominated profession. The commission took four years, during which time she occasionally undertook some freelance illustration.

In 1911 Edwin Austin Abbey died while working on other aspects of the same project, and she assumed his workload in addition to her own. During the next 19 years, she completed the murals and also illustrated six illuminated manuscripts and a book describing them. A committed artist of great integrity, she documented her works, had numerous exhibitions, and worked up until the day she died in 1961.

Coles Phillips (1880–1927)

At work during the period between the First World War and the late 1920s, Coles Phillips was the first to bring Art Deco styles to advertising design. He illustrated many covers for *Saturday Evening Post*, using very modern and seductively depicted women. Some social historians actually give Phillips credit for creating the first pin-up girl, later known to all America as 'The Fadeaway Girl'. During a 20-year period between 1907 and 1927, Coles Phillips ranked with Parrish, Leyendecker and Flagg as one of the most popular illustrators in America.

Born Clarence Coles Phillips in Springfield, Ohio, his lower middle-class family had no aspirations for him other than working at the local American Radiator Company, where his first job was as a clerk. Realizing that it was a dead end and greatly preferring a career in art, he quit that position, enrolling at Kenyon College in 1902. His first illustrations were for the Kenyon College monthly magazine,

Clarence Coles Phillips
Girl Reading, c.1925
Gouache on board, 22 x 18in (56 x 46cm).
Good Housekeeping magazine,
23 February 1925.

Clarence Coles Phillips
Diary of a Mere Man, 1913
Gouache on paper, 32 x 22in (81 x 56cm).
Illustration used in Saturday Evening Post
for an Oneida Community Silver
advertisement, 20 September 1913.

The Reveille, which published his work between 1902 and 1904. He dropped out of Kenyon in his junior year to go to New York City to start his career as a professional artist. He arrived there with a letter of reference from American Radiator and was hired by its local office. After a brief time, he was caught drawing a caricature of his boss, for which he was instantly fired. That very evening, a friend from work told the story to J.A. Mitchell, publisher of *Life*, who looked at the cartoon and asked to meet Phillips. The unfortunate sketch turned out to be fortunate as Mitchell offered Phillips a job, but he decided instead to take more art instruction. A few years later, Mitchell hired him as a staff artist and Coles Phillips became a name immediately recognizable by the *Life* readership. From 1908 until just a month before his death in 1927, Coles Phillips' covers appeared on *Life* magazines at least once every month.

In 1908, Coles Phillips created a magazine cover which was to become his signature trademark, 'The Fadeaway Girl', whose dress colour fades cleverly into the background, giving the impression that she is close and far away at the same time. It is a graphic device commonly used today, called a vignette, but its use by Phillips was a new technique and was as effective in an Oneida Silver advertisement as it was on a fashion magazine cover. To create the effect, it was necessary to study the proportions of the canvas, the cover dimensions and the negative shapes, so as to know whether they worked with the positive shapes. It was all very clever, simple to understand in its solution, but difficult to plan.

Coles Phillips' many illustrated books included *Michael*

Thwaites' Wife by Miriam Michelson, *The Fascinating Mrs. Halton* by E.F. Benson, *The Siege of the Seven Suitors* by Meredith Nicholson, and *The Gorgeous Isle* by Gertrude Atherton. He

produced a voluminous amount of advertising illustrations, particularly for Willys Overland automobiles and trucks. In 1920, Phillips entered the Clark Equipment Company's competition, 'The Spirit of Transportation', his entry astonishing everybody for its unique composition and theme, as well as for its use of pastels. He sometimes wrote the advertising copy to accompany his images, for example a Holeproof Hosiery advertisement attracted customers with the line, 'Trim ankles demurely alluring. How they fascinate, captivate. And well she knows glove-fitting Holeproof Hosiery makes them so'.

Although Phillips painted many covers for *Life*, they were not exclusive contracts, and he also produced covers for *Good Housekeeping*, *Colliers*, *Ladies' Home Journal*, *McCall's*, *Saturday Evening Post*, *Women's Home Companion* and *Liberty*. His graphic images of women were so popular that several books of them were published, including *A Gallery of Girls* and *A Young Man's Fancy*. As times changed, his work changed with it, for Phillips was among the first to introduce more overt sexuality, which provided more flesh and more 'titillation' for the reader. In 1924, Phillips caused a sensation with his 'Miss Sunburn', a bathing beauty created for Unguetine sun-tanning lotion: the image appeared in drug stores nationwide, but were all stolen within a few weeks.

Many of Coles Phillips' images are reminiscent of Maxfield Parrish's in their composition, if not technique, particularly his Jell-O advertisements in 1919; even the advertisements for Oneida contain images similar to those of the Knave of Hearts, as do some

FAR LEFT
Clarence Coles Phillips
Elephant Offering to Egyptian Woman, 1922
Tempera on illustration board, 36⁷/₈ x 24⁵/₈in (94 x 62cm). Fiberloid Corporation advertisement, 1922.

Clarence Coles Phillips
Our New Silverware, c.1913
Gouache on illustration board,
24¹/₄ x 20in (62 x 51cm). Illustration for
Oneida Community Silver, which appeared
in Saturday Evening Post, 22 November
1913.

Luxite Hosiery advertisements with their Parrish-like side profiles.

While other illustrators created more elegant images, Phillips took a more cerebral approach and used devices which made his images stylish and different, much in demand by connoisseurs of the graphic arts and the public at large. He died at the age of 47 in 1927 at New Rochelle, New York, a location popular with illustrators, including J.C. Leyendecker and Norman Rockwell. In fact, the day he died, his good friend and neighbour, J.C. Leyendecker, had taken the four Phillips children to Manhattan to see the parade on Fifth Avenue welcoming Charles Lindbergh home.

Norman Price (1877–1951)

Norman Mills Price was born in Brampton, Ontario, Canada. He was a powerful illustrator with all the characteristics of a disciplined Royal Academician. He studied first at the Ontario School of Art and in 1901 travelled to London to continue his education at the Goldsmith's Institute, the Westminster School of Art and with George Cruickshank. After all this schooling, Price founded the Carlton Studios in London, but left shortly thereafter. From England, he went to Paris and studied at the Académie Julian with Jean-Paul Laurens, Benjamin-Constant and Richard Miller. With a fine classical education such as this, one would hardly have guessed that illustration would have been Price's future profession.

Price returned to Canada in 1912, but left almost immediately for New York City with the view to becoming a professional

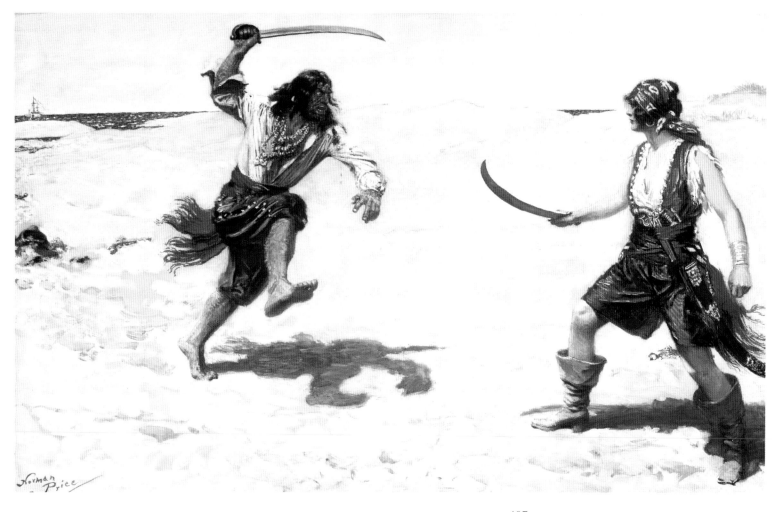

Norman Price
Mary Reed, 1929
Oil on board, 20¹/₂ x 30in (52 x 76cm).
Illustration for The Sea Rogue's Moon, *by Robert W. Chambers.*

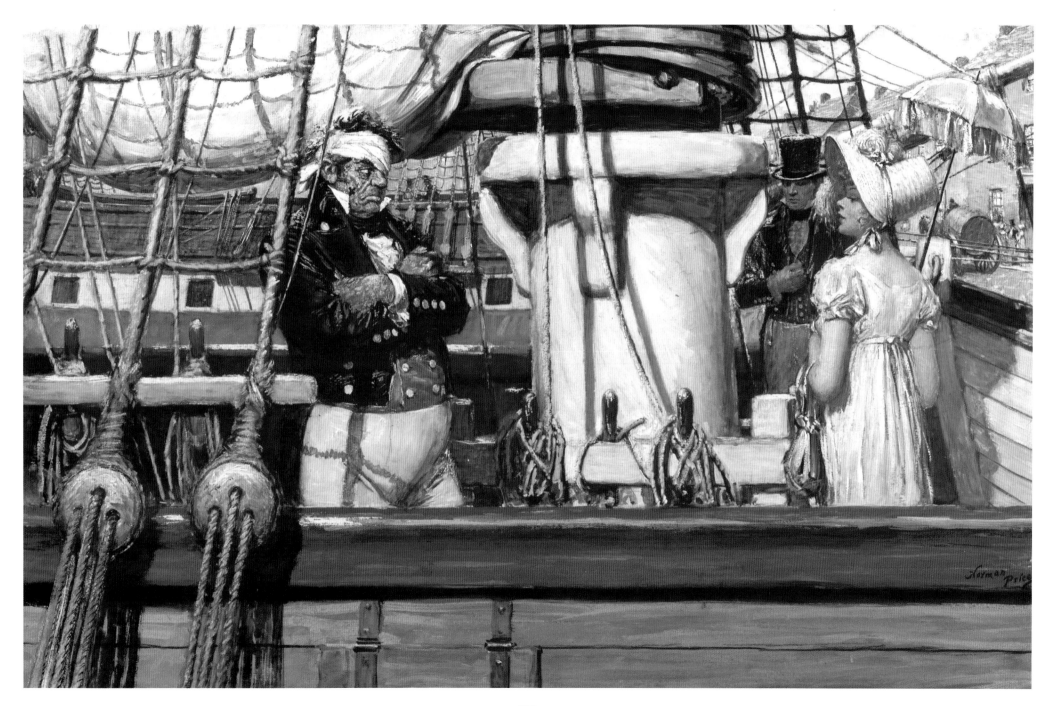

illustrator. He was almost instantly successful, his attention to detail and accuracy of execution making him widely popular. Price looked to the great classics of literature for his subjects and everything was painstakingly researched, down to the last historical detail. Perhaps his best-known images are his illustrations for Shakespeare and the historical novels of Robert W. Chambers and Frederick Arnold Kummer. Some of the historical authors with whom he worked closely included May C. Byron, Dorothea F. Fisher, George Sampson, Flora Warren Seymour and Rebecca West. His magazine illustrations were published by *American Magazine*, *Cosmopolitan*, *Liberty*, *St. Nicholas* and *Women's Home Companion*. Price's powerfully authentic images were most frequently used as cover illustrations.

Norman Price's talents as an illustrator have gone relatively unsung. Researching his work was probably of more interest to him than creating the artwork itself. He was not given to self-promotion but was nonetheless regarded by the publishers as a solid, reliable and efficient illustrator, who accepted assignments considered less exciting by others. His all-consuming quest for accuracy and authenticity in his art may have been remarkable, but it could also be seen as something of a setback to his career.

Howard Pyle (1853–1911)

Howard Pyle has long been considered 'The Father of American Illustration', as much for his prolific and superb work as a writer and illustrator as for his commitment to teaching, which he turned his attention to in the 1890s. He founded the first school of illustration

OPPOSITE
Norman Price
The Happy Parrot, 1928
Gouache, 16¹/₂ x 27in (42 x 69cm).
Illustration for The Happy Parrot *by Robert W. Chambers for D. Appleton & Company.*

FAR LEFT
Norman Price
Each Had a Hand on the Other Rival's Throat, c.1926
Oil on board, 14¹/₂ x 10in (37 x 25cm).

RIGHT
Howard Pyle
After the Massacre, c.1901
Oil on canvas, 24 x 16in (61 x 41cm).
From Colonies and Nations *for Harper's*
magazine, August 1901.

Samuel Adams demanding of Governor
Hutchinson the instant withdrawal of the
British troops

FAR RIGHT
Howard Pyle
LaSalle Christening the County
'Louisana', c.1905
Oil on canvas, 24 x 16¹/4in (61 x 41cm).
Illustration for The Great LaSalle *by*
Henry Loomis Nelson for Harper's
Monthly, February 1905.

OPPOSITE
Howard Pyle
Garden of Youth (Couple by a Summer
Cottage), c.1902
Oil on canvas, 39¹/2 x 25¹/4in
(100 x 64cm).

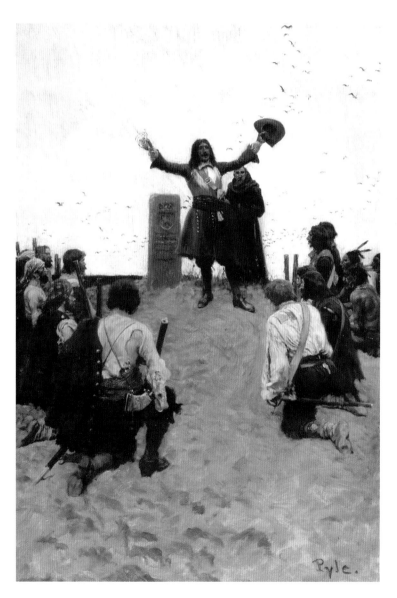

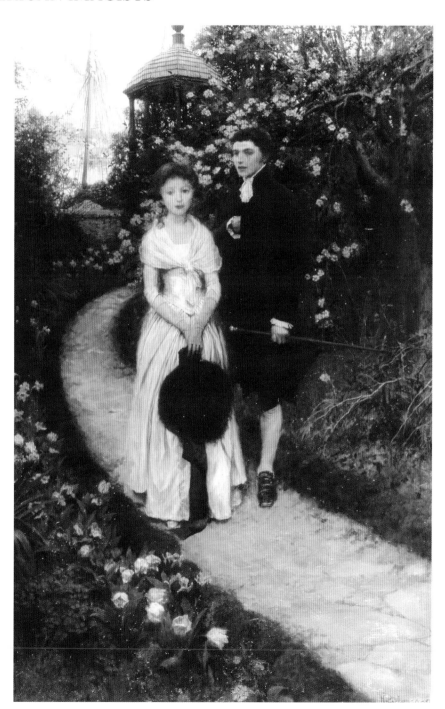

in America at the Drexel Institute in Philadelphia (1894–1900). He had already published 99 illustrations, which had earned him substantial fees, yet he would never accept payment for his teaching. Many of the greatest illustrators attended his classes at Drexel, later at the Howard Pyle School of Art in Wilmington (1900–05), and in the summers alongside the Brandywine River at Chadds Ford, Pennsylvania.

Howard Pyle's school in Wilmington ensured that the city became the most important centre for illustration as the 19th century drew to a close. Pyle had about 200 students in the course of his teaching career of whom more than 80 became well known and two dozen more achieved fame and success. Many of the students, and their students in turn, were known as members of the 'Brandywine School', some of the best known being Stanley Arthurs, Clifford Ashley, William Aylward, Arthur Becher, Anna Whelan Betts, Ethel Franklin Betts, Harvey Dunn, Anton Otto Fischer, Philip R. Goodwin, Elizabeth Shippen Green, Gayle Hoskins, Oliver Kemp, W.H.D. Koerner, Violet Oakley, Maxfield Parrish, Ernest Peixotto, Frank Schoonover, Jessie Willcox Smith, Henry J. Soulen, Sarah Stillwell Weber, C. Leslie Thrasher and N.C. Wyeth.

Even more extraordinary was the fact that Pyle's classes were composed of about 50 per cent female students – almost unheard of in those days.

Pyle was born into a Quaker family from Delaware and lived his whole life there except for two years at the Art Students League

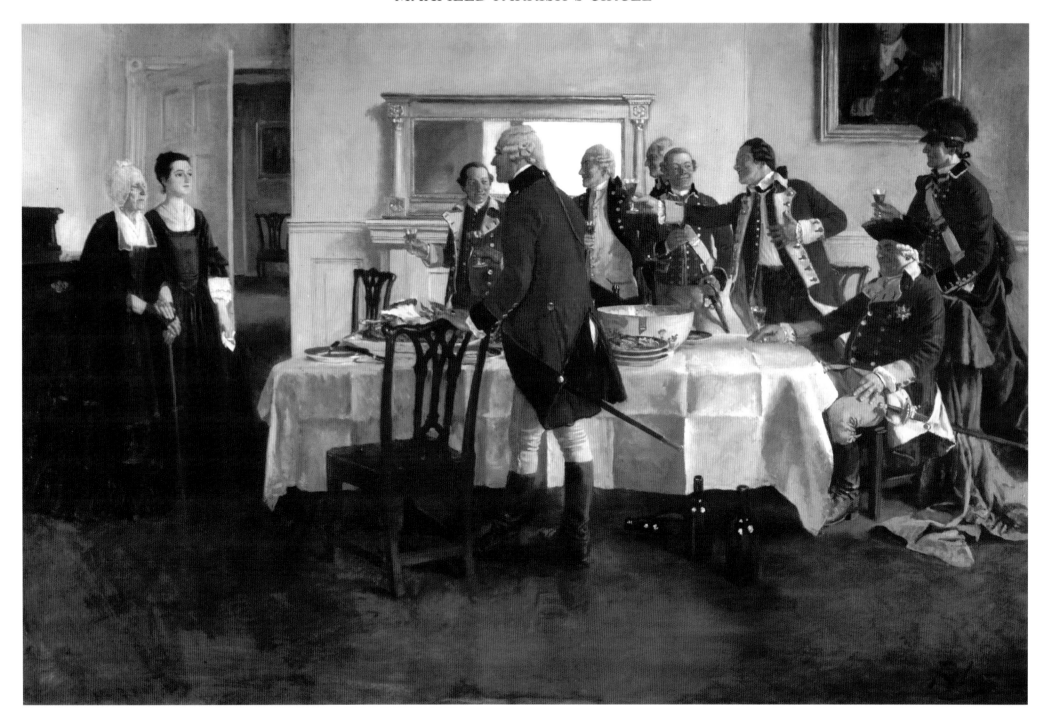

early in his career, and a year in Italy where he died. His family was not unhappy when he expressed an interest in studying art, although such a thought was not usually on any Quaker agenda. His first art teacher was Van der Weilen, but at the age of 23 he moved to New York to attend the Art Students League. There, he expected to be educated as an easel painter, for illustrators were not then regarded as a special group; in any case, his first thoughts were of making art rather than a living. Like most of his students, Pyle later became an illustrator with a view to earning a living from his craft.

While studying in New York, however, Pyle was able to get small commissions producing illustrations for *Century Magazine*, which gave rise to others from *Collier's Weekly*, *Everybody's Magazine*, *Harper's Weekly*, *Harper's Monthly*, *Cosmopolitan*, *Ladies' Home Journal*, *McClure's Magazine*, *Scribner's*, *Wide Awake* and *St. Nicholas*. Each commission was more lucrative than the previous one, and each illustration was received enthusiastically by the magazine art editors and their readership, ensuring that Pyle was a success from the very beginning.

In 1879, Pyle returned to Delaware and produced a number of books, which he both wrote and illustrated, including *Howard Pyle's Book of Pirates*, *The Story of King Arthur and His Knights*, *Men of Iron*, *The Merry Adventures of Robin Hood*, and for other publishers, which included *Riverside Press*, *The Bibliophile Society*, *Century*, *Little Brown and Company*, *Scribner's*, and *Houghton Mifflin, Co.*, the most important publishers in the U.S.A.

Howard Pyle was a master of all forms of media, working

equally well in pen and ink, watercolours, oils, pencil and charcoal. From his experiences as an art student, he realized that no form of training existed which could teach the difference between a cover illustration and an interior one or how to apply masthead lettering to an image, for it took a certain type of design technique not available in the training of a fine artist. He realized that with the advent of better publishing technologies had come a corresponding need to train illustrators. He himself had discovered what he needed to know from experience, by intuition or by listening to the host of magazine art directors who knocked on his door. His goal, therefore, was to train a new generation of illustrators capable of defining the American way of life through their work, while at the same time imparting to them his own philosophy of life.

Pyle recommended that his pupils look to their own country and their own lives for inspiration. He expected much from his students, both spiritually and artistically; he expected them to experience the environments they wished to replicate and to make their images as authentic as possible. As a result, Howard Pyle became the greatest of all influences on American illustrators, with teaching methods that were as bold as his own paintings of the nation's story, which defined what it meant to be an American. It is said that Pyle had the ability to transport himself into any period of history, turning his figures into the flesh and blood people of their times. He had the power to captivate and stimulate the imagination to a remarkable degree: in short, he was the best illustrator of his day.

Howard Pyle was born in 1853, at probably the most propitious

OPPOSITE
Howard Pyle
Redcoat Soldiers Toasting the Ladies of the House, 1895
Oil on canvas, 24$^{1}/_{2}$ x 36$^{1}/_{4}$in (62 x 92cm).
Illustration for Harper's Weekly, 14 December 1895.

time for a future illustrator of genius. It was a time when a kind of Renaissance was happening in America, when people were beginning to look towards creating their own cultural icons rather than borrowing them from Europe. Pyle had the foresight to realize that along with progress in printing would come the demand for more images for reproduction.

During his career, Howard Pyle produced illustrations for nearly 3,500 publications and illustrated books and articles he wrote himself. The Delaware Museum of Art was founded specifically to house his artworks.

Norman Rockwell (1894–1978)

'I'm not a historian. I just painted the things I saw around me. I was showing the America I knew and observed to others who might not have noticed.' Rockwell truly reflected the currents of American life and times, from his earliest drawings to the patriotic themes of the Second World War to more politically oriented themes in his later years. His genius lay in being able to capture the essence of what is now considered largely 'an America vanished', before it began to identify with Norman Rockwell magazine covers. These cover illustrations captured the emotions of the times, not only what they actually were, but also what people would have liked them to be. One only has to look at one of his original painting to be aware of the quality of his technique, style and artistic skills.

Born in New York, Rockwell also spent his childhood and adolescence in the city, with summer excursions into the

countryside that were to be significant to his work. He felt a strong sense of connectedness not only with nature but also with the people who had chosen to live 'on nature's terms'. Rockwell's early

FAR LEFT
Norman Rockwell
Liberty Girl, 1943
41³/₄ x 31¹/₄ (106 x 79cm). Cover of
Saturday Evening Post, 4 September 1943.

LEFT
Norman Rockwell
Disabled Veteran, 1944
Oil on canvas, 43 x 34in
(109 x 86cm). Cover of Saturday Evening
Post, 1 July 1944.

inspiration to draw and paint came not only from his father, an enthusiastic Sunday painter, but also indirectly from his grandfather's primitive canvases of bucolic scenes. He studied painting at the newly formed Arts Students League, where he was taught anatomy by George Bridgeman and composition by Thomas Fogarty.

The most popular and fashionable illustrators of the time, N.C. Wyeth, J.C. Leyendecker, Maxfield Parrish and Howard Pyle, were also powerful influences on Norman Rockwell's development; indeed, hanging in his studio were several Pyles, a Leyendecker and a Parrish. The Parrish painting is a self-portrait seated at his easel in a side view. It is thought that the Rockwell Museum in Stockbridge's logo was taken from Rockwell's famous painting entitled, *The Triple Self-Portrait*, which was directly inspired by Parrish's own self-portrait. Rockwell frequently borrowed from other artists whom he admired, another such example being his *Shave and a Haircut* (1940), taken directly from the earlier James Montgomery Flagg's *A Man of Affairs* (1913). In Rockwell's early years, he studied every magazine containing Howard Pyle's illustrations, and his admiration for J.C. Leyendecker was even more obsessive for in 1915, after completing his studies, Rockwell moved to New Rochelle to be near the object of his admiration. He even rented a studio in the same building and the two later shared models, including the indomitable Pops Fredericks.

At the age of 22 Rockwell sold his first cover piece to the *Saturday Evening Post* – a great achievement for an illustrator. It

Norman Rockwell
The Peace Corps in Ethiopia, 1966
Oil on canvas, 17 x 25in (43 x 63cm).
Illustration for Look magazine, 14 June
1966.

Norman Rockwell
Willy Takes a Step, 1935
Oil on canvas, 26 x 44in (66 x 112cm).
The American Magazine, January 1935.

was the beginning of a 321-cover relationship between Rockwell and the *Post*, only one cover fewer than Leyendecker. As late as 1919, four-colour printing was still very expensive, and the use of colour was limited in most popular storytelling magazine covers. In a sense, Rockwell was the last of the 19th-century genre painters, but one who came into his creative own at a time when a new audience and a new market was opening up. Mass-circulated national magazines of great popularity catapulted certain artists into millions of households weekly and Rockwell clearly had the right talent at the right time. In the 1920s and 1930s, Rockwell's work developed more breadth and a greater degree of character. His use of humour, which had already been developed in the character of 'Cousin Reginald' (a young boy who was always prim and proper),

became an important part of his work. It was an effective technique whereby he would draw the viewer into the composition to share a moment in time with the artist.

In his daily life, Rockwell was constantly searching for new ideas and new faces. He once wrote that everything he had ever seen or done had gone into his pictures. He painted not only the scenes and people close to him but in a quest for authenticity would also approach total strangers and ask them to sit for him, his facility for 'storytelling' becoming integrated with his external skills as an artist. What emerged was what we know today as an incredible ability to judge the perfect moment; when to freeze the action, snap the picture ... when all the elements that define and encapsulate a total story are in place.

In 1936, the editor George Horace Lorimer retired from the *Saturday Evening Post* and the second of two successive editors, Ben Hibbs, altered the circular format of the cover. In fact, Hibbs allowed Norman Rockwell more freedom to create within a different cover layout. The new mood of both the magazine and the country was reflected in Rockwell's work, as he used the entire cover, unconfined by borders and logos, in which to express what he wanted.

In the 1940s, Rockwell moved to Arlington, Vermont, where he started to produce the full-canvas paintings that are increasingly treasured by collectors today. With Grandma Moses as a friend and neighbour and local townspeople as his models, Rockwell became a living element of Americana – a national treasure. His painting, *The*

Bridge Game, is from this period, and captures four Arlington townspeople playing cards from a unique overhead perspective. During his Vermont years Rockwell flourished, but always within the framework of illustration, and he was acutely aware of his goals as an artist and his lack of critical acceptance. During the Second World War, Rockwell joined the legion of artists and writers involved in the war effort to help boost the sale of savings bonds. He tried to explain what the war was all about, the result of his efforts being *The Four Freedoms*, at first rejected by the government and then printed as posters by the millions. *The Disabled War Veteran* (page 415) travelled with *The Four Freedoms* to raise money and $32 million dollars were realized as a result.

From his home in Stockbridge, Massachusetts, in the 1960s, Rockwell struck out in a new direction. Though by then his reputation was rooted in American nostalgia, he was not afraid to tackle political issues. *The Peace Corps in Ethiopia* (page 417) captured the idealism of the Kennedy years in a realistic setting, and he painted portraits not only of President Kennedy, but also of Eisenhower, Nixon and Johnson, together with portraits of other world leaders, including Nehru of India and Nasser of Egypt. In 1962, Rockwell was quoted in *Esquire* magazine thus: 'I call myself an illustrator but I am not an illustrator. Instead I paint storytelling pictures which are quite popular but unfashionable.' He was extremely sensitive as to how the art world and the public judged him.

Norman Rockwell
Bridge Game ('The Bid'), 1948
Oil on canvas, 46¹/₂ x 38¹/₂in
(118 x 98cm).
Cover for Saturday Evening Post, 15 May 1948.

Mead Schaeffer (1898–1980)

Mead Schaeffer was Norman Rockwell's contemporary and his Vermont neighbour. The two became close friends and Schaeffer and his family were even Rockwell's models for a number of paintings. Born in Freedom Plains, New York, Schaeffer grew up in Springfield, Massachusetts, with the express goal of becoming an illustrator. After high school he enrolled at the Pratt Institute and was considered one of its most outstanding students in the Class of 1920, reputed to be their best ever. While at Pratt he was influenced by Harvey Dunn, who occasionally gave his opinion of the students' work and was quite impressed by Schaeffer's projects. While still a Pratt student Schaeffer illustrated his first of seven 'Golden Boy' books written by L.P. Wyman.

At the age of 24, Schaeffer was hired by the publisher Dodd-Mead to illustrate a series of books, much as N.C. Wyeth had done for Scribner's Classics. Among the titles were *Moby Dick*, *Typee*, and *Omoo* by Herman Melville. Other books for Dodd-Mead included *The Count of Monte Cristo* and Victor Hugo's *Les Misérables*. He also illustrated *Adventures of Remi*, *The Wreck of the Grosvenor*, *The Cruise of the Cachalot* and *King Arthur and His Knights*. These book illustrations began in 1922 and culminated in 1930. When this first phase of his career ended, his illustrations of classic novels also came to an end. It was during this period that he met Dean Cornwell, possibly in 1926, and decided he needed further painting instruction to explore a different direction in his career.

From the 1930s to the 1940s, Schaeffer decided to stop painting

Mead Schaeffer
George Washington and Sally Fairfax, 1931
Oil on canvas, 32 x 26$\frac{1}{2}$in (81 x 67cm).
Everybody's Washington, *a book illustration for Dodd-Mead & Company.*

LEFT
Mead Schaeffer
Stede Bonnet Takes Aim, 1920
Oil on canvas, 24$\frac{1}{2}$ x 37$\frac{1}{2}$in (62 x 95cm).
Illustration for The Black Buccaneer, Harcourt, Brace & Co.

Mead Schaeffer
The Adventures of Remi, 1928
Oil on canvas, 38 x 28in (96 x 71cm).
The Adventures of Remi, *by Hector Malot,*
translated by Phillip Schuyler Allen.

Remi and Mattia pause for a moment on
their way from Paris to Boulogne.

buccaneers, Captain Blood and European aristocrats, and to focus on real people in real settings. This may have been due to the influence of Rockwell or was perhaps a result of the shocking developments in the Second World War, but he was quoted as saying, 'I suddenly realized I was sick of painting dudes and dandies ...I longed to do honest work, based on real places, real people and real things.' In fact, he travelled several times out West with Rockwell and they shared many exciting experiences on these trips. They both felt that there was too much of New England in their paintings and began a phase of intense search for subject matter elsewhere. In the meantime, Schaeffer continued with commissions from *Good Housekeeping* and *McCall's*, while Rockwell continued his close relationship with the *Post*. Due, perhaps, to Rockwell's contacts, Schaeffer was introduced to the *Saturday Evening Post*'s art director, for he too began to receive assignments, with commissions from *Ladies' Home Journal*, *Country Gentleman* and *Cosmopolitan*.

During the course of his career, Mead Schaeffer's work clearly divided itself into three, the first part of which was illustrating the classic novels mentioned above. The second area of his interest was to document contemporary American scenes for current magazine publication, and the third comprised his depictions of the American military life, which obviously occurred after his military reportage.

Mead Schaeffer could not be called prolific, for he was methodical and somewhat painstaking in his execution and his output was as a result limited. Yet, his armed forces paintings are considered to be some of the most authentic of the Second World

War, and many hang today in the headquarters of U.S.A.A. in San Antonio. Schaeffer eventually retired to his air-conditioned Vermont barn with a trout stream flowing by his studio window, where he died in 1980.

Frank Schoonover (1877–1972)

Frank Earle Schoonover was born in Oxford, New Jersey, where his father worked in an iron foundry. He applied to Howard Pyle's first classes at Drexel and was overjoyed at being admitted, remarking, 'I felt honored because his class was a pretty strong one – made up of big shots …Jessie Willcox Smith, Maxfield Parrish, Thornton and Violet Oakley, and others.' In 1896, therefore, he joined Pyle's classes at Drexel to study illustration rather than the ministry, which his parents had hoped would be his calling in life.

As a student of Howard Pyle, Frank Schoonover was an enthusiastic follower of his teacher's precept that an artist should 'live what he paints'. After his second year of study, Pyle accepted him into the Chadds Ford summer school on a scholarship and by 1899 he was illustrating books such as *A Jersey Boy of the Revolution* and *In the Hands of the Red Coats*. A few years later, he was illustrating outdoor adventure stories, which interested him most, *In the Open* by Mary Raymond Shipman Andrews being the first of a long list of such works. In 1903, encouraged by Pyle, Schoonover made repeated travels to the Hudson Bay area to experience the environment so that he could illustrate it. Schoonover's trips to Canada and Alaska are all the more remarkable when one realizes that he travelled some 1,200

Frank E. Schoonover
Only Jules Verbeaux, 1905
Oil on canvas, 28¹/₂ x 19in (72 x 48cm).
Story of the Far North-West *by Laurence Mott. Century Magazine.*

RIGHT

Frank E. Schoonover

The Fisherman and the Genie, 1932

Oil on canvas, 32 x 25in (81 x 63cm).
Cover for Stories fron the Arabian Nights,
1932, Garden City Publishing Co., Inc.

FAR RIGHT

Frank E. Schoonover

The Little Wet Foot, c.1914

Oil on canvas, 34 x 24in (86 x 61cm).
Illustration for an article for Harper's
Magazine, 1914.

OPPOSITE

Frank E. Schoonover

To Build a Fire, 1908

Oil on canvas, 23 x 37in (58 x 94cm).
Century Illustrated Monthly magazine.

miles (2000km), entirely by canoe and dog sled and using snowshoes. Over the following years, a great number of his illustrations were based on those daunting excursions, which allowed him to portray the living conditions of these recently settled remote frontiers. He lived for a time with the Blackfeet Indians, and his depictions could not be more accurate, *To Build a Fire* (right), from Jack London's story of the same title being a perfect example. Like Jack London, Schoonover had learned what it takes to survive in the wild. Also like Pyle and Wyeth, Schoonover's understanding of the rugged life made him eminently suitable for illustrating classic tales of adventure, among them *Kidnapped, Robinson Crusoe, Swiss Family Robinson* and *Ivanhoe*. He also illustrated Zane Grey's serials and novels including *Open Range, Avalanche, Rustlers of Silver Ridge, Rogue River Feud* and *Valley of Wild Horses*. He illustrated more than 200 classic books, and with classmate Gayle Hoskins organized the Wilmington Sketch Club in 1925, and forming his own art school in 1942. He taught until he was 91 years old.

His earliest commissions came through Howard Pyle and on at least one occasion a commission was shared with fellow Pyle student, Philip R. Goodwin. In 1900, Schoonover did a cover for the *Saturday Evening Post*, with many cover and interior illustration commissions to follow. Subsequent commissions were for *American Girl, Century, Collier's Weekly, Girl Scouts Magazine, Harper's, McCall's, McClure's, Everybody's Magazine, Frank Leslie's Monthly, Outing, Progressive Farmer, Redbook, Sunday Magazine* and *Scribner's Magazine*. In 1905, author Clarence Edward Mulford developed a

character with one short leg and called him Hopalong Cassidy, or 'Hoppy' to his fans. Frank Schoonover found a real-life model for the character during his travels, immortalizing him in the process.

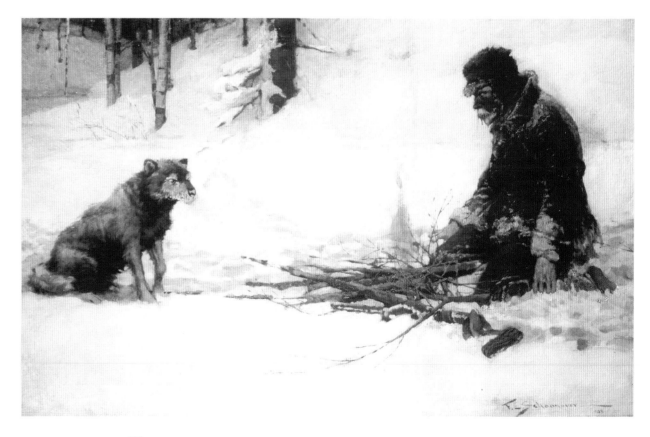

FAR RIGHT
Jessie Willcox Smith
Going into Breeches, 1910
Oil and charcoal on paper, 22¹/2 x 16¹/2in
(57 x 42cm). A Child's Book of Old
Verses, Duffield & Co.

OPPOSITE
Jessie Willcox Smith
Mother and Child, 1921
Charcoal and gouache on illustration
board, 20in (51cm) diameter. Cover for
Good Housekeeping, December 1921.

Schoonover and Pyle's studios in Wilmington were adjacent to one another, for Pyle sometimes asked Schoonover to assist him on occasional commissions. Schoonover made a friend of fellow student, Stanley Arthurs, and in 1906 they travelled to Jamaica with Howard Pyle. That same year Schoonover rented a studio and his neighbours turned out to be more Pyle students; N.C. Wyeth, Henry Jarvis Peck and Harvey Dunn.

'Schoonover Red' became a signature element in many of Frank's paintings. He loved the colour and in each of his illustrations contrived to inject a dash of cadmium red, varnishing it more heavily than elsewhere to heighten its intensity and draw attention to its meaning. This was his way of giving a 'signature' to his art.

Frank Schoonover helped to organize what is now the Delaware Museum of Art and was chairman of the fund-raising committee charged with acquiring works by Howard Pyle. In his later years he restored paintings, including some by Pyle, and turned to painting Brandywine and Delaware landscapes. He also gave art lessons, established a small art school, designed stained-glass windows and dabbled in science fiction when he illustrated Edgar Rice Burroughs' *A Princess of Mars*. He was known locally as the 'Dean of Delaware Artists'. Frank Schoonover died at the age of 94, leaving behind more than 2,000 illustrations.

Jessie Willcox Smith (1863–1935)

Although she never married and had no children of her own, Jessie Willcox Smith is considered to be one of the best illustrators of children's books, her *Little Miss Muffet* (overleaf) being one of the best of its kind. In addition to children's books, she illustrated advertisements for Kodak, Procter and Gamble and Ivory Soap and painted over 200 magazine covers for *Good Housekeeping* alone.

Born in Philadelphia, Smith originally trained to teach young children and only came to illustration in her early 20s after discovering how much she enjoyed drawing. She enrolled at the Pennsylvania Academy of the Fine Arts and studied under Thomas Eakins before graduating in 1888. A year later, her interest in illustration attracted her to a job in the *Ladies' Home Journal* advertising department. Nearly five years later, she learned that Howard Pyle was starting a school of illustration at the Drexel Institute to which she was accepted into the inaugural class along with Maxfield Parrish, Violet Oakley and Elizabeth Shippen Green.

Her first commission was the result of a recommendation by Pyle for an 1897 edition of Longfellow's *Evangeline*, which she and Violet Oakley worked on jointly. In fact, Pyle suggested that they get a studio so that they could work together and they invited their friend, Elizabeth Shippen Green, to join with them.

Unusually for its time, Howard Pyle's Drexel Institute class was composed of nearly 50 per cent women students, Jessie Smith being the oldest, having previously studied at PAFA and having already worked for five years. She was nearly ten years older than most of

Jessie Willcox Smith
Little Miss Muffet, 1912
Oil on board, 18 x 25½in (46 x 65cm).
Good Housekeeping magazine (black-and-white), 1912.

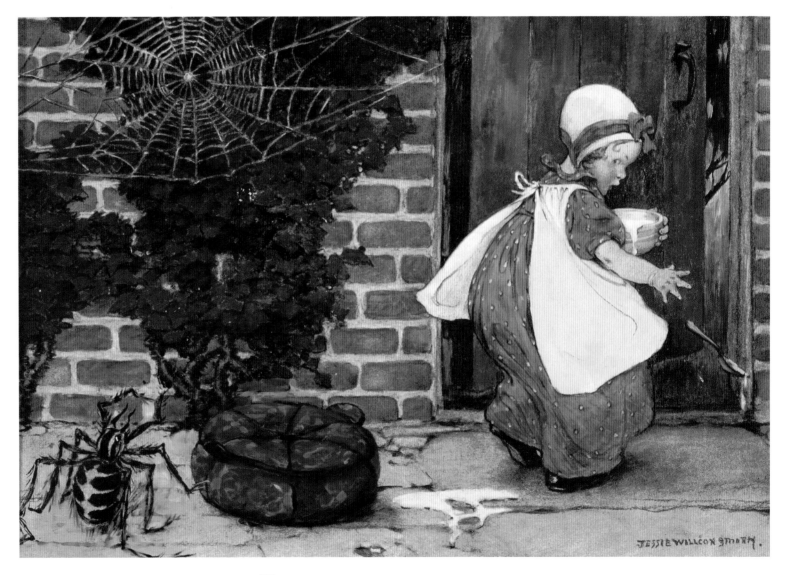

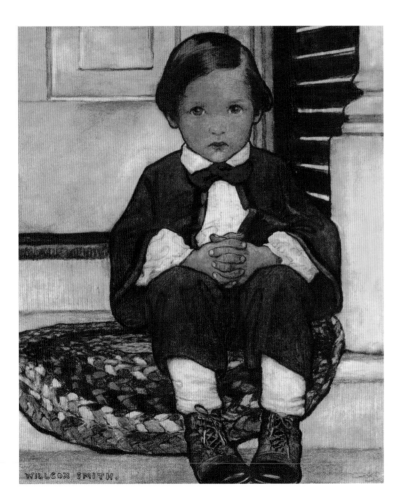

the other students, which perhaps made her all the more eager to make up for lost time. Jessie, Elizabeth Shippen Green and Violet Oakley immediately hit it off and became known as the 'Red Rose Girls', spending 15 years living and working together from 1901 onwards at the Red Rose Inn in Villanova, Pennsylvania. The three women became lifelong friends, art collaborators and colleagues.

After Pyle's school, Jessie began to work for magazines, which by then wanted more and more illustrations, and collaborated with Elizabeth Green on calendars while illustrating stories for *Scribner's Magazine*. She and Violet Oakley also collaborated at times, but from about 1905 she was inundated with commissions. Within a few years, Jessie was working for *Century*, *Collier's Weekly*, *Harper's Bazaar*, *Frank Leslie's Popular Monthly*, *McClure's Magazine*, *Scribner's Magazine*, *Women's Home Companion* and *Good Housekeeping*.

From 1918 through to 1932, Smith illustrated covers exclusively for *Good Housekeeping* magazine, and her images were seen everywhere in nurseries and schoolrooms. Books illustrated by her include *A Child's Book of Stories*, *A Children's Book of Modern Stories*, *Dickens' Children*, *Little Women*, *A Child's Garden of Verses*, *At the Back of the North Wind*, *Boys and Girls of Bookland*, *Heidi* and *The Water-Babies*.

Her fame as an illustrator made her in demand for portraits of children for which she was also well known. Her sensitive handling of children, their moods and expressions, is apparent in each image, which is all the more extraordinary since she was never a mother herself. Jessie Willcox Smith has often been compared with Mary Cassatt, the American Impressionist, also noted for painting children.

FAR RIGHT
Jessie Willcox Smith
Rhymes of Real Children, 1903
Watercolour on illustration board,
20 x 18in (51 x 46cm).
Rhymes of Real Children, *1903, Duffield.*

FAR RIGHT
N.C. Wyeth
Archers in Battle, 1922
Oil on canvas, 42 x 29³/4in (107 x 76cm).
The White Company *by Arthur Conan*
Doyle, David McKay Company, 1922.

OPPOSITE
N.C. Wyeth
Frontier Trapper, 1920
Oil on canvas, 34 x 32in (86 x 81cm).
Cover of The Treasure Chest *by Olive*
Miller Allen for My Book House, Chicago.

N.C. Wyeth (1882–1945)

One of the most successful illustrators of all time, Newell Convers Wyeth studied under Howard Pyle between 1902 and 1904 in Chadds Ford, and was perhaps the student who followed Pyle most closely. During his career, Wyeth painted nearly 4,000 illustrations for the *Saturday Evening Post* and for many other magazines and books. He was an early admirer of Pyle, to the extent that Wyeth settled his family in the Brandywine area and in Maine, where members of the family still live today.

Much of N.C. Wyeth's art was concentrated on American Western themes, with cowboys and Indians, gun fighters and gold miners in abundance. He also illustrated popular children's classics such as *Treasure Island* and *Tom Sawyer*, embellishing them with strong visual images never to be forgotten. N.C. Wyeth is also famous as the father of artist Andrew Wyeth and the grandfather of artist Jamie Wyeth, having founded a dynasty of major consequence in American art history.

N.C. Wyeth sold his first illustration to the *Post* in 1903, when he was 21 years old, his first book commission arriving in 1911 to illustrate *Treasure Island* for the publisher Charles Scribner. So well received was his first book, that he went on to illustrate a whole range of well-loved boys' adventure books, which came to be known as Scribner's Classics, and included *Kidnapped*, *Robin Hood*, *Robinson Crusoe*, *The Boy's King Arthur* and *The Last of the Mohicans*, together with 20 other titles. The Scribner's Classics have never waned in popularity and many are still in print today. Wyeth

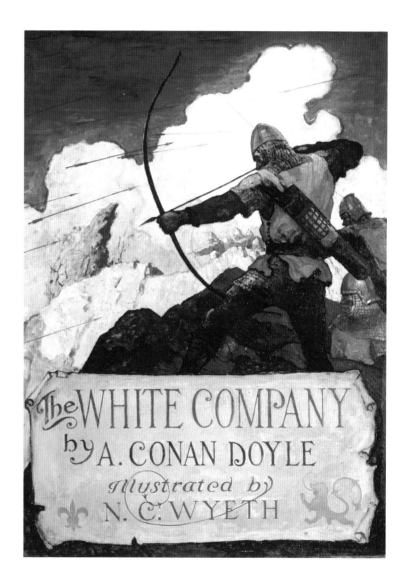

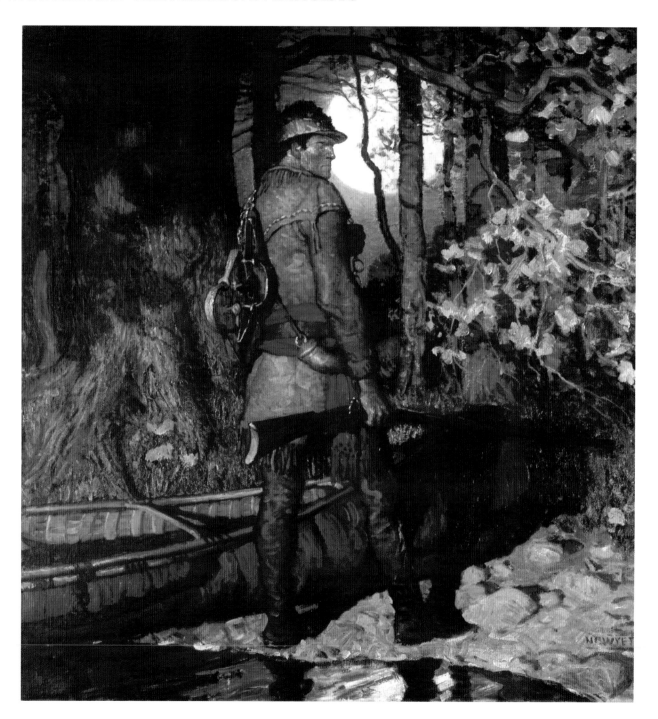

created such valiant and heroic images that they have been adopted as American exemplars, setting the standard in movies, television, and computer games. People never seem to tire of these archetypes; the character of Indiana Jones could well have come directly from the pages of a Scribner's Classic, as envisaged and painted by N.C. Wyeth himself.

Born in Needham, near Boston, Massachusetts, in 1882, Newell Convers Wyeth showed an early passion for drawing and received much encouragement from his family. From 1903 until his tragic death in a 1945 car accident at a railroad crossing, N.C. Wyeth set new standards for illustrators, in style, technique and use of imagination. He had an extraordinary ability to bring fictional characters to life, emphasizing subtleties in the text only touched upon by the author himself.

As a youth, his parents enrolled him in the Massachusetts Normal Arts School with further study at the Eric Pape School of Art. In 1901, Wyeth was in Annisquam, Massachusetts, attending private classes taught by George L. Noyes, a landscape artist, from whom he got his love of nature and *plein-air* painting. He also made a new friend in Clifford Ashley, who had just been accepted into Howard Pyle's new art school in Wilmington. Ashley suggested that Wyeth should also enroll.

N.C. Wyeth arrived in Wilmington on his 20th birthday, where he met Howard Pyle for the first time. Some say that Pyle's greatest contribution to his students, other than teaching and inspiring them, was his many contacts with publishers and art directors. He was

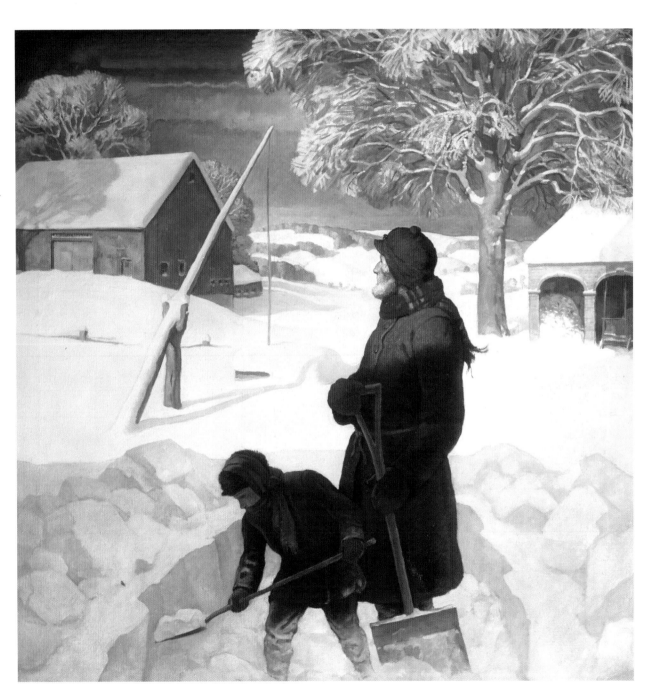

quite often able to secure commissions and even positions on the staff of magazines for his students. Pyle exhorted his students to 'jump into their paintings to know the place' they were depicting, and to experience environments at first hand. Wyeth took him at his word, going out West and living with the Ute and the Navaho. For three months he punched cattle, herded them and was a mail-carrier, documenting his experiences in a series of meticulous drawings

N.C. Wyeth married in 1906, moved to Chadds Ford and continued to produce books and magazines, advertisements and murals, and that which he cherished most, the rural American scene. Wyeth also illustrated a number of books for the Cosmopolitan Book Corporation, Houghton Mifflin Company, Little Brown and Company, David McKay Company and Harper and Brothers, notable among them being the *Mysterious Stranger* (1916), *Robin Hood* (1917), *Robinson Crusoe* (1920), *Rip Van Winkle* (1921) and *The White Company* (1922).

Wyeth found it financially lucrative to accept commercial work in the form of advertisements, calendars and posters. The range and the quality of the advertisements vary from the utilitarian Lucky Strike and Coca-Cola series to the beautiful paintings of Beethoven, Wagner and Liszt for Steinway & Sons.

For years, Wyeth looked upon illustration as a financial means of support for his family but wanted most of all to be recognized as a fine artist. By the 1930s he was accepting fewer illustration and advertising commissions and was devoting more time to painting landscapes.

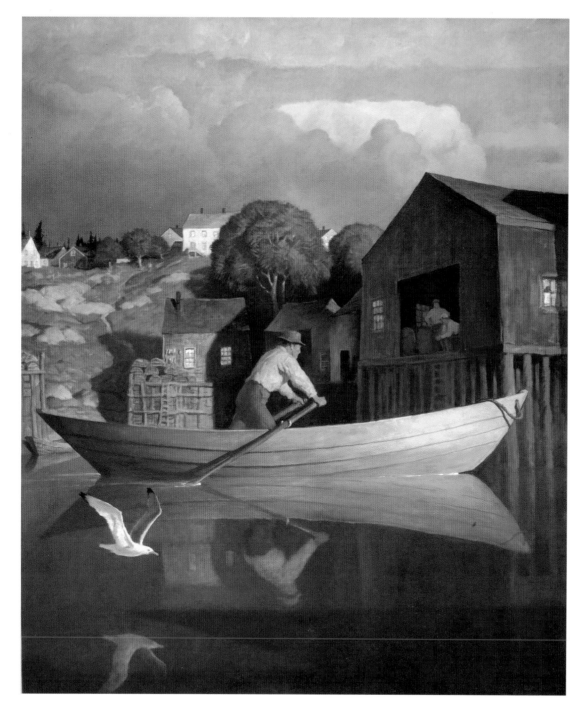

OPPOSITE
N.C. Wyeth
Snow-Bound, 1928
Oil on canvas, 36 x 34in (91 x 86cm).

LEFT
N.C. Wyeth
The Doryman, 1933
Oil on canvas, 42 x 35in (107 x 89cm).
Trending into Maine *by Kenneth Roberts,*
for Little Brown and Company, 1938.

A CHRONOLOGY OF MAXFIELD PARRISH

1870–1966

1637
Captain Edward Parrish (1600–79) arrives in U.S.A. from England. Appointed Surveyor-General of the Maryland Province

1747
Parrish family seeking religious freedom moves to Pennsylvania

1778
Isaac Parrish (1735–1827), great-great grandfather of Maxfield Parrish (MP), founder of an abolitionist organization, appointed haberdasher to President George Washington

1779
Birth of Joseph Parrish (1779–1840), great-grandfather of MP, one of Philadelphia's most prominent physicians and a great civic leader

1805
The Pennsylvania Academy of the Fine Arts (PAFA) is founded

1809
Dillwyn Parrish (1809–86), MP's grandfather, is born. Known for founding the Women's Medical College and the

Orthopedic Hospital and Infirmary for Nervous Diseases, an earnest proponent of woman's suffrage and the abolition of slavery

1835
Artist-illustrator Howard Pyle is born, acknowledged as 'The Father of American Illustration'

1846
On 9 July, Stephen (1846–1938), MP's father, is born in Philadelphia to Dillwyn and Susanna Maxfield Parrish

1849
Gold Rush in California

1859
As a sophisticated young man, Stephen Parrish adds a middle initial 'M' to his name, taking it from his mother's maiden name, 'Maxfield'

1861
Civil War begins

1863
Stephen Parrish's first trip to Europe to visit the Grande Exposition in Paris

1865
Civil War ends

President Abraham Lincoln assassinated

1867
Stephen Parrish's second trip to Europe to visit art museums

1869
On 21 April, Stephen Parrish marries a Quaker, Elizabeth Bancroft of Philadelphia

1870
Frederick Maxfield Parrish (MP) is born on 25 July in Philadelphia, the only child of Stephen and Elizabeth Bancroft Parrish of 324 North Tenth Street

1872
MP's wife, Lydia Ambler Austin (1872–1953) is born in Woodstown, New Jersey, to Hicksite Quakers

1876
Stephen Parrish takes his six-year-old son Maxfield to the Philadelphia Centenary Exposition

1877
MP's first trip to Europe at the age of seven. His father

delights in taking him to the Louvre to watch art students copying the old masters

1881
Samuel L. Parrish, MP's great uncle, commissions Louis Saint-Gaudens, lifelong assistant and younger brother of Augustus Saint-Gaudens, to sculpt a bust of Dr. Joseph Parrish

1882
Stephen and Elizabeth Parrish visit Cornish, New Hampshire, at the invitation of Augustus Saint-Gaudens

Maxfield completes grammar school in Philadelphia and enters Swarthmore Preparatory School

1883
Dillwyn Parrish, grandfather of Maxfield Parrish, dies. Stephen Parrish and his brother Joseph inherit Philadelphia office buildings and dwellings

1884–86
MP spends time in Europe with his parents, his father teaches him to paint and etch. Writes voluminous letters home to relatives and friends, each of which is decorated with cartoons and sketches

In 1885, MP contracts typhoid fever and nearly dies while in Honfleur, France

1888
Enters Haverford College, Class of 1892, intending to become an architect. He signs up for the Bachelor of Engineering degree, but disillusioned by repetitive exercises 'drops out' in 1891

1889
Susan Lewin, MP's favourite model and companion for 55

years, is born on 22 November in Hartland, Vermont, to Elmer and Nellie Westgate Lewin. The Lewins had five daughters: Susan, Annie, May, Nellie and Emily. Susan's cousin, Marguerite, was housekeeper to Stephen Parrish

1891
Maxfield enrolls as a painting student at the Pennsylvania Academy of the Fine Arts (PAFA) in Philadelphia and studies under artist-instructors Thomas P. Anschutz and Robert Vonnoh. MP meets Lydia Ambler Austin, a young art student

1892
Maxfield summers at Gloucester, Massachusetts, in the Annisquam artist colony with his father

MP paints *The Chaperone* on the door of the sail loft rented as a studio by his father for the summer. It is meant as a joke to welcome two maiden aunts visiting from Philadelphia

Lydia Parrish teaches painting at Drexel Institute

1893
MP's uncle Joseph Parrish dies, leaving his entire estate to Stephen Parrish

Stephen Parrish buys 18 acres in New Hampshire and hires architect Wilson Eyre, Jr. of Philadelphia to design 'Northcote', his estate in the Cornish Colony

MP spends the summer with his father in Gloucester and paints his first picture, *Moonrise*. The painting is exhibited at the Philadelphia Art Club in November – his first exhibited artwork.

Stephen Parrish stops painting for nearly a decade.

MP visits a Boston Museum of Fine Arts exhibition of paintings by Japanese artist, Katsushika Hokusai

In October, MP and Haverford classmate Christian Brinton travel together to Chicago to visit the World's Columbian Exposition where they see Stephen's etchings on display

1894
Architect Wilson Eyre, Jr. suggests to the University of Pennsylvania's Mask and Wig Club that it commission MP to paint a mural for its new clubhouse, a former stable on Quince Street.

MP's watercolour study for the Mask and Wig Club 'Old King Cole' mural is exhibited at PAFA and the Architectural League in New York

Spends summer with his father in Gloucester in Annisquam

MP opens a studio at 320 South Broad Street, Philadelphia

1895
Matriculates at Drexel Institute, the nation's first formal school of illustration art. During the winter session attends classes taught by Howard Pyle,

MP completes illustrations for Kenneth Grahame's book, *The Golden Age*

Sells his first painting, study for 'Old King Cole' to PAFA

MP marries Lydia Ambler Austin on 1 June, then departs to England, Belgium and France alone, visiting museums and galleries

MP produces his first magazine cover for the Easter issue of *Harper's Weekly*. More *Harper's* covers painted 1895–1906.

Other magazine illustrations continue from this point until 1936

1896
Executes poster for an exhibition held at Pennsylvania Academy, establishing a reputation as a major graphic designer. Another MP poster design wins second prize with 'Century Midsummer Holiday Number, August' in *The Century Magazine* poster contest, with first prize going to J.C. Leyendecker, the most noted illustrator of the day. Later MP's submission is published in *Maitre de'l Affiche*, a French publication, opposite a painting by Henri de Toulouse Lautrec. It becomes the most reproduced poster of the decade

1897
MP wins other competitions and commissions such as book covers for *Scribner's*, Wanamaker's catalogues, and posters including the famous Columbia Bicycle contest-winning submission. Work for *Scribner's* continues thenceforth through to 1931

The Sandman is included in an important exhibition at the Society of American Artists – Parrish is elected into the Society

MP completes his first illustrated book, L. Frank Baum's *Mother Goose in Prose*. Book illustration commissions continue until 1925

MP rents a new studio at 27 South Eleventh Street

1898
Parrish designs and builds 'The Oaks' in Plainfield in the Cornish Colony, and like his father permanently moves from Philadelphia. Sadly, at this time of success and accomplishment, his mother abandons his father to join a commune in California

The *Century Magazine* commissions begin and continue through to 1917

Kenneth Grahame's *Dream Days* is published, with 18 superb illustrations

'Vernon Court,' designed by architects, Thomas Hastings and Josephe Carrère, venue of the National Museum of American Illustration, is constructed in Newport, Rhode Island

1899
A major MP exhibition at the Keppell Art Gallery, New York

Parrish illustrates Kenneth Grahame's *The Golden Age*

Life magazine commissions begin and continue until 1924

1900
Sick with tuberculosis MP recuperates at Saranac Lake in the Adirondacks. It is a major turning point in his career as colour assumes a new importance in his work

The Sandman receives honourable mention at the Paris Exposition

Washington Irving's *Knickerbocker's History of New York* is published with Parrish illustrations

MP joins The Players Club in Gramercy Park

1901
Wins Silver Medal at Pan American Exposition in Buffalo
1901–02

Leaves Saranac Lake in April, travels to Castle Creek, Hot Springs, Arizona, to further recuperate. MP visits the Grand Canyon and begins 'The Great Southwest' series

1902
MP has an exhibition of his work at the Book Shop, 259 Fifth Avenue, New York City. Late December, MP travels again to Castle Creek and stays for several months to capture the light and colours of the area

Kenneth Grahame's *Dream Days* is published with MP's illustrations

1903
Commission from *Century* magazine to illustrate Edith Wharton's *Italian Villas and Their Gardens*. Parrish travels to Italy, Monaco and France. The trips to Italy make a lasting impression on his future subject matter

A.B. Frost, one of Parrish's artistic heroes, gives him a signed copy of his book, *The Bull Calf*, published by Charles Scribner's Sons in 1892

Stephen Parrish begins to paint again, but only oil landscapes of the Cornish countryside

1904
Maxfield and Lydia's first child, Dillwyn, born on 1 December, named after Maxfield's paternal grandfather

Saint Patrick is executed for *Life* magazine. This work is a favourite of the Parrish family and was repurchased from Austin Purves by Lydia Parrish as a gift for MP's granddaughter

Collier's magazine commissions begin and last until 1936

Exhibition of Maxfield's work at the International

Exposition in St. Louis, Missouri. One of his paintings, *A Venetian Night*, is purchased by the St. Louis Museum of Art – the first purchase of his art by a museum

MP paints almost exclusively using the old master technique of oil glazes on wooden panels

Susan Lewin, a 15-year-old local girl, is hired to help Lydia with the children as au pair. She moves into The Oaks

1905

Maxfield is honoured by the National Academy of Design and the Pennsylvania Academy of the Fine Arts, and receives an award from the Architectural League of New York.

Socializes with Ethel Barrymore, Walter Lippmann and other luminaries at The Oaks

At the suggestion of his father, MP builds a separate studio at The Oaks

Kenyon Cox paints Parrish's portrait for the National Academy of Design

Einstein announces his Theory of Relativity

1906

A second son is born, Maxfield Parrish, Jr.

Susan Lewin poses for *Land of Make-Believe*

MP elected to the National Academy of Design

1907

Death of the sculptor Augustus Saint-Gaudens at Cornish, a blow to the Cornish Colony community that he founded in the hills of New Hampshire

1908

Maxfield Parrish elected to membership in Phi Beta Kappa at Haverford College

Award for best picture, *Landing of the Brazen Boatman*, in the Pennsylvania Academy of the Fine Arts annual exhibition

1909

A third son is born, named after MP's grandfather, Stephen M. Parrish

The Arabian Nights: Their Best-Known Tales, edited by Kate Douglas Wiggins and Nora A. Smith is published with MP's illustrations

MP paints a mural for the Palace Hotel (Sheraton Palace), San Francisco, entitled *The Pied Piper*

1910

MP produces illustrations for a combined edition of Nathaniel Hawthorne's *A Wonder Book* (1852) and *Tanglewood Tales* (1853)

Parrish begins his greatest and largest commission for the Curtis Publishing Company, a suite of 17 murals entitled 'A Florentine Fête', finishing the last painting, an 18th mural in 1916

1911

The Parrishes' only daughter, Jean, is born in June

MP formally became a 'businessman with a brush' due to his displeasure with Duffield and Company for publishing *A Golden Treasury* without his permission. He thereafter demands agreements and stipulates 'one time use only'

1912

Lydia Parrish takes her first trip to St. Simons Island, Georgia, and rents a house at Bloody Marsh, where she begins a long study of its Afro-American inhabitants. She spends all her winters in Georgia from this time forth

Hearst's magazine commissions begin and last until 1914

1913

Kimball Daniels, a former suitor of Susan Lewin (he married her sister Annie), is found dead of a broken neck at The Oaks, where he worked in the fields. He modelled for Parrish in the painting *Dawn*, 1906

President Woodrow Wilson rents Harlakenden House at Cornish from the American novelist, Winston Churchill, and returns for the next few years, using it as a summer 'White House'

1914

MP and Christian Brinton are awarded Honorary LL.D degrees by Haverford College

MP designs a mural executed by Louis Comfort Tiffany for the Curtis Publishing Company building in Philadelphia

The First World War begins

1915

Invitation from Edith Wharton to paint the cover for her *Book of the Homeless*

1916

Maxfield concludes the last of a series of Florentine Fête murals for the Curtis Publishing Company to be displayed in the Girls' Dining Room, a 500-seat hall on the top floor of the Curtis Building in Independence Square, Philadelphia. In the 1960s, the murals are removed and put into storage until 1998

A CHRONOLOGY OF MAXFIELD PARRISH

Meets Martin Birnbaum of the art gallery Scott & Fowles at its 590 Fifth Avenue galleries. He hosts an exhibition entitled, 'First Exhibition of Original Works by Maxfield Parrish' in New York City, everything sells. The exhibition includes work of George Bellows, Paul Dougherty, Paul Manship, Elie Nadelman, Jules Pascin, Mari Peixotto, Everett Shinn, and Gertrude Vanderbilt Whitney

1917
Awarded Medal of Honor for painting by the Architectural League of New York

1917–1932
General Electric Company publishes calendars for its Edison Mazda Lamps Division with images by Maxfield Parrish

MP begins a relationship with House of Art (Reinthal and Newman), a fine art distribution company to produce art prints; the relationship continues until 1937

1918
Parrish spends nine months with Susan Lewin at 49 East 63rd Street, New York City

1920
Garden of Allah is published as an art print and is a resounding success

MP travels to Colorado Springs and works on sketches and photographs for the Broadmoor Hotel mural, while exhibitions, commissions and awards proliferate

Lydia Parrish forms the 'Spiritual Singers Society of Coastal Georgia'

Susan Lewin poses nude for *Primitive Man*

1922
Daybreak is published by Reinthal and Newman and

distributed as an art print by House of Art. The most successful print of the decade, it secures Parrish's position as the country's most popular illustrator. Over the next three years, Parrish earns over $100,000 in royalties from this one work

1923
Lydia Parrish joins Winston and Mabel Churchill for a trip to Europe. Before leaving, the Churchill's hire Susan Lewin to look after their house, Harlakenden, which catches fire and burns down, just after they leave. Susan immediately moves back to The Oaks and remains there until 1960

1925
The *Knave of Hearts* by Louise Saunders is published. This is the last book illustrated by Maxfield Parrish

New York art gallery, Scott and Fowles, holds another major Parrish exhibition in November. A one-man show, the originals from many earlier commissions were put on display

1926
Enchantment is published by General Electric Edison Mazda as a calendar

1931
Associated Press interviews Maxfield Parrish when he says, 'I'm done with girls on rocks'

George S. Ruggles dies, Parrish's handyman and friend for 33 years

1932
Last commission for Edison Mazda calendars is completed
1934

Last pose by Susan Lewin for *Enchanted Prince*; now over 45, her figure is no longer what it was. MP begins his landscape period in earnest, and with a few exceptions continues exclusively in this genre hereafter

1935
MP signs a contract with the Brown & Bigelow Publishing Company of St. Paul, Minnesota, to produce illustrations for calendars, playing cards and greeting cards

1936
MP's last work for a magazine comes in the form of the famous *Collier's* cover, *Jack Frost*. The subject and layouts are daughter Jean's ideas though executed by MP; they split the commission

Exhibition of MP's 'New Hampshire Landscapes' at Ferargil Gallery, 63 East 57th Street, NYC

1937
Last commission for the House of Art is completed, yet MP continues to receive residual royalties for years to come

1938
MP's father, Stephen M. Parrish, dies at the age of 92 in Cornish

Haverford College honours Maxfield Parrish with an exhibition from 23 April–8 May

1939
Second World War begins

1942
Lydia Parrish's book, *Slave Songs of the Georgia Sea Islands*, is published, a milestone documentation of Afro-American history

MAXFIELD PARRISH AND THE AMERICAN IMAGISTS

1945
Second World War ends

1950
Exhibition of MP's paintings at the Saint-Gaudens Memorial, Cornish, New Hampshire

Korean War begins

1953
On 29 March, Lydia Austin Parrish dies at 81 years of age on her beloved St. Simons Island, in Georgia

Sporadic retrospective exhibitions with a major show at Dartmouth College. MP lives the life of an elder statesman in Cornish

1954
Maxfield Parrish is awarded an honorary degree at the University of New Hampshire

1960
John F. Kennedy elected President

At the age of nearly 71, Susan Lewin marries her childhood sweetheart, Earle Colby

MP stops painting at 90 years of age due to arthritis in his right hand

1961
MP's final painting, entitled *Away from it All* is completed, but is rejected by Brown & Bigelow for publishing

MP changes his will leaving Susan Lewin Colby $3,000 and two oil paintings

1963
President Kennedy assassinated

Maxfield Parrish is presented the *Boston Post* Cane by Town of Plainfield, New Hampshire – given to the town's oldest citizen

1964
Exhibition 4–26 May at Bennington College, 'Maxfield Parrish – A Second Look'

MP attends a major exhibition in June at Huntington Hartford's Gallery of Modern Art in New York City. On his return, the Parrish family employs a nurse to look after him

1965
The Metropolitan Museum of Art purchases *The Errant Pan*

Exhibition at Chesterwood (Daniel Chester French Estate) in Stockbridge, Massachusetts. MP does not attend

Exhibition, 'Artists, Friends, and Neighbors' at St. Gaudens Memorial Museum, Cornish, New Hampshire

1966
'Maxfield Parrish – a Retrospect', exhibition at the George Walter Vincent Smith Art Museum from 23 January–20 March, ending just ten days before his death

On 30 March, Frederick Maxfield Parrish dies at The Oaks at the age of 95 years

On October 22, Anne Bogardus Parrish dies at the age of 88 in Lebanon, New Hampshire. A second cousin of MP, she was Stephen Parrish's companion for many years

1968
Susan Lewin's husband, Earle Colby, dies just seven years after their marriage

Exhibitions at Vose Galleries of Boston, the Berkshire Museum and the Talbot Gallery of Hyannis, Massachusetts. Vose sells the Maxfield Parrish Estate paintings

1969
The Maxfield Parrish Estate sells The Oaks. The buyers hire Dillwyn as caretaker

MP's son, Dillwyn, commits suicide at The Oaks

1970
The Oaks is sold and becomes a bed-and-breakfast establishment with a restaurant and gift shop

1978
Susan Lewin dies on 27 January at the age of 88

The Oaks is sold and becomes a commercial art gallery and museum

1979
The Oaks is destroyed by fire

1983
Parrish's son, Maxfield Parrish Jr., dies. Throughout his life he did his best to document and authenticate the works of his father

1989
'Romance and Fantasy', the first Parrish one-man exhibition since his death, is curated by Judy Goffman (Cutler), at the American Illustrators Gallery in New York City

A CHRONOLOGY OF MAXFIELD PARRISH

1993

Parrish's artwork is featured in 'The Great American Illustrators' exhibition. The exhibition opens in Tokyo at the Odakyu Museum before travelling to Fukushima Prefectoral Museum and the Daimaru Museum in Osaka. Curated by Judy Cutler, organized by the American Illustrators Gallery for the *Yomiuri Shimbun*, the world's largest circulation newspaper. The US Embassy patronizes the exhibition

1995

'Maxfield Parrish', an international retrospective exhibition honouring the 125th anniversary of the artist's birth. The exhibition, curated by Judy Cutler and organized by the American Illustrators Gallery, opens in Tokyo at the Isetan Museum. The exhibition travels across Japan before returning to the Norman Rockwell Museum in November. Sponsored by NHK, Japanese public television and patronized by the US Embassy, the exhibition breaks attendance records everywhere, including the Norman Rockwell Museum

1996

Daybreak sells at auction for $4.3 million, a record price for an illustration, making Maxfield Parrish the 17th highest-priced American artist in history

1998

The National Museum of American Illustration is founded by Judy and Laurence Cutler, featuring the artworks of Maxfield Parrish, Norman Rockwell and N.C. Wyeth, as well as other greats from the 'Golden Age of American Illustration'. The NMAI has the largest collection of Maxfield Parrish original paintings as well as vintage prints, advertisements and memorabilia

1999

'Maxfield Parrish: 1870–1966', an exhibition organized by the Pennsylvania Academy of the Fine Arts, opens in Philadelphia and travels to several venues concluding at the Brooklyn Museum

'Stephen Parrish: Rediscovered American Etcher', an exhibition held at the Woodmere Art Museum in Philadelphia, is a testimony to the continuing popularity and artistic skills of MP's father

2000

The National Museum of American Illustration opens to the public on 4 July, sharing much of Maxfield Parrish's original art with the public in a permanent venue for the first time. The late J. Carter Brown, Director Emeritus of the National Gallery of Art in Washington, D.C., after first visiting the American Imagist Collection, remarks: 'I am bowled over ... [by the] broad-ranging, extremely patriotic, and cutting-edge material in terms of the evolution of American taste'

2003

Maxfield Parrish's greatest and largest work, A Florentine Fête (1910-1916), a suite of 18 murals, each 10ft 6-inches high, together with his smallest work, a Mother of Pearl button $1^1/_2$ inches in diameter, 'The Tallwood Pearl' (1955), are put on permanent exhibition at the National Museum of American Illustration in Newport

BIBLIOGRAPHY

A Selected Bibliography
This bibliography is included as an assistance to those undertaking further research on Maxfield Parrish and/or the American Imagist illustrators. It is not meant to be comprehensive, but rather a starting point from which to delve more deeply into a subject which, until recently, was not accepted as a scholarly pursuit by the fine arts establishment. For a long time, many blindly thought that illustration was 'commercial art'. Consequently, there is a dearth of material available, but this bibliography will hopefully fill that gap and inspire new research and documentation of illustration art – an incredibly rich and vibrant segment of the fine arts spectrum.

Abbott, Charles D., *Howard Pyle – A Chronicle*, Harper and Brothers, New York, 1925.

A Century of Illustration, The Brooklyn Museum, Brooklyn, 1972.

Adams, Adeline, 'The Art of Maxfield Parrish', The American Magazine of Art, Vol. 9, January 1918, pp. 84–101.

Agosta, Lucien L., *Howard Pyle*, Twayne Publishers, Boston, 1987.

Allen, Douglas and Douglas Allen Jr., *N. C. Wyeth: the Collected Paintings, Illustrations and Murals*, Crown, New York, 1972.

Alloway, Lawrence, 'The Return of Maxfield Parrish', Show, Vol. 4, May 1964, pp. 62–67.

American Art by American Artists, P.F. Collier & Sons, New York, 1914.

Annuals of American Illustration, Watson-Guptill, New York, 1959–2001.

Apgar, John F. Jr., *Frank E. Schoonover, Painter-Illustrator: A Bibliography*. Morristown, New Jersey, 1969.

Arthurs, Stanley, *The American Historical Scene*, University of Pennsylvania Press, Philadelphia, 1935.

Baum, L. Frank, *Mother Goose in Prose*, Way and Williams, Chicago, 1897.

Best, James J., *American Popular Illustration*, Greenwood Press, Westport, Connecticut, 1984.

Bland, David, *A History of Book Illustration*, The World Publishing Company, Cleveland, 1958.

Bok, Edward, *The Americanization of Edward Bok*, Charles Scribner's Sons, New York, 1922.

Bolton, Theodore, *American Book Illustrators: Bibliographic Check Lists of 123 Artists*, R.R. Bowker Co., New York, 1938.

Bossert, Jill, *John LaGatta – An Artist's Life*, Madison Square Press, New York, 2000.

Bowers, Q. David, et al., *Harrison Fisher*, Bowers, Budd and Budd, Cinncinati, Ohio, 1984.

Bradley, Will, 'The Art of Illustration', The Nation (July 1913).

Bradley, Will, 'Maxfield Parrish', Bradley: His Book (Nov. 1896) pgs. 13–15.

Brandywine River Museum, *Frank E. Schoonover Illustrator*, Brandywine Conservancy, Chadds Ford, 1979.

Brinton, Christian, 'Master of Make-Believe', The Century Magazine. Vol. 84, July 1912, pp. 340–52.

Broder, Patricia Janis, *Dean Cornwell: Dean of Illustrators*, Balance House Ltd., New York, NY, 1978.

Brokaw, Howard Pyle, *The Howard Pyle Studio: A History*, The Studio Group, Wilmington, Delaware, 1983.

Brokaw, Howard Pyle, *History and Romance – Works by Howard Pyle*, Brandywine River Museum, Chadds Ford, Pennsylvania, 1998.

Brooklyn Museum, *A Century of American Illustration*, Introduction by Duncan F. Cameron, Brooklyn Museum Press, New York, 1972.

Burg, David F., *Chicago's White City of 1893*, University of Kentucky, Lexington, Kentucky, 1976.

Buechner, Thomas S., *Norman Rockwell, Artist and Illustrator*, Harry N. Abrams, New York, 1970.

Butterfield, Roger, *The Saturday Evening Post Treasury*, Simon & Schuster Inc., New York, 1954.

Canaday, John, 'Maxfield Parrish, Target Artist', New York Times, 7 June 1964.

Carrington, James B., 'The Work of Maxfield Parrish', The Book Buyer, XVI, 3 April 1898, pgs: 340–52.

Carruth, Garton, ed., *Encyclopedia of American Facts and Dates*, 8th Edition, Harper Collins, New York, 1987.

Carter, Alice A., *The Red Rose Girls*, Harry N. Abrams, New York, 2000.

Christy, Howard Chandler, *The Christy Girl*, Indianapolis, The Bobbs-Merrill Company, New York, 1906.

Christy, Howard Chandler, ed., *Liberty Belles: Eight Epochs in the Making of the American Girl*, Indianapolis, The Bobbs-Merrill Company, New York, 1912.

Claridge, Laura, *Norman Rockwell*, Random House, New York, 2001.

Cohn, Jan, *Covers of the Saturday Evening Post*, Viking Studio Books, New York, 1995.

Colby, Virginia Hunt Reed, *Maxfield Parrish 'In The Beginning'*, published privately, 1976.

Colby, Virginia Hunt Reed and Atkinson, James B., *Footprints of the Past*, New Hampshire Historical Society and George Reed II, Concord, NH, 1996.

Copley, Helen F., *The Christy Quest*, The Patrice Press, Tucson, Arizona, 1999.

Cortissoz, Royal, 'Recent Work by Maxfield Parrish', New York Herald Tribune, 16 Feb 1936, Section V: 10.

Crane, Walter, *The Decorative Illustration of Books*, G. Bell & Sons, Ltd., London, 1896.

Cutler, Laurence S. and Judy Goffman, *Maxfield Parrish*, Bison Books Ltd., London/Brompton Books, Greenwich, Conn., 1993.

Cutler, Laurence S., and Goffman, Judy, *The Great American Illustrators*, The Great American Illustrators Catalogue Committee, Tokyo, 1993.

Cutler, Laurence S. and Judy A. G. Cutler, *Maxfield Parrish: A Retrospective*, Maxfield Parrish™: A Retrospective Catalogue Committee, Tokyo, 1995.

Cutler, Laurence S., and Judy A. G. Cutler, *Parrish & Poetry*, Pomegranate Artbooks, San Francisco, 1995.

Cutler, Laurence S., and Judy A. G. Cutler, *Maxfield Parrish: A Retrospective*, Pomegranate Artbooks, San Francisco, 1995.

Cutler, Laurence S., and Judy A. G. Cutler with The National Museum of American Illustration, *Maxfield Parrish: Treasures of Art*, Gramercy Books/Random House Value Publishing, Inc., New York, 1999.

Cutler, Laurence S., and Judy A. G. Cutler, *Maxfield Parrish*, Thunder Bay Press, San Diego, 2001.

Delaware Art Museum, *Howard Pyle: Diversity in Depth*, The Wilmington Society of Fine Arts, Wilmington, Delaware, 1973.

Dodd, Loring Holmes, *A Generation of Illustrators and Etchers*, Chapman & Grimes, Boston, 1960.

Dohanos, Stevan, *American Realist*, Van Nostrand Rheinhold, New York. 1980.

Duncan, Francis, 'Maxfield Parrish's Home and How He Built It', Country Calendar, Vol. 1, September 1905, pp. 435–37.

Ellis, Richard, *Book Illustration*, Kingsport Press, Kingsport, Tennessee, 1952.

Elzea, Rowland and Elizabeth H. Hawkes, General Editors, *A Small School of Art: The Students of Howard Pyle*, Delaware Art Museum, Wilmington, Delaware, 1980.

Elzea, Rowland, *The Golden Age of Illustration, 1880–1914*, (exhibition catalogue), Delaware Art Museum, Wilmington, Delaware, 1972.

BIBLIOGRAPHY

Faunce, Sarah, 'Some Early Posters of Maxfield Parrish', Columbia Library Columns XVII, 1 November 1967: 27–33.

Field, Eugene, *Poems of Childhood*, Charles Scribner's Sons, New York. 1904.

Gelman, Woody, *The Best of Charles Dana Gibson*, Bounty Book, New York, 1969.

The Gibson Book, Charles Scribner's Sons, R. H. Russell, New York, 1907.

Gillet, G. E., 'Maxfield Parrish at Ninety-three', Saturday Review, Vol. 47, 14 March 1964, pp. 129–30.

Gillon, Jr., Edmund Vincent, *The Gibson Girl and Her America*, Dover Publications, New York, 1969.

Glueck, Grace, 'Bit of a Comeback Puzzles Parrish', New York Times, 3 June 1964.

Glueck, Grace, 'Maxfield Parrish', American Heritage XXII, 1 December 1970, pgs. 16–27, 96.

The Golden Age of American Illustration: 1880–1914, Delaware Art Museum, Wilmington, 1972.

Grahame, Kenneth, *Dream Days*, John Lane, London and New York. 1902.

Grahame, Kenneth, 'It's Walls Were As Of Jasper', Scribner's Magazine, New York. 1897.

Grahame, Kenneth, *The Golden Age*, John Lane, London and New York. 1899.

'Grand-Pop at Manhattan's Gallery of Modern Art', Time, Vol. 83, 12 June 1964, p. 76.

Gregg, Richard N., *Howard Chandler Christy: Artist/Illustrator of Style*, (exhibition catalogue), Allentown Art Museum, Kutztown Publishing Inc., Kutztown, Pennsylvania, 1977.

Grunwald Center for the Graphic Arts, *The American Personality: The Artist-Illustrator of Life in the United States*, 1860–1930, Introduction by E. Maurice Bloch, University of California, Los Angeles, 1976.

Guptill, Arthur L., *Norman Rockwell, Illustrator*, Watson-Guptill, New York, 1975.

Halsey, Jr., Ashley, *Illustrating for the Saturday Evening Post*, American Book – Knickerbocker Press Inc., New York, 1951.

Hambidge, Jay, *Dynamic Symmetry of The Greek Vase*, Yale University Press, New Haven. 1920.

Hambidge, Jay, *The Elements of Dynamic Symmetry*, Brentanos, New York. 1926.

Harburg, E. Y. and Parrish, Maxfield, *Over the Rainbow*, Welcome Enterprises, Inc., New York, 2000.

Haskell, Barbara, *The American Century: Art & Culture 1900–1950*, W.W. Norton Company, New York, 1999.

Hastings, Thomas, 'Architectural League of New York Exhibition', Harpers Weekly; vol. XXXIX, 2 March 1895, pgs. 197–98.

Hawthorne, Nathaniel, *A Wonder Book and Tanglewood Tales*, Duffield & Company, New York. 1910.

Henderson, Helen, 'The Artistic Home of the Mask and Wig Club', House and Garden V, 4, April 1904, pgs. 168–74.

Holland, William and Congdon-Martin, Douglas, *The Collectible Maxfield Parrish*, Schiffer Publishing, Ltd., Atglen, Pennsylvania, 1993.

Horwitt, Nathan G., *A Book of Notable American Illustrators*, The Walker Engraving Company, New York, 1926.

Hutchinson, W. H., *The World, The Work & The West of W. H. D. Koerner*, University of Oklahoma Press, 1978.

Irving, Washington, *Knickerbocker's History of New York*, R. H. Russell, New York, 1900.

Jackson, Gabrielle, *E. Peterkin*, Duffield & Company, New York. 1912.

Jacobsen, Jack W., *Maxfield Parrish: The Man Behind the Make-Believe*, West Chester, Penn., 1995.

Jennings, Kate F., *N.C. Wyeth*, Crescent Books, New York, 1992.

Jordan, Alice M., 'Children's classics', The Horn Book Magazine, July–August, Boston, 1947.

Karolevitz, Robert F., *Where Your Heart Is: The Story of Harvey Dunn, Artist*, North Plains Press, South Dakota, 1970.

Klemin, Diana, *The Art of Art for Children's Books*, Clarkson N. Potter, New York, 1966.

Korshak, Stephen D., *A Hannes Bok Treasury*, Underwood-Miller, Lancaster, Pennsylvania, 1993.

Larson, Judy L., *American Illustration 1890-1925*, Glenbow Museum, Calgary, Canada, 1986.

Larson, Judy L., *Enchanted Images: American Children's Illustration 1850-1925*, Santa Barbara Museum of Art, California, 1980.

Lehmann-Haupt, Hellmut, *The Book in America: A history of the making and selling of books in the United States*, R. R. Bowker Company, New York, 1951.

Levine, J. H., 'Professor von Herkomer on Maxfield Parrish's Book Illustrations', International Studio, Vol. 29, July, 1906, pgs: 35–43.

Ludwig, Coy, *Maxfield Parrish*, Watson-Guptill Publications, New York. 1973.

Lynes, Russell, *The Taste-Makers*, Harper and Brothers, New York, 1949.

Margolin, Victor, *The Golden Age of the American Poster*, Ballantine Book, New York, 1976.

Martignette, Charles G., and Louis Meisel, *The Great American Pin-Up*, Taschen, Germany, 1996.

'Maxfield Parrish Artist Observes 70th Birthday at Plainfield', The Claremont Advocate (N.H.), 25 July 1940.

'Maxfield Parrish as a Mechanic', Literary Digest LXXVII, 6 May 1923, pgs. 40–44.

Maxfield Parrish Collection, The Quaker Collection, Haverford College, Haverford. 1992.

Maxfield Parrish: Master of Make-Believe, Brandywine River Museum, Chadds Ford, PA., 1974.

Meigs, Cornelia, et al., *A Critical History of Children's Literature*, The Macmillan Company, London, 1969.

Merrill, Charles, 'Dreams Come True in His Workshop', Mentor, Vol. 15, June 1927, pgs. 20–22.

Meyer, Susan E., *America's Great Illustrators*, Harry N. Abrams, Inc., New York, 1978.

Meyer, Susan E., *James Montgomery Flagg*, Watson-Guptill, New York, 1974.

Moffitt, Laurie Norton, *Norman Rockwell – A Definitive Catalogue*, The Norman Rockwell Museum at Stockbridge, Massachusetts, vol. 1 & 2, 1986.

Moffat, William, 'Maxfield Parrish and His Work', Outlook, Vol. 78, 3 December 1904, pgs. 838–41.

Mortenson, Rita C., *R. Atkinson Fox His Life and Work*, L-W Book Sales, Gas City, Indiana, 1991.

Nesbitt, Elizabeth, *Howard Pyle*, The Bodley Head, London, 1966.

New Britain Museum of American Art, *Stevan Dohanos: Images of America*, New Britain, Connecticut, 1985.

New Britain Museum of American Art, *The Sanford Low Memorial Collection of American Illustration*, New Britain, Connecticut, 1972.

Palgrave, Francis Turner, *The Golden Treasury of Songs and Lyrics*, Duffield & Company, New York. 1911.

Parrish Family Papers, Dartmouth College Special Collections, Hanover, New Hampshire, 1992.

Parrish, Lydia, *Slave Songs of the Georgia Sea Islands*, Creative Age Press, Inc., New York, 1942.

Parrish, Maxfield, 'Art at Haverford', The Haverford Review, Autumn 1942, pp. 14–16.

Parrish, Maxfield, 'Inspiration in the Nineties', The Haverford Review, II, Autumn, 1942, pgs: 14–16.

Parrish, Maxfield, Jr., Stephen Parrish (1846-1938), Vose Galleries of Boston, 1982.

Patterson, Ruth, The Influence of Howard Pyle on American Illustration, University of Rochester Press for the Association of College and Research Libraries, Rochester, NY, 1955.

Pennell, Joseph, Pen Drawings and Pen Draughtsmen: Their Work and Their Methods, Macmillan and Company, London and New York, 1889.

Pennell, Joseph, Modern Illustration, George Bell & Sons, London, 1895.

Pennell, Joseph, The Adventures of an Illustrator, T. Fisher Unwin, Ltd., London, 1925.

Philadelphia Museum of Art, Three Centuries of American Art – Bicentennial Exhibition, Philadelphia Museum of Art, Philadelphia, 1976.

Pitz, Henry Clarence, The Brandywine Tradition, Houghton-Mifflin Co., Boston, 1968.

Pitz, Henry Clarence, The Practice of Illustration, Watson-Guptill, New York, 1947.

Pitz, Henry Clarence, 200 Years of American Illustration, Society of Illustrators, New York, 1977.

Pollard, Percival, 'American Poster Lore', The Poster, Vol. II, London: Nilsson and Company, March, 1899, pgs. 123–24.

Price, Charles, Posters, George W. Bricka, New York, 1913.

Pyle, Howard, The Book of Pirates, Harper & Brothers, New York, 1921.

Rayner, E., Free to Serve, Copeland & Day, New York, 1897.

Read, Opie, Bolanyo, Way & Williams, Chicago, 1897.

Reed, Walt, Great American Illustrators, Cross River Press, New York, 1979.

Reed, Walt, John Clymer – An Artist's Rendezvous with the Frontier West, Northland Press, Flagstaff, 1976.

Rubenstein, Charlotte, American Women Artists, Avon Books, New York, 1982.

Saint Gaudens, Homer, 'Maxfield Parrish', The Critic, Vol. 46, June 1905, pgs. 512–21.

Saunders, Louise, The Knave of Hearts, The Atlantic Monthly Press, Boston, 1925.

Saylor, Henry H., Tinkering with Tools, Little Brown & Company, Boston, 1903.

Schau, Michael, 'All-American Girl': The Art of Coles Phillips, Watson-Guptill, New York, 1975.

Schau, Michael, J.C. Leyendecker, Watson-Guptill, New York, 1974.

Schauffler, Robert Haven, Romantic America, The Century Company, New York, 1913.

Schoonover, Cortlandt, Frank Schoonover: Illustrator of the North American Frontier, Watson-Guptill Publications, New York, 1976.

Schnessel, S. Michael, Jessie Willcox Smith, Thomas Y. Crowell, New York, 1977.

Scudder, Horace E., The Children's Book, Houghton Mifflin Company, New York, 1907.

Simon, Howard, 500 Years of Art and Illustration, World Publishing Company, Cleveland, 1942.

Skeeters, Paul W., editor, Maxfield Parrish: The Early Years, 1893-1930, Nash Publishing Corp., 1973.

Stuart, John Goodspeed, Young Maxfield Parrish, T. H. Pickens Technical Center, Aurora, Colorado, 1992.

Sunshine, Linda, The Maxfield Parrish Poster Book, Harmony Books, New York, 1974.

Smith, Francis Hopkinson, American Illustrators, Charles Scribner's Sons, New York, 1892.

Taft, Robert, Artists and Illustrators of the Old West, Charles Scribner's Sons, New York, 1953.

Tarrant, Dorothy, and John Tarrant, A Community of Artists – Westport-Weston 1900–1985, Westport Weston Arts Council, 1985.

Tebbel, John, A History of Book Publishing in the United States, Vol. 2, R.R. Bowker, New York, 1975.

Tennyson, Alfred, The Lady of Shalott, Illustrated by Howard Pyle, New York, Dodd, Mead and Company, New York, 1881.

Tiffany, Louis Comfort, 'Dream Garden', Curtis Publishing Company brochure, Philadelphia, 1916.

Twain, Mark, Saint Joan of Arc, Illustrated by Howard Pyle, Harper and Brothers, New York, 1919.

Wagner, Margaret E., Maxfield Parrish & the Illustrators of the Golden Age, Pomegranate Communications, Inc. Rohnert Park, California, 2000.

Watson, Ernest W., Forty Illustrators and How They Work, Watson-Guptill, New York, 1946.

Weinberg, Robert, A Biographical Dictionary of Science Fiction and Fantasy Artists, Greenwood Press, Westport, Ct., 1988.

Weitenkampf, Frank, The Illustrated Book, Harvard University Press, Cambridge, Mass., 1938.

Wilson, Woodrow, George Washington, Illustrated by Howard Pyle, New York, Harper and Brothers, 1896.

Wyeth, Betsy James, ed., The Wyeths: The Letters of N. C. Wyeth, 1901–1945, Gambit, Boston, 1971.

Wyeth, N. C., 'Howard Pyle as I knew him', The Mentor, June 1927.

'We Know Him Well', Newsweek, Vol. 55, June 6, 1960, pg. 110.

Wharton, Edith, Italian Villas and Their Gardens, The Century Company, New York. 1904.

Wharton, Susanna Parrish, The Parrish Family (Philadelphia, Pennsylvania), George H. Buchanan Company, Philadelphia, 1925.

Wiggin, Kate Douglas, The Arabian Nights, Charles Scribner's Sons, New York. 1909.

Willsie, Honore, 'Charles Dana Gibson Mobilizes American Illustrators', Delineator, November 1918. pg. 18.

Wisehart, M. K., 'Maxfield Parrish Tells Why the First Forty Years Are the Hardest', American Magazine, Vol. 109, May 1930, pp. 28–31.

Wolohojian, Stephan, Editor, A Private Passion – 19th-Century Paintings and Drawings from the Grenville L. Winthrop Collection, Harvard University, The Metropolitan Museum of Art, New York, 2003.

Wyeth, Betsy James, ed., The Letters of N.C. Wyeth, 1901–1945, Gambit Inc. Publishers, Boston, 1971.

Wyeth, Betsy James, ed., The Wyeths, Gambit Inc. Publishers, Boston, 1971.

Wyeth, N.C., 'For Better Illustration', Scribner's Magazine, #66, 1919, pg. 638–42.

Wyrick, Charles L., Jr., Director, The American Magazine 1890–1940, Delaware Art Museum, 1979.

Zea, Philip, and Nancy Norwalk, editors, Choice White Pines and Good Land: A History of Plainfield and Meriden, New Hampshire, Peter Randall, Portsmouth, N. H., 1991.

INDEX

INDEX